Richard D. Cohen Lectures on African & African American Art

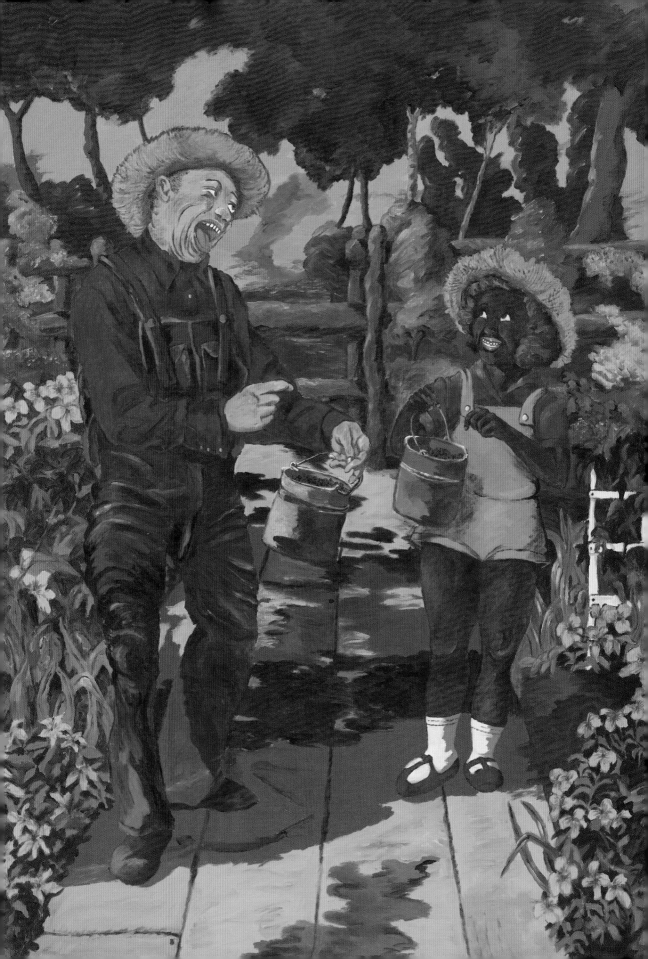

GOING *THERE*

Black
Visual Satire

Richard J. Powell

YALE UNIVERSITY PRESS New Haven and London
in association with the
HUTCHINS CENTER FOR AFRICAN & AFRICAN AMERICAN RESEARCH Harvard University

Parts of this book were presented as the Richard D. Cohen Lectures on African & African American Art, delivered by Richard J. Powell in March 2016 at Harvard University. The lectures, begun in 2013, are supported by Harvard's Hutchins Center for African & African American Research.

yalebooks.com/art

Designed by Wilcox Design
Set in Scala by Amy Storm
Printed in China by 1010 Printing International Limited

Library of Congress Control Number: 2020932053
ISBN 9780300245745

A catalogue record for this book is available from the British Library.

This paper meets the requirements of ANSI/NISO z39.48 – 1992 (Permanence of Paper).

10 9 8 7 6 5 4 3 2 1

Jacket illustrations: (front) David Hammons, *How Ya Like Me Now?* (fig. 85); (back) Beverly McIver, *Silence* (fig. 87)
Frontispiece: Robert Colescott, *Shirley Temple Black and Bill Robinson White* (fig. 63, detail)

CONTENTS

For Gloria Wade-Gayles
who taught me to read between
the lines

Well into the research, writing, and editing of this book, a new work of art came to my attention and compelled me to revisit several of the premises I initially had about this topic. Shortly after I submitted the book's outline to Yale University Press, hip-hop musician Donald Glover (in collaboration with filmmaker Hiro Murai) released the music video *This Is America,* a strange and beguiling amalgam of images and sounds that immediately captured the imagination of virtually everyone who viewed it in the spring of 2018, including me (see fig. 93). "Its allusions to the Charleston church massacre, to Jim Crow—era minstrel shows, and to police brutality," wrote *GQ* correspondent Amy Wallace in November 2018, "seemed a perfect crystallization of our national mood—a grim snapshot of where we are now." Glover confessed to Wallace about this music video, "There was a lot of room for it to be bad. Like: really, really bad. Like preachy bad. Over-reaching bad. Pretentious, racist-in-a-different-way bad." Glover's acknowledgment about the potential pitfalls of an artistic approach that, when exploring African American—related themes, concerns, and sensibilities, might easily flop and tumble into an ethnic harangue or an overly sentimental polemic, was revelatory, and made even more significant by his and Murai's decision to surround this music video/portrait in an unequivocal African American sarcastic framework.

While the third chapter of this book goes into greater depth about Glover and Murai's *This Is America,* it is perhaps useful to take special note of how this music video's satirical thrust—its patent trivializing of death, its spoofing of performativity, and its locus in a kind of collective madness and nihilism—is inextricably tied to black realities, artistry, and pathos: the narrative threads and parallelisms that, arguably, made *This Is America* so potent a work of art in the first place. When Glover admitted to how routine and simplistic it would have been to create an opinionated, journalistic, and categorical artistic statement, he was, in effect, conceding to how robust and efficacious *another* creative path could be—one that employed humor, irony, parody, caricature, exaggeration, burlesque, and derision in undertaking a national exposé, or in revealing the vices, follies, abuses, and shortcomings of a society or individuals. *This Is America* dramatically confirmed that the idea of a black visual satire wasn't an aesthetic anomaly or an Afro-

centric whimsy but, rather, a discursive mode whose artistic endurance and catalytic, even censorious and iconoclastic demands merited an extended, critical study.

As *This Is America* revealed across the wide spectrum of comments about it in multiple social media platforms, the protean nature of satire and its varying results are further confounded and realigned when the specter of race enters the discourse. The black satirist (or her/his surrogate) is an especially fascinating agent provocateur, frequently directing critiques within the black community (much to the chagrin of the intended targets), or against white supremacy and the customary race-based practices and discriminatory policies of that system. Black satirists *and black visual satirists in particular* form a unique body of artists/interlocutors who, in the wake of racial stereotyping and the reactive calls to create a positive, racially propagandistic art, instead produced an intriguing and often troubling body of work that prioritized a black cultural perspective within this trenchant, counter-narrative mode. Although a consideration of *This Is America* came toward the culmination of my approximately five-year investigation into the notion and formal workings of black, visual, and satirical forms of expression, its pulsating criticisms of early twenty-first-century conceit, tawdriness, and superficiality—embodied in Glover's alter ego, Childish Gambino, and in his expository, coryphaeus-like role—ricocheted and reverberated throughout this inquiry, but with fruitful and expansive consequences.

In retrospect, at the precise moment I received the invitation from Harvard University's Hutchins Center for African & African American Research to speak in the Richard D. Cohen Lectures on African & African American Art, I was deeply engaged in curating and programming for the Archibald Motley, Jr., exhibition at the Nasher Museum of Art at Duke University. But in my eventual acceptance letter to Henry Louis Gates, Jr., Alphonse Fletcher University Professor at Harvard and the director of the Hutchins Center, I had already shifted my outlook for a lecture topic away from Motley *proper* and toward modern and contemporary artworks that, similar to many of Motley's paintings, were dedicated to dismantling a racial status quo through the mindsets and mechanisms of satire. A Duke University graduate seminar on black visual satire was already slated for the fall 2014 semester, so that summer—with both the 2016 Cohen lectures and the graduate seminar in mind—I immersed myself in the literature about satire and gathered satirical imagery from across the art historical spectrum.

I was ably assisted that summer by Michael Tauschinger-Dempsey, then a PhD candidate at Duke in visual and media studies, and a research-

based artist working at the intersection of visual culture, anthropology, and social studies. The fall 2014 graduate seminar covered a range of topics, from satire in antiquity and early modern Europe to the clowns and satirists in many West African performance traditions and a host of subtopics (for example, theatrical and cinematic satires, satirical strategies in African American literature, "post-black" satire, blackface minstrelsy in 1970s African American art, and monographic studies of artists such as Robert Colescott, Renée Cox, Jeff Donaldson, Ollie Harrington, Spike Lee, Melvin Van Peebles, and Kara Walker). Seminar participants Anita Bateman, Mora Beauchamp-Byrd, Ivana Blago, and Shahrazad Shareef were central in helping to formulate a theory of black visual satire and fundamental to the seminar's overall success.

Skip Gates was a gracious host at Harvard, and my three Cohen lectures—an introduction to black visual satire, an examination of racial stereotypes as a tool in satire, and a discussion about painter/satirist Robert Colescott—elicited many thought-provoking comments for each of the lectures, especially from professors Suzanne Blier, Wallace Chuma, Cheryl Finley, Patricia Hills, Sarah Lewis, and from Skip Gates. Yale University Press editors Patricia Fidler and Amy Canonico were also present, and it was there that a preliminary outline for the book was conceived.

Along with transforming the lectures into book-length chapters, Yale University Press and I agreed that the book would have one more section—on the legendary black editorial cartoonist Ollie Harrington—so the next two years were spent conducting research, much of it in libraries and archives across the United States and abroad. At the invitation of Anne Lafont, directrice d'étude, L'École des Hautes Études en Sciences Sociales, I spent the fall of 2016 at the Institut National d'Histoire de l'Art (INHA) in Paris, where I studied, among other topics, Harrington's initial years of exile in Paris. Oddly enough, it was during my residency at INHA that I was fortunate enough to discuss Harrington's life and career with several knowledgeable individuals, such as Wendy Kay Johnson, Robert G. O'Meally, Daniel Soutif, Hervé Télémaque, and Walter O. Evans, MD, the latter one of the world's leading collectors of African American art and Harrington's American patron and advocate in the cartoonist's final years.

In 2017–19 research I conducted at several libraries and archives yielded an abundance of information, especially about Harrington's early Harlem career, his student days at Yale, and his tremendous cartoon output in American newspapers and German magazines. Librarians and archivists at the following institutions were quite helpful: Beinecke Rare Book and Manuscript Library and Sterling Memorial Library, Yale University; Vivian

G. Harsh Research Collection, Chicago Public Library; Joseph Regenstein Library, University of Chicago; Memorial Library, University of Wisconsin–Madison; Schomburg Center for Research in Black Culture, New York Public Library; Stuart A. Rose Manuscript, Archives, and Rare Book Library, Robert W. Woodruff Library, Emory University, Atlanta; and the Bibliothek für Sozialwissenschaften und Osteuropastudien–Zeitschriftenabteilung, Freie Universität, Berlin. Sarah W. Duke, curator of Popular and Applied Graphic Art, Prints and Photographs Division, Library of Congress, kindly guided me through the library's important collection of original Harrington cartoons. And several librarians at Duke have been instrumental in helping me locate certain newspapers, especially Carson Holloway, librarian for History of Science and Technology, Military History, British and Irish Studies, Canadian Studies and General History; Heidi Madden, librarian for Western European and Medieval/Renaissance Studies; and Lee Sorensen, librarian for Visual Studies and Dance. A special thanks goes to Marvin Tillman, manager, Duke University Library Service Center, for facilitating access to literally decades of bound volumes of the U.S. Communist Party's weekly newspaper, the *Daily World*.

Scholarly exchanges with Christine McKay, archivist and the author of a forthcoming biography of Harrington, and Gerald Horne, John J. and Rebecca Moores Chair of History and African American Studies at the University of Houston, were very informative, as were my conversations with Harrington's widow, Dr. Helma Harrington, their son, Oliver Harrington, and one of his daughters, Dr. Judy Kertesz. As with the three Richard D. Cohen Lectures at Harvard, I also delivered a lecture about Harrington's life and career on the occasion of the Yale University Art Gallery's annual Andrew Carnduff Ritchie Lecture, which served as a basis for this additional chapter. Jock Reynolds, the gallery's former Henry J. Heinz II Director and a longtime friend and past collaborator, kindly extended the invitation to deliver this talk in the spring of 2018.

The renowned printmaker and former Bay Area artist Margo Humphrey introduced me to Robert Colescott in Oakland, California, many years ago, which initiated my interest in him and in his delightfully irreverent paintings. Over the years, the writings of curator, art historian, and Colescott specialist Lowery Stokes Sims have kept me apprised of and constantly querying what motives lay behind Colescott's radical and satirical imagery: intellectual nourishments for which I am eternally grateful. Duke alum and Nasher Museum of Art board member Jason Rubell opened my eyes in 2008 to Colescott's pictorial and narrative audacity, and I profusely thank

him and the Rubell Family Collection for their *30 Americans* exhibition, one of the first clarion calls in the twenty-first century for something *black* and *fresh* in contemporary art. Elizabeth Brown, a PhD candidate in Duke's Department of Art, Art History and Visual Studies, kindly assisted me with some northern California library research, and, more recently, I have bene-fited from Colescott's biographical and visual records at Blum and Poe Gal-lery, Los Angeles, with special thanks to Nicoletta Beyer, Patricia Liu, and Minna Schilling. Jandava Cattron, Colescott's surviving wife, has champi-oned her husband's work for years, and I deeply appreciate her insights and support.

All of my colleagues at Duke University have been unstinting in their advice and counsel related to this book, but three deserve special mention. N. Gregson Davis, Andrew W. Mellon Research Professor of the Humanities, generously guided me through the classical literature concerning satire and, in some instances, translated key Latin texts. Neil McWilliam, Walter H. Annenberg Professor of Art and Art History, has intelligently written about French, English, and American political caricatures, and our conversations about this subset of Western art history have been invaluable to my research. Toril Moi, James B. Duke Professor of Literature, Romance Studies, English, Philosophy, and Theatre Studies, and director of Duke's Center for Philoso-phy, Arts, and Literature, provided me at a crucial moment with a key trans-lation of and an extended exegesis about an important interview pertaining to the 1972 film *Georgia, Georgia* in an obscure Swedish film journal.

Words can't express how grateful I am to all of the copyright holders who allowed me to publish the artworks and images under their reproduction rights and privileges. I am especially appreciative of the artists and their rep-resentatives who had enough confidence in me, or in their inspired genius, to permit their creations to appear alongside my thoughts and, thus, to pro-vide a visual counterpoint to the stated theories, critiques, and interpretations.

The final edits and requests for rights and reproductions for this book were completed with the administrative support and institutional input of the faculty and staff at the National Gallery of Art's Center for Advanced Study in the Visual Arts (CASVA). While serving as the spring 2019 Edmond J. Safra Visiting Professor at CASVA, I was aided in resolving the book's remaining edi-torial prerequisites by my adept CASVA assistant, Megan Driscoll. And thanks to CASVA deans Elizabeth Cropper, Peter Lukehart, and Therese O'Malley, many of the outstanding questions and issues about my manuscript were given an invaluable forum for critical examination and clarification. My editor at Yale University Press, Amy Canonico, has been a champion for this

book project from the start, and I am forever beholden to her for her advocacy, editorial guidance, and confidence in bringing this complicated and at times provocative topic into print. Special thanks to Raychel Rapazza, Sarah Henry, Laura Hensley, and Heidi Downey at Yale University Press. Without question, the thoughtful comments and wise suggestions that the anonymous reviewers provided greatly improved this manuscript.

As is the case with any long-term research and writing project, conversations with colleagues and friends over these past few years have yielded plenty of insights, thoughtful questions, demands for amplifications, and emotional support. For this unstinting encouragement I thank Lamonte Aidoo, Elizabeth Alexander, P. Elizabeth and Norman Anderson, Davarian L. Baldwin, Nada Ballator, Dawoud Bey, Lonnie G. Bunch III, Randall Burkett, Clifford Charles, Jasmine Nichole Cobb, Diego Cortez, Kareem Crayton, David C. Driskell, Allyson Duncan, Darby English, Teresa Grana, Michael D. Harris, Ranjana Khanna, Robert and Amy Lehrman, Pellom McDaniels III, Kobena Mercer, Amy Mooney, Derek Conrad Murray, Mark Anthony Neal, Steven Nelson, Nell Irving Painter, James T. Parker, Rebecca Roman, Kimerly Rorschach, John Staddon, Kristine Stiles, Greg Tate, Ruth Turner, and Bill Webb. My family has borne the greatest burden in connection to my "woodshedding" and years of labor on this book. Lisa, Michael, C. T., and Latté (2004–2018) have been a real blessing in this regard.

In the midst of my research, and while sharing with my wife, C. T., many of the more scathing and sarcastic artworks under discussion, she reminded me about the public's varying responses to this incendiary material and, paraphrasing a character from Alice Walker's novel *Meridian* (1976) who finds herself in a somewhat similar, politically incorrect creative enterprise, she caringly and half-jokingly said to me, "You'll pay for this." C. T. might be right. But, given the significant number of artists, past and present, who have intrepidly made their work a platform for an affective satirical statement within an African American cultural context and, as a result, faced critical bewilderment, unforgiving reviews, forms of censorship, or worse, this artistic phenomenon is clearly a subject worthy of serious study, and a scholarly enterprise that I want to believe is a meritorious one for facing the possible consequences—and the art historical rewards—of critically "going *there*."

"MORE THAN A ONE-LINER"

Ever since I started doing those appropriations, there's been criticism. And I was surprised at the criticism. I thought everybody would get it. . . . So I started doing that in '75 when I painted *George Washington Carver Crossing the Delaware*—which is a much more complicated painting than a lot of people think. It's a lot more than a one-liner. . . .

We've already come to understand that it's about white perceptions of Black people. And they may not be pretty. And they may be stupid. We didn't make up these images. So why should we take the heat? But it's satire. It's the satire that kills the serpent, you know.

— ROBERT COLESCOTT, INTERVIEW WITH PAUL KARLSTROM, 1999

There was the first time I was on a magazine cover — it was a cartoon drawing of me with a huge afro and machine gun. Now, yeah, it was satire, but if I'm really being honest, it knocked me back a bit. It made me wonder, just how are people seeing me?

— FIRST LADY MICHELLE OBAMA, TUSKEGEE UNIVERSITY COMMENCEMENT SPEECH, 2015

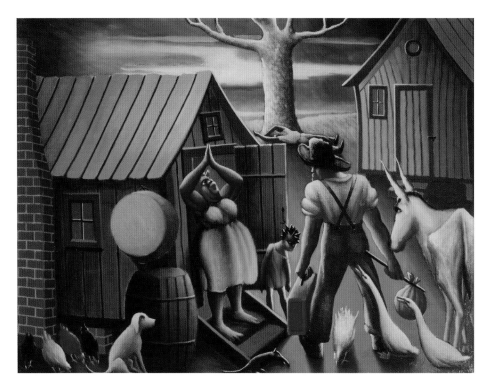

Fig. 1 / Archibald J. Motley, Jr., *Lawd, Mah Man's Leavin'*, 1940. Oil on canvas, 30⅛ × 40⅛ in. (76.5 × 101.9 cm). St. Louis Art Museum. Gift of the Federal Works Agency, Works Projects Administration 361:1943.

In a 1992 review of artist Archibald J. Motley, Jr.'s first major retrospective exhibition, *New York Times* art critic Michael Kimmelman acknowledged his struggles with understanding Motley's approach to representing African Americans. "It's difficult to get a handle on the art of Archibald J. Motley Jr. . . . ," Kimmelman began, "50 of whose paintings are at the Studio Museum in Harlem. In the 1920s this black artist from Chicago devoted himself to painting black life, and he made portraits of family and friends that bestow on their subjects a remarkable, rarefied dignity." Kimmelman continued, "How could he also be responsible for pictures like 'Lawd, Mah Man's Leavin'' (1940) with its cartoonish stereotypes of the lazy farmhand snoozing under a tree and the bosomy mammy?"[1]

Art critics were not alone in their confusion over works such as Motley's *Lawd, Mah Man's Leavin'* (fig. 1). During the two-year run of *Archibald Motley: Jazz Age Modernist* (an exhibition I curated in 2014 for the Nasher Museum of Art at Duke University, and which subsequently traveled to museums in Fort Worth, Los Angeles, Chicago, and New York), I repeatedly responded to

exhibition-goers about this painting.[2] Visitors who were otherwise enthralled by Motley's consummate portraiture, lively genre scenes, and sophisticated, colorful compositions were, like Kimmelman, troubled by the exaggerated black bodies and stereotypic settings in which they were placed. "You know, I just love Motley's paintings," is how many people would begin their comments, but as they turned to *Lawd, Mah Man's Leavin'*, they would continue their remarks with, *"But what about those big red lips on that fat ugly woman, and the nappy hair on that raggedy little black girl?"*

Like centrifugal, double bull's-eyes, the woman's lips and little girl's hair drew viewers deep into the bizarre pastorale of *Lawd, Mah Man's Leavin'*, where barnyard critters and their human attendants seemingly share the same lineage. Standing barefoot on the steps of a diminutive wooden hut straight out of a Russian folktale, the woman in this painting—serpentine, pendulous, and exultant—comes across as more chimerical than realistic: a remotely human creature, flaying about in a shimmering, fungus-covered underworld. And her partners in corporeal outlandishness—a hulking idler in overalls, his recumbent doppelgänger in the far distance, and a picaninny straight out of *Uncle Tom's Cabin*—embodied the worst racial stereotypes imaginable that, in tandem with the pecking hens, aggressive geese, a lusty dog, a lazy cat, and a backside-revealing, knee-knocking mule, all conjured an African American phantasm of major proportions: an image of rural black life so outrageous and ridiculous as to single-handedly campaign, by negative example, for the mass migration of self-respecting southern blacks to the urban North, with nary a look backward.

Taken at face value, these grotesque figures—from the creative mind and skilled hands of an accomplished black artist—are either unadulterated stereotypes, the signs of racial self-hatred, or simply inexplicable. But if one considers Motley's painting in the broader contexts of African American popular culture in the introspective years of the late 1930s, leading up to the seventy-fifth anniversary of the Emancipation Proclamation, and Motley's professed, career-long mission to "truthfully represent the Negro people," there might be another, more tactical reason for his broad and outlandish characterizations.[3] Rather than limiting his portrayals to a visual version of literary or historical naturalism—an approach that relies upon documenting the social conditions to help compose, script, and, eventually, to propagandize the picture—Motley deployed narrative-producing strategies of an insubordinate kind and, at times, a symbolic character. The anxieties that blacks felt in these years concerning racial discrimination, political disenfranchisement, and social hierarchies within their communities were such

that, for a truth-seeker like Motley, painting realistically was only marginally effective in capturing a profound, subcutaneous black reality. Instead, what Motley's paintings executed were complacency-jarring renderings of African Americans that, through their fictive settings and expressionistic configurations, opened floodgates of racial memories, phobias, and fantasies, so visceral and inescapable that, upon experiencing them, more authentic concepts of the race could emerge.[4]

Motley's rebellious side cannot be understood without considering it in the context of satire. Commonly linked to prose, poetry, or the dramatic arts, the art of satire uses a variety of literary and rhetorical devices to expose the perceived failings or shortcomings of individuals, institutions, or social groups. By way of the full spectrum of literary constructs and bit players, a satirist may employ invective, sarcasm, burlesque, irony, mockery, teasing, parody, exaggeration, understatement, or stereotype in a discursive presentation, all to hold his or her predetermined target up to extreme ridicule and scorn.[5]

Going There: Black Visual Satire proposes that the art of satire not only has a long-standing and infamous place in world culture, but that it also has a distinctly African American lineage and presence in modern and contemporary visual art. The challenge of developing a set of working definitions for satire is itself a formidable task, but locating this genre in a black American tradition of visual, verbal, and performative practices raises the intellectual stakes and poses multiple questions about art, its reception, and its repercussions. One of those questions is the notion of creative risk and how satire relentlessly puts the artist and the artwork's audience in an antagonistic relationship: a situation that, rather than fostering comprehension and degrees of certainty, fuels the effrontery and confusion for which satirical works are notorious. Another issue this study investigates is the logic and the rationale behind deploying stereotypic and racist referents in black satirical art, and whether this strategy achieves the artistic objectives of its creators. Finally, the dialectical paradigms that the art of satire invariably bring to the surface—artist and audience, words and images, comedy and crisis, and mockery and valor, to name a few—complicate a straightforward understanding of this form of discourse. Apperceptions of satire's motives and targets that also take into account the biographical and historical contexts of its initiators further confuse the critical enterprise but, as *Going There: Black Visual Satire* shows, these multifocal inquiries intercept and analyze satire's active ingredients and greatly assist interpreters in measuring its overall effectiveness.

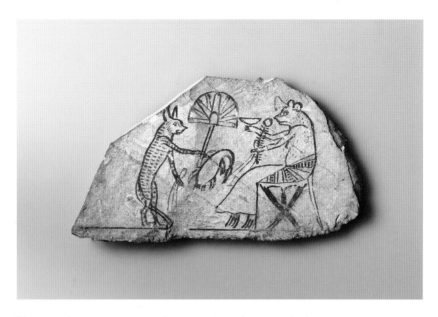

Fig. 2 / Wall fragment depicting a cat approaching an enthroned mouse with offerings, c. 1295–1075 BCE, ancient Egypt, Thebes. Limestone, 3 1/2 × 6 13/16 × 7/16 in. (8.9 × 17.3 × 1.1 cm). Brooklyn Museum. Charles Edwin Wilbour Fund, 37.51E.

Fig. 3 / Hieronymus Bosch, *Ship of Fools, or the Satire of the Debauched Revelers*, c. 1490–1500. Oil on wood, 28 13/16 × 12 13/16 in. (58 × 32.5 cm). Musée du Louvre, Paris. © RMN — Grand Palais/Art Resource, NY.

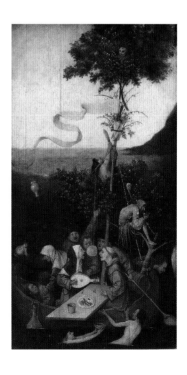

Although firmly ensconced in literature, satire and its constantly changing, combustible aspects may be expressed more powerfully in visual art. Utilizing caricature and its propensity for visual shorthand, anatomical distortion, narrative hyperbole, and symbolism, artists since antiquity have produced striking and often incisive commentaries on the peoples and events of their times.[6] An ancient Egyptian limestone painting of a cat submissively approaching a seated, corpulent mouse demonstrated that, even in New Kingdom Egypt, an artist felt empowered enough to question conventional social hierarchies, albeit through an illustrated animal fable (fig. 2). The late fifteenth-century panel paintings by the Netherlandish artist Hieronymus Bosch, depicting apocryphal scenes of folly, gluttony, and miserliness, are paradigmatic of this artist's mockeries and condemnations of religious heretics and hypocrites, via his visual renderings of metaphors and puns (fig. 3).[7]

Visual satire's illustrious triumvirate from the early modern periods of Western art—England's William Hogarth, Spain's Francisco Goya, and France's Honoré Daumier—placed hard-hitting commentaries about peoples and politics at the very center of their paintings and prints, giving particular weight to the pretentiousness of elites, greed and corruption within the professional classes, and vanity across the entire social spectrum (figs. 4–6).[8] The twentieth century—with its unconventional warfare, geopolitical realignments, and interminable deliberations from decade to decade about human rights and changing social mores—provoked countless artists to unapologetically satirize the defects and failings of the status quo, from the antiwar and anti-capitalist statements of George Grosz and David Smith, to the post-Hiroshima expressions of human vulnerability and military madness by sculptors Ed Kienholz and Robert Arneson (figs. 7, 8).[9]

Historically, the preferred art media for visual satirists were the graphic arts (that is, drawing and printmaking) and, since the twentieth century, film and video, in which pictorial criticisms were often accentuated by a memorable title, a wry caption, or a provocative, accompanying narration. The roots for this collusion between image and text were established in the eighteenth and nineteenth centuries, when British artists such as Hogarth, Thomas Rowlandson, and James Gillray both delighted and antagonized audiences with irreverent broadsides and sardonically captioned comics that directed critical barbs and fault-finding charges at all levels of society. "One of the key changes that took place during the seventeenth century and which eventually multiplied to become a major social force during the eighteenth century," writes historian Steven Cowan about the growth of literacy in England, "was the twofold process of the secularisation of reading amongst

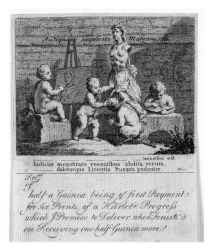

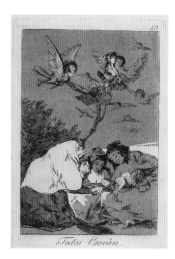

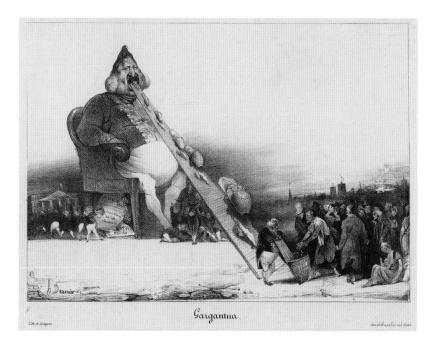

Fig. 4 / William Hogarth, *Boys Peeping at Nature*, 1731–37. Etching, 5⅞ × 4¹³/₁₆ in. (15 × 12.2 cm). British Museum, London. 1857, 0509.17.

Fig. 5 / Francisco de Goya y Lucientes, Plate 19 from *Los Caprichos: All Will Fall* (*Todos Caerán*), 1799. Etching and burnished aquatint, 8⁷/₁₆ × 5¹¹/₁₆ in. (21.4 × 14.4 cm). Metropolitan Museum of Art, New York. Gift of M. Knoedler & Co., 1918, 18.64(19).

Fig. 6 / Honoré Daumier, *Gargantua*, 1831. Lithograph, 9¼ × 12¹/₁₆ in. (23.5 × 30.6 cm). Yale University Art Gallery, New Haven. Everett V. Meeks, B.A. 1901, Fund, 2016.155.1.

the poor and labouring classes and the transformation of reading practices from being essentially private . . . into being freely acknowledged and performable within the public domain."[10] Satirical graphic art with incisive, witty captions was clearly part of this literacy-generating curriculum. Across the channel, French caricaturists Honoré Daumier and Charles Philipon wreaked comparable havoc with their drawings and cartoons of people, largely in the illustrated satirical journals *La Caricature* and *Le Charivari*. In the United States and, notably, in the years immediately following the Civil War and coinciding with the global financial crisis in the 1870s, political cartoonist Thomas Nast combined scathing caricatures of politicians and social policies with polemical declarations and combative subheadings, which irrevocably set the template and tenor in American editorial cartoons for more than a century.[11]

In the relatively short history of Western cinema, satirizing warfare, politics, and powerful institutions such as the mass media has been very popular, whether the specific target was a particular figure, as in Nazi Germany's Adolf Hitler in Charles Chaplin's *The Great Dictator* (1940) and North Korea's Kim Jong-il in Trey Parker's *Team America: World Police* (2004), or governing institutions and political systems, as in Stanley Kubrick's *Dr. Strangelove, or How I Learned to Stop Worrying and Love the Bomb* (1964) and Terry Gilliam's *Brazil* (1985).[12] At the turn of the twenty-first century, when many filmmakers rediscovered and eagerly embraced satirical frames of reference in their work, director Spike Lee created *Bamboozled* (2000), a film that directed its outrage not just toward contemporary mass media and its lowbrow enter-

Opposite: Fig. 7 / George Grosz, *Drinnen und Draussen* (*Inside and Outside*), 1926. Oil on canvas, 31½ × 46¾ in. (80 × 118.7 cm). Yale University Art Gallery, New Haven. Promised gift of Dr. and Mrs. Herbert Schaefer, ILE 1981.9.12. © 2019 Estate of George Grosz/Licensed by VAGA at Artists Rights Society (ARS), NY.

Above: Fig. 8 / Robert Arneson, *General Nuke*, 1984. Glazed ceramic and bronze on granite base, 77¾ × 30 × 36¾ in. (197.5 × 76.2 × 93.3 cm). Hirshhorn Museum and Sculpture Gardens, Smithsonian Institution, Washington, DC. Gift of Robert Arneson and Sandra Shannonhouse, 1990.12. © 2019 Estate of Robert Arneson/Licensed by VAGA at Artists Rights Society (ARS), NY.

tainment designs, but toward racial stereotypes and their insidious circulation throughout American life. Scattered throughout *Bamboozled* (which will be discussed in greater depth later) are behind-the-camera soliloquies, the protagonist's disembodied confessionals, and "fourth wall" explanations that, when juxtaposed against the film's script and plethora of stereotypic props, infused Lee's story line with both keen social insights and emotionally ambivalent musings.[13]

The give-and-take in visual satire between image and text is fundamental to developing a working definition of this particular idiom. In his short but useful essay "Pictorial Satire: From Emblem to Expression," literary critic and William Hogarth specialist Ronald Paulson put this issue at the forefront of his treatise, paraphrasing from art historian Ernst Gombrich's essay "The Cartoonist's Armoury" the idea that words have a precedence over images, and that "a form of *ekphrasis*—a poem reprised in an image or, alternatively, a picture put into words" commonly operates in satirical imagery. But after Paulson briskly carried his readers through pictorial satire's classical and Christian models, the roles of narrative and rhetoric more broadly, the implementation of Rococo styles and their gestures toward the grotesque, and, finally, the elements of parody, caricature, and humor in pictorial satire, he qualified Gombrich's textual precedent, or at least its capabilities, with the actuality of the multiple readings (or "multiple gestalts") for pictures: a heterogeneous component whose interpretative possibilities in graphic satire "may have ultimately a greater potential for subversion . . . than [the] verbal."[14]

When artists are not exclusively relying on text or narrative, the imagery often has an uncanny way of taking control of an artwork's accompanying text or title and, then, pressing that covert visual realm and/or associative dimension into illuminating recalibrations of the picture's subject. "When Marx in *Capital* asks what commodities would say if they could speak," art historian and theorist W. J. T. Mitchell reminds us in *What Do Pictures Want?*, "he understands that what they must say is not simply what he wants them to say. Their speech is not just arbitrary or forced upon them, but must seem to reflect their inner nature as modern fetish objects."[15] Similarly, one could say that images are rarely subservient to their titles or accompanying narratives but, instead, hijack these textual guideposts into performing supporting roles in a frequently inchoate realm of optical illusions, pictorial traces, and ideographic symbols that converse with the viewer's inner angels and demons. Channeling in *Lawd, Mah Man's Leavin'* a virtual songbook of blues singers and their lyrics of unrequited love and desertion—such as Ma Rainey's "Boys,

I can't stand up; I can't sit down / The man I love has done left this town," or Blind Blake's "Ain't no need of sittin' with my head hung down / Your black man ought to get outta town" — Archibald Motley reworked the conventional social realist context of American scene painting in his canvas and broadcasted these blues-inflected sorrow songs, satirically, from a surrealistic, "down-home" backwater, and their ecstatic howl (or is this an emancipatory shout-out?) from the jaws of an otherworldly figure.[16]

Motley's dual targets in *Lawd, Mah Man's Leavin'*—the southern United States' disputably backward African American underclass and, in sharp contrast, the urban North's "black bourgeoisie" and its paralyzing paranoia concerning caste and class—are, admittedly, unlike the satirical vehemence of, say, Weimar Germany's most reproachful, mudslinging artist, George Grosz. And yet, as an African American satirizing his fellow African Americans, Motley undertook in *Lawd, Mah Man's Leavin'* a comparable challenge: a broad character sketch that, not unlike Grosz's antiwar sentiments and parodies of modern German life, lampooned the blues tropes of abandonment and loss and, simultaneously, mocked the socioeconomic biases and color prejudices within Motley's own black middle class.

As the virulent responses to Motley's *Lawd, Mah Man's Leavin'* demonstrated, the social and psychological impact of visual satire is huge. For most people, being the target of criticism is, of course, embarrassing and painful, but satire's peculiar blend of censure, wit, and ridicule brings an especially cutting quality to the criticism, enough to push the targets of satire toward the metaphorical and literal edge. Political and religious authoritarians have long recognized satire's derisive potential (and felt its sting) and, at moments of heightened political tensions and social dissent, political cartoonists are frequently among the first victims of the censors.[17]

Two of the most notorious cases in recent history of political cartoons instigating religious figures and governmental officials to take public, censorious actions—cartoons by Kurt Westergaard in 2005 of the prophet Muhammad, published in the Danish newspaper *Jyllands-Posten,* and cartoons by Zapiro (Jonathan Shapiro) in 2009 of "The Rape of Justice" being perpetrated by South African president Jacob Zuma and his political allies, published in the South African newspaper *Mail and Guardian*—laid bare the inflammatory repercussions of contemporary visual satire, as well as the competing ideological positions such cultural skirmishes bring to the surface. These two instances of political cartoons generating social unrest and national introspection, as detailed and analyzed by literary critic Mikkel Simonsen, raised a very complicated situation within Denmark and South Africa:

balancing a democracy's commitment to freedom of expression with constituents (including the religious leaders and government officials in the political cartoonist's line of fire) who, whether justifiably or instinctively, question the satire's political motives, critical reach, or moral integrity. Paradoxically, it is frequently within democracies, points out Simonsen, "where governments and media use exceedingly powerful measures to systematically indoctrinate as well as infringe on our human rights." Simonsen continues, "It is increasingly difficult to tell right from wrong as the democracies, within themselves, and in turn with the world around them, change." That something as seemingly innocuous as a flippant drawing has the capacity to stir people's emotions and, in the most extreme cases, incite them to violence argues for taking these works of art seriously and, considering the satirical context in which they operate, querying their social value and underlying power.[18]

"BUT ONE'S IRONIC"

Before delving into greater detail on how visual satire works, and if an artistic entity such as black visual satire even exists apart from visual satire in general, it would be useful to first ask, "Why is black visual satire a topic worth exploring?" Besides Archibald Motley's work triggering this line of art historical inquiry, the works of another African American artist, Robert Colescott, also prompted me to think about black visual satire. Although I had been aware of Colescott's controversial works for many years (having first encountered the artist and his work in his Oakland, California, studio in 1978), it wasn't until seeing a selection of his paintings—in the 2008 exhibition *30 Americans,* from the Rubell Family Collection—that I realized Colescott's satirical stance deserved a closer look. *Pygmalion,* the Colescott painting I kept circling back to in *30 Americans,* intrigued me on several levels: Colescott's unexpected and wicked portrait of the celebrated Irish author George Bernard Shaw, the artist's visual commentaries on great works of art, and how Colescott's allusions to narcissism, voyeurism, and metamorphosis inadvertently intersect and act as satirical agents (fig. 9).[19] It dawned on me that by marshaling a sequence of figural juxtapositions and racial reversals—from the painting's assorted, odd couplings, to its black Mona Lisa and, one can assume here, a black Eliza Doolittle—Colescott conveyed the same satirical effects of, say, literary parodies or semantic word games. And that situating Shaw's early twentieth-century comedy about class transformation and female refashioning within an African American context could, in the postmodern era, reframe this acculturation parable inside a post-black melodrama with broad, farcical results.

Fig. 9 / Robert Colescott, *Pygmalion*, 1987. Acrylic on canvas, 90 × 114 in. (228.6 × 289.6 cm).
Rubell Family Collection, Miami.

Another set of images I encountered around the same time also prompted a deeper look into the workings of satire as related to African Americans. Cartoonist Barry Blitt's cover for a 2008 issue of the *New Yorker,* featuring future U.S. President Barack Obama and First Lady Michelle Obama appearing, respectively, as a turban-wearing jihadist and an Afro-coiffed 1970s black radical, brought into wide public scrutiny the never-ending power of cultural and racial stereotypes, as well as the difficulties in differentiating between stereotype and satire (fig. 10). Portraying the ersatz radical president and first lady in the Oval Office of the White House, Blitt took the *New Yorker*'s right-wing parody to even greater extremes, including in the depicted interior a framed portrait resembling al-Qaeda terrorist leader Osama bin Laden and an American flag burning inside the Oval Office's fireplace.

The *Washington Post*'s editorial cartoonist Tom Toles immediately recognized the interpretative puzzle posed by Blitt's image and, just days after its publication, Toles created his own, inter-referential cartoon that underscored satire's pictorial equivocality and the necessity of a genre-defining, clued-in audience (fig. 11). Toles's cartoon depicted two people in front of a newsstand looking at the cover of the infamous *New Yorker* and an identical cover of "*American Racist Monthly*" magazine, with one of the people

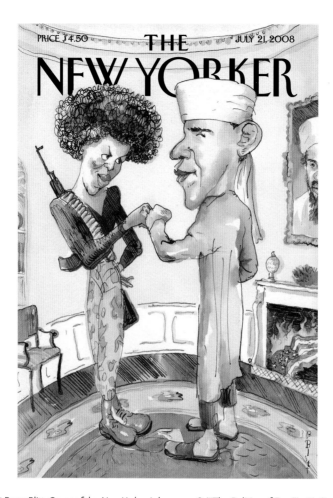

Fig. 10 / Barry Blitt, Cover of the *New Yorker*, July 21, 2008 ("The Politics of Fear"). © Conde Nast.

declaring, "But one's ironic." And along the cartoon's lower-left margin, Toles added two parenthetical mini-commentators, one of whom exclaims, "The sophisticated can spot the difference."[20]

Blitt's and Toles's cartoon colloquy regarding the president and Mrs. Obama wasn't the first time I encountered such cross-conversational, stereotype-laden satires of African Americans in print culture. I immediately thought of the nineteenth-century pictorial repartee between *Harper's Weekly*'s Thomas Nast and the *Daily Graphic*'s Thomas Worth that I came across years ago. In response to Nast's 1874 illustration *Colored Rule in a Reconstructed (?) State*—a stereotypic picture of buffoonish black South Carolina state legislators—Worth created *"Tu Quoque!"* ("You, also" in Latin), in which an "Artistic Colored Gentleman" is drawing Nast with a stick-figured rat's body (figs. 12, 13). "I wonder," glibly asks the depicted black artist, "how

Harper's artist likes to be offensively caricatured himself?" while a second, seated black man replies, "Golly, if *Harper*'s picture is nasty, yours is nastier!" Apart from the obvious punning on Nast's name, the representation of a black artist functioning as Worth's quasi-surrogate introduced an especially novel concept in 1874: a black satirist hurling the pictorial daggers at a white target.[21] And like Blitt's and Toles's cartoons of almost 130 years later, Worth's pictorial critique of Nast's illustration troubled the certitude of distinguishing stereotype from satire, as well as the idea of an assumed white audience for these "nasty" pictures.

Before embarking on a more fully developed exegesis of black visual satire, it is important to differentiate satire from stereotype. Perhaps the key to this definitional disaggregation can be found in this chapter's second epigraph, which quotes artist Robert Colescott saying his painting *George Washington Carver Crossing the Delaware: Page from an American History Textbook* is "a lot more than a one-liner" (fig. 14).[22] Colescott's deliberately cartoon-like painting, although populated with every imaginable black stereotypic persona one could conjure, nevertheless incorporated several additional elements—such as a new title for his painting modified from Emanuel Leutze's

Fig. 11 / Tom Toles, Editorial cartoon for the *Washington Post*, July 2008.

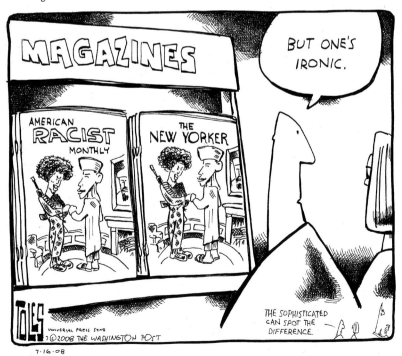

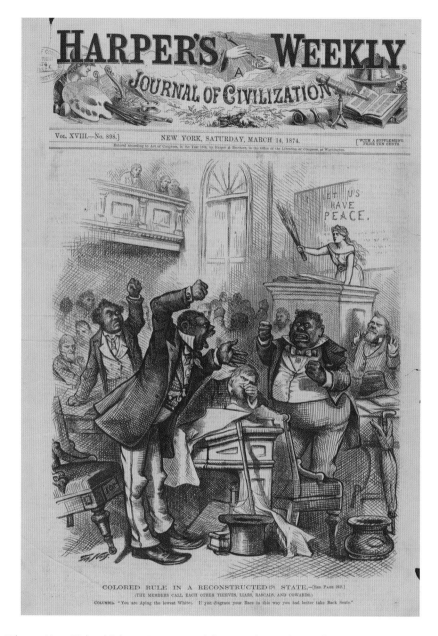

Fig. 12 / Thomas Nast, "Colored Rule in a Reconstructed (?) State (The Members Call Each Other Thieves, Liars, Rascals, and Cowards")" "COLUMBIA—'You are Aping the lowest Whites. If you disgrace your Race in this way you had better take Back Seats.'" *Harper's Weekly*, March 1874. Library of Congress, Washington, DC.

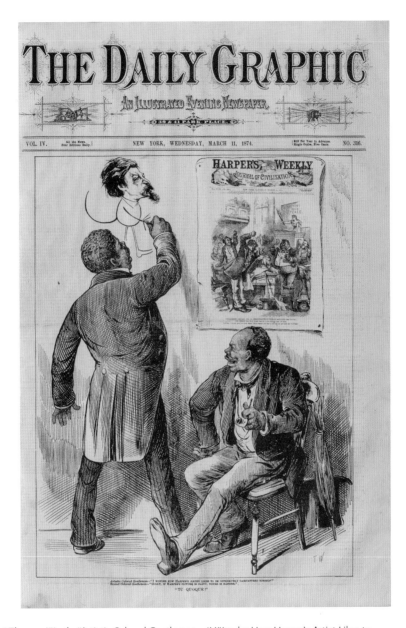

Fig. 13 / Thomas Worth, "Artistic Colored Gentleman—'I Wonder How Harper's Artist Likes to Be Offensively Caricatured Himself?" "Second Colored Gentleman—'Golly, If Harper's Picture Is Nasty, Yours Is Nastier.' 'Tu Quoque!'" *Daily Graphic*, March 1874. American Antiquarian Society, Philadelphia.

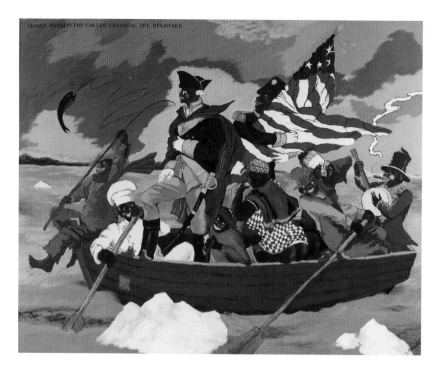

Fig. 14 / Robert Colescott, *George Washington Carver Crossing the Delaware: Page from an American History Textbook*, 1975. Acrylic on canvas, 84 × 108 in. (213.4 × 274.3 cm). Private collection, St. Louis.

1851 original (mischievously stenciled onto the canvas in the upper-left corner) and a flag-hugging, black standard-bearer—which, in combination with the motley crew of stereotypes, pushed the painting into the irony-filled, satirical realm.[23] In Colescott's view, one should not confuse the rather simplistic, one-dimensional denigrations of a rudimentary stereotype with the more complicated, multidirectional attacks of a carefully crafted satire. Revisiting Nast's *Colored Rule in a Reconstructed (?) State,* the artist's Republican Party credentials and legendary talent for politically astute caricatures could not lift this particular cartoon beyond a racist diatribe against African American men.[24] In contrast, Worth's *"Tu Quoque!"*—featuring two well-dressed black respondents, one drawing Nast as a hybrid academic portrait bust and crude, graffiti-like figure—offered the *Daily Graphic*'s subscribers a layered, largely satirical assault: on *Harper's Weekly*'s criticism of Reconstruction politics; on Nast's racist depictions of black men; and against the American press's default, white male point-of-view, to which political cartoonists (including Worth himself on numerous occasions) habitually slanted their work.[25]

　　Several definitions of stereotype contribute, in their respective ways, to this shared notion of a one-dimensional, predetermined image. The

Barnhart Dictionary of Etymology (1988) traces the word back to 1789, and to the French adjective *"stéréotype,"* referring to printing technologies that utilized solid molds of composed type. The English version of this word and its metamorphosis into a noun describing a fixed and unchanging image, formula, or phrase emerged before 1819. *A Dictionary of Literary and Thematic Terms* (2006) encapsulates both of these, describing "stereotype" as "a highly generalized idea, situation, or character, derived from an oversimplified treatment in a work." Interestingly, *A Dictionary of Film Studies* (2012) extends this idea of a stereotype's generalized handling of its object, modifying the previous definitions with the following: "a fixed, repeated characterization of a person or social group that draws on the real world whilst serving as a shortcut to meaning and expressing shared values and beliefs." What is clear from all of these definitions is the enduring concept of a single, unitary perception that, as in printing technologies, produces an unvarying, flat rendering of its victim.[26]

Instead of putting stereotype on the same level as satire, these previous examples suggest that, like parody and irony, stereotype is a tool, or mode of expression, that a satirist, in combination with other discursive strategies, might use to target an object of criticism. In other words, a satire might include a stereotype (such as Motley's grotesque group in *Lawd, Mah Man's Leavin'* and Colescott's offensive crew in *George Washington Carver Crossing the Delaware*), but a stereotype's oversimplified image or idea of a type of person or thing is, by definition, incapable of developing or complicating its critique beyond one, overarching, ingenuous opinion. What a stereotype needs in order to transcend that singular, dead-end path, as evidenced in both Motley's and Colescott's multiple perspectives and interpretive entrées, is a calculated placement *within* the polysemic sprawl and breadth of a deft, penetrating satire.

The ancient Egyptians, Greeks, and Romans all referenced in their respective notations and texts particular discursive forms that, utilizing combinations of sarcasm, parody, and humor, could be described as satires. When literate Romans eventually named this special style of poetic communiqué *"satura"* (which translates into "medley"), it was often folded into the Latin phrase *"lanx satura"* ("a full dish" or "hotch-potch"), possibly alluding to the oldest known form of satire that originated with the Greek cynic Menippus, who lived in the Hellenistic-Roman town of Gadara in present-day Jordan.[27] "Menippean satire," writes classicist Joel C. Relihan, "is an indecorous mixture of disparate elements, of forms, styles, and themes that exist uneasily side by side, and from which no coherent intellectual, moral, or

aesthetic appreciation may be drawn."[28] Although Menippus's poetry and verse are lost, his Roman followers consulted the surviving, fragmentary homages to his style by his contemporaries that, as described by Relihan, were multivalent and mixed gravity and mockery, usually in the form of highly animated diatribes, and through scripted dialogues between fools, rogues, and cynics.

Seeing Hellenistic and Roman *grylli*—figural engravings on gemstones that imaginatively combined human, animal, and vegetal elements—as the visual equivalent to a Menippean satire, art historian Barbara Maria Stafford extended that ancient parallelism to art forms several millennia into the future, typified by Spanish artist Francisco Goya's *Los Caprichos* series of aquatints and etchings. Plate 19 from Goya's *Los Caprichos,* a macabre scene of three peasant women disemboweling a hybrid half bird, half human creature, while a flock of similar monstrosities fly overhead, formed part of a Menippean medley that, according to Stafford, created "coarse aphorisms, giving evidence for proverbial superstitions, injustice, and vice" (see fig. 5).[29]

Other early forms of satire also have their origins in the ancient world, especially the Roman Empire.[30] The famous first-century BCE Roman poet Horace is known for helping formulate a satirical voice that, modeled on the seventh-century BCE Greek poet Archilochus, has a relatively moderate tone, gently criticizing and making fun of the vices and follies of his times, and playfully goading his fellow Romans to abandon their improper, antisocial behaviors and embrace a more righteous path to citizenship. Possibly channeling Horace and several passages from his *Art of Poetry* that put ribald, ancient literary styles in opposition to an ostensibly more uplifting and noble approach to art, William Hogarth's *Boys Peeping at Nature* (his illustrated subscription ticket for his "Modern Morals" print series *A Harlot's Progress*) juxtaposed the artistic diligence (and exhibited prudence) of three putti with the audacity of a satyr, the latter peering under the skirt of a Great Mother Goddess effigy (see fig. 4). Hogarth included in his print a caption with two quotations from *Art of Poetry,* which can be translated into English as "[If by chance] difficult (or hidden) subjects must be presented (or revealed) in new terms, . . . (artistic) license will be granted if it is used with moderation": these Horatian sentiments, in tandem with Hogarth's instructive, constitutively comparative image, primed the subscribers to *A Harlot's Progress* for the artist's self-controlled but satirical perspective within his work.[31] And yet, in Hogarth's quintessential way, his juxtaposition of discretion and discourtesy in *Boys Peeping at Nature* did not completely idealize or vilify either sentiment but, rather, created a "satiric norm" in which the

artistic stakes are built upon the ability to introduce a dialectical narrative that, in all likelihood, troubled an audience's sense of moral grounding. "I'll pursue poetry made of what's known, so anyone could hope to do it," Horace further mused in *Art of Poetry*, presciently providing Hogarth with an artistic way forward, "yet, trying it, sweat and toil in vain." The Roman poet added, "Such is order and juxtaposition's power, [such] may its beauty crown the commonplace."[32]

Juvenal, a Roman poet of the late first and early second centuries CE, wrote a collection of satirical poems that positioned himself as an outraged witness to social corruption and cultural decline. Juvenalian satire, unlike Horatian satire, churns with indignation and outrage, railing against contemporary transgressions and moral decay with the help of exemplars from mythology and an idealized past.[33] Juvenal's tendency to vociferously complain and, in the words of the classicist Victoria Rimell, to make overtures toward "satiety, to fulfillment of the grossest hunger, ambition, and wickedness," perhaps found a kindred spirit in François Rabelais, the sixteenth-century French cleric, physician, and humanist, whose controversial novels *Pantagruel* (1532) and *Gargantua* (1534–35)—about mythical giants and their extravagant appetites, scatological habits, and violence-prone lives—made satire in its more experimental, heterogeneous form an important component of early modern literary discourse.[34]

"These texts," writes literary critic Bernd Renner about Rabelais's novels, "are dominated by [a] farcical satire that, despite the clearly comical violence, seems closer, at times, to Juvenalian indignation than to Horatian elegance." Renner's observations about Rabelais's litigious tone probably had its origins in philosopher and semiotician Mikhail M. Bakhtin's writings on "the carnivalesque" and in his essay "Discourse in the Novel" (1934–35), where he probes, among numerous forms of human address, propaganda, or "publicistic" speech, a form that criticizes, polemicizes, exposes, and ridicules in ways not dissimilar from Juvenalian rhetoric. Because of Rabelais's Horatian and Juvenalian models, Renner continues, "this open, dialogic form is predestined for an attack on authoritative voices, such as dominating narrators, received truths and dogmata, and classical exempla." One also finds in Rabelais's *Gargantua,* writes Renner, a focus on satire's "culinary connotations and . . . aspect of the Bakhtinian lower-bodily stratum, [such as] excrement," as well as on other corporeal excesses (that is, gluttony, indigestion, the odors of human flesh, corporeal grime and secretions, among other physiological immoderations).[35]

The nineteenth-century visual satirist Honoré Daumier was also smit-
ten by the combination of a Juvenalian and Rabelaisian "one-two punch,"
as seen in his *Gargantua,* a satirical portrait of Louis Philippe, France's king
between 1830 and 1848 (see fig. 6). Coming into power immediately after
the July Revolution's mass uprisings, Louis Philippe and his cabinet soon
earned the public's ire (on account of France's precipitous economic decline
and the government's conservative, monarchical protocols), and he became
the frequent target of ridicule in the weekly newspapers *La Caricature* and
Le Charivari. Daumier's merciless *Gargantua*—depicting an enormous Louis
Philippe continually being fed people's tax money, while enthroned on an
armchair-commode through which he defecates French currency—was cen-
sored by the French government, elicited a 500-franc penalty, and led to
Daumier's incarceration for six months in Paris's Sainte-Pélagie prison.[36]
"Daumier's work is the magnifying mirror on our moral as well as physical
ugliness," wrote the French literary critics Edmond and Jules de Goncourt
in retrospect, "where the grotesque becomes frightening and the comic rises
to the level of Juvenal's punishing verse."[37]

Canonical works of Western satire, from the writings of Chaucer, Rabe-
lais, and Molière, to the contemporary efforts of comedian Stephen Colbert,
filmmaker Spike Lee, and novelist Paul Beatty, employ discursive strategies
that, while in sync with their respective art forms and historical moments,
reflect many of the same modalities that also animated the ancients. The
devices of the satirist—unflattering portraiture, strange accounts and occur-
rences, fictional sojourns, startling comparisons and juxtapositions, fables
in which animals enact human deeds, word games, rhetorical debates, per-
tinent aphorisms, and hypercritical orations—all become the vehicles for
attack, and bring to the fore appeals to virtue. The satirical spirit infiltrates
virtually all literary forms and discursive practices and, thus, it is often dif-
ficult to separate this particular impulse and mark its literal boundaries.[38]
From the comedic to the tragic, satires tug on an au courant audience's under-
standings and vague moral underpinnings, with an insistence and militancy
on par with manifestoes, or even curses. Indeed, Greek comedy's satirical
roots developed in that culture's Dionysian celebrations and ritualistic pub-
lic exhortations of obscenities and verbal abuses, which were thought to
drive away evil spirits and bring fertility to the community. And this vituper-
ative and Dionysian side of satire, despite philological arguments to the con-
trary, traces its ancestry, or at least its libidinal disposition, back to the satyr,
the half-human, half-goat mythological creature whose physical and social
attributes aligned with satire's hybrid qualities and liberatory impulses.[39]

BLACK VISUAL SATIRE

But how do these definitions and prototypic examples of satire correspond with visual art and, specifically, black visual culture? One important qualifier is the role that racism can play as satire's target, or primary foil. In works of black visual satire that rely on pictorial narratives or recognizable social settings, a depicted story line that addresses racial discrimination, chattel slavery, or other explicit examples of racism has the license to illustrate the irrationality, the absurdity, or the gross inequity of racist acts, policies, and social practices.[40] Take, for example, Elizabeth Catlett's print *I Have Special Reservations,* from her 1946–47 *Negro Woman* series (fig. 15). In addition to the print's tongue-in-cheek title—a wry euphemism for segregated accommodations in public transportation systems before the civil rights era—the grim faces on the four black women seated behind the "Colored Only" sign contradict the insinuation of fashionable exclusivity implied by having reservations. Not only is racism Catlett's narrative vehicle in *I Have Special Reservations,* but its aberrance, condescension, and slippery escalation into physical confrontations and bloodshed all invite a politically committed artist

Fig. 15 / Elizabeth Catlett, *I Have Special Reservations*, from the *Negro Woman* series, 1946. Linocut on cream wove paper, 6³⁄₈ × 6⁵⁄₁₆ in. (16.2 × 16 cm). Brooklyn Museum. Emily Winthrop Fund, 1996.47.2. © 2019 Catlett Mora Family Trust/Licensed by VAGA at Artists Rights Society (ARS), NY.

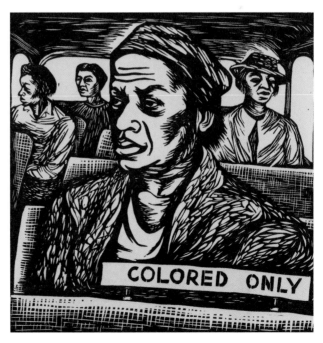

Fig. 16 / Oscar Micheaux, *Body and Soul*
(still), 1925. Film (black and white, silent), 79
minutes.

Fig. 17 / Robert Downey, Sr., *Putney Swope*
(still), 1969. Film (color, black and white,
sound), 85 minutes.

such as Catlett to register a decidedly sarcastic and emotionally seething
visual response.

But racism is not the only target in black visual satire. Criticisms are
frequently directed at the black community itself, bringing to light the social
hypocrisies, political compromises, and moral failures of African Americans.
A classic example of this satire-generating, community-based introspection
is Oscar Micheaux's 1925 film *Body and Soul,* which builds its story around
a corrupt African American pastor, self-sabotaging acolytes, and gullible
churchgoers. Using such character-disclosing, silent film techniques as cross-
cuts, close-ups, and iris in/out effects, Micheaux transformed his lead, played
by the celebrated and much-beloved actor Paul Robeson, into an avaricious
and brutish villain whose offensives provocatively mirrored the black com-
munity's more predacious aspects (fig. 16).[41] As if such disgusting charac-
ters weren't enough, Micheaux placed alongside these figures their derisive
counterparts: members of the community whose buffoonish behaviors and

comical hijinks made them equally contemptible in the satire's design. This inward-directed criticism is an especially complicated maneuver, as it is often dismissed by community apologists as racist and, as seen in the negative reactions to Archibald Motley's *Lawd, Mah Man's Leavin'*, swiftly denounced with the stereotype label.

Curiously, another famous work of visual satire that, despite drawing a scathing portrait of African Americans, dodged the "racist" label, was *Putney Swope* (1969), filmmaker Robert Downey, Sr.'s hilarious and stinging commentary on the immorality of Madison Avenue, its profit-driven creative vacuity, and the corrupting influences of the United States' corporate culture, especially on socially committed and, presumably, uncompromised solicitants (fig. 17). It was this last target of *Putney Swope's*—toward a segment of society that was perceived as morally principled—that ensnared the film's African American characters who take control of a New York advertising agency, depicting them as materialistic, despotic, gangster-like, debauched, and just as ethically corrupt as the white ad-men who previously led the company. Sarcastically and mischievously branding the usurped and, now, black advertising firm "Truth and Soul," Downey performed a sly, narrative coup in this name, by critiquing the average person's sense of proprietorship over all things verifiable, and by mocking contemporary claims by African Americans of an authentic, spiritual quintessence.

Making use of the discursive strategy of role reversals, some of *Putney Swope's* most biting scenes involved the few surviving white employees at Truth and Soul, each experiencing the verbal abuse and racial discrimination of which they were once the authors and beneficiaries, but which is now committed by their black department heads. Through a string of workplace-based skits, borscht-belt comedy routines, and several farcical examples of Truth and Soul's awful television commercials (the latter, shot in Technicolor as opposed to the black-and-white film stock of the majority of the scenes), *Putney Swope* revealed its countercultural, anti-corporate message—but, ironically, by way of a "Black Power" story line and its subtexts of political insurgency, proactive self-defense versus nonviolent engagements, and community empowerment. However, in the absurdist world that Downey cinematically created—a Menippean satire of the most extreme, dissolute kind—no one emerged untouched by ridicule, and despite the streetwise warnings uttered throughout the film by the "wise fool" character "the A-rab" (played by the soon-to-be "blaxploitation cinema" actor Antonio Fargas), none of *Putney Swope's* black characters showed an iota of social consciousness, accountability, or dignity. The film's final scene—a soaring glass storage unit,

once filled to the brim with U.S. currency, but now looted, irreparably shattered from a Molotov cocktail lobbed by the A-rab, and dripping wet from firefighters' water hoses and overhead sprinklers—was a wry commentary on capitalism's hollowed-out promise in the politically turbulent, radical-chic late 1960s: a state of affairs in which African Americans, vociferously insisting on their fair share of the American Dream and its economic rewards, were essentially coopted and left with that dream's worthless, waterlogged dregs.[42]

Although black visual satire aims at an array of targets, a preponderance of these satires are either leveled at the African American masses or are discursively situated within a black vernacular context. Scholars of African American literature, from James Weldon Johnson and Sterling Brown in the early twentieth century to Henry Louis Gates, Jr., and Trudier Harris at the end of that same century, have argued for the centrality of black vernacular traditions in African American arts and letters.[43] Likewise, the importance of black vernacular or popular culture in black visual satire—as a target of criticism, as a source for the satirizing agent, or as a cultural or theoretical framework for the critique—cannot be overstated. For example, when New York–based artist Jayson Musson took on the role of the hip-hop art doyen Hennessy Youngman for his mock series of Internet primers on successfully navigating the contemporary art world, the parody seamlessly shifted between satirizing the alleged genius of vaunted hip-hop personalities and lampooning a hopelessly self-important art world, all within the context of a vernacular, profane, and, yet, commonsense perspective.[44] Like many of the black comedians from the so-called "chitlin' circuit" era who performed in an impecunious, African American "clown" mode (such as Jackie "Moms" Mabley and Dewey "Pigmeat" Markham), Musson's comic, hip-hop masquerade allowed him to criticize the often farcical world of hip-hop, and to simultaneously voice unfiltered, uncomfortable truths about the at times absurd contemporary art scene and its encounters with African American artists.

Around the same time Musson was showing his *Art Thoughtz* series on YouTube, performance artist Kalup Linzy was presenting in galleries and museums his playful spoofs of television soap opera–like scenarios as live performances and short videos. These small-screen media works—shot with hand-held cameras and featuring Linzy in campy melodramas about interpersonal relationships gone wrong and the anguish of aspiring artists with dubious talents—put the ethnic colloquialisms, mannered affectations, and sartorial styles of working-class African Americans, especially women and gay men, at the center of each video. Linzy's default characters in these pieces (for which he donned women's clothing, wigs, and cosmetics) were arche-

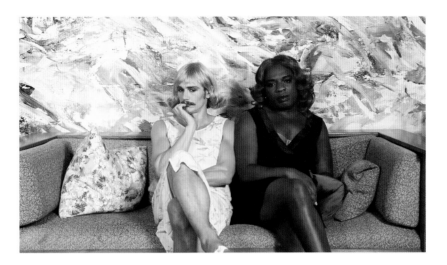

Fig. 18 / Kalup Linzy, *Ozara and Katessa* (still), 2017. Video (color, sound), approx. 60 minutes.

typal, or stereotypic, black women: meddlesome elders, self-sacrificing mothers, status-conscious professionals, and superficial party girls who, in this era of instant mobile communication, played out their particular story lines and neuroses in cell phone conversations with one another.

In contrast to Musson's rather pointed, unforgiving critiques of hip-hop philosophers and the contemporary art scene's pigeonholing of African American artists, Linzy's parodies all had an air of gentle prodding; he was not leveling harsh critiques at the histrionics and social dramas of his "churen" but, rather, lightheartedly satirizing and making fun of the layers of illusions through which everyday black people communicate. "I am role-playing, satirizing, and paying tribute at the same time to the genre of the soap opera," Linzy told an interviewer about his art practice in 2012.[45] Recent works by Linzy, such as *Ozara and Katessa*—a ten-part video collaboration with Hollywood actor and filmmaker James Franco—continued his parodic trajectory but, with both Linzy's and Franco's respective careers as the collaboration's metanarrative, *Ozara and Katessa* broadcasted its dramas as if a mockumentary, yet in the emotionally earnest and superficial guise of a drag performance (fig. 18). Linzy's videos betrayed more than a familiarity with the underground films of Andy Warhol and John Waters, as well as with the more recent, African American "morality tales" of filmmaker Tyler Perry, but what Linzy augmented this cinematic subgenre with was a tender, African American–inflected razzing of female and/or queer masquerades, drawn from the rarely traversed zones and milieus of the black vernacular. "The sheer comic absurdity lies in the satirical sending-up of everything that

ciful, black rural world that contains the scene's bizarre cast of characters is key to unraveling Motley's satirical intentions and intimations. The dream world, or the *nightmare* of a turquoise sky, purple shacks, and acidic yellow terra firma, all point to an illusion, made even more otherworldly and cerebral by Motley's reiteration on the distant horizon of the departing "Man," his body—either an anecdotal flashback, or a premonition—lying underneath the cut-off branches of a lavender tree. Not only is Motley's satire situated here in a fictional, rural outback, but it also resided, circa 1940, in the guffaw-producing, tongue-in-cheek milieu of hokum: the deliberate and playful deployment in urban blues music of African American vernacular elements and colloquial idioms for aural, comical, and satirical effects. The highly rhythmic, countrified sounds of hokum, along with the sexually suggestive double entendres in its lyrics, found an aesthetic home in Motley's *Lawd, Mah Man's Leavin'*, with its multiple insiders' messages and racial affronts. Again, Motley's likely targets—African American illiteracy, rural underdevelopment, and excessive sensitivity concerning class throughout the black community—are contained and visually anatomized within this absurdist black frame.[50]

The *black* in black visual satire not only refers to the satirist, or to the broader social context of satire; it points toward the discernable cultural elements within the satire that contribute to the identificatory affect of the work and, most importantly, to its decipherability as a black satire for selected audiences. A classic example of how these identifying tropes function in black visual satire can be seen in conceptual artist David Hammons's late 1970s and early 1980s art installations and assemblages (fig. 20). The elements that Hammons incorporated into these satire-infused works—tiny whorls of wooly African American hair, broken pieces of 33-rpm black vinyl records, discarded pork rib and chicken bones, and assiduously flattened, grease-stained brown paper bags—appeared to most art audiences as urban detritus and evocations of post-minimalist sculpture. But for black audiences these same things—redolent with a corporeal blackness and an evidentiary black material culture—had a significance that, when experienced as art, invested these installations with a poetry and spiritual dimension that was not only recognizable to many black Americans, but critical of an emotionally detached, Euro-American avant-garde and its vacuous explorations of visual conceptualism.[51]

This high-stakes game in satire—when its content is held hostage by an ostensible subject and implicit metanarrative, the latter recognizable only to a conversant subset of spectators—is key to its appeal *and* dismissal.

Fig. 20 / David Hammons, Installation view of *Victory over Sin* in the PS1 exhibition
Afro-American Abstraction (February 17–April 6, 1980), PS1, Long Island City, New York.
Digital Image © The Museum of Modern Art/Licensed by SCALA/Art Resource, NY.

For knowledgeable observers—including the flesh-and-blood objects of
the satire—the entire affair works on multiple levels: ideally, as a brilliant
riposte or, as demonstrated in the above epigraph recounting First Lady
Michelle Obama's response to her portrayal on the cover of the *New Yorker,*
a misguided assault.[52] For those audiences who remain clueless about the
satirical intent or effect of the artistic critique or attack, the response is either
nonexistent, mildly irritated, unfavorable, or, as played out in several early

twenty-first-century responses to Western cartoons satirizing the Islamic faith, lethal threats and retributions.[53] What all these examples suggest, and what remains constant in the context of a black visual satire, is a substantial repertory of cultural signs and discourses upon which the satire depends for its meaning, and upon which its audience relies for full membership in this critical undertaking. And, yet, what is also at play is a kind of jovial and comedic spirit, roguish in nature, that is present especially in satire's visual manifestations.[54]

"You do not simply 'decode' an utterance," writes linguist Norman Fairclough about human comprehension. "[You] arrive at an interpretation through an active process of matching features of the utterance at various levels of representations you have stored in your long-term memory." In the case of comprehending satire, prototypes (or what Fairclough refers to as "members' resources") are collectively shared by affiliates who, through years of similar processes of socialization and comparable interactions, form communities of common understanding about a social subdivision's coded communiqués. Therefore, what the satirist depends on is an audience's ability to tap into its memory bank of word/image recognition, grammatical syntaxes, narrative constructs, typologies of living and inert matter, assorted situational scenographies, and other "members' resources," in order to make sense of nonliteral, visual communications.[55]

In African American culture, delivering a harsh yet rhetorically imaginative and usually entertaining critique of someone or something is called "signifying." In *Juba to Jive: A Dictionary of African-American Slang* (1970, 1994), editor and novelist Clarence Major defines signifying as "performance talk; to berate someone; to censure in twelve or fewer statements; [to speak] ironically."[56] Anyone who has been on the receiving end of schoolyard or sidewalk signifying knows all too well that being signified upon is like being slapped unexpectedly: a stinging and sudden event and, yet, more primal and elementary in nature than something accomplished and sophisticated. Major's definition—which makes note of the pithy, whiplash transience of this type of African American verbal deprecation—is not easily overlaid onto visual art, nor onto the highly developed craft of satire. The closest visual analogy to black verbal signification is the contemporary image macro, often referred to as the meme: an Internet-generated image—usually a photograph—of someone or something, which is superimposed with a brief, large-font text message, and that transmits a sarcastic, often humorous thought. The image macro's simple concept and, especially, its image/text format that offers signifying capabilities to practically anyone with a modicum of com-

puter skills and a somewhat discerning critical eye, feel light-years removed from visual satire's more conceptually nuanced and multilayered performances. Like a stereotypic picture's singular, biased synopsis of a person or a notion, an image macro's conceptual essence is its unipolar defamation: a digital "drive-by" shooting that, in spite of its vernacular wit and spot-on discernment, doesn't allow for a deep and sustained critique of its target.[57]

In contrast to the signifying powers of image macros, satires, which bring to the forefront of their criticisms moral correctives or social restitution, form a unique, discursive body, usually through juxtaposed pictorial narratives and contiguous visual comparisons and contrasts (for example, Horace's gloss about the power of "order and juxtaposition"). Such productive models, as in John Wilson's print *Deliver Us from Evil,* are usually composed in a symmetrical, equation-like fashion (also evident in George Grosz's *Drinnen und Draussen*), in order to make explicit the satirist's dialectical argument (in the particular instance of Wilson's World War II–era lithograph, the differences *and* the similarities between an anti-Semitic, Nazi-stricken Europe and a capitalist-dominated, white supremacist United States) (fig. 21).

However, many satirists reject restorative projects such as Wilson's *Deliver Us from Evil,* built upon carefully structured, clear-cut formulas, instead choosing to castigate entire social systems and to conceptually wreak havoc upon the world as we know it. Literary critic Steven Weisenburger

Fig. 21 / John Wilson, *Deliver Us from Evil*, 1943. Lithograph, artist's proof, 12 ⅛ × 15 ⅛ in. (38.7 × 49.2 cm). Metropolitan Museum of Art, New York. Gift of Reba and Dave Williams, 1999, 1999.529.191id. © Copyright Agency. Licensed by Artists Rights Society (ARS), New York, 2019.

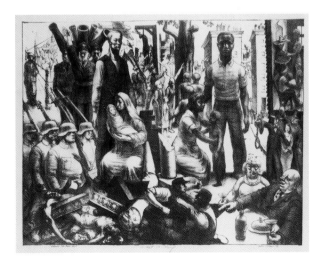

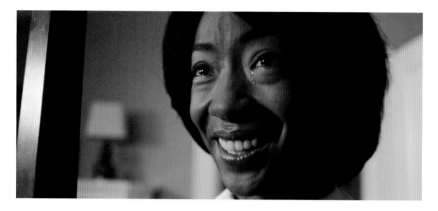

Fig. 22 / Jordan Peele, *Get Out* (still), 2017. Film (color, sound), 104 minutes.

describes these "slash-and-burn" satires as "degenerative," striving to "subvert hierarchies of value and to reflect suspiciously on all ways of making meaning, including its own." This degenerative model—comparable in its no-holds-barred, discursive annihilation to the Menippean mode of satirical assaults, and to Russian philosopher Mikhail Bakhtin's theories of the "carnivalesque"—aims for mass destruction, indiscriminate ridicule, and, as seen in Motley's *Lawd, Mah Man's Leavin'* and Robert Downey, Sr.'s *Putney Swope,* allover chaos, where no spot within the work, or part of the story, escapes a sense of madness or abnormality.[58]

On the subject of African American literary satires, literary critic Darryl Dickson-Carr argues that "satire frequently fails or succeeds according to its ability to make the reader feel as if she or he has entered a world that is immensely disgusting and clearly mad, except for those corners of the text's universe where the sensible, albeit not infallible, satiric voice resides."[59] This degenerative approach—which African American visual artists have frequently undertaken, from Depression-era provocateur Motley to *fin-de-siècle* postmodernists Robert Colescott and Kalup Linzy—calls for a virtual collapse of any semblance of narrative continuity or pictorial order. This seismic effect, as seen for example in Colescott's *Pygmalion,* generates a fragmented world where the only rational respite is the painting's most recognizable art historical element—the center-left *Venus de Milo* figure—and its assorted human actors, whose gesturing bodies and facial expressions roughly support an experimental, nonlinear account revolving around reflection, self-analysis, aesthetic discernment, and the psychological conundrum of racial blackness (see fig. 9).

A more recent example of a black visual satire depicting a world gone insane—apart from the sporadic and droll voice of consciousness and ver-

nacular common sense — is filmmaker Jordan Peele's *Get Out* (2017): a work that, despite its widespread critical and commercial success, reviewers struggled to categorize cinematically (fig. 22). That these reviewers and commentators were unable to agree if *Get Out* was a comedy, a drama, a work of science fiction, a horror film, or a racial allegory spoke to its locus in the amorphous realm of satire, where juridical instability is customary, and shifting ontologies exemplify the genre's insubordinate reputation within the arts.

Almost immediately *Get Out* transported viewers to an otherworldly place, where the seemingly random kidnapping of an unsuspecting black man is accompanied aurally by a strange musical pairing: a World War II – era song, "Run Rabbit Run," by the British music hall duo Flanagan and Allen, and the contemporary hip-hop artist Childish Gambino's funky strut "Redbone." If viewers listened closely, they heard in these two, rather disparate musical excerpts the shared call to circumvention and awareness: Peele's relentless critique of African Americans proffered throughout the film, in the weird unfolding of suspicious events that the main black protagonist experiences, and in the words of racial paranoia and conspiratorial theorizing comically uttered by the lead character's best friend, a Transportation Security Administration (TSA) officer and fellow African American. Unafraid to venture into such racially charged mythologies as exceptional black male athleticism and sexual prowess, *Get Out* actually incorporated these stereotypes into its improbable story of African American abductions orchestrated by a clandestine biotechnological company harvesting black bodies for infirmed white ones. Ridiculing and playing on the audience's easy identification with a neoliberal, Barack Obama – era, racially inclusive worldview, Peele's brilliant script and deft direction ably dismantled that sanctimonious position and, by making the folksy TSA officer (played by actor and comedian "Lil Rel" Howery) the black protagonist's savior and *Get Out*'s principal articulator of race-based instances of body snatching (also an artistic metaphor for cultural appropriation and spiritual evisceration), Peele essentially entrusted his satire's success to black popular culture's historically ingrained apprehensions and doubts when it comes to African Americans assuming their long-denied but rightful place in the greater American enterprise.[60]

Many strategies of black visual satire go beyond the generative or degenerative models, employing specific pictorial devices and narrative structures in order to strike at the heart of perceived shortcomings and injustices. As mentioned earlier, the depictions of incongruous and/or problematic social situations, such as Joyce J. Scott's *Man Eating Watermelon* — a beaded

sculpture of a naked black man unsuccessfully crawling out of the clutches of a bear trap–like watermelon—produced visual ironies that most audiences would have understood as legitimate attacks on deeply held racial stereotypes and dominate white narratives (fig. 23). But Scott's sculpture took an additional step beyond a more conventional, sarcasm-filled diatribe against stereotypes. Subliminally alluding to the "humorous" twentieth-century postcards and ceramic tchotchkes that depicted black children being stalked and devoured by predatory Florida alligators, Scott interjected a decidedly more sinister concept into her sculpture, in concert with the all-too-familiar racist trope of black people instinctively craving this particular farm produce. Another device in the black visual satirist's repertoire, and which was also a part of Scott's satirical strategy in *Man Eating Watermelon* (as adduced from the fluctuating syntactical roles of the words "Man Eating"), is the art of visual punning, or giving pictorial form to metaphorical concepts, as well as to familiar aphorisms and proverbs. Again, Archibald Motley's *Lawd, Mah Man's Leavin'* makes greater satirical sense if audiences can link the painting's folksy scenes and characters to such common sayings as "Good riddance to bad rubbish," "A hit dog'll hollah," or something or someone being "ass-backwards." The ideal audience for these works requires a certain level of African American cultural comprehension and the ability to appreciate each work's ironies and visual puns in order to grasp the satirical intent and impact.[61] Without this common understanding of verbal and visual messaging in art, other interpretations and, possibly, misperceptions, will supersede a satirical locus of meaning.

Fig. 23 / Joyce J. Scott, *Man Eating Watermelon*, 1986. Beads, thread, 2 × 8 × 3 in. (5.1 × 20.3 × 7.6 cm). Collection of Linda DePalma and Paul Daniel.

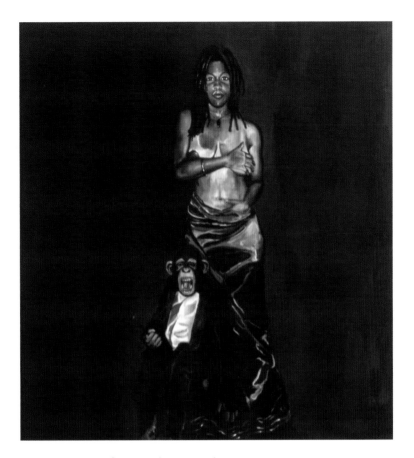

Fig. 24 / David McGee, *Portrait of Picasso/Side A*, 1997. Oil on canvas, 99 × 96 in. (251.5 × 243.8 cm). Location unknown.

Another work that helps explicate the satire-creating possibilities in African American art is Houston-based painter David McGee's *Portrait of Picasso/Side A* (fig. 24). The convening of a realistic, starkly rendered, partially clothed woman; a realistic depiction of a tuxedo-wearing, paintbrush-wielding chimpanzee; and a somewhat incongruous title for this painting perfectly illustrates some of the most common artistic tactics for producing visual satires. By bringing together two or more pictorial elements—black woman, chimpanzee, tuxedo, and paintbrush—that are not typically associated with one another, McGee ushers into the painting an irrational and, perhaps, humorous factor, underscoring satire's vexing, often trickster-like character. When the artwork's title is, as in this particular instance, incompatible or oppositional to the painting it labels, the artist creates a contentious ambience around the work, in which satire's characteristic opacity and

combativeness are given full rein. If a viewer attempts to link this painting's cryptic title to its corresponding images of a seductive black woman and a screaming, paintbrush-brandishing ape, then the results invariably yield multiple, image-and-text-supported interpretations: satirical perceptions that identify McGee's intended targets as the legendary artist/womanizer Pablo Picasso or, alternately, the prototypical male chauvinist artist; circumscribed European American standards of feminine beauty; art's dehumanizing, objectifying exploits, and so on. As a textbook example of black visual satire, *Portrait of Picasso/Side A* utilizes all of the compositional strategies and conceptual tools McGee has at his disposal—including a receptive and culturally sophisticated audience—to castigate the Western art world for its historical failures of peoples of color, and artists like Picasso's notoriously unprincipled, primate-like behaviors toward women.[62]

A more recent example of this image/text/context covenant in black visual satire appeared in 2012 on Berlin-based conceptual artist Adrian Piper's website. On the right side of the website's September 2012 "News" page, the artist posted—in a white, italicized serif font, within a light-gray rectangular inset against the page's intergalactic, Milky Way–like background—the following announcement: "Adrian Piper has decided to retire from being black. In the future, for professional utility, you may wish to refer to her as The Artist Formerly known as African American." On the left side of the same page's light-gray rectangular inset was a color photographic headshot of the smiling Piper, digitally altered in such an amateurish way as to chromatically render her entire face, neck, and hairline in sickening shades of orange and purplish-brown. Superimposed on the photograph's lower quadrant—in a white, typewriter-like font—is a signed and dated note that reads:

> Dear Friends,
>
> For my 64th birthday, I have decided to change my racial and nationality designations. Henceforth, my new racial designation will be neither black nor white but rather 6.25% grey, honoring my 1/16th African heritage. And my new nationality designation will be not African American but rather Anglo-German American, reflecting my preponderantly English and German ancestry. Please join me in celebrating this exciting new adventure in pointless administrative precision and futile institutional control!
>
> **ADRIAN M. S. PIPER [HER SIGNATURE]**
> **20 SEPTEMBER 2012**[63]

Beneath the photographic headshot is a caption that, in addition to providing Piper's name and other descriptive information, lists the photographic work's title as *Thwarted Projects, Dashed Hopes, A Moment of Embarrassment*. Taken as a whole, Piper's September 2012 post fits effortlessly into a discussion of black visual satire, not only because of its uncanny way of addressing virtually every imaginable category of a satirical statement, but because it offers a model exemplar of how racial blackness, whether socially constructed or historically experienced, asserts its ontological will onto cultural discourses in such ways as to narratively buttress a sardonic position. "Her race is fully an art move," art historian Darby English is quoted as saying concerning Piper's philosophical and sarcastic uses of the socially discerned self, "cynical in the way that Duchamp's toilet is cynical."[64] Considering this acclaimed artist's complicated yet incontrovertible investment in African American issues and, since the early 2000s, her decision to not support scholarly or curatorial efforts that group and/or categorize her with other African Americans, Piper, notwithstanding her "retirement" from the "job" of blackness (in the similar parlance of popular musician Prince's short-lived rejection of his name), knows that her post sarcastically touts (vis-à-vis its none-too-subtle overtures to blackface minstrelsy) the professed utility and adventures of being "6.25% grey."

But let's not pretend that, as a result of satire's informational and cultural requirements and the mental stretch spectators must undertake in order to understand its pictorial complexities, all members of the audiences will have the capacity to comprehend and embrace its labyrinthine, conceptual breadth. Many viewers will not understand what the satirist is up to and, frankly, this abandonment of a significant segment of an artwork's potential audience is part and parcel of satire's modus operandi. The instability of meaning plays a large role in black visual satire's artistic profile, prohibiting not only those we assume won't fathom the circuits of African American cultural insinuations and verbal colloquialisms (as articulated in the 1970s catchphrase "It's a black thang; you wouldn't understand"), but excluding many so-called cultural insiders, too. A historical example of this is the intra-racial debates in the 1990s and the conterminous denunciations directed at the defiantly satirical works of artist Kara Walker.

One can see how unsuspecting spectators with an unswerving ethical core were either confused or offended by Walker's artworks: meticulously rendered silhouettes of gratuitous sex and violence, all situated in a vague antebellum mise en scène, in which neither slaves nor masters emerged morally unscathed, nor where innocents are narratively privileged or blacks

idealized. Furthermore, as literary critic Phillip Brian Harper has argued, Walker's deviations from (and, paradoxically, her subtle acknowledgments of) representational verisimilitudes and, instead, her visual gestures toward "abstractionist aesthetics" irretrievably estranged her from her critics who, themselves, were constrained by socially informed, reality-based expectations of figuration in art.[65] For Walker and other artistic traffickers in sociocultural narratives of chaos, the only way the visual arts can even come close to the terrors of slavery, the horrifying, documented examples of white-on-black violence, and the psychological damage that racism has inflicted upon subsequent generations of Americans is through this narratively hyperbolic, distorted lens. "It takes a bold person," writes novelist Paul Beatty, "to buy a dime bag of absurdity."[66]

Although unspoken in the numerous critiques of Walker, it is her status as a female satirist sine qua non that possibly resided behind so much of the condemnation of her work. Even considering that her biggest critics in the mid-1990s—the renowned artists Betye Saar and Howardena Pindell—were themselves African American females and occasional satirists (and both of whom have important works that will be discussed later), the idea of an African American woman diving head-on into the dangerous (that is, male-dominated) waters of unstable meaning in art, indiscriminate ridicule of both blacks and whites, and coarse narratives of satyr-like profligacy and licentiousness was noteworthy, if not unprecedented.[67] "The alchemy of satire into political discourse for black women in the U.S. has not come easily," writes cultural critic and American studies specialist Jessyka Finley. And yet satirical strategies that reference stereotypes and are "overlaid by an attitude of disgust, . . . as a preponderance of affect, an excess of emotion" become the tactics that black female satirists frequently employ and that distinguish them.[68] Indeed, the standard-bearers of twentieth-century black satire—novelists George S. Schuyler and Ishmael Reed, playwrights LeRoi Jones (Amiri Baraka), Ed Bullins, and George C. Wolfe, and artists Oliver Harrington and Robert Colescott—unwittingly formed an "all-men's society" in which only the occasional female satirist—author Zora Neale Hurston, comedian Jackie "Moms" Mabley, and playwright Adrienne Kennedy, for example—were coconspirators. That is, not until Walker emerged in the 1990s, alongside Adrian Piper, Joyce J. Scott, and Carrie Mae Weems throughout the fin de siècle, with their unforgiving and pointed interrogations of institutional racism, their resurrections of suppressed histories, their Foucauldian meditations on the give-and-take between the oppressors and the oppressed, and their explorations of satire.

RACE, RIDICULE, AUDIENCE

With a better sense now of the discursive strategies that black visual satirists employ, it would be useful to, again, recount the main elements that go into making this distinct satirical subgenre. These are: 1) the black visual satirist (or the black proxy); 2) the object or target of black visual satire; and 3) black visual satire's audience and cultural context. Hazarding here an oversimplified, reductive understanding of something admittedly large in scope, complex in theory, and protean in nature, this exercise will ideally assist audiences in grasping the principal components of this myriad, historically significant, but, arguably, miscomprehended form of artistic discourse. The phenomenon's unique incarnation in the visual arts and, in this specific study, by way of creative statements filtered through an African American lens, gives reassurances for the following attempt at developing some broad, overarching parameters for the ensuing deliberation.

Labeling a satire's creator in the satire's own, disquieting self-image invests its inventor/troublemaker with an intrinsic role in its reception, understanding, and interpretation. The biography, the assumed first-person voice, and even the body and physical characteristics of the satirist are not insignificant; rather, they are paramount in shaping and undergirding the satire's conceptual affect. The satirist's race defines the critique as racially informed, and this descriptor, for better or for worse, stabilizes, at least in cultural terms, a genre that otherwise repudiates constancy and equilibrium. In other words, for a black satire's audience there is some comfort, and an assured step toward comprehension and a full appreciation, in knowing that its creator is, indeed, black. A black satirist moves within a sea of inglorious histories, cultural flash points, unspoken self-admissions, and coded eye-rolls and grimaces. Not afraid to lash out at life's absurdities, whether that means calling out the powers-that-be or exposing one's own secret deficiencies, the black satirist is buoyed by the mantle of an avenger.

Even when the black satirist is actually white—as with French playwright Jean Genet and his riveting, 1961 off-Broadway play, *The Blacks: A Clown Show,* or film director Robert Downey, Sr., and his 1969 countercultural classic, *Putney Swope*—the black proxies and agents of these satirists—the visible black actors/representative spokespersons in both productions—fulfilled that racialized prerequisite, giving a black-themed satire an authentic voice, face, and, in effect, performing a modern, reverse minstrel show that spoke black truth to white power and imbued the satire's diatribes and insults with an added, lethal twist of the rhetorical garrote. The audiences who sat in St. Mark's Playhouse for the 1961 production of *The Blacks,* rather

than foregrounding its French playwright and white American director, Gene Frankel, in their reception of the play, looked to the play's electrifying cast members, future stage and screen luminaries Maya Angelou, Roscoe Lee Browne, Godfrey Cambridge, Louis Gossett, Jr., James Earl Jones, and Cicely Tyson, among the production's other African American actors, for that drama's covert messages of racial resentment, misrecognition, and revolt.[69] Perhaps *Putney Swope* was an even more glaring example of a black surrogacy at work in cinematic satire in that, despite the film's white director (who, unbeknownst to most viewers at the time, ended up dubbing the African American lead, actor Arnold Johnson), the film's predominately black cast and their scripted takeover of a white advertising agency occluded any suggestions of a dominant white voice and narrator.

That racism and its attendant social ills would be the most likely targets of black visual satirists isn't surprising. What *is* remarkable is the lengthy time frame during which racism has maintained its thematic importance for artists, from the early twentieth-century black editorial cartoonists who excoriated white racist politicians and systemic Jim Crow policies, to early twenty-first-century black artists who continue to find apt targets for satire in innumerable social situations and contemporary instances of racial discrimination.

Bridging a racist past and a discomforting, shade-throwing present through the layered devices of a visual burlesque was artist Carrie Mae Weems's apparent intention in *The Louisiana Project:* a photography, video, and "shadow theater" installation reflecting on Louisianans' preoccupations with matters of race and gender. Especially pertinent to a satirical investigation of race and racism were Weems's four black-and-white self-portraits of herself dressed in a black tuxedo, top hat, and white gloves, and wearing a series of animal masks. Weems's four portraits reenacted an 1873 white supremacist Mardi Gras club, or krewe, whose members, motivated by Charles Darwin's then-controversial theories of evolution and the state's rapidly changing political landscape during the Reconstruction era, promenaded along the parade route in animal masquerades meant to belittle Darwin and Louisiana's newly elected African American politicians. In one of Weems's portraits from this group, entitled *Missing Link: Despair,* she wears a gorilla mask and mischievously postures before the camera, conjuring the Mistick Krewe of Comus's nineteenth-century signifying masquerade, as well as creating her own multidirectional parody (fig. 25). By shifting the satirical practice of social commentary and masking in New Orleans Carnival to the present, and strategically making use of her self-portrait in

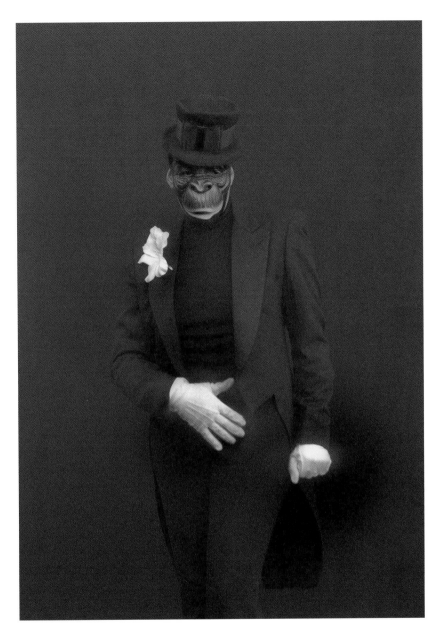

Fig. 25 / Carrie Mae Weems, *Missing Link: Despair*, 2003. Iris print, 41¼ × 29¼ in.
(104.8 × 74.3 cm) (framed).Collection of the artist.

her critique, in her words, of "the Krewes, each holding fast to bizarre notions of heritage, systems of traditions and European aristocracy, reveling in transgression, pomp and circumstance, laughing at you, laughing at me," Weems upended the travesties and tragedies of Louisiana's dark past through the weapon of a black visual satire.[70]

Other institutionally sanctioned systems of oppression—sexism, religious discrimination, class bias, and other garden-variety forms of subjugation—are also fodder for visual satirists, who delight in ridiculing the status quo in society *and* its guardians and apologists. But the relative nature of power means that *any* governing body or organizing system, no matter how small or historically subjugated, is potentially the object of scorn and mockery, and that includes assorted segments of the black community. Indeed, anybody who thinks they are "the righteous ones" and above criticism in black America will, without warning or a friendly insider's tip, soon discover that they, too, might become a target and, through satire's tool kit of various devices and tactics, be taken down a peg, or two.

No satire can truly be called one unless it is collectively recognized as such and, thus, it requires a world in which the targeted ridicule and exposed nonsense *makes* sense. A black satire, like a black satirist, needs a sufficiently knowledgeable, culturally conversant audience who can receive the satire's manifold elements, coded messages, and racially centered criticisms; who can absorb the satire's acrimony without succumbing to the vitriol themselves; and who can bring to culmination, via their deep understanding and viewer's response, the satire's critical transactions. Literary theorist Linda Hutcheon, in her examination of irony, goes a step further, arguing that it is the interpreter who makes irony. Employing literary critic Stanley Fish's theories of "interpretive communities," Hutcheon reasons that irony is not "something intrinsic to a text, but rather something that results from the act of construing carried out by the interpreter who works within a context of interpretative assumptions." Hutcheon continues, "Irony is always (whatever else it might be) [and I would add satire to that 'whatever else'] a modality of perception—or, better, of attribution—of both meaning and evaluative attitude."[71]

Wayne F. Miller's photographs of African Americans on Chicago's South Side, circa 1946–48, documenting common laborers, leisure seekers, and the neighborhood's "everyday people," can be extrapolated to help elucidate Fish's notion of "interpretive communities" and the roles these discriminating entities play in deciphering satirical discourses more broadly.[72] For example, consider Miller's *Parade Watchers,* a photograph of an assem-

bled audience for the Bud Billiken Parade, a spirited procession and color-
ful convoy annually held on one of the South Side's main thoroughfares
(fig. 26). The porch stoop turned grandstand accommodates somewhere in
the vicinity of forty spectators, a few shown standing, but the majority seated
and watching the parade with rapt attention. Although as with any crowd,
one sees a few members of the audience inattentive and distracted, the major-
ity are clearly fascinated by the parade, and one can only imagine what they're
witnessing: the uniform-, fez-, and satin-wearing members of masonic
temples and assorted social clubs; high-stepping majorettes in indelicately
short, flouncy skirts; militaristic, foot-stomping-in-unison drill teams; and
bouquet- and banner-clad beauty queens, riding on crepe paper–decorated,
locally sponsored floats. Even without seeing the marchers moving down
South Parkway Boulevard, one senses through this engrossed audience their
rhythmic assertions and visual allure.

As viewers of Miller's *Parade Watchers* span the assembled gathering,
they see broad smiles, mouths opened in amazement, diplomatically "set"
jaws, discerning expressions, knowing glances, desiring looks, and the
masked faces of black urban cool. Indeed, Miller's photograph doesn't allow
us to ignore or discount the audience; like Fish's hypothetical readers, the

Fig. 26 / Wayne F. Miller, *Parade Watchers, Chicago, Illinois, USA,* 1946. Gelatin silver print, 11 × 14 in.
(278 × 35.6 cm). © Wayne Miller/Magnum Photos.

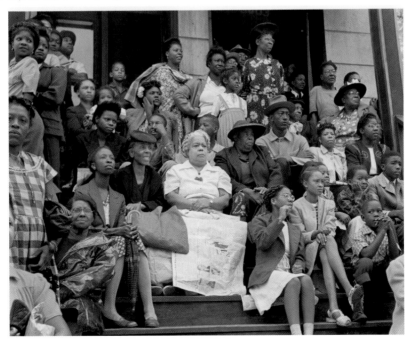

depicted audience members are, in their own way, "at the center of attention, where they are regarded, not as leading to meaning, but *having* meaning." And it would not be an exaggeration to say that, in their expressed pleasure, surprise, questioning, monitoring, acknowledgment, coveting, and veneer of immovability, they produce what Fish calls a "moving field of concerns" that, as manifested with other black audiences in settings such as churches, beauty parlors, barbershops, nightclubs, theaters, and so on, the extrasensory processes of artistic satire and criticism invite the spectators, in turn, to perform. Although Fish's focus is the readers of John Milton's *Variorum Commentary,* when he writes about "interpretive communities" he could have just as easily described Miller's black spectators and critics in his *Parade Watchers,* where "the only 'proof' of membership is fellowship, the nod of recognition from someone in the same community, someone who says to you what neither of us could ever prove to a third party: 'we know.'"[73]

As artist Robert Colescott acknowledged in this chapter's second epigraph, the realization that the audience and cultural context weren't entirely in place for seeing the satirical locus of his *George Washington Carver Crossing the Delaware* thwarted the painting's position as an unequivocal satire for many viewers, only carrying that designation for the relative few who could nod with awareness and chuckle at his irreverent, playful merger of the story of American art, his illustrated examples of racial stereotypes, and an implied "Negro history." This knowledge, writes Linda Hutcheon about a comparable Colescott painting, "of both the history of art and the racist representations of blacks," imposes a special challenge onto Colescott's prospective audience.[74] Given the already limited audience for satire, especially for spectators with adequate degrees of visual and cultural literacy, it is a high bar for viewers to also have the racial competencies to meet black visual satire and its conceptual challenges halfway.

The following chapters closely consider three, somewhat chronological case studies of black visual satire, beginning with Chapter 2, "Drawing the Color Line: The Art of Ollie Harrington," a look at the early to mid-twentieth-century satires of artist/cartoonist Oliver "Ollie" Wendell Harrington, visual strikes that, in both theory and practice, either combatively took aim at racism or were critically directed toward black America itself. Chapter 3, "The Minstrel Stain," examines satires created in the second half of the twentieth century and well into the twenty-first century by an array of artists—Jeff Donaldson, Melvin Van Peebles, Betye Saar, Howardena Pindell, Spike Lee, Kara Walker, among others—whose visual assaults deliberately made use

of stereotypes and racist performance practices such as blackface minstrelsy. Finally, Chapter 4, "Robert Colescott: Between the Heroic and the Ironic," looks at the artist's late twentieth-century satires, whose madhouse worlds of interracial couplings, cultural ironies, and social exposés continue to intrigue and vex audiences. Although this fourth chapter focuses primarily on Colescott's art and career, his paintings will intermittently surface throughout the course of this study, providing counterpoints to the other black visual satires, and bringing added signification and conceptual weight to the various strains of racial offenses in modern and contemporary art.

Some of the highlights in this examination revolve around not just closely considering and critically deconstructing the black visual satires themselves, but looking at and investigating the broader, art historical sweep of selected artists as satirists. Along with Colescott and many of the other genre-defining figures, one of those artists/satirists is editorial cartoonist Harrington, the subject of the second chapter of this book. With a career that lasted over sixty years and an unrelenting focus in his artwork on racial, economic, and political injustices, Harrington almost single-handedly defined this discursive approach within African American visual art, creating highly polished and, yet, pointedly sarcastic drawings—with equally mordant, politically acerbic captions and subheadings—that were merciless in their attacks on the perceived enemies of a tolerant and moral society. From his editorial cartoons for African American newspapers against racially motivated lynching in the 1930s, 1940s, 1950s, and 1960s, to his anti-imperialist and anti-apartheid drawings for the U.S. Communist Party's weekly newspaper the *Daily World* and the East Berlin humor magazine *Eulenspiegel* in the 1970s and 1980s, Harrington produced an assortment of visual satires in the cartoon genre, perfecting the satirical mode with a fluidity of line, a knowing, compositional artifice, and a core, dual sense of indignation and comic sarcasm.

Much of the confusion surrounding black visual satire often stems from the appropriation and redeployment of stereotypic imagery by modern and contemporary black artists. As products of a post-1960s cultural reeducation in the United States that looks unfavorably upon racist imagery and categorically dismisses it, modern and contemporary audiences were largely unprepared to accept this pernicious material as having any social or aesthetic value, even in the new context of art. So the confidence many satirists had in audiences being able to see how stereotypic imagery could be used in sophisticated, satirical ways was clearly misplaced. And yet the artists of the Black Arts movement—Amiri Baraka, Ed Bullins, Jeff Donaldson, Maya

Angelou, Betye Saar, Melvin Van Peebles, and so on—and their successors—
including Spike Lee, Kara Walker, Beverly McIver, Donald Glover, and
Robert Colescott—readily adopted Aunt Jemima, Uncle Tom, watermelons,
disembodied, toothy grins, and other stereotypic black characters and insig-
nia, seeing in this material a vehicle for making a burlesque of racism, and
for interjecting into post–civil rights discourses an antithetical, irony-creating
element. Storing this chapter's panoply of stereotypic imagery and racist
caricatures all under the heading "The Minstrel Stain" isn't simply a function
of blackface minstrelsy's historical praxes and dramaturgical habitudes.
Contemplating the physics and symbolism of stains and splatters, and con-
necting these associations with the psychological stigmata or lingering res-
idue of racially offensive imagery on people's subconscious, proposed the
metaphorical reach of this ethno-cultural smear. Also paradigmatic of this
satirizing impulse—and a key part of "The Minstrel Stain"—is the African
American reinvention of blackface minstrelsy that, rather than blacking up
white people for racist performances, frequently puts white pigment on
black faces for highly ritualized counterattacks.[75] These stylized, white-faced
presentations in African American art, from Douglas Turner Ward's *Day
of Absence* (1965) to Howardena Pindell's *Free, White and 21* (1980; see fig. 84)
and David Hammons's *How Ya Like Me Now?* (1988–89; see fig. 85), were
contingent upon audiences having some familiarity with blackface, and being
able to envision the possibility of a black satirical usurping and revamping of
this controversial tradition in American theater and contemporary art.

Interracial relations between the sexes, one of Colescott's constantly
revisited themes for visual satires, received a retrofitted treatment in turn-
of-the-twenty-first-century works by several African American satirists.
Unlike Colescott's pioneering generation of racial/sexual outlaws, artists of
a younger cohort—such as Kara Walker, Renée Cox, and Beverly McIver—
used the interracial sexual scenario as conduits into postmodern uncer-
tainties surrounding dominance and submissiveness, and the parallel notion
of a selective myopia, or outright blindness, between races and sexes. Derek
Conrad Murray, writing about the ideological differences between Saar's
and Walker's respective works, rightly states that the distinction between
the two approaches "rests on the fault line between an externalized critique
of white racism and an internalized and decidedly more Foucauldian explo-
ration of power and its abuses"—the latter a critical concern of other black
visual satirists of Walker's generation.[76] For example, in McIver's *Invisible
Me*—one of several works from the late 1990s pairing a naked white man
and McIver in the exaggerated disguise of a blackface minstrel-like, female

clown—rather than emphasizing the long-held social taboo of interracial sex, or simply targeting bigotry around interracial unions (as Colescott often did), McIver attacks a deep-seated, universally shared psychology of racial and sexual imperceptibility, represented here in expressive brushstrokes, plotted erasures, and black-faced anonymity.[77] This particular theme, as well as other critical refrains in Colescott's black visual satires, will be examined in greater depth in Chapter 4.

Thinking about Colescott between the polarities of heroism and irony might seem, at first, like an evasion, or an unresolved critical assessment: a wavering view that is unwilling to historically situate this artist on either extreme of the spectrum. And yet an objective and clear-eyed evaluation of this painter (of the same generation as other major American artists such as Helen Frankenthaler, Jasper Johns, Faith Ringgold, Betye Saar, Cy Twombly, and Andy Warhol) reveals a not-at-all typical career in modern and contemporary art—a calling that straddled a cocky, Vietnam-era pictorial impertinence and the late twentieth century's cultural critiques of assorted institutions and hegemonies, including the practice of painting itself. Largely removed from the major art movements of the second half of the twentieth century, Colescott nevertheless emerges as an American original, forging an identity that, while contributing significantly to multiple American art traditions (including Bay Area art, African American art, figurative art, and more), can also be viewed as that of an artistic outsider and a disrupter of traditions. Especially known for his thematic embrace of controversial issues, his parodies of iconic paintings that he admired, and his evocative canvases lampooning racial and sexual stereotypes, Colescott certainly belongs in a study about visual satire. But in analyzing Colescott's satirical paintings that mock and narratively poke and prod at the conundrums of race, sex, and Western culture in humorous yet thought-provoking ways, one can't help but note how Colescott's distinctive background and affiliations—African American, creole, male, Northern Californian, and social misanthrope—have colored his artistic outlook and, as Chapter 4 argues, bestowed upon him a dubious double honor: innovative trailblazer *and* hapless social observer.

THE "CHURCH" OF VISUAL SATIRE

When a self-designated critic decides to satirize someone or something, the idea of taking one's particular skills for wit and reprimand—and one's fearlessness in leveling contempt and ridicule—to an extraordinary, almost unfathomable point of execution is called "going *there*." This euphemism suggests a trek of sorts: a journey, no matter how long or short, toward a target

and its expansive ruination, figuratively speaking. And it hopefully doesn't take too long or too much deciphering for that critic's audience or community to realize what has just transpired: a figural pathway, or a gauntlet, through insinuations, through analogies, through comparisons, through exaggerations, and through subtleties, to bring into the light of day the offenses and failures of a particular antagonist or collective concern. The italicized *"there"* in "going *there*" isn't casually or melodramatically consigned: it suggests the distinctiveness of, and the articulated emphasis on, a conceptual climax—the ultimate denunciation in which the satirist fully and devastatingly converges on the vices and follies of her or his target. Think of the italicized *"there"* as the akimbo arms and hands that perch on the hips of a paradigmatic, attitude-consumed black woman. A corporeal accent on an already blistering, dead-on judgment. And given the exigencies that black women have shouldered in a culture that has historically devalued their personhoods and dismissed their humanity, they have become, ironically, the embodiments in popular U.S. culture of a censorious, satire-spewing chorus: the Cassandras of the Internet era and eternity, who intimately know the crossbows and projectiles of deprecation and, therefore, use the power of "going *there*" with a heightened sense of its critical force against a justified target of ridicule, and with an awareness about the accompanying psychological reverberations of such critiques.[78]

Archibald Motley and Robert Colescott painted *Lawd, Mah Man's Leavin'* and *George Washington Carver Crossing the Delaware,* respectively, with not just the noble objectives of demonstrating fine arts competency, or even making a critical splash in the art world. No. What drove them to paint black madness and a world conceived in absurdity was a sense of outrage over their respective moments of too much complacency and too little transparency. And add to this indignation a devilish streak that stirred Motley and Colescott into taking African American art to an uncharted yet potentially exciting place. A remote, faraway location, light-years removed from the dignified products of a Henry Ossawa Tanner or a Charles White, where racial stereotypes, rather than being ignored or vociferously condemned, are made manifest in all of their grotesque visibility, but also tactically used, like cider vinegar on collards, or a black mother's saliva on her baby's ashy cheek. And when these artists dared to visually enter into this no-man's-land of attacking "the race," or ridiculing the idea of a separate American history and Negro history, they were, in essence, "going *there*," like many other cultural critics before them, most notably in the literary and performing arts, but also in the visual realm.

Elucidations of discursive practices repeatedly remind us that "satire is everywhere." Most would agree that it's certainly present in humanity's cultural bloodstream, but one still has to know that what one is experiencing *is* satire in order to properly identify it. And one also has to know where to find it: for example, in an awkward yet knowing reply to obvious balderdash. In a glibly delivered counterpoint. In the extemporized silences following ad nauseam hot air. In a carefully orchestrated, closed-mouth smile. On virtually every television situation comedy since borscht-belt comedians and their heirs started writing for them. Out of the know-it-all mouths of millennials. In the wry cultural assessments of twenty-first-century skeptics. In a raised eyebrow. And in an inordinate amount of modern and contemporary art.

Searching for satire in black visual culture has opened up a virtual exhibition hall for me and, in tandem with this immaterial yet insinuated "house of unforgiving truths," an adjacent chapel of artistic inroads and maneuvers: retaliatory, pictorial acts against the sins of the world, both mortal and venal, but "not without laughter" (as poet Langston Hughes once said), nor without a sly but firm poke in the rib cage. This escapade into the irreverent tones and droll schematizing of visual satire has revealed the communicative reach and sociopolitical risk that a black visual satirist takes on, in effect, to go *there,* into the daunting, thankless realms of reprobation and candor. Moving circuitously and, yet, assumedly taking the most direct path (as in the fallacious expression "as the crow flies"), the black visual satirist raises a succession of screens and pictographs that complicate easy justifications for one's condemnations, while also drawing special attention to an intended target's more absurdist and comical aspects. As in the echo chambers of the often-satirized world of jackleg religious figures and hypocritical paragons of moral probity, and as one expects to hear following a rousing, membership-generating African American sermon, *"The doors of the church are open."*

DRAWING THE COLOR LINE

THE ART OF OLLIE HARRINGTON

In 1926 the poetry editor for the *Chicago Defender,* Dewey Roscoe Jones, published the following "catalogue poem" in his popular column, "Lights and Shadows: A Little Bit of Everything":

ARISTOCRACY

Low-Brow

Neckbones and black eyes. "us seen him." "haven't came." black bottom. chitlin rags. U. N. I. A. burlesque. craps. policy. Ike Fisher. shorter. alcorn. holy rollers. tongues.

High Low-Brow

Spirituals. stewed chicken. Charleston. musical comedy. Marcus Garvey. cabarets. Urban league. poker. Tuskegee. Hampton. Methodist. Baptist.

Low High-Brow

The Race. folk dance. "I shahn't because I cahnt." N. A. A. C. P. tennis. fraternities. operetta. banquets. receptions. Kelly Miller. Fisk. Howard. Lincoln. Presbyterian. Episcopalean.

High-Brow

Your folks. Russian ballet. opera. Freudian complex. psychoanalysis. golf. pink teas. "slumming." forums. W. E. B. Du Bois. Yale. Harvard. Chicago. free thinkers. Christian Science.

EL VAGAMUNDO

Heeding Jones's call for contributions "in the line of wit, humor, satire, sarcasm," the author of this poem, "El Vagamundo," clearly directed the satire toward class systems among African Americans, encapsulating social status and hierarchies through categories of food, leisure activities, personal and institutional names, and stereotypical voices, each evocative enough for the *Chicago Defender*'s readers to form vivid mental pictures of their fellow community members and, when applicable, to censoriously and humorously tag them. Only cultural insiders, circa 1926, would have understood and appreciated such entries as "policy," "Hampton," "The Race," and "Your folks": floating signifiers that, when attached to internal discussions among African Americans about class and culture, became immediately recognizable markers of social status. Ciphers such as these were only fathomable within "the race" and within publications such as the *Chicago Defender* and other vehicles for communication and dialogue in African American communities.[1]

The power of coded, individual words and, relatedly, of "word pictures," or illustrations, to summarize and make comprehensible what was an essentializing yet constitutively layered self-portrait was the sole domain of African Americans prior to the 1960s and that decade's major cultural shifts. For much of the twentieth century, many black Americans, living under the proverbial "veil" of racial segregation and affective distance from the white majority, developed bilingual modes of communication: a strictly regulated, restrained speech, or often silence while in the presence of whites and, in sharp contrast, an improvising, emblematic tongue and complete candor within black communities. As seen in the "Aristocracy" poem, this black lingua franca—facetiously bringing into play such stereotypic upper-class Euro-American preoccupations as the "Queen's English" ("I shahn't because I cahn't"), "pink teas," and "slumming"—occasionally incorporated "in-house," cross-class criticisms that were antithetical to and, yet, quite mindful of perceived and/or actual insinuations from the world beyond the "veil."

Almost forty years later the black American cartoonist Morrie Turner—whose cartoons carried the single-named signature "Morrie"—would also build his comical satires around this systemic racial disconnect and, correspondingly, around an implicit African American viewpoint and one-upmanship. For example, in a 1965 cartoon by Morrie (from the Johnson Publishing Company's literary and public policy magazine *Negro Digest*), a white biophysicist in a space laboratory tells his fellow white scientist, "I have been assigned to dehydrate meals for the first Negro astronaut . . . just what is 'soul food' anyway?" (fig. 27). Morrie's drawing style, in the frugal manner of Charles Schulz's popular *Peanuts* comic strip, worked in tandem with

Fig. 27 / Morrie Turner, *Humor in Hue:* "I have
been assigned to dehydrate meals for the first
Negro astronaut . . . just what is 'soul food' anyway?"
Negro Digest, December 1965.

the caption's mockery of a culturally ill-informed white intelligentsia, with
the cartoon's drawn lines and printed texts mutually supporting the satire's
legibility for this review's black readers.[2]

What bridged Morrie's *Humor in Hue* cartoon and El Vagamundo's jazz
age classifications was their locus in a twentieth-century African American
print milieu, and their shared trade in a "for-blacks-only" idiom in which
selected words, phrasings, and pictures subscribed to a discursive attitude
of racially informed innuendo, meta-messaging, and criticism. The social
and cultural circumstances for African Americans from the 1920s through
the 1960s—concurrently thought of as the dark ages of racial segregation
and, in spite of this social impediment, the golden age of Negro resource-
fulness—prompted a range of responses from black cultural commentators,
the ideological temperament of these depending upon the commentator's
sentiments and preferred means of editorializing in the public sphere. The
most acerbic of the lot (and one of the most widely read commentators in
black communities), the longtime *Pittsburgh Courier* columnist George S.
Schuyler, was also a staunch political conservative and, rather than embrac-
ing easy racial allegiances, took great pride in penning irony-filled, scornful
editorials about African American elites, civil rights activists, and blacks
who rejected America's core beliefs and values. Schuyler was perhaps best
known for his 1931 novel, *Black No More* (to be discussed in greater depth

below), which was not only a stinging critique of America's racist treatment of its black citizens, but a harsh assessment of many African Americans. Schuyler—frequently compared to the acclaimed journalist and cultural satirist H. L. Mencken—is a key figure in any discussion of black satire, and his decades-long position as black America's premier satirist is indisputable and, consequently, will resurface throughout this study.[3]

A consideration of this particular moment in time invariably gravitates toward that era's most conspicuous visual variety of African American commentary and critique in a satirical vein: editorial cartoons. Again, the black press's central role in providing African Americans with their own forums for addressing local news, national and international events, politics, current affairs, and the burgeoning civil rights movement gave the staff and freelance artists who worked for these black newspapers and other media outlets pertinent subject matter, much of it filtered through a humorous and often satirical lens (such as Morrie's *Negro Digest* cartoon of two white scientists puzzling over a Negro astronaut's "soulful" provisions). The unspoken but omnipresent pact between the gag-devised imagery and the witty captions in these black press–commissioned editorial cartoons—filtered through the coded colloquialisms, corporeal signs, and "jive" of mid-twentieth-century African American discursive repartee—is the focus of this chapter, with an emphasis on how, conceptually and visually, these satires operated, and to what extent they were understood and interpreted by black audiences. Writing in the exhibition catalog *Black Pulp!* about the possibilities of an alternative, sometimes slanderous African American visual critique, painter and *Black Pulp!* co-curator William Villalongo noted, "The tools of fiction and satire seem to evolve as primary forms of address with which to speak truth to power in the Black press and Black art." Villalongo continues to say, using a concept comparable to the term "jive," that "the pulp impulse foments cunning acts of resistance, punchy expressions of Black agency, joy, and desire."[4]

In this period the black editorial cartoonist Oliver ("Ollie") Wendell Harrington (1912–1995) was lauded for conveying, via his cartoon sketches, a satirical assessment of African American life under segregation. In a career that spanned over half a century, Harrington created literally hundreds of cartoons, much of it focused on racial discrimination, political corruption, and class divisions in American society. Harrington's comical drawings— many with recurring black characters and captions scripted by him with black voices and distinct vernacularisms—regularly appeared in the United States' major black newspapers, books, and, increasingly, in leftist periodicals, print portfolios, and satirical magazines.

Fig. 28 / Ollie Harrington, *Dark Laughter:* "Boss, sump'n tells me that dis referee is drawin' the color line." *New York Amsterdam News*, August 10, 1937.

This chapter attempts to bring a greater understanding to how the editorial art of Harrington transmitted its satirical meanings (distinct from his cartoons with a largely comical and less critical thrust), paying special attention to the uncanny relationship between relatively straightforward yet condensed compositions and their sparing yet incisively captioned, adjacent texts and/or explanations. As with all print art and graphic imagery, what must be accounted for is the black-and-white image's subliminal inference to a kind of *summoned literacy* or, in other words, recognizing the shared task of the drawn line and the printed text to *entreat a reading.* This notion of cartoons offering a hybrid, summoned literacy is indebted to more recent, post-Saussurian theories of language that argue for viewing communication as essentially multimodal, especially in a world where, beyond text-based information, various forms of visual communication play an important role.[5] Not only do cartoons and other combinatory communiqués prompt a literal *reading,* but, in the cultural and critical contexts in which Harrington produced his cartoons, an accusatory and performative *reading,* where the object of satire is thoroughly sized up, perceptively anatomized, and creatively

adjudicated, all in a stylistically rich, propagandizing manner. In other words, *reading* here is not solely the domain of black audiences, but, rather, the black editorial cartoonist is charged with employing visual and verbal clues that, in addition to deciphering a proposed scenario, also disassemble and excoriate the objects of satire. To have been *read,* retrospectively *and* rhetorically speaking, meant an interrogation that, like in a 1937 Harrington cartoon pointing out a blatant example of racial discrimination, cut deep into the façade of impartiality in America to exhume embarrassing truths and farcical absurdities (fig. 28). In this sketch, *to read,* say, the referee's triumphant

Fig. 29 / Robert Colescott, *Ace of Spades*, 1978. Acrylic on canvas, 79 × 59 ½ in. (200 × 151.1 cm). University of California, Berkeley Art Museum and Pacific Film Archive. Gift of Robert Harshorn Shimshak and Marion Brenner, 1997.7.1.

arm-lifting of the knocked-out white boxer to the apparent consternation of the standing black boxer extended the cartoon's lexical quotient to, in turn, enable all African Americans *to recognize and read* the depicted irony and the intended targets of criticism, individual and institutional.

The sixty-years-plus artistic antics of Harrington were viewed, more or less, through a discursive lens that their African American patrons colloquially described as "jive." Defined for much of the twentieth century as "gossip," "false talk," "con game," "loose talk," or "to sneer," the word "jive" has historically wafted between inferring the nonsensical or denoting a kind of oblique, verbal subterfuge.[6] In the realm of the visual, "jive" might also manifest itself between reductio ad absurdum and artifice, present not only in the editorial cartoons of Harrington, but in a later work of art such as Robert Colescott's *Ace of Spades* (fig. 29). From its titular euphemism for an aviator ("Ace") and its invocation of an African American slur ("Spades"), to its depicted black airman, noticeably flummoxed by being unbecomingly splattered with American bald eagle excrement, Colescott's *Ace of Spades* established an artist/audience repartee whose interpretive systems—metaphorical, allusive, and ironic—neatly corresponded to the discursive trappings and tones of mid-twentieth-century African American jive. Colescott's precursor in visual jive, Harrington, came to this particular *lingua afro-americana* in his own respective time and cultural milieu, as the following account of his career and satirical work will reveal.

SATIRACY

Ollie Harrington's frequently cited essay "How Bootsie Was Born" gives a brief, colorful, and embellished account of Harlem during the Depression years and its formative role in providing the artist with the attributes (the folksy appearance, the droll voice, and the tongue-in-cheek demeanor) of his most famous cartoon character, the African American ne'er-do-well Bootsie. But it was not until almost a decade later, in his written tribute to the legendary artist/activist Paul Robeson, that Harrington also provided audiences with an eye-opening look into his impoverished pre-Harlem youth in the South Bronx, whose gritty environs, multiethnic inhabitants, and garrulous street commentators also contributed to Bootsie's "birth" and, as one might expect, helped fuel the satirical point of view of the future cartoonist.[7]

"The Bronx street where I grew up must have been the world's puniest black ghetto, one block long, and only half of it at that," Harrington began his part-autobiographical essay. "On the other side of the street," he sarcastically continued, "were the pungent Sheffield Farms stables whose sleek

tenants in their warm stalls were the envy of every shivering black kid on the block."[8] The Bronx apartment building where Harrington lived, at 996 Brook Avenue, was, as he stated, steps away from an urban dairy, one of the largest in the world and a major milk supplier to New York. The South Bronx and its demographic mix of German Americans, Irish Americans, Jewish Americans, and African Americans was the social setting for one of Harrington's earliest and most traumatic memories. He recalled that painful moment many years later, dredging up the moment when Ms. McCoy, his sixth grade teacher, instructed him and another African American student to stand in front of the class:

> Pausing for several seconds she pointed her cheaply jeweled finger with what I think she considered a very dramatic gesture at the trash basket and said: "Never, never forget these two belong in that there trash basket." The white kids giggled rather hesitantly at first and then fell out in peals of laughter. For those kids it must have been their first trip on the racist drug. It was several days before I managed to pull myself together.
>
> Gradually I felt an urge to draw little caricatures of Miss McCoy in the margins of my notebook—Miss McCoy being rammed into a local butcher shop meat grinding apparatus; Miss McCoy being run over by the speeding engines on the nearby New York Central Railroad tracks. I began to realize that each drawing lifted my spirits a little bit. And so I began to dream of becoming a cartoonist.[9]

Discovering how a death-wish drawing can serve as a tool of retaliation against a spirit destroyer such as Ms. McCoy, Harrington unknowingly took the first steps toward becoming a visual satirist at Bronx Public School 139. His adolescent revenge art, along with his close scrutinizing and critical coverage of the South Bronx neighborhood's more colorful characters, planted the seeds of satire in him that, once he graduated from the New York City Textile High School in 1931 and moved from his South Bronx home and into the Harlem YMCA, were nurtured and further developed in subsequent years.

Harrington's dream was also supported by that particular historical moment—the 1920s through the 1930s—when newspaper comic strips, editorial cartoons in magazines and journals, and the art of illustration in general were popular components of the mass media, attracting their own dedicated audiences across a wide cultural spectrum and the set social divisions in the United States. In the 1920s Harrington would have been exposed to a virtual smorgasbord of excellent commercial art with no more of an

effort than coming across a discarded newspaper or picture magazine and thumbing through its pages. From the spare and modernistic cartoons of George Herriman, Bud Fisher, and Chic Young, to the stylized and tightly composed illustrations of Norman Rockwell, John Held, Jr., and Miguel Covarrubias, commercial art during the jazz age and years of the Great Depression presented young, would-be artists with a career path that, through assiduously fostered alliances within the greater publishing world or a print syndication contract, promised notoriety and ensured a measure of financial comfort and stability.[10]

For Harrington, a budding black artist, the shining example of commercial art world achievement by "the race," circa 1931, was not, as one might have expected, the renowned Paris-based painter Henry Ossawa Tanner, or even the contemporary muralist and book illustrator Aaron Douglas. Rather, the freelance cartoonist Elmer Simms Campbell, a recent New York arrival from St. Louis, had arguably become the most successful African American artist in the United States, with vivid, gag-filled cartoons and illustrations regularly appearing within and on the covers of *Life, Judge,* and other humor and general interest magazines. Campbell's shrewd ability to both suppress his blackness (through creating mostly racially segregated, "all-white" cartoon scenarios) and, on rare occasions, to exploit his Negro identity, would have appealed to Harrington and his generation of African American artists seeking a broader platform for their talents.[11]

By the early 1930s Harrington had begun drawing cartoons and other illustrations primarily for two Harlem-based newspapers, the *New York Amsterdam News* and the *National News,* the latter an African American–marketed newspaper published by the United Colored Democracy Party and edited by author and journalist George S. Schuyler. Schuyler was, by all accounts, a brilliant if complicated personality, having made a name for himself by the mid-1920s as an intellectual contrarian, in his published writings disparaging the New Negro arts movement, celebrating atheism, and endorsing interracial marriages. A lone voice in what he would have described as the "New Negro wilderness," Schuyler's infamous essay for the *Nation,* "The Negro-Art Hokum" (1926), disagreed vociferously with that era's cultural spokespersons to individuate and pigeonhole the artistic creations of African Americans, arguing instead for viewing these works as "just plain American." Schuyler's critically acclaimed novel, *Black No More* (1931), playfully subtitled *Being an Account of the Strange and Wonderful Workings of Science in the Land of the Free, AD 1933–1940,* was a hilarious yet scathing account of color prejudice in jazz age America, and how institutional and personal

racism was a highly profitable social commodity. Schuyler's *Black No More* is the story of a scientist who invents a medical procedure that makes African Americans appear Caucasian and, as a result, ignites, via a dizzying array of subplots, a succession of interpersonal deceptions and far-fetched national conspiracies, each with disastrous and hilarious results. This satirical novel made vivid how America's preoccupation with race in these years fueled subterfuges around racial hegemony, interracial sex, and even for the "race men" of that day such as W. E. B. Du Bois and Marcus Garvey, naked opportunism for socioeconomic ascent and political clout.[12]

Given that he had an editor and mentor like Schuyler, one can see how Harrington's initial artworks for the *National News* would embrace a similar satirical air, with his visual barbs and sardonic captions not necessarily directed toward the most likely objects of derision. Harrington's weekly, multipaneled cartoon for the *National News,* appropriately titled *Razzberry Salad,* poked fun at the oafish ways and social pretentions of the people of Harlem, exposing in one of his earliest comic spreads examples of petty larceny, graft, and, as seen in this cartoon's "Hall of Fame" portrait of "Laffayette I. Cumming," the promotion and peddling of bogus gadgetry and goods on Harlem's street corners (fig. 30). Harrington's stark, linear, and, yet, vaguely realistic rendering of the *Razzberry Salad* comic spread, while the ideal technique for the newspaper's limited budget for photogravure reproductions, subliminally supported Harrington's wry, matter-of-fact commentary on the Harlem community's moral deficits.[13]

After the demise of the *National News,* and while studying at New York's National Academy of Design, Harrington began publishing cartoons in the *New York Amsterdam News,* Harlem's leading weekly newspaper. Given the rare opportunity to publish a serial comic strip, Harrington created *Scoop* for the *Amsterdam News,* a short-lived cartoon series about an orphan named Scoop and his travails with his evil stepmother, Lizzie May Naddycheek, and her partner-in-crime, Hammy Green (fig. 31). The very short run of *Scoop*—probably because of its lack of originality and near-identical story lines with other popular cartoons featuring child protagonists—may have also experienced its premature end because of Harrington's propensity to insert jokes and asides in the strip, whose intended audience was the *Amsterdam News*'s staff rather than the paper's general readership. Harrington was clearly smitten with his newfound career as a newspaper cartoonist: an infatuation he would have to suppress in order to focus on creating compelling cartoons and succeed in that frenetic, dog-eat-dog world of "beats," "exclusives" (or "scoops"), "windows," and "deadlines."

Fig. 30 / Ollie Harrington, *Razzberry Salad:* "Our Hall of Fame: Laffayette I. Cumming who will apply his inventive ability . . . ," *National News,* February 18, 1932.

While living and working in Depression-era Harlem, Harrington developed a keen ear and a perceptive eye for that community's more comical and farcical aspects—attributes that would prove advantageous for a budding black cartoonist and satirist in New York. These sharp insights, along with Harrington's paradoxical perspectives on race and class as a result of being of mixed racial ancestry—the son of an African American laborer father and a Hungarian Jewish stay-at-home mother—provoked an especially trenchant humor in his earliest single-panel cartoons for the *Amsterdam News,* which he suggestively titled *Dark Laughter, or Harlem in the Spotlight.* Relying on both the racial and psychological insinuations of the adjective "dark" in the cartoon's title, Harrington's first single panels considered Harlem's stereotype-informed contradictions, voiced in one cartoon by a walking-and-talking, human advertisement for a racist Hollywood "jungle movie," instructing his children to tell their mother to iron a not-at-all-savage, very British winged collar "fer de bridge tournament tonight" (fig. 32). Harrington's juxtaposition of the film's bold "Jungle Death" marquee, a supposed grass-skirt-wearing black primitive, and the so-called savage's comments about English haberdashery enacted its satire by way of both exposed incongruities and shattered expectations, the latter largely originating from black stereotype–wielding white Americans. A similar process of satirizing outsiders' misunderstandings of Harlem's non-monolithic community was asserted in another early *Dark Laughter* panel, this one juxtaposing members of Harlem's black bourgeoisie with the predominately white and Jewish radicals who proselytized their Marxist-Leninist politics on Harlem's street corners (fig. 33). By having a gesticulating, bare-fisted white activist atop a makeshift dais refer to an elegantly attired black couple as "Comrades, fellow workers," Harrington

Fig. 31 / Ollie Harington, *Scoop:* "Pardon the delay folks, but . . . ," *New York Amsterdam News,* July 5, 1933.

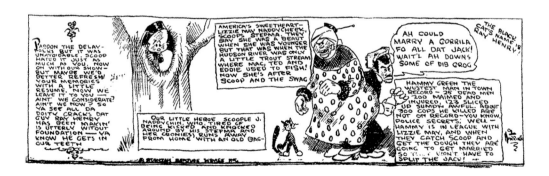

Fig. 32 / Ollie Harrington, *Dark Laughter*: "An' tell ma to iron my wing collar fer de bridge tournament tonight." *New York Amsterdam News*, August 10, 1935.

satirized the radical left's myopia when it came to black people, as well as the black middle class's disconnect with the issues affecting Harlem's black masses. Mildly caricatured and yet naturalistically conceived overall, Harrington's *Dark Laughter* characters had enough of a foothold within a perceived reality to avoid the standard racial stereotypes, while not forfeiting the opportunity to criticize and ridicule the more shortsighted and biased among various Depression-era constituencies.

Funds earned from the Works Progress Administration's Federal Arts Project, where he "taught brats to draw," and from temporarily filling in for Bill Chase, another *Amsterdam News* staff cartoonist, enabled Harrington to attend the Yale University School of Fine Arts, beginning in the fall of 1936.[14] "Harrington moved into the back room" of 152 Grove Street, recalled Owen Dodson, co-tenant, fellow Yale School of Fine Arts student (in drama), and future poet/playwright. Dodson, also a New Yorker, recognized his new housemate's name from the *Amsterdam News,* to which Harrington replied, "Yes, I draw the cartoon; that's what I will be living on at Yale." Continuing to draw his weekly cartoons for the *Amsterdam News* at Yale, Harrington also bused dining room tables and washed dishes at the Chi Psi fraternity house,

Fig. 33 / Ollie Harrington, *Dark Laughter:* "Comrades, Fellow Workers." *New York Amsterdam News*, September 28, 1935.

a form of employment that not only provided Harrington with additional money for tuition and free meals, but offered him a pretext for eavesdropping and spying on Yale's elite students and alums, potential source material for his satires.[15]

But rather than making affluent whites the butt of his caricatures and jokes, Harrington continued to zero in on Harlem's inhabitants, their day-to-day foibles, and their droll observations on life behind America's invisible boundaries and within its racially demarcated territories. "Boss, sump'n tells me that dis referee is drawin' the color line," a black boxer in one of Harrington's cartoons expressed to his corner-man in exasperation, inexplicably losing to his downed white opponent (see fig. 28). For Harrington the intended pun of "drawin' the color line" — a flurry of spare pencil gestures coalescing into an all-too-familiar account of bias — takes on even more potency here as voiced by a superficially inarticulate, rough-looking black pugilist. Like the surprising comment about a "wing collar" coming from a caricatured savage in Harrington's 1935 cartoon (see fig. 32), this brawny black boxer disrupted the audience's race and class assumptions with such Du Boisian discourse as being subjected to a racially drawn "color line."

Fig. 34 / Ollie Harrington, "Bootsie, Syndicated Cartoon Character through Which
the Humorous Angles of the Urban Negro's Economic and Social Tragedies Have
Been So Cleverly and Sympathetically Expressed." *People's Voice*, August 8, 1942.

Not only the profound bigotry of racism, but its utter absurdity were
the subjects of many of Harrington's first *Dark Laughter* cartoons. A ludi-
crous element he began incorporating into these cartoons during this period
was of an oafish, overweight, and habitually out-of-work African American
character named Bootsie (fig. 34). Either a witness to life's irrationalities or
the object of ridicule himself, Bootsie performed an instrumental role for
Harrington, personifying a kind of picaresque protagonist in the Depression-
era world of the average Harlem citizen. For example, in a cartoon that turns
the euphemistic "black and white sundae"—a dessert alternately layered with
vanilla and chocolate ice cream and marshmallow and chocolate sauce—
into a silly rejoinder about racial segregation, the bystander Bootsie joined
Dark Laughter's readership in pondering the wide-ranging contours of Amer-
ican racism, ridiculously located here in a Harlem ice cream parlor (fig. 35).
Frequently driving to New York from New Haven in his 1929 Model A Ford
named "Nimrod," Harrington (often accompanied by Dodson) continued
to make Harlem and its colorful community an extended case study, from
taking notes on the peculiar and humorous things people said to cataloguing
the distinctive human specimens and fashions one might see on Harlem's
streets. It is not coincidental that the young cartoonist befriended Dodson,
a promising playwright and thespian who shared Harrington's people-

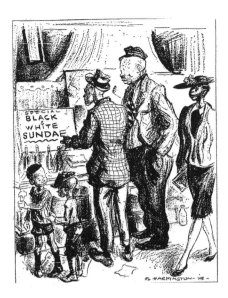

Fig. 35 / Ollie Harrington, *Dark Laughter:* "Look a'there, Bootsie, they got a Sundy fer Easter an' one for Palm Sundy but when they give us one, we got split it wid the white folks!" *New York Amsterdam News*, April 9, 1938.

watching proclivities and deep artistic interest in documenting Harlem's more dramatic and comical dimensions.[16]

A February 1940 *Life* magazine article about Yale's School of Fine Arts gave its readers a photo-documentary glimpse into the school's drawing and painting studios, a photograph of the latter showing art student Harrington mixing powdered pigments at a shared worktable (fig. 36). Also included in the article was a photograph of Harrington's oil on canvas *Deep South*, which, according to the writer, Harrington described as an "imaginary flood scene . . . influenced some by [Thomas Hart] Benton, more by El Greco" (fig. 37).[17] Intentionally or inadvertently missing from Harrington's art historical analogies was one of the painting's pivotal—and competing—characters: the yellow, stoop-back dog sharing a patch of dry land with a tall, downtrodden man. Not so much morose as wonderfully weird, the caricatured hound lampooned this catastrophe and, in the manner of a tongue-in-cheek, hokumstyled parody of southern folkways, Harrington revealed his comedic and sarcastic leanings by drawing attention in *Deep South* to such a preposterous character, especially in a painting ostensibly about a natural disaster. Old Yeller's master (for whom Dodson was the figure's model) may have had the aura of an El Greco courtier, but his barefoot, half-naked appearance and down-in-the-mouth demeanor were the stuff of potential ridicule, especially in the hands of an urbane sophisticate and "Yalie" such as Harrington.[18]

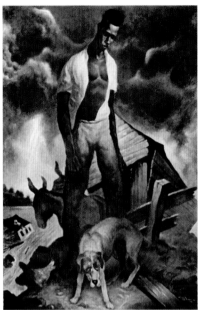

Fig. 36 / Eric Schaal, "Students Learn Frame-Making and Guilding" (including Ollie Harrington grinding his own pigments), January 1, 1940. Published in *Life*, February 12, 1940. The LIFE Picture Collection/Getty Images.

Fig. 37 / Ollie Harrington, *Deep South*, 1939–40. Oil on canvas, approx. 60 x 36 in. (152.4 x 91.4 cm). Location unknown.

"Stark tragedy and humor are often separated by a mere hair's breadth," Harrington was quoted as saying. "That's why there is so much [of these] in Harlem."[19] Speaking years later about these contiguous emotions and their discernment, Harrington noted that other oppressed peoples, such as members of the gay and lesbian communities, also had well-honed insights that enabled them to recognize implicit attacks, disavowals, and shared secrets. Describing one of his friends, a gay African American valet to a Yale University professor, Harrington recalled: "Thurgood [Jones] was gay, but I didn't know it. I did know that he was very gentle and different. He had that strange twinkle in his eye that I learned later that many gays have, that they were aware of something that escaped everyone else. But then, most Blacks had that twinkle, too."[20] Harrington's remarks about the "strange twinkle" in Jones's eye, or a kind of second sight that allowed gays, blacks, and other beleaguered segments of society to see things "that escaped everyone else," clearly included artists like himself: a satirist whose social observations and intuitions yielded pictorial assessments that, like his cartoon of the defeated yet standing black boxer, captured the paradoxes and ironies of African

American life whose emotional valences, from dark despair to delirious mirth, were the core ingredients of Harrington's *Dark Laughter* cartoon strips.

Of course, the success of the *Dark Laughter* cartoon strip hinged not only on each cartoon's legibility, both visually and narratively, but on the capacity of the *Amsterdam News*'s readers to wholly comprehend each cartoon and to parse their respective satirical stratagems. In other words, the audience's visual literacy had to be matched by a cognizance and familiarity with satire or, to use a more descriptive, concocted term, Harrington's audiences required "satiracy" in order to fully grasp what they were encountering on the page. "Satiracy" fuses the two designations "satire" and "literacy," so as to characterize in this study what African Americans brought to this particular strain of black artistic critique: a cultural competence in reading "between the lines," and an insider's one-upmanship in decoding the visual signs and clues that satirists such as Harrington embedded in their art. Comparable to literary critic E. D. Hirsch's concept of cultural literacy (that is, the ability to understand and participate fluently in a given culture), satiracy is achieved through the formal or informal study of discursive censure, a lifetime of experiencing critical social interactions, and developing fluency and extra-linguistic discernment in sociocultural communication. For Harrington, growing up in genteel poverty in the South Bronx, living and working in Depression-era Harlem, and, most importantly, participating in the lively repartee between different black New York constituencies and absorbing that community's constantly shifting psychological moods and ontological modes of self-conceptualization all schooled him in African American life, and instilled in him a satiracy that, via the *Dark Laughter* cartoon strip, made palpable incongruities and aberrant social realities, as metaphorically experienced under a black American, blues-inflected soundtrack.[21]

Recognizing the cultural niche his *Dark Laughter* cartoons could potentially fill for African American consumers of print media, beginning around 1938 Harrington attempted to syndicate the strip. Reaching beyond his contract with the *New York Amsterdam News* (which at the time was losing staff because of their thwarted attempts to unionize), Harrington tried securing subscriptions from the other leading black newspapers of the day, such as the *Pittsburgh Courier,* the *Chicago Defender,* and the *Baltimore Afro-American.* While in theory an excellent idea, in practice Harrington's long-distance overtures to the *Amsterdam News*'s competitors were not entirely successful, and the idea of *Dark Laughter* simultaneously appearing in black newspapers nationwide, at least during in the Depression years, was premature, administratively difficult, and ultimately unprofitable.[22]

BOMB SHELTER

Following graduation from the Yale University School of Fine Arts and after briefly working for the National Youth Administration (a New Deal program providing education and employment for young adults), in 1942 Harrington began serving as art director for the *People's Voice,* a New York–based, politically progressive, African American newspaper founded by Abyssinian Baptist Church pastor and Harlem activist Adam Clayton Powell, Jr. Unabashedly used by the flamboyant Powell as a personal platform for his political aspirations, the *People's Voice* nevertheless addressed important local news and U.S./international affairs impacting Harlem's citizens and African Americans nationwide.[23] Eternally the satirist, Harrington's earliest cartoons for the *People's Voice* poked fun at Harlem's more outrageous customs, for example, men's creatively tailored zoot suits and wide-brimmed fedoras (fig. 38). Harrington's cartoons that accompanied Powell's weekly *People's Voice* editorials, such as the one adjacent to a mock eulogy for the blatantly racist Eugene Talmadge's recently failed Georgia governor's election, were surrealistic, heart-rending, and, at times, allusive to other iconic images (fig. 39).[24] Similar to his *People's Voice* drawing of a walking Harlem bomb shelter, the naked and crucified black soldier—with accusatory placards posted on the cross alongside him—put the black body in service to satirical goals and, whether executed as caricatures or naturalistic, these figures enacted their insurgencies via strategically placed texts, corporeal jolts, and an overall graphic urgency.

Fig. 38 / Ollie Harrington, "Bomb Shelter." *People's Voice*, August 8, 1942.

Fig. 39 / Ollie Harrington, "Untitled" (editorial cartoon of crucified black soldier). *People's Voice*, September 19, 1942.

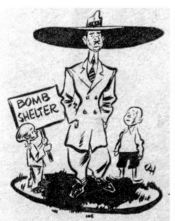
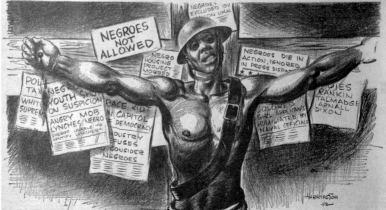

The creative license and critical latitude the *People's Voice* allowed Harrington was most evident in his *Blues in the News,* a weekly, multipanel cartoon that, with its sketchy, linear design, commented on current events and the artist's day-to-day musings on racial matters (fig. 40). An especially biting strip from this series showed two white journalists who, after being instructed by their managing editor to "portray the Negro in a more favorable light," are unable from one panel to the next to see black heroism during World War II, even while experiencing it firsthand. The end results of their assignment—a photograph of two black children eating watermelon—would have woefully resonated with the readers of the *People's Voice* and, again, like Harrington's cartoon of the white referee ignoring the still-standing black boxer (see fig. 28), made a sarcastic centerpiece of the mainstream media's systemic blindness to black achievements. On the topic of myopia as pertaining to American racism but, alternatively, afflicting some black people, another *Blues in the News* strip parodied the distinguished and first African American brigadier general of the U.S. Army, Benjamin Oliver Davis, Sr., who in the early 1940s was assigned to inspect the conditions faced by black soldiers abroad (fig. 41). Harrington, refusing to heed the call to "refrain from criticism" of "the good general," depicted the sixty-five-year-old trailblazer as blind and unreceptive to the racial discrimination surrounding him, resulting in General Davis—wearing Coke-bottle eyeglasses and potbellied—receiving military honors "for a job well done." On the heels of a news item about the Commonwealth of Virginia authorizing a commission to plan a memorial commemorating "the landing . . . of the first Negroes at Jamestown," Harrington couldn't resist the absurdity of such a proposal, especially coming from Virginia's governor, Colgate Darden, an acknowledged segregationist and avowed racist (fig. 42).[25] Turning his *Blues in the News* strip into the galleries of the so-called "Negro Memorial," Harrington refused to censor any of the vile truths of slavery, exposing his readers to shackled, hunted, and raped black bodies, instruments of torture and terror, and, in the last panel, a reminder of the black lives lost on World War II battlefields as more appropriately deserving veneration.

Regularly depicting World War II themes and military personnel in his *Blues in the News* strip, Harrington acknowledged what was of great topical importance to so many in the black community during the early to mid-1940s: the experiences and shifting status of African American soldiers. During World War II, approximately 1.2 million African Americans served in the military, overwhelmingly in segregated service units and, only gradually, as combatants. While keeping the names "infantry," "cavalry," and

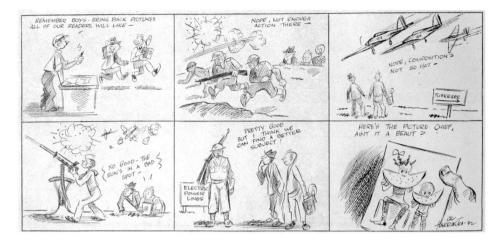

Fig. 40 / Ollie Harrington, *Blues in the News:* "Beef Dept.; An optimistic cartoonist, hearing that many of our white newspapers have decided to portray the Negro in a more favorable light, investigates. The photo in panel six appeared in one of our most scholarly dailies . . . ," *People's Voice*, August 1, 1942.

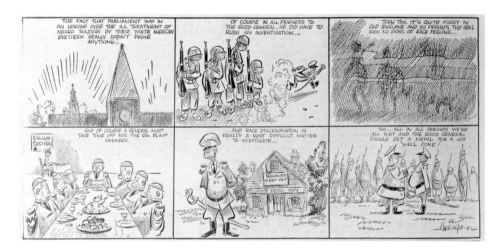

Fig. 41 / Ollie Harrington, *Blues in the News:* "News Item: — More on the good general. As a result of this cartoonist's opinions concerning General Davis's report on the race situation in the AEF in England, quite a few folks objected on the grounds that since the good general was the only one of the brethren wearing stars, we, above all folks, should refrain from criticism . . . ," *People's Voice*, November 7, 1942.

"artillery," most black outfits were labor and service organizations, working as port battalion stevedores, truck quartermasters, ammunition engineers, and other hard labor services units. When U.S. Navy Cook Third Class Doris "Dorie" Miller, while serving aboard the USS *West Virginia* at Pearl Harbor, swiftly mounted and successfully operated a machine gun following a sneak attack by the Japanese on December 7, 1941, demands for a more active fighting role for black soldiers began in earnest, and did not stop until the military's color barriers on battlefields were eventually lifted in 1944. In that pivotal year the U.S. Army Air Corps authorized the all-black 99th Pursuit Squadron to fight over Morocco and Algeria, and the all-black U.S. Army Buffalo Soldier Division, trained to fight on the ground and on war horses, also arrived there to defeat Nazi forces. Serving their country with distinction, black soldiers during World War II made important contributions, and the collective hope among African Americans was that their struggles and sacrifices in that time of great need would be answered by America's institutions and its white majority, finally giving African Americans the rights and privileges of full citizenship.[26]

Harrington's responses to the "war effort" were manifold. In addition to continuing to work for the *People's Voice,* he inaugurated a new comic strip, *Jive Gray,* an adventure strip conceived especially for the *Pittsburgh Courier.* In the mode of the syndicated cartoonist Milt Caniff's serialized and popular comic strip *Terry and the Pirates, Jive Gray*'s story line revolved

Fig. 42 / Ollie Harrington, *Blues in the News:* "News Item: Governor Darden of Virginia has authorized a commission to plan a memorial commemorating the landing at Jamestown in 1619 of the first Negroes. These landed, of course, as slaves, so . . . ," *People's Voice,* January 23, 1943.

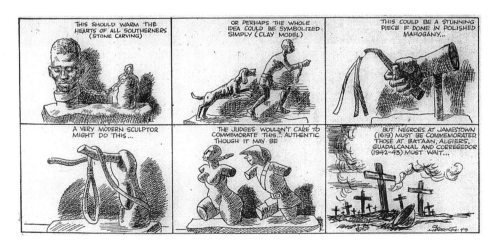

around an African American protagonist who, having been trained as a pilot at Tuskegee Institute's acclaimed aviation school, flies fighter aircraft during and after World War II. Appearing in the *Pittsburgh Courier* from 1943 until 1951, *Jive Gray* merged the adventure strip's more conventional preoccupations with criminality and political intrigue with what literary critic Edward Brunner described as the social circumstances of African Americans in the 1940s, involving issues of racial segregation, class conflicts, and gender bias. Harrington's *Jive Gray* and, for the *People's Voice,* a serialized comic strip version of author Richard Wright's acclaimed novel *Native Son* (1940), depicted African American culture with far less irony and comedic hyperbole than Harrington's other visual pursuits during these years.[27]

In the spring of 1943 Harrington became a war correspondent for the *People's Voice* and the *Pittsburgh Courier,* with regular field reports and on-site sketches covering African American troops (fig. 43). In contrast to Harrington's stinging portrayal a year earlier of Brigadier General Benjamin Oliver Davis, Sr., his May 1943 report for the *People's Voice* on the all-black 93rd Infantry Division's staged field operations at Camp Polk, Louisiana—where he finally met General Davis in person—was respectful and clearly attuned to the 93rd's fervent desire to not just support the war effort in service units, but to engage in combat on the battlefield. Later that year Harrington saw black soldiers' fighting capabilities firsthand, reporting for the *Pittsburgh Courier* on the progress that the celebrated Tuskegee Airmen were making during their training exercises at the Selfridge and Oscoda Army Air Fields in Michigan.[28] When the U.S. government finally acquiesced to political pressure and allowed the Tuskegee Airmen and the other all-black Army division, the 92nd Infantry, to become combatants in the spring of 1944, Harrington followed those African American fighting units, first to North Africa and then to Italy, from the summits of the Apennine Mountains to the Anzio beachhead and the other Italian campaign battlegrounds south (Naples and Salerno) and east (Cassino).[29] Also present for the Allied forces' landing on the southern coast of France, Harrington's August 1944 report made special note of the contributions of the 332nd Fighter Group to the invasion's ultimate success, quoting one of the black escorting pilots as saying, "My number may be up on this one, but you can bet your bottom dollar we're going to prove something to the race supremacy boys before we go down."[30] Sometimes flying with the 99th Squadron in their red-nosed Curtiss P-40 Warhawk aircraft and, frequently, shoulder-to-shoulder with African American infantrymen in grueling, rugged land operations, Harrington experienced the war not as a far-off and sheltered spectator but, rather,

Fig. 43 / Associated Press Photo, "Oliver W. Harrington, of New York City, artist correspondent, sketching Anti-aircraft Section Sgt. Carl K. Hilton, of Pine Bluff, Arkansas, who is with the Fifth Army in Italy, 1944." Gelatin silver print. Prints and Photographs Division, Library of Congress, Washington, DC.

as one of the men in harm's way, and someone whose racial identity, like the soldiers upon whom he was reporting, invariably shaped and transformed his wartime experiences.[31]

After returning to the United States in November 1944, Harrington resumed cartooning for the *People's Voice* and the *Pittsburgh Courier,* and yet those eighteen months as a war correspondent deeply affected him and profoundly impacted his future work. Having witnessed the incalculable sacrifices black soldiers made for American democracy—and questioning whether those sacrifices would result in better treatment stateside for them and their families—Harrington began creating cartoons that reflected those encounters (and their comical aftereffects), and also engaged in more political activities apart from his cartoon work. In contrast to his typical regime in the *Dark Laughter* cartoons of exposing the foibles and follies of average African Americans, Harrington began including in his cartoons scenarios with an unmistakable racial dimension, often featuring black soldiers. In one of Harrington's *Dark Laughter* cartoons of 1945, an Italian woman naively observes to the now-enlisted and uniformed Bootsie, "Whenever I go out with brown Americanos there are so many meelitary poleece," as both sit in a typical Italian café. The woman's rejoinder, that "[this] ees a great com-

Fig. 44 / Ollie Harrington, *Dark Laughter*: "Whenever I go out with brown Amer-
icanos there are so many meelitary poleece. Thees ees a great compliment to the
brown Americanos, yes?" *Pittsburgh Courier*, May 19, 1945.

pliment to the brown Americanos, yes?," was pure irony, as reflected in
the angry white military police surrounding her and her date, a quite nervous
Private Bootsie (fig. 44). While Harrington was making a lighthearted gag
in this *Dark Laughter* cartoon about the difficulties black servicemen faced
when fraternizing across "the color line," the more lethal and violent
consequences of interracial relations clearly lie behind Bootsie's anxious
expression and, no doubt, were also contemplated by Harrington's African
American audiences.

Miscegenation and other perceived acts of racial insubordination put
many African Americans, including some active service members and veter-
ans, at the center of several notorious, bloody confrontations with white
supremacists in the years just after World War II. Still annoyed by the U.S.
government's unfulfilled promises to patriotic African Americans, Harrington
partially shifted his energies away from cartoons and, instead, toward publi-
cizing these racial incidents, calling for punishing the perpetrators of the
atrocities and demanding justice for the victims. In 1946 Harrington was

hired as the public relations director for the National Association for the Advancement of Colored People (NAACP) and, among the cases for which he generated publicity, two in particular brought to bear Harrington's personal outrage and his sense of kinship with black servicemen.[32]

On February 25, 1946, James Stephenson, a U.S. Navy veteran, accompanied his mother to a Columbia, Tennessee, department store to pick up a radio that Mrs. Stephenson had left for repairs. An argument about the repair order between Mrs. Stephenson and a young white male clerk ensued, and the clerk threatened her. James Stephenson stepped between the two and struggled with the clerk, who ended up crashing through a window of the department store. The police arrested both the mother and son for disturbing the peace, and they pleaded guilty and paid a fifty-dollar fine. The following day James Stephenson was again arrested for the same crime but, this time, charged with assault with the intent to commit murder. Bond was posted, and Stephenson was able to return home that evening. In the days that followed mobs of whites and blacks exchanged gunfire with one another and, after several white police officers were struck, state patrolmen fired randomly into Columbia's black neighborhood, searched homes without warrants, and impounded people's personal property. Before the riot had ended, several blacks in police custody had been killed, more than one hundred blacks had been arrested, and about three hundred weapons from the black community had been confiscated. NAACP executive secretary Walter White, Legal Defense Fund director Thurgood Marshall, and public relations director Harrington immediately flew to Nashville to organize a legal defense and, as part of the NAACP's defense plan, Harrington created *Terror in Tennessee,* an illustrated ten-page brochure describing the incident and requesting defense funds. Eventually a federal grand jury was convened to investigate and, predictably, an all-white jury absolved the officers of any wrongdoing. Twenty-five blacks were tried for the shootings of the white officers; two were found guilty but were never retried due to lack of evidence.[33]

Just one week before the Columbia, Tennessee, riot, U.S. Army Sergeant Isaac Woodard, along with several other recently discharged soldiers, boarded a Greyhound bus in Augusta, Georgia, to return to their homes. Following an exchange between Woodard and the bus driver after the soldier's request to stop for a bathroom break, Woodard was met at the next stop—in Batesburg, South Carolina—by the town's chief of police who, along with his deputies, removed Woodard from the bus and brutally beat him with their nightsticks, leaving him permanently blind. Charged with drunken and disorderly conduct and jailed without any medical care, Woodard was even-

tually taken to a veterans' hospital in Columbia, South Carolina. The NAACP took up Woodard's case, pressing military officials to provide assistance to the gravely injured veteran while also calling for legal action against Batesburg's chief of police (fig. 45). Harrington enlisted a roster of media figures and political activists to publicize Woodard's plight, including Hollywood director/actor Orson Welles, who discussed the case at length on his weekly radio program. The flamboyant Welles may have found a soul mate in Harrington, who regularly updated Welles on the Woodard case throughout the summer of 1946, which provided Welles with enough material for a series of stirring radio commentaries.[34] In October Batesburg's chief of police was tried in federal courts, but found not guilty on all charges and released after an all-white jury deliberated for only thirty minutes. As news of this attack circulated, and after the NAACP's Walter White petitioned President Harry S. Truman about this travesty of justice, President Truman created the first President's Committee on Civil Rights. This led to the eventual desegregation of the military in 1948 and new federal attention to racial inequality.

These glaring examples of racial injustice, especially toward African American servicemen, and other NAACP cases of racial discrimination and violence against black people drove Harrington progressively toward the activists and social agendas of the Communist Party of the United States of America (CPUSA). At a time when, in matters of race relations and issues of racial inequality, U.S. governmental agencies, from the judiciary to law enforcement, were either unresponsive to, ineffective about, or, at worst, complicit in racial discrimination, partisans on the far political left offered African Americans like Harrington the only glimmer of hope for the future. Although Harrington never explicitly advocated that African Americans embrace the Communist Party's platform, his controversial appearance on October 28, 1946, at a *New York Herald Tribune* forum on "The Struggle for Justice as a World Force," during which he criticized in person the U.S. Attorney General Tom C. Clark for the government's futile efforts concerning the Columbia, Tennessee, riots and the Isaac Woodard case, was viewed by many as extending an olive branch to the CPUSA.[35]

First exposed to Communist Party members while employed at the *New York Amsterdam News,* Harrington had long-standing friendships with many of them in New York, and shared their sense of outrage toward the status quo and its role in oppressing black people and maintaining race and class hierarchies. From his political work for the black Communist New York councilman Ben Davis, Jr., to his public support for such well-known black Communists and leftists as William Patterson and Paul Robeson, Harring-

Fig. 45 / Llewellyn Ransom News Features Photos, "African American veteran Isaac Woodard, who was beaten and blinded by police, applying for maximum disability benefits, seated with David Edwards; standing (l to r) Oliver W. Harrington, Edward Nottage, and his mother, Mrs. Isaac Woodard, 1946." Gelatin silver print. Prints and Photographs Division, Library of Congress, Washington, DC.

ton grew further and further away from the NAACP's more moderate approach to social change (leading to his 1947 termination from the organization), and by the late 1940s, even his *Dark Laughter* cartoons were espousing left-ist views.[36] "Bootsie, you make me sick when you keep sayin' they ought'a let Ben Davis an' them Reds out on bail," an elderly black man addressed Harrington's protagonist in a 1949 cartoon (fig. 46). But when that indignant elder, his fist raised, continues with, "Now let me ask you one thing. . . . How would you like YOUR daughter to marry one of them Reds?," it's clear that, by revising an all-too-common racist provocation into a political accusation of "red-baiting," Harrington was just as much at ease with calling out African American illiberalism (as per politics) as he was with revealing white American hypocrisy (vis-à-vis racial prejudice).

Cognizant of the growing perception in the United States that the country and its democratic values were being threatened from within by Communists and their agents, both native and foreign, Harrington increasingly believed that, like so many of his associates on the political left, he would soon be labeled "subversive," judged unemployable, questioned by the U.S. government for his outspoken beliefs and Communist sympathies,

Fig. 46 / Ollie Harrington, *Dark Laughter:* "Bootsie, you make me sick when you keep sayin' they ought'a let Ben Davis an' them Reds out on bail. Now let me ask you one thing. . . . How would you like YOUR daughter to marry one of them Reds?" *Pittsburgh Courier*, November 5, 1949.

and possibly denied official documents to travel abroad. Stating on his 1951 passport application that, during an upcoming trip to France and Italy, he planned to continue his studies in art history and painting with funds attained from the G. I. Bill, his passport was miraculously granted early in 1952 and, within days, he had booked transatlantic passage from New York to Paris. As it turned out, he would renounce his American life and make Paris his home for almost a decade.[37]

"ONE OF THEM LYNCH COMPLEXES"

In Paris, Harrington became part of a legendary and highly visible black American émigré community, befriending and forming close intellectual alliances with such famous African American authors as Richard Wright, Chester Himes, and William Gardner Smith, among other black Americans in exile. Frequently at the center of that group's clandestine affairs and interpersonal clashes, Harrington exemplified for that era's commentators the liberated soul of the black expatriate in France. "Ollie became my best friend at the Café Tournon," wrote Himes about his and Harrington's favorite meeting place in the sixth arrondissement, just steps from the Luxembourg Gardens.

"The proprietors [of Café Tournon] . . . loved Ollie and he was a sort of accepted leader for all of the blacks of the Quarter. . . . It was really Ollie who singlehandedly made the Café Tournon famous in the world."[38]

During his time in Paris, Harrington supported himself by sending, via international mail, his *Dark Laughter* cartoons to the *Pittsburgh Courier*. Harrington's geographical distance from black America and his absenteeism from the stateside debates concerning the American Negro's civil rights did not hamper his ability to interrogate these topics, especially in his characteristic, satirical fashion. "He can't hit. He can't run. And he can't even stop a baseball," asserted a white coach about an inept black player on his Little League team, from one of Harrington's earliest cartoons produced in Paris (fig. 47). "But, if we DON'T let him play second base on the varsity," the coach conceded, "we'll have the NAACP climbing all over the school!" A far cry from Harrington's previous cartoons that criticized racial discrimination by white people, here he mocked black nepotism by whites and, perhaps more inflammatory, the sense that civil rights organizations such as the NAACP encouraged black favoritism when it was clearly undeserved. One can imagine this cartoon's ironic and somewhat cynical scenario dramatically performed by Harrington in front of a captive audience at the Café Tournon — with his reference to "second base" an unmistakable allusion to the Dodgers' acclaimed black second baseman, Jackie Robinson — and the guffaws emanating from everyone following Harrington's NAACP punch line. "We were fantastically absurd, all of us blacks," said Himes about the African American writers and artists who congregated at the Café Tournon. "But Ollie was funny. I could always follow Ollie's lead."[39]

As seen in this and other cartoons from his time in Paris, Harrington's rambling character, Bootsie, appeared less frequently in these one-panel strips, superseded by other characters and social situations where a range of current issues, many of a political nature, were broached by the artist. One of those "hot" topics, school desegregation in the United States, was the subject of a September 1956 cartoon in which an African American boy, being escorted to school by a phalanx of National Guardsmen, playfully asks his fellow black schoolmate, "You reckon these fools expect us to run through this hassle every day an' do our homework too?" (fig. 48). Published just days after a brigade of National Guardsmen and state troopers escorted two black children into a formerly all-white public elementary school in Kentucky, Harrington's cartoon was a sarcastic rejoinder to the landmark U.S. Supreme Court *Brown v. Board of Education of Topeka* decision, abolishing state-sponsored racially segregated educational facilities.[40] Seeing in these tumultuous

Fig. 47 / Ollie Harrington, *Dark Laughter:* "He can't hit. He can't run. And he can't even stop a baseball. But, if we DON'T let him play second base on the varsity, we'll have the NAACP climbing all over the school!" *Pittsburgh Courier*, May 31, 1952.

societal changes blind spots, tomfoolery, and gallows humor, Harrington had a satirist's field day from afar with American racial politics, whether his cartoon's purveyors of privilege and objects of ridicule were white or, in the previous example of the schoolboy pundits, the depicted satirists were black.

It was a few months prior to his school desegregation cartoon that Harrington dropped the *Dark Laughter* title for his popular strip and began entitling the series *Bootsie*. Perhaps the new name was an attempt to compensate for the marked absence of Harrington's definitive cartoon protagonist and, instead, to symbolically incorporate him into the strip's greater narrational matrix of absurdities under which black lives persevered. Under the serial title *Bootsie,* another cartoon exploring the madness of black life, even after segregation, took Harrington's audience into a wood-paneled inner sanctum of an aerospace conference room, where the only African American among a group of white scientists and executives is asked, before reading his "paper on inter-stellar gravitational tensions in thermo-nuclear propulsion," if he would "sing [to the assembled group] a good old spiritual" (fig. 49). What soon becomes apparent is that the title *Bootsie* not only

Fig. 48 / Ollie Harrington, *Bootsie:* "Goodness, gracious, Gaither. You reckon these fools expect us to run through this hassle every day an' do our homework too?" *Pittsburgh Courier*, September 29, 1956.

Fig. 49 / Ollie Harrington, *Bootsie:* "Doctor Jenkins, before you read us your paper on inter-stellar gravitational tensions in thermo-nuclear propulsion, would you sing us a good old spiritual?" *Pittsburgh Courier*, November 16, 1957.

refers to Harrington's missing, ne'er-do-well black loafer. In this 1957 cartoon it also refers to the character Dr. Jenkins who, despite his advanced degrees and technological expertise, is seen by many white people as a beloved, plan-tation-bound, Negro spiritual–singing "Uncle," caught in racism's stifling, stereotype-trafficking grip.

In a 1957 letter, author Langston Hughes suggested that the cartoonist, whom he referred to New York publisher Dodd, Mead and Company, "do a book of Negro cartoons . . . not of Negro cartoons in general, but one devoted to your own 'Bootsie,' since he is the leading cartoon character of our col-ored world."[41] Published almost one year later, *Bootsie and Others: The Cartoons of Ollie Harrington,* in effect, dropped the curtain on the *Dark Laughter* ban-ner and instead encouraged audiences to satirically engage with the subal-tern, recapitulated in the new title's subliminal/aural demand, "Boot, see!"

In his introduction to *Bootsie and Others,* Hughes wrote, "As a social satirist in the field of race relations, Ollie Harrington is unsurpassed." Hughes continued, "Visually funny almost always, situation wise, his pictures frequently have the quality of the blues." What replacing the cartoon serial title *"Dark Laughter"* with *"Bootsie"* did was, in effect, shift the expectations of Harrington's audience away from an equivocal, dark/light, tear-jerking/laughter-inducing sentimentality and, arguably, toward a bitterly humorous state of consciousness in which allusions to the downtrodden and a spectral blackness underpinned Harrington's acerbic agenda.[42]

Harrington's rancor concerning American race relations, social policies, and politics emerged in many *Bootsie* cartoons created throughout the remainder of his self-imposed exile in Paris, but two cartoon panels conveyed this accumulative indignation in particularly thought-provoking ways. The first example, published in the *Pittsburgh Courier* in the fall of 1959, brought back the actual Bootsie character, standing in a black painter's studio and closely inspecting one of the artist's abstract paintings (fig. 50). "No, it don't make sense to me neither, Bootsie," the black artist admitted. "But white folks jus' won't buy nothin' if it makes sense!" Apart from the cartoon's critical stance vis-à-vis abstract painting (a position Harrington probably forged a few years earlier when the Museum of Modern Art's abstract expressionism–steeped *The New American Painting* exhibition was on view in Paris), the criticisms leveled at "white folks" could be interpreted as a condemnation of the esoteric and impractical musings of a white American intelligentsia, represented by expatriate writers and journalists such as George Plimpton and Peter Matthiessen, who founded the literary journal *Paris Review,* and who also held court in those years at Café Tournon. Bootsie's cynical black artist may have also been voicing Harrington's sense of an encroaching American cultural imperialism in the post–World War II years: an opinion no doubt raised during the Paris run of *The New American Painting* exhibition, and also articulated while Harrington was visiting Moscow that same year.[43]

The other stinging *Bootsie* cartoon appeared in the *Pittsburgh Courier* toward the end of Harrington's Paris residency. A black mother, watching one of her sons playfully pulling the younger one by a rope tied around his neck, says to the eldest, "Now, lead 'im nice an' gentle an' don't go pullin' on 'im. Don't want 'im to develop one of them lynch complexes" (fig. 51). Willing to evoke the most horrific practices of American racism and terrorism, Harrington sarcastically turned child's play and its real-life emblem of mob justice and repression into a psychoanalytic condition, invoked no less by

 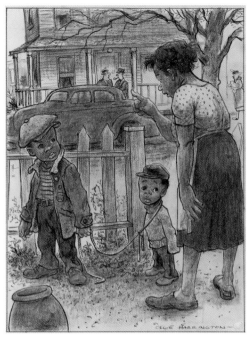

Fig. 50 / Ollie Harrington, *Bootsie:* "No, it don't make sense to me neither, Bootsie. But white folks jus' won't buy nothin' if it makes sense!" *Pittsburgh Courier*, October 17, 1959. Collection of Dr. and Mrs. Walter O. Evans, Savannah.

Fig. 51 / Ollie Harrington, *Bootsie:* "Now, lead 'im nice an' gentle an' don't go pullin' on 'im. Don't want 'im to develop one of them lynch complexes." *Pittsburgh Courier*, April 21, 1961. Prints and Photographs Division, Library of Congress, Washington, DC.

an average, working-class African American mother. Such a potentially insensitive cartoon—rendered in a straightforward, fairly realistic fashion for added effect—was only conceivable because of an earlier tradition, detailed by the literary critic Koritha Mitchell, of making white-on-black violence a tolerable subject for African American art, and also because of Harrington's own psychological and emotional state at the time.[44] With the sudden and mysterious death just months earlier of his close friend, novelist Richard Wright, and given Paris's Cold War–fueled, paranoiac, "spy-versus-spy" atmosphere among the American expatriate community, Harrington was increasingly feeling beleaguered for his anti-American views, and his cartoons were the ideal vehicles for this editorializing and personal venting.[45]

During the fall of 1961, Harrington ended up in East Berlin—behind the newly erected Berlin Wall of the German Democratic Republic (GDR)

and, ostensibly, unable to return to the West. He offered up visa problems and his untimely chance location there as the reasons, but the reality was perhaps more deliberate and largely of his own volition. Invited by the GDR's National Broadcasting Service and the East Berlin–based Aufbau-Verlag to illustrate for the latter a series of English-language classics, Harrington's short-term visit eventually became a permanent move and self-willed expatriation from the United States; the prospects for steady work in East Berlin as a freelance cartoonist/journalist and making a life and home in a more politically hospitable place appealed to the forty-nine-year-old artist. Relocating behind the Iron Curtain and participating in an international critique of not just American racism, but American imperialism, militarism, capitalism, and America's disreputable support of fascist regimes worldwide, put Harrington in the ideological company of other black Communists and politically left-leaning artists and activists, many of whom he knew from his earlier years in Harlem and his periodic work for the black leftist quarterly *Freedomways.* "I never wanted to leave the United States," Harrington told an interviewer many years later. "I'm part of that fight, but you know, in America they can box you in by really lowering it on you so that nothing you do is produced if it is telling [something about] or hurts the system. I've been much more effective from Europe."[46] Continuing to send his cartoons to several African American newspapers and regularly contributing illustrations and cartoons to the *Daily World,* the newspaper of the CPUSA, and, eventually, to East Germany's general interest periodical *Das Magazin* and the satire magazine *Eulenspiegel,* Harrington's artistic production increased commensurately while based in East Berlin and, amazingly, remained capacious until the late 1980s.

What also grew in this thirty-odd-year period was Harrington's artistic imagination, moving beyond simplistic, moral denunciations and realistic cartoon scenarios and, instead, exploring complicated issues in which his satire-laden censures took on an inflammatory, reductio ad absurdum quality. In 1963—a cataclysmic year of assassinations, bombings, and mass demonstrations in the United States—a *Bootsie* cartoon paired an elderly African American farmer with a squadron of dark-skinned, curly-haired, diminutive Martians. After greeting the extraterrestrials and remarking on their resemblance to black earthlings, the farmer continues, "But you better not hang around here in Mississippi or those fools'll think you want to go to school" (fig. 52). A few months after this cartoon was published, Harrington returned to a more recognizable subject for the times, mass protests, but

Fig. 52 / Ollie Harrington, *Bootsie:* "Now, who would'a thought you martians was cousins? But you better not hang around here in Mississippi or those fools'll think you want to go to school." *Pittsburgh Courier*, February 16, 1963. Collection of Dr. and Mrs. Walter O. Evans, Savannah.

Fig. 53 / Ollie Harrington, *Bootsie:* "Here, Brother Bootsie, take this extra hammer I got here in case the gentlemens of the law decides that this demonstration is too peaceful!" *Pittsburgh Courier*, June 29, 1963. Collection of Dr. and Mrs. Walter O. Evans, Savannah.

instead of showing the Reverend Dr. Martin Luther King, Jr.'s mantra-in-practice of nonviolent resistance, Bootsie's fellow protester, a mature and watchful African American woman, digs into her purse and says, "Here, Brother Bootsie, take this extra hammer I got here in case the gentlemens of the law decides that this demonstration is too peaceful!" (fig. 53). The success of these cartoons (and others from this same period) in transmitting to African American audiences the absurdity of the times, when staunch segregationists defied federal laws (and human decency) and protesters "turned the other cheek" against violence-prone law enforcement, largely hinged on Harrington's artistic skills, which endowed each character with anatomical precision and lifelike details that, along with the suggestive mise-en-scéne, supported the spectacular premise of each cartoon.

PRACTICE MAKES PERFECT

Harrington's cartoons of the 1960s—meticulous, virtuosic, and acerbic—
might suggest that his East Berlin base and proximity to the graphic arts
traditions of the German Renaissance and later may have played a key role
in his artistic turn toward a more refined drawing technique. But the affinities
these cartoons might have with, say, the works of early modern draftsmen
such as Albrecht Dürer and Hans Baldung Grien only partially explain Har-
rington's figural prowess at mid-century. Harrington's deft skills with ren-
dering the human form—first developed as a young art student in the early
1930s at the National Academy of Design, and further perfected during his
time at Yale's School of Fine Arts—were on full display well before his 1961
move to East Berlin, as evidenced in the drawings that appeared in *Bootsie
and Others: The Cartoons of Ollie Harrington*. Especially noteworthy from these
1950s cartoons and thereafter was Harrington's almost alchemic blend of
figural realism and caricature, which gave these cartoons an illustrative,
documentary feeling. In addition to this genre mash-up, the incorporation
of culture-specific gestures, physical mannerisms, and bodily attitudes—
such as akimbo arms, contrapposto stances, turned heads, rolling and
averted glances, and raised eyebrows—all elevated the satire quotient, while
viscerally bringing the depicted African Americans into the realm of wry
parodists and corporeal signifiers. Based on her body alone, we know the
suspicious and militant woman in Harrington's civil rights demonstration
cartoon; even without the accompanying caption, she exudes a conspiratorial
assertiveness with Bootsie and a mischievously circumspect, Pearl Bailey–like
attitude as per his hesitancy toward self-defense.[47]

As a bona fide member of what the historian Brian Dolinar has coined
the "Black Cultural Front"—a group of politically left-leaning black artists
and intellectuals that included Paul Robeson, Shirley Graham Du Bois, Frank
Marshall Davis, Margaret Burroughs, Elizabeth Catlett, and Charles White—
Harrington more and more viewed his artistic mission in geopolitical terms,
conceptually linking the civil rights struggles of African Americans with the
struggles of oppressed peoples worldwide.[48] Harrington's thematic shift
toward international malpractices, as evinced in the Vietnam War and the
United States' increased militarism under President Richard M. Nixon, was
artistically amplified to such an extent in this period that a selection of these
cartoons was republished in *Soul Shots* (1972), a portfolio of lithographic
prints with an introduction by a fellow "Black Cultural Front" comrade, artist
Elton Fax.[49] Although Harrington's *Bootsie* cartoons for the *Pittsburgh Courier*
and the *Chicago Defender* in the 1960s and 1970s maintained a focus on

racial matters that targeted African American audiences, beginning around 1968 Harrington started submitting single-panel cartoons to the CPUSA's official newspaper, the *Daily World,* and those cartoons, while not entirely ignoring African American issues, expanded Harrington's commentaries to other problems whose appeal was international in scope and Marxist-Leninist in tenor.

For example, in a 1971 editorial cartoon for the *Daily World* captioned "Beauty and the Beast," Harrington made Angela Davis—a well-known black political activist, an acknowledged Communist, and, at the time, the focus of a nationwide Federal Bureau of Investigation (FBI) hunt—one of the cartoon's primary subjects. Davis, in the guise of Lady Liberty (or, rather, Lady Liberation), her right fist defiantly raised in that era's archetypal Black Power salute, is shown ensnarled in the FBI's boa constrictor–like grip (fig. 54). Channeling the nineteenth-century political cartoonist Thomas Nast's satirical depictions of the Union-assailing, anti–Civil War/anti-abolitionism "Peace Democrats" (who were popularly labeled "Copperheads"), Harrington gave Davis's beastly, serpentine nemesis the facial features of FBI director J. Edgar Hoover, a frequent target of criticism by civil rights activists, left-leaning liberals, and political radicals. Davis's righteous indignation and the FBI's evil behavior were more or less agreed upon by moderate-to-liberal political constituencies, circa 1971, so the satirical thrust of Harrington's "Beauty and the Beast" was universally understood and appreciated by audiences far beyond the *Daily World*'s readership.[50]

Harrington's differing approaches to the two figures in "Beauty and the Beast," juxtaposing Davis's naturalism with Hoover's distorted, grotesque form, adhered to a well-established practice in the history of caricature, where the artist's intended sympathy or ridicule for the depicted characters frequently corresponded to the degrees of figural realism or exaggeration deployed within the cartoon. "Both caricature and the grotesque rely on invention, a predilection for metamorphosis, and irreverence for the boundaries that separate human figures from animal or inanimate forms," writes art historian Alison Hafera Cox about caricature's power to shift people's perceptions of the individuals portrayed.[51] Creating this divergent emotional scale so as to project a set of empathetic or antagonistic positions vis-à-vis the imagery and its implied scenario was no easy task, as it required the ability to convincingly render its cast of characters across a wide representational spectrum, as well as the prudence to not generate too deviant or outrageous a caricature on either side. Harrington's distinctive drawing style—rooted in academic figural naturalism—was already a representational mode that

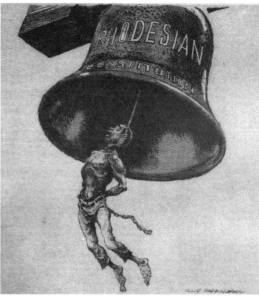

Fig. 54 / Ollie Harrington, "Beauty and the Beast" (also known as "The Statue Seen from 'Uptown'"). *Daily World*, April 23, 1971. Prints and Photographs Division, Library of Congress, Washington, DC.

Fig. 55 / Ollie Harrington, "I believe it is not only acceptable to Rhodesians, but with a clear conscience we can argue this constitution outside the borders of our country. (Rhodesian Prime Minister Ian Smith)." *Daily World*, February 27, 1969.

was psychologically sympathetic to its subjects, so to interject a satirical element (as seen in "Beauty and the Beast"), Harrington had to sparingly and carefully reconstitute his object of derision through deforming the FBI director's anatomical features or, more subtly, through the symbolic inferences of figural zoomorphism or proximate accessories.

Responding to the Rhodesian prime minister Ian Smith's widely reported comments about a newly written constitution that strengthened the country's white minority rule by limiting the number of electable black members to the Rhodesian Parliament, in a 1969 *Daily World* cartoon Harrington juxtaposed a Smith quote about the new constitution with a huge "Rhodesian Constitution Bell" containing a bound black man as the bell's clapper, hanging inside from a rope and noose (fig. 55). Comparable to his 1961 *Bootsie* cartoon depicting a black mother warning her children about "[developing] one of them lynch complexes" (see fig. 51), Harrington actually depicts this phobia-triggering image here, but in the context of British colonialism in southern Africa and its lethal repercussions.

But unlike many of Harrington's previous cartoons, the "Rhodesian Constitution Bell" drawing and several others published in the *Daily World* relied less upon their captions and, instead, produced ironic pictorial premises, in which visual elements were altered or repositioned in such a way as to satirically suggest contradictions in the depicted characters, to show an entity's clandestine aspects, or to introduce revelatory imagery within an assumed narrative. For example, Harrington's *Daily World* cartoon of the U.S. Capitol capped with a Ku Klux Klan hood was typical of these cartoon ironies in which the audience's prior assumptions concerning a portrayed pictorial element (and its agreed-upon meaning) were augmented and transformed by the added ingredient, usually in a fault-finding way. This particular strategy in editorial cartooning was a tried-and-true approach, with cartoonists such as Art Young and Robert Minor notably taking this tactic to a critical apogee in early twentieth-century leftist periodicals such as *The Masses*.[52]

One of the issues that resonated in particular with the *Daily World*'s readership was U.S. government surveillance of American Communists and politically left-leaning U.S. citizens: a topic to which Harrington brought a measure of levity in a 1975 cartoon (fig. 56). With its figures rendered in the exaggerated manner of *Mad Magazine*'s Jack Davis, this *Daily World* cartoon appreciably pivots between the gigantic mailbag, the snarling comic strip dog, and the cartoon's explanatory, dispassionate caption: three vantage points choreographing a visual/literal two-step that, itself, was comparable to the FBI's notorious history of shadowing and secretly recording so-called American subversives.[53]

American domestic policies and their political reverberations abroad were also of great interest to the editors of *Eulenspiegel,* a popular German humor and satire magazine that, because of its East Berlin headquarters, was ideally located for Harrington to offer his talents. *Eulenspiegel,* which in English roughly translates into "owl mirror," is also etymologically derived from the Middle Low German verb "*ulen*" ("to wipe") and the noun "*spegel*" ("mirror"), the latter also a euphemism for "buttocks." The combined words' scatological imperative to "wipe the ass" was the moniker for a folkloric German personage, Till Eulenspiegel, the late medieval jokester for whom the twentieth-century satire and humor magazine was named.[54] Randall L. Bytwerk, a scholar of modern German propaganda, quotes *Eulenspiegel*'s mission statement, which proclaimed that its objective was to "fight with the weapon of satire against everything harmful to the people, everything that hampers development." With *Eulenspiegel*'s editorial eye focused more on the GDR's particular shortcomings, the statement further clarified that the maga-

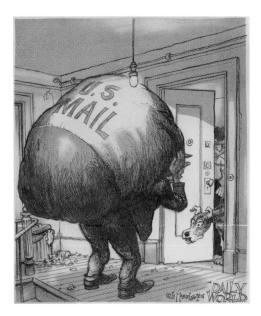

Fig. 56 / Ollie Harrington, "The FBI's been checkin' your mail since you was spotted at a tenants' meetin' in '47. They told me to deliver these an' tell ya they're sorry." *Daily World*, October 21, 1975. Prints and Photographs Division, Library of Congress, Washington, DC.

zine "uses humor to point out, in a friendly manner, the wrong ways people have of getting along with each other and to expose poor quality work, rudeness, laziness, mistakes, in short, defects and weaknesses in all areas of life. But *Eulenspiegel*'s task is also to spread cheerfulness, to entertain, to educate."[55] Peter Nelken, a *Eulenspiegel* editor, noted that in the 1960s "*Eulenspiegel* . . . sold out issue after issue." Nelken continued, "[*Eulenspiegel*'s] editorial staff estimated that [in one year's time] 650,000 copies could have sold if sufficient paper (perennially in short supply in the GDR) had been available."[56]

Harrington began submitting artworks to *Eulenspiegel* in the 1970s, and as was the case with the other satirical pieces published in that magazine, his cartoons covered a range of subjects, from humorous, innocuous knocks against East Germany's often incompetent bureaucracy to visual diatribes against the Soviet bloc's pet global villain: the United States of America. How Harrington managed to produce cartoons for *Eulenspiegel* while simultaneously sending cartoons to African American newspapers such as the *Chicago Defender* and to the CPUSA's weekly *Daily World* indicated his ability to compartmentalize his professional obligations and his cartoon's intended audiences. This targeting of different audiences for his work wasn't a recent phenomenon. In the 1940s, while creating his satirical cartoons for the *Pittsburgh Courier* and the *People's Voice,* he also drew a comic strip version of

Richard Wright's novel *Native Son*, the melodramatic adventure strip *Jive Gray*, and, working in an entirely different vein, he illustrated two of author Ellen Tarry's children's books, *Hezekiah Horton* (1942) and *The Runaway Elephant* (1950).[57] Already accustomed to forging his own business ties and making syndication arrangements with numerous black newspapers, it would not have been an onerous task in the 1970s for Harrington to enter into multiple freelance cartoon contracts, even from afar. "I have always insisted on determining the content of my work," Harrington is quoted in a profile for the *Daily World* in 1972. "That is why I have always refused to work for any publication that would not allow that luxury."[58] The objects of Harrington's critiques of the United States were varied (for example, government assaults on free speech, Hollywood's malignant influence worldwide, police brutality and corruption, the United States' "superpower" status and interventionist tendencies in the world, and so on), but a recurring issue for the East Berlin–based black satirist was American racism, and there was no shortage of notorious racial incidents in the 1970s from which Harrington created compelling, hypercritical images.

Eulenspiegel's locus in Germany and that country's long and highly developed tradition of satirical graphic arts—historically extending back to the Northern Renaissance illustrated print genre of *narrenliteratur*, or "fool's literature"—brought Harrington, figuratively speaking, into the heart and soul of modern visual satire. The artistic descendant of an American cartoon heritage dating back to the nineteenth-century newspaper *Harper's Weekly* and the early twentieth-century socialist journal *The Masses,* Harrington would have recognized in the cartoons for *Eulenspiegel* pictorial ideas that, while in ways comparable to the satirical strategies of American artists such as Thomas Nast or Robert Minor, were based on centuries of graphic art practices whose criticisms, more often than not, were astutely crafted against selected societal and institutional targets. Whether illustrations of common proverbs (such as "*Man soll das Kind nicht mit dem Bad ausgiessen,*" or "Don't throw the baby out with the bathwater"), representations of interpersonal miscalculations (such as the early modern, "ill-matched" cross-generational lovers pictures), or political/religious propaganda (as in the anti-papal, anti-Semitic, antiwar, and anti-capitalist prints and broadsides), Germany's satirical graphic arts presented Harrington with a unique, art historically grounded set of pictorial stratagems that he would place alongside and gauge with his own, decades-in-the-making artistic formulae.[59]

The confrontational and volatile desegregation of the public schools in Boston in the mid-1970s—which led to massive protests, fierce rioting, and a

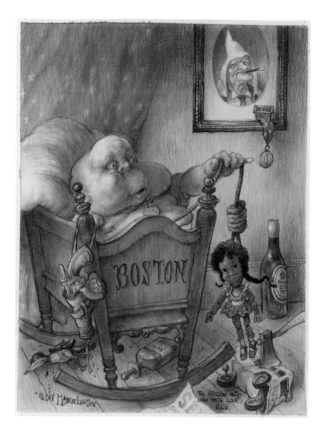

Fig. 57 / Ollie Harrington, "Wiegenfeststellung einer Ausgeburt" ("Boston, Cradle of Liberty"). *Eulenspiegel*, no. 40 (1975). Prints and Photographs Division, Library of Congress, Washington, DC.

well-coordinated anti-school desegregation/antibusing campaign, primarily in the city's predominately Irish-Catholic neighborhood of South Boston — captured Harrington's attention even as far away as East Berlin, and his cartoons for *Eulenspiegel* about this ugly episode concerning American race relations were particularly stinging. Harrington entitled one especially elaborate and narratively dense drawing "Boston, Cradle of Liberty," which accompanied a tongue-in-cheek anecdote about Boston and was ostensibly set in an infant's nursery (fig. 57). The depicted baby, bloated and ensconced in a cradle engraved with the name "Boston," is surrounded by an array of symbolic accouterments (a pistol, a dead bird, alcoholic beverages, a lynched black doll, an axed toy school bus, and Ku Klux Klan mementos). Sometime after appearing in *Eulenspiegel*, "Boston, Cradle of Liberty" was given and dedicated to two of Harrington's closest American friends (and longtime members of the Communist Party), James and Esther Cooper Jackson, who eventually donated it to the Library of Congress. Harrington's composition

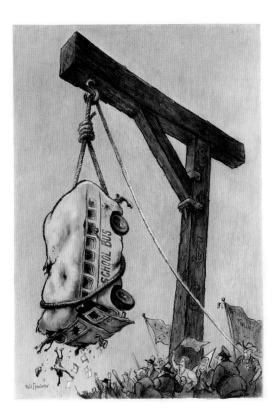

Fig. 58 / Ollie Harrington, "Da hat die Menschheit wieder mal Glück gehabt!"
("Once again, humanity has been lucky"). *Eulenspiegel*, no. 49 (1977). Collection of
Dr. and Mrs. Walter O. Evans, Savannah.

brimmed over with visual information, matching the infant's corporeal
excesses, as if American racism itself could not claim in any way ideological
moderation, restraint, or economy. Again, the display here of a seasoned
draftsman's skills, a sophisticated sense of color, and compositional acuity
activated the satirical thrust of "Boston, Cradle of Liberty," and its appear-
ance in the East German satire magazine further confirmed Harrington's
contempt for an inconsistent, American "freedom-loving" account.[60]

Not someone to let a successful idea receive just one visual outing,
Harrington took up the Boston anti–school integration theme in another
cartoon for *Eulenspiegel* several years later. The second Boston cartoon, inex-
plicably depicting a lynched and battered school bus with black children and
their textbooks tumbling to the ground and angry white protesters gathered
beneath the lynchers' gallows, probably would not have been alien to modern
German audiences, given that nation's own nefarious history of anti-Semi-
tism and mob violence (fig. 58). Harrington had actually originated the

Fig. 59 / Ollie Harrington, "Vorsicht, Darling! Denk schatz was der Präsident über de Terroristen gesagt hat" ("And remember what the photo instructor at the Forest Hills Photo Group always said: 'In bright sunshine, always use a fast shutter'"). *Eulenspiegel*, no. 44 (1982). Collection of Dr. and Mrs. Walter O. Evans, Savannah.

lynched school bus idea a few years earlier, as seen in a 1972 *Daily World* cartoon ironically entitled "School Integration" and set in the nation's capital. But the 1977 *Eulenspiegel* version, rendered with minute details (and originally conceived by Harrington in color), took the idea to an entirely different level, one that empathized with innocent schoolchildren and, again, subliminally channeled Harrington's comments from two decades earlier about psychological "lynch complexes."

Harrington's work for *Eulenspiegel* also recognized other victims and perpetrators of wrongdoings in the world. The apartheid-upheld government in South Africa, the Contras and their U.S. backers in Nicaragua, and the West's counterinsurgency tactics that often contributed to political instability and famine in the developing world were just a few of the international crimes against humanity about which Harrington drew satire-filled cartoons. One drawing, of white tourists stopping in a desolate, drought-afflicted ter-

Fig. 60 / Ollie Harrington, "Laufendes Training"/"Practice Makes Perfect." *Eulenspiegel*, no. 1 (1980). Collection of Dr. and Mrs. Walter O. Evans, Savannah.

rain to take a photograph of an emaciated black woman and her starving children, appeared on the cover of a 1982 issue of *Eulenspiegel* with the caption (translated from German), "Careful, darling. Remember what the president said about the terrorists" (fig. 59). Following the drawing's acquisition in the early 1990s by the American art collector Dr. Walter O. Evans, Harrington replaced the previous German caption with a different one in English: "And remember what the photo instructor at the Forest Hills Photo Group always said: 'In bright sunshine, always use a fast shutter.'" Although both captions supported Harrington's scathing image of Western insensitivity in the face of suffering, especially in the global South, *Eulenspiegel*'s caption

was clearly aimed at the United States and its ignoble legacy of racial stereo-typing. In contrast, Harrington's subsequent English-language caption attacked an oblivious, white American sense of privilege and cultural hege-mony in the world that, epitomized by the photographer's camera and its telephoto lens, colonizes and cannibalizes everything in its sight.[61] Criticisms of Harrington's default mode of focusing on the victims of oppression rather than the exemplars of Marxist-Leninist resistance were leveled in 1977, tell-ingly, by a fellow *Daily World* cartoonist, Seymour Joseph, although a writ-ten apology to Harrington, by then an esteemed figure among American Communists and political exiles, was demanded shortly thereafter and sent to the artist.[62]

The interchangeable nature of the captions in many of Harrington's *Eulenspiegel* cartoons, or their comprehension without texts altogether, was demonstrated in a rare, virtually captionless strip from 1980, on the sub-ject of the never-ending real and symbolic sprint through life of the African American male (fig. 60). From stealthily dodging tenement rats as a toddler, through fleeing white gangs in one's youth and bullets from a police offi-cer's gun, and swiftly escaping on foot from racist Klansmen to, triumphantly, finishing in first place in an Olympics track event, Harrington's cartoon, translated as "Continuous Training" from the German, transformed the everyday trials and near brushes with death that black men daily faced into a "running" joke (pun intended). Adapted from one of his old *Pittsburgh Courier* cartoons about a black football player who, despite the southern loca-tion of the goalpost, instinctively runs north, to the part of the United States metaphorically referred to as "the land of liberty," Harrington's updated version—loosely drawn and yet naturalistic and specific enough to effectively narrate its five episodes—both expanded and condensed the black runner's existential condition, by way of a hilarious and poignant perspective. The *Eulenspiegel* cartoon's later English caption, "Practice Makes Perfect," perhaps had an autobiographical significance, as only an ex–track athlete and sea-soned black satirist such as Harrington could deploy.[63] Although the trajec-tory of Harrington's own life—from the South Bronx to East Berlin, with many places and hurdles in between—arguably wasn't as traumatic a gauntlet as experienced by his depicted black runner, the allegory and reality of flight was not lost on him.

If Harrington's pre–East Berlin life could be perceived as the quint-essential sojourn of a modern artist in the West, then his life after settling in East Germany in 1961 was truly that of a global citizen: taking excursions and connecting with fellow cartoonists and satirists throughout Europe and

Fig. 61 / Jeff Stahler, *Ollie Harrington* (caricature from the 1992 Festival of Cartoon Art Program), 1992. Ink on paper, 8 ¹¹⁄₁₆ × 5 ½ in. (22 × 14 cm). Jeff Stahler Collection, The Ohio State University Billy Ireland Cartoon Library and Museum, The Ohio State University Libraries, CGA.JS. 1992.

the Soviet Union, traveling to Ghana at the invitation of President Kwame Nkrumah, visiting a U.S.-embargoed Cuba, and returning to the United States as an acclaimed cartoonist on several occasions in the 1970s through the 1990s. Critical accolades in these years, such as the gold medal he received during the *Satire in the Struggle for Peace* exhibition in Moscow (1977) and Berlin's Eddi prize for satire (1985), underscored the international dimensions of Harrington's reputation, even while experiencing a relatively sequestered existence behind the Iron Curtain. All of this was thrown into great instability following Germany's reunification in 1989: a significant moment that, for a settled, American-born antagonist such as Harrington, led to numerous personal and political readjustments.[64]

Experiencing a collegial, somewhat nostalgic, and not-at-all politically fraught American homecoming in the 1990s, Harrington's credentials as an unwavering satirist were put to a severe test. Public talks and exhibitions during artist-in-residencies at American universities encouraged Harrington to look retrospectively at his life and career and, most importantly, to compare those earlier, pre–civil rights years in the United States with the America he was now experiencing. In 1991 Harrington delivered a speech at Wayne State University entitled "Why I Left America," in which, in a part-autobiographical, part-confrontational voice, he recounted his peripatetic life and gave a rationale for his East German exile. The following year he returned to the United States—as part of Ohio State University's Festival of

Fig. 62 / Ollie Harrington, *Bootsie:* "Officer, What Alabama bar was you holed up in back in '44 when I was in Normandy protectin' your civil rights?" *Pittsburgh Courier*, August 8, 1964. Collection of Dr. and Mrs. Walter O. Evans, Savannah.

Cartoon Art—and, in conjunction with the festival's special tribute to him, his public address, "Sitting on the Back Stairs," put forward his biracial, underprivileged Bronx upbringing as a Frankenstein-like laboratory in which a black satirist and cartoonist is created (fig. 61). And two years later, while Harrington was a visiting artist at the School of Journalism at Michigan State University, he admitted, "I've been developing a bit of optimism about the situation here in America." He then hedged, "[Not] a whole hell of a lot, but some, enough to excite my curiosity."[65]

This sudden hopefulness and, in a sense, the symbolic demise of black America's premier visual satirist (with Harrington's actual death occurring in the following year), came on the heels of the 1991 collapse of the Soviet Union and, just months before his acknowledged optimism, the widely reported 1994 conviction of Klansman Byron De La Beckwith for the 1963 murder of civil rights leader Medgar Evers.[66] These two historical book-ends—one marking the end of the totalitarian political system Harrington lived under for thirty years, and the other rectifying one of the more horrific crimes and offenses of the civil rights movement—undermined many of the artist's past critiques of American democracy and doused his incendiary

points of view on capitalism, leaving the longtime satirist with little more than begrudging admiration for America's progress toward racial equality and socioeconomic mobility since his self-imposed exile in 1951. This was hardly the stuff with which a satirist could build a vicious critique, and like many surviving veterans of the long civil rights struggle—and of the mid-twentieth-century "Red Scare"—Harrington had lived long enough to finally see substantive changes and improvements in the lives of African Americans. The black communities Harrington encountered in these later years, while still mired in poverty and government neglect, still kept alive much of the same urban folk spirit and human comedy that he intimately knew from his Harlem years, but his decades of living in East Germany made even that well-traversed cartoon subject more remote by the 1990s and, therefore, no longer a prime target for his African American–directed satires.

Given this different perspective of his cartoons' objects for ridicule, Harrington's inability toward the end to even hold a pencil, on account of his debilitating arthritis, perhaps made this dearth of satirical intendments less painful.[67] He could have also found some satisfaction and comfort in looking back on his remarkable career, spanning almost sixty years, working for over a dozen newspapers and journals, forging alliances and friendships with a virtual "who's who" of twentieth-century cultural and political luminaries, and "sticking it" to an array of perceived villains, social nuisances, and living contradictions. At his satirical best—as seen, for example, in a 1964 *Bootsie* cartoon for the *Pittsburgh Courier* showing violent clashes between black unarmed protesters and baton-wielding, pistol-toting white policemen—Harrington's graphic mastery in rendering the variances of human anatomy, paired with a pungent, context-laden setting and caption, planted in viewers' minds the all-too-real ironies of a modern black existence (fig. 62). As the progeny of a century and of a nation in which racial blackness elicited social ostracizing, physical assaults, and legislation prohibiting people like him from having the full rights and privileges of American citizens, Harrington's recourse, as his life and labors demonstrated, was both pugnacious and artistic. And recognizing the ability to fuse these two impulses into the art of satire, Harrington's indictment, like that of the indignant double amputee in this cartoon, demanded an accounting for past transgressions and immediate restitution by way of a wry comparison, astutely sketched and brilliantly synchronized in penciled communiqués and bodies of evidence.

THE MINSTREL
STAIN

In 1980 Robert Colescott painted a double portrait of one of the most beloved dance partnerships of Hollywood's golden age, but, in the artist's unique fashion, *Shirley Temple Black and Bill Robinson White* posed an affront rather than an affirmation (fig. 63). Instead of the popular conception of a jovial but deferential old black man instructing a spirited little white girl in a complicated tap dance step, Colescott painted a lascivious, tongue-wagging Caucasian man ogling a blond-haired, brown-skinned, prepubescent girl, her wide-eyed gaze brazenly meeting his amidst an excessive, simulated arcadia. "I got my idea," Colescott explained to *Washington Post* art critic Paul Richard, "from Shirley Temple Black. She was Shirley Temple and then she married and became Black. When she went to Ghana as ambassador for the United States, I felt something in my insides; I should have known that when a 'Black' went to Africa as ambassador, it would be Shirley Temple."[1] Swinging between creative wordplay, a fantasy about this famous actress and her irony-filled married name, and Hollywood's questionable history regarding African American actors and their roles, Colescott's explanation acknowledged how his adaptation of an old film still *tapped,* pun-intended, into his inner satirist, resulting in an off-color, psychedelic, and sarcastic version of what moviegoers in the Depression years almost universally considered an innocent intergenerational encounter between the races.

Colescott's innuendos as regards to African American social compromise and his racial transpositions in paintings were, by 1980, a curious, frequently explored thematic strain in American art. These stereotypic depictions and racial reversals (more symbolic than illusionistic) were, in effect, a dash of insult and betrayal from an earlier time, but couched in a satirical frame of mind that, given Colescott's moment of a heightened black consciousness and race pride, often felt strange and precipitously veering toward heresy.

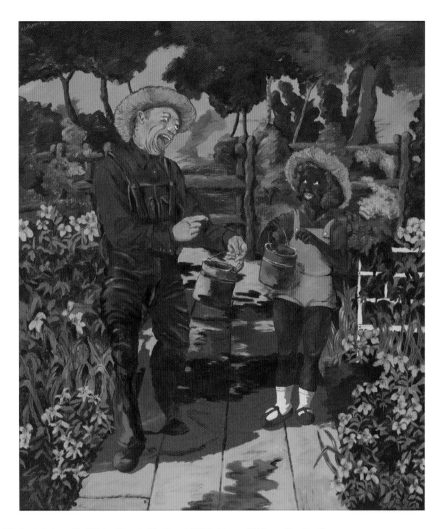

Fig. 63 / Robert Colescott, *Shirley Temple Black and Bill Robinson White*, 1980. Acrylic on canvas, 84 × 72 in. (213.4 × 182.9 cm). Collection of Harold and Arlene Schnitzer.

This artistic impulse — toward an incongruous, emblematic racial about-face, and the insertion of stock, racist representations of African Americans into pictorial narratives — is the phenomenon this chapter will investigate. Why so many African American artists since the 1960s chose to venture into these racially problematic territories is the question, along with how this "minstrel stain" tainted so many artistic imaginations and embedded itself in that era's most iconic works. Clearly the goal in much of this art was to satirize a preferential racial status quo and to show contempt for individual and institutional racism. However, the artistic judgment to incorporate the symbols and effects of those same vile elements in order to deride and mock them raised additional questions — for example, about the overall

efficacy of such an artistic strategy, the particular visual elements used from a bigoted bill of fare, and the communicative capacity of those tropes.

As gleaned from Colescott's *Shirley Temple Black and Bill Robinson White*, what characterized the minstrel stain was more than a cosmetic veneer, or an observable inversion from one racial phenotype to another. Rather, the minstrel stain was a received historical and psychological element that resonated far beyond the tar-brushed features of its hosts.

As documented in its early modern performances of perceived African American inferiority and folly, minstrelsy conveyed not just racial difference, but a variety of cultural mythologies, stereotypes, phobias, and obsessions. When modern and contemporary artists consciously inserted this invidious historical layer into their work — being fully aware of its highly suspect and entrenched psychological nature — they often did so with the expectations that their audiences not only knew minstrelsy's dramaturgical praxes, but understood the artist's satirical game plan in a reconstituted, frequently humorous, and often infractious presentation of this stigmatizing component. The minstrel stain, therefore, required from those who artistically implemented it spectators' presumptive knowledge, as well as their visual acuity, judgment, and a "satiracy" so that the work of art could achieve its intended objectives.

Tracing the path the minstrel stain has left in African American visual culture necessitates some historical backtracking to its origins: geneses not only located within antebellum and postbellum American popular theater, but extending back centuries earlier to Europe and Africa, where masking traditions and itinerant entertainers in the public sphere often used their performances as occasions for aiming satire-imbued critiques at various social, political, or religious targets. Starting in the late nineteenth century, African American artists began intricate, potentially backfiring engagements with minstrelsy, having enough cultural confidence and imagination to enter this murky, racially charged realm and put it to creative, critical use. Oddly, the strategic uses of blackface (and whiteface), stereotypic imagery, and, in general, the tropes and fixtures of minstrelsy came to a crescendo at the height of the Black Arts movement, circa 1965 to 1980. African American writers, playwrights, painters, sculptors, filmmakers, and even political activists all experimented with these racially disparaging elements from the past, seeing in their creative redeployment an ideal satirical weapon, as well as something talismanic and antidotal to counteract modern forms of racism.

After briefly recounting how the minstrel stain came into existence and looking at its evocations in African American art in the last quarter of

the twentieth century, this chapter will examine the manifestations of it in contemporary art practices, paying special attention to Spike Lee's *Bamboozled* (2000), the legendary filmmaker's fin de siècle critique of (and, arguably, his homage to) blackface minstrelsy. From the references to racial stereotypes in the works of contemporary artists such as Sanford Biggers, Ellen Gallagher, Hank Willis Thomas, and others, to the none-too-subtle allusions to blackface in the recordings and videos of hip-hop artists such as Kanye West, Little Brother, and Childish Gambino, the minstrel stain held an especially elevated status at the turn of the twenty-first century. What set apart much of the work of contemporary artists for whom minstrelsy and its assorted forms figured prominently was its shared conceptual alignments with early twenty-first-century deliberations around artistic representation, racial identity, artifice, and "the real."[2] Artists such as Kerry James Marshall, Kara Walker, Beverly McIver, Zanele Muholi, and Arthur Jafa, while cognizant of minstrelsy's recurring, irritating presence in contemporary visual culture, subsumed the minstrel stain within the larger theoretical investigations of authenticity and virtual reality in their respective works. The infusion of this historically fraught element by these and other contemporary artists substituted blackface minstrelsy's burnt cork makeup with a kind of "digital dirt," metaphorically speaking, which through conceptual means irrevocably perturbed and sullied more straightforward and conventional interpretations of a black identity.

Artist Kara Walker, whose inexhaustibly titled *A Subtlety, or the Marvelous Sugar Baby, an Homage to the unpaid and overworked Artisans who have refined our Sweet tastes from the cane fields to the Kitchens of the New World on the Occasion of the demolition of the Domino Sugar Refining Plant* provides this chapter with a historical caveat, also offers a fitting riposte to the idea of the minstrel stain (see fig. 90). Among the sixty-six drawings in Walker's collectively named compendium *Do You Like Crème in Your Coffee and Chocolate in Your Milk?* emerged one pertinent to this discussion (fig. 64). Featuring a singular, stereotypic African American "mammy" figure, but conceived in the form of a Russian nesting doll, Walker's drawing underscored its cultural contagion with the inscription "Demeaning Portraits Should be Seen & Not Heard." Modified from the traditional saying "Children should be seen and not heard," Walker's tongue-in-cheek, punitive pronouncement, alongside an effluvial, cartoonish watercolor, perfectly captured the satirical powers—and perils—of the minstrel stain, sarcastically showing how *seeing* so-called "demeaning" depictions can be just as precarious, if not more, as *voiced* detractions.[3] Whether a social stigmata or an artistic act of defiance,

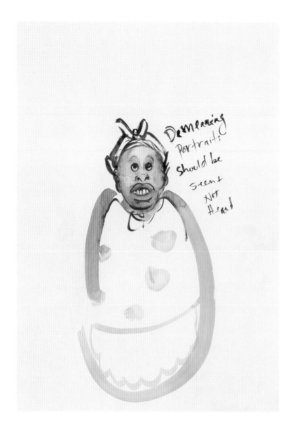

Fig. 64 / Kara Walker, Detail from *Do You Like Crème in Your Coffee and Chocolate in Your Milk?* (66 parts), 1997. Watercolor, colored pencil, and graphite on paper, each 11⅝ × 8³⁄₁₆ in. (29.5 × 20.8 cm). Walker Art Center, Minneapolis. Justin Smith Purchase Fund, 1998.100.1–66.

the minstrel stain is a conspicuous aspect of artistic expression in modern and contemporary African American discourse, and its implicit critiques of the habitudes of racism—as well as its inherent shortcomings—all make for a compelling inquiry into its modern formations and, as the numerous artworks discussed here exemplify, its elusive, postmodern aftereffects.

BLACK JOKES

As nearly all of the histories of the early American theater consistently narrate, the early to mid-nineteenth-century blackface performer Thomas Dartmouth Rice is considered the originator and proverbial father of American minstrelsy. After noticing a ragged, physically disabled black man near the Louisville, Kentucky, theater where he was performing in the early 1830s, "Daddy" Rice donned rags and a cotton wig, adopted the most exaggerated gestures and broken English from African Americans he could imagine, and applied

burnt cork and other colored pigments to his white skin in order to "por-
tray" this black man and perform a much admired, gangling "Jump Jim
Crow" routine. Before too long, Rice's "Jim Crow" character was immortalized
in printed broadsides and in Staffordshire porcelain effigies, and the Amer-
ican stage became inundated with white entertainers in blackface, whose
coarse representations and distortions of black bodies and culture were sta-
ples of the American theater well into the twentieth century. Concurrently,
blackface minstrelsy's popularity outside of the United States grew, attract-
ing music-hall audiences in England, continental Europe, and as far as
Australia, New Zealand, and Tasmania.[4]

Although blackface minstrelsy and its allusions to the institution of
slavery and black life in the southern United States were considered quint-
essentially American to foreign audiences, for many nineteenth-century
Europeans, blackface performers reminded them of their own minstrels, the
itinerant commedia dell'arte actors in seventeenth- and eighteenth-century
Italy and France whose costumed, masked, and heavily made-up actors also
trafficked in stock character types. It is especially noteworthy that the com-
media dell'arte personalities who represented the *zanni,* or the servants,
tricksters, and other lowbrow types in early modern Europe, usually wore
black or brown masks and, occasionally, black or dark-brown face paint. And,
conversely, the commedia dell'arte's most iconic and often tragic character,
Pierrot, usually performed in pantomime and wore a loose-fitting white
shirt, white, baggy pantaloons, and a ghastly complexion derived from white
face paint.[5]

Among the assorted zanni characters in commedia dell'arte, the most
popular one was Harlequin who, along with his customary dark mask and/
or makeup and patchwork/contrasting diamond-patterned costume, was
usually cast as a devilishly dissolute and taunting figure (fig. 65). The sce-
nario in which Harlequin and the other commedia dell'arte characters played
was usually a domestic one (involving a patriarchal master and his attrac-
tive daughter), but there were often moments in these plays when Harlequin
expanded his satirical orbit to mock a variety of targets, societal as well as
individual. Again, the American links to this European theater tradition and,
specifically, to Harlequin have been noted by numerous scholars, several of
whom remark on this character's alleged African or Moorish roots and his
debased social status.[6]

This very brief account of European and American performing arts
traditions that utilized face-painting in black and white is key to understand-
ing the modern and contemporary expressions of this theatrical practice,

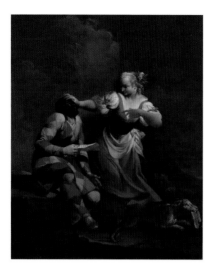

Fig. 65 / Giovanni Domenico Ferretti, *Harlequin as a Rejected Lover*, from the *Disguises of Harlequin* series, 18th century. Oil on canvas, 38⅜ × 30½ in. (97.5 × 77.5 cm). John and Mable Ringling Museum of Art of the State Art Museum of Florida, Florida State University, Sarasota. Museum purchase, 1950, SN646.

in that it indicated not so much an attempt to trick audiences into believing these figures were real, or closely resembled actual people, but rather indicated the desire to symbolically represent the racial, cultural, or social other. Operative in these aforementioned minstrel traditions is the nineteenth-century aesthetician Samuel Taylor Coleridge's theory of suspended disbelief, in which audiences overlooked the limitations of theatrical illusionism so as to not interfere with the performance's narrative propositions and the audience's acceptance of them.[7] Comparable in a sense to the ritualized, painted face and body decorations of many African peoples and of some Native Americans, these aforementioned minstrels adopted their painted personas with such a passion and personal sense of metamorphosis that, despite the makeup's patent superficiality, they succeeded in convincing their audiences of their respective characters' assumed personality traits, whether pitiful, ludicrous, ferocious, or benign.[8]

One is also reminded here of anthropologist Claude Lévi-Strauss's theory of the role of the mask in traditional societies, which explained one of the ways that humans acquired social import and, relatedly, assumed a spiritual dimension:

> Under what conditions are the plastic and graphic components necessarily correlated . . . so that the modes of the one always transform those

of the other, and vice versa? . . . We saw, indeed, that the relationship had to be functional when the plastic component consisted of the face or human body and the graphic component of the facial or corporal decoration (painting or tattooing), which is applied to them. Decoration is actually *created* for the face; but in another sense the face is predestined to be decorated, since it is only by means of decoration that the face receives its social dignity and mystical significance. . . . In the final analysis, the dualism is that of the actor and his role, and the concept of *mask* gives us the key to its interpretation.[9]

Stressing the unalterable link between the persona (that is, the mask) and the social/spiritual being, Lévi-Strauss would have plunged into an especially convoluted theoretical swamp had he expanded his concept of the masquerade and its transformative powers to include blackface minstrelsy, an American cultural practice that, as argued by historian Eric Lott, was infamous for its psychological projections of white working-class male incompetencies and desires onto African American bodies.[10]

In sharp contrast to much of the nineteenth century, when white entertainers, by means of blackface, participated in farcical routines and highly stylized, mocking performances about African Americans, the 1870s ushered in the era of African American minstrels: black performers who, while presenting much of that tradition's standard repertoire, interjected cultural elements that were perceptibly different from their white counterparts, both in artistic specificities and in the overall tenor of the performances. As black men mimicking white men who were pretending to be black, African American blackface minstrels performed in an existential "Twilight Zone," shuffling these various personas onstage while striving to deliver as pleasurable and "authentic" a theatrical experience as possible. African American troupes such as Haverly's Genuine Colored Minstrels featured some of the leading African American musicians, dancers, and comedians of the day: popular artists such as George and James Bohee, James Grace, Billy Kersands, and Tom McIntosh who, in a radical departure from the standard blackface practices, sometimes performed without the burnt cork makeup or related paraphernalia (fig. 66).[11]

In an 1882 Philadelphia newspaper article entitled "The Uncorked Minstrels: Training the Dusky Sons of Song," William Welsh, a white, former blackface performer and a so-called "trainer" of African American minstrels, provided a fascinating account of this recently instituted brotherhood. Although one suspects that Welsh exaggerated his professed authority over

such already established theatrical luminaries as Kersands, Grace, L. L. Brown, and Sam Lucas, his insights into the aesthetic dynamics and dilemmas facing these black performers are illuminating:

> In jubilee songs and plantation dances they are superior to white men and they have the advantage of possessing natural dialects. They have to be taught everything else. . . . Their powers of imitation are great. They do not learn clog dancing easily, as their old-fashion swinging style is hard to eradicate. Then most of them have what we call feet with kidneys in them, and a big-footed man does not learn neat dancing easily. After months of work, however, I have ten who do a first-class clog. They pick up ballads with wonderful ease and once learned they never forget them. No, their natural humor is crude and coarse. They all desire to tell gags that would come very appropriately from white performers, but are not suitable for colored minstrels. . . . Only last week . . . one of them wanted me to allow him to recite a pathetic ballad. Now just imagine a colored end-man reciting "Bingen on the Rhine" or something of that kind! Of course I refused to allow it. All of the jokes and gags in use by them have been selected on account of their appropriateness and the line of thought in all is what people expect to come naturally from colored people.[12]

Contradictions proliferate throughout Welsh's critique of African American minstrels, but what vividly comes through is the black performer's artfulness within a timeworn tradition and, sadly, the impenetrability of the racial stereotype when it came to performing in front of many white audiences. Still, many of these black minstrels managed to artistically usurp the banal music and nonsense lyrics of blackface, instead bringing out the kernels of humanity in this repertoire and working with the creative possibilities of banjo, buck and wing, body percussion, and social allusion.

Blackface minstrelsy's African American performers contradicted an interpretation of this tradition as altogether vilifying of African Americans and their culture and, therefore, profoundly complicated the standard perceptions of this theatrical practice. If one also considers the irony of these African American minstrels not just idly performing that tradition's offensive routines, but refashioning them in such a way as to lampoon and satirize their bigotry and black cultural inauthenticity, then many of our received notions of minstrelsy should undergo a reassessment. "African Americans were hyperconscious of how much their self-presentation on stage would

Fig. 66 / "Academy of Music. T. B. Pugh, Lessee and Manager. Positively last week Haverly's Genuine Colored Minstrels, increased in number to 100 colored performers. J. H. Haverly, Proprietor. Gustave Frohman, Manager," c. 1880. Printed playbill, 9½ × 6⅔ in. (24.1 × 17 cm). Library Company of Philadelphia.

be read through stereotype and how a modern sensibility required distancing oneself from pervasive black imagery," said the historian Karen Sotiropoulos about these turn-of-the-century black performers and the artistic challenges they faced. "Black entertainers consciously used racist stereotypes in their performances in part to distance themselves from these images, since it was abundantly clear (at least to themselves and their black audiences) that they were performing these roles, . . . in an effort to expose the fictions within the imagery."[13] The literary critic Jayna Brown writes, "[Black] artists during the 1890s were working within a particularly violent field of referents, and the burlesque shows were always multi-signifying, risibly glancing in many directions, giving the sly nod and sharp chuckle to one audience present while shucking and jiving for the other."[14] Performances by these

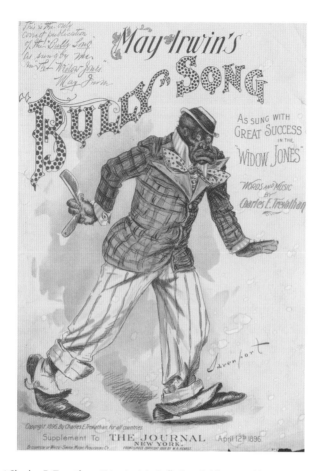

Fig. 67 / Charles E. Trevathan, "May Irwin's Bully Song" (illustrated by Homer Davenport). Supplement to the *Journal* (New York), 1896. Duke University, David M. Rubenstein Rare Book and Manuscript Library, Historic American Sheet Music Collection, TN 178650.

"uncorked minstrels" not only reformulated blackface with new players and a more nuanced repertory, but they provided the more enlightened white members of their audiences with glimmers of African American humanity and, through the lens of a satirical angle on blackface and stereotypic portrayals, the possibility of acknowledging bias and a path to interracial empathy.

Besides the ubiquitous and intimidating presence of blackface cosmetics and masquerades, the American minstrel tradition is also imbricated in advancing selected racial stereotypes, such as the wide-girthed and bossy "mammy," the elderly and obsequious "Uncle Tom," and the wooly-headed, almost feral in behavior "pickaninny," among other African American typecasts (fig. 67). Blackface minstrels performed these popular roles for decades

and, along with the countless literary and visual representations of these same racial distortions and cultural exaggerations, the sensory and psychological ramifications of these African American stereotypes made a permanent and insidious impression on the American psyche.[15] In addition, the promotion of these racial stereotypes is not confined to white American performers, writers, and visual artists; indeed, African Americans, too, have trafficked in these same broad characterizations, and it is debatable whether black artists, as presumed cultural insiders, have transformed these stereotypes into less pernicious and more subtle impressions. As addressed in this book's first chapter, the power of the stereotype resides in its affirmations of fleeting glances of reality: misrepresentations that, through their isolation, magnification, and repetition, expanded from capricious and harmless to fixed and devastating. Instead of a rhetorical device that was easily managed and exchangeable, the stereotype frequently resisted editorial afterthought and, like its outsized presence within a phenomenon labeled the "minstrel stain," hung on indefinitely and, too often, with destructive consequences.

Early twentieth-century African American artists struggled, on the one hand, to not fall into the racial stereotype's trap of a one-dimensional portrayal of black people while, on the other hand, to not restrict themselves to a propagandistic, colorless depiction of black life. "I saw that not even [Paul Laurence] Dunbar had been able to break the mold in which dialect poetry had, long before him, been set by representations made of the Negro on the minstrel stage," wrote Harlem Renaissance author and political leader James Weldon Johnson about this artistic conundrum. "I saw that he had cut away much of what was coarse and 'niggerish,' and added a deeper tenderness, a higher polish, a more delicate finish; but also I saw that, nevertheless, practically all of his work in dialect fitted the traditional mode."[16] Several years prior to Johnson's observations, the poet Langston Hughes, writing on behalf of his fellow "younger Negro artists," refused to fret over the possibility of artistically crossing over into impolitic portrayals of African Americans, seeing in the reticence to wholly embrace folk and popular black culture shades of racial self-hatred and artistic conservatism. Among the unexplored black cultural assets that Hughes believed might furnish African American artists with a lifetime of creative work was its "incongruous humor that, so often, as in the Blues, becomes ironic laughter mixed with tears."[17]

Although Hughes's representative Negro painter at the time was the illustrator, muralist, and his frequent collaborator, Aaron Douglas, a trio of fellow Harlem Renaissance–era visual artists — Palmer C. Hayden, Sargent Claude Johnson, and Archibald J. Motley, Jr. — more closely approximated

Fig. 68 / Sargent Claude Johnson, *Divine Love (Mother and Child)*, 1930. Etching, plate
5⅝ × 4⅜ in. (14.3 × 11.1 cm). Metropolitan Museum of Art, New York. Gift of Reba and
Dave Williams, 1999, 1999.529.75.

Hughes's radical vision for an artistic license that held few thematic limita-
tions or moral strictures on racial expressions. Whether the imagery recalled
the worst racial stereotypes imaginable, or referenced an African physiog-
nomy that made even the most "color-struck" of the so-called "new Negroes"
uncomfortable, selected works by these African American artists are some of
the earliest examples of a conceptual recalibration of blackface minstrelsy,
artistically achieved through modern painting styles and satirical reformula-
tions of racial stereotypes.

As already discussed in the first chapter, Motley's *Lawd, Mah Man's
Leavin'* drew from a deep reservoir of caricatures, aspersions, and jokes whose
objects of derision—visualized by the artist in nightmarish hues and bizarre
forms—went far beyond the banalities of the average stereotype and, instead,
made xenophobic hyperbole and highbrow chauvinism themselves the
painting's subjects (see fig. 1). Lost on Motley's critics was the disconnection
in *Lawd, Mah Man's Leavin'* and similar Motley paintings from reality per
se, with Motley placing these works in a Negro fantasia where blues-derived
moans and double-edged laughter insinuated far more than words or a literal
reading could ever convey. The criticism that Motley's art generated—that it
inaccurately or derisively portrayed black life—would be leveled against the
works of subsequent black artists (most notably Kara Walker), indicating

how the tyranny of a vaunted artistic realism conflicted with more abstract and/or modernist approaches to art-making.[18]

Johnson and Hayden took similar artistic routes as the one Motley pursued by prominently featuring black subjects who easily aligned with recognizable racial stereotypes and stock black characters. In the early 1930s Johnson created a series of sculptures, drawings, and prints featuring a full-figured black woman flanked by small children. As Johnson's etching *Divine Love* suggests, the traditional Madonna theme in Western art has been superseded by an African American maternal figure sharing her love and largesse with two infants, one white and one black (fig. 68). Apart from a none-too-subtle commentary on undisclosed filial bonds across the racial divide, Johnson blurs in *Divine Love* the black mother's righteous selflessness with a constitutive servitude, and in this ironic device disturbed the audience's preconceived notions of this cultural type in either direction. Art historian Lizzetta LeFalle-Collins has remarked on Johnson's visual invocation of the mammy figure in his work, proposing his focus on this stereotype was "a subversive act, meant to challenge the degrading comic use of black women in popular and fine art."[19]

Hayden's *10th Cavalry Trooper* operated in a similarly ambiguous, interpretative terrain (fig. 69). The titular subject—one of the "Buffalo soldiers" who served in racially segregated U.S. Army regiments—appeared more like a caricature than an equestrian war hero, his black-faced, pink-lipped pro-

Fig. 69 / Palmer C. Hayden, *10th Cavalry Trooper*, 1939. Oil on canvas, 20 × 30½ in. (50.8 × 77.5 cm). Collection of Laura and Richard Parsons.

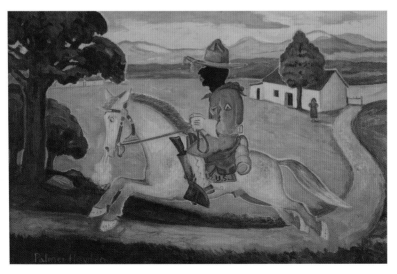

file resembling the disembodied head of a "Jolly Nigger" mechanical bank (see fig. 81). Nevertheless, Hayden's painting was an ironic eulogy for the 10th Cavalry which, around the same time the artist painted this canvas, was experiencing marked reductions in its numbers and significant structural changes to its celebrated military unit. Hayden's cavalryman assumed a resolute, dutiful bearing in this otherwise pictorial parody, with his fair lady faithfully appearing in the distance and his carousel-like, undersized steed exhaling cartoonish puffs of hot air.[20]

The artistic trade in racist imagery and in the conventions of blackface minstrelsy was not only present in the works of artists such as Motley, Johnson, and Hayden; these same worrisome elements were the staples of popular African American entertainment in the early to mid-twentieth century. Visitors to theaters and nightclubs that catered to black audiences were exposed to African American comedians and other performers who "acted a fool," or engaged in hokum—the latter a mode of performance that, using a southern black American voice, a wry and acerbic sense of humor, and often a "countrified," unfashionable demeanor, enlisted black audiences in multilayered, call-and-response routines and playful banter around shared black experiences.[21] Many of these African American comedians also used burnt cork makeup on their faces and bodies, some well after World War II. Jacob Lawrence's *Vaudeville* (1951) visually chronicled one of those mid-century performances, with two ludicrously dressed black comics standing in front of a strange, multi-patterned background. Commenting on this and similarly themed paintings from a 1953 exhibition, the *New York Times* noted, "[Feelings] of cruelty, pity, or a sort of wild humor conveyed through almost unbearably shrill color and line that cuts like a hot sharp blade, expose the whole nerve of the theatre and entertainment."[22] This reviewer, sensing Lawrence's visual grasp of black minstrelsy's emotional and psychological fluctuations, in a sense echoed Langston Hughes's comments of more than forty years earlier about the "incongruous humor" of African Americans providing black artists across different media with a continuous pipeline of rich artistic material.

"Black minstrelsy is a paradoxical element in black entertainment history," wrote Mel Watkins in his important study of African American humor, *On the Real Side*. "Stigmatized by critics, its performers considered disreputable or, worse, racial turncoats, it remains a cornerstone in the development of the black performing arts." He continued, "It was the proving ground on which their reputations were earned and from which their careers were launched," referring to such legendary early twentieth-century black entertain-

ers as Bert Williams, W. C. Handy, Bessie Smith, Josephine Baker, Dewey "Pigmeat" Markham, and Jackie "Moms" Mabley.[23] What these African American performers knew was that their off-color humor and critical insights into black lives in the pre–civil rights era were acknowledged and accepted by black audiences through the adoption of a disarming yet scathing minstrel mask: a personality whose symbolic alterity and comic dispatches allowed black artists to utter uncomfortable truths before their attentive fans and bear witness to historic injustices.

SKINNED ALIVE

While teaching high school studio art in Chicago in the early 1960s, the visual artist and future black cultural activist Jeff Donaldson published *The Civil Rights Yearbook* (1964), a book of cartoons that, as described by the artist, presented "a partisan and subjectively satirical glance" at some of the people and topics that figured prominently in the civil rights movement (fig. 70). Without naming that period's segregationists, politicians, and protesters, Donaldson comically portrayed these civil rights movement actors and parodied what had become by the mid-1960s a media circus surrounding the struggle for civil rights. "While there is little levity in the denial of freedom and justice, or of human dignity," Donaldson wrote in his book's introduction, "the human gropings of the individuals involved in this drama were often quite humorous."[24] Able to see the comical and absurdist aspects of a serious, socially transformative time in American history, Donaldson crystalized in black and white the personalities and eccentrics of the civil rights movement, taking into account the circumstances and contingencies of race, as seen in the book's cover cartoon of a black man impishly removing his white Klansman's hood and revealing his true self, an oft-repeated punch line of 1960s black comedians and a transposition of race and class that this particular moment playfully imagined. *The Civil Rights Yearbook*'s subject matter, acerbic humor, and timely appearance — coinciding with the ratification of the Civil Rights Act of 1964 — certainly deserves recognition as a pioneering mid-twentieth-century example of black visual satire. After *The Civil Rights Yearbook,* Donaldson would apply these same critical skills to painting and cultural policy work under the banner of the Black Arts movement, circa 1965–80, attesting to the importance of this earlier foray into satire, which blended humor, censure, and social realities into a potent mixture.

By the mid-1960s Donaldson's racial subterfuges in *The Civil Rights Yearbook* seemed tame, especially in light of that decade's rhetoric and con-

Fig. 70 / Jeff Donaldson, Cover illustration from *The Civil Rights Yearbook*
(Chicago: Regnery, 1964).

crete expressions of black agency. In 1966 writer LeRoi Jones encapsulated
the necessity for a cultural realignment among African Americans, pro-
claiming, "There are some of us who will not be Negroes, who know that
indeed we are something else, something stronger . . . [that] there are some
of us who know we are black people." This call for a rehabilitated racial
self-consciousness among African Americans, not only from Jones but from
a broad scope of black intellectuals and activists, formed the ideological core
of what would be called the Black Arts movement: a cultural insurgency
that, utilizing the literary, visual, and performing arts, placed black peoples
and their political conditions at the center of creative works. From cataclys-
mic scenes of revolutionary actions and violence to the pictorial details of
articulated bodies, African faces, and halo-like "natural" hairstyles, the Black
Arts movement made black sovereignty its narrative rationale, couched in
an expressionistic, pan-African aesthetic. "[We] black people know what our
reality is," continued Jones. "Look out your window, or into your heart, and
you know who we are, where you are. You know what you feel. You know what
you have to do!!!!"[25]

Jones's incitements to black people in 1966 echoed his then-recent
work in the theater, having produced several important off-Broadway plays—

Dutchman (1964) and *The Slave* (1964)—and not long before establishing the Black Arts Repertory Theatre. A recurring feature of these and other black theatrical productions in the 1960s was, oddly enough, minstrelsy, or to be more precise, the introduction of racial stereotypes and the vestiges of blackface in contemporary plays, so as to satirically emphasize (by way of antithesis) a radically different, revolutionary path for black people. For example, in the 1965 short play *J-E-L-L-O*, Jones used the old Jack Benny radio program and its repartee between Benny and his black man-servant, Eddie "Rochester" Anderson, as the foundation for an ideological conversion that, progressively occurring over the course of play, turned the subservient "Ratfester" (née Rochester) into a marauding black rebel.[26]

This artistic sleight of hand—that is, proclaiming one's blackness and cultural/ideational independence from a white power structure by satirically using some of the most egregious emblems and tropes of the past—is not something that, even considering the earlier examples of this in African American art and in the world of entertainment, can be easily understood. What transpired in the 1960s was a gambit that gave the stereotype a new function—one that included the assertion of a black political agenda— while concomitantly eviscerating the stereotype of its venom and one-dimensionality. "The Black Arts Movement," summarized the theater historian Mike Sell, "appropriated and deployed blackface in a fashion that both purified its insurgent potential and disabled its role in the commodification and denigration of African Americans."[27]

In addition to Jones's black theatrical interventions of the 1960s and 1970s, the other Black Arts movement artist who fearlessly trafficked in stereotypes and absurdist points of view in order to raise the collective consciousness of African American audiences was Ed Bullins. During Bullins's six-year playwright-in-residency at Harlem's New Lafayette Theatre (1967–73) and throughout the remainder of the 1970s, at least twenty-five of his plays were produced and presented, many featuring broad racial characterizations that performed against their established desultory types and, penultimately, morphed into culturally self-conscious, duty-bound black radicals, or parodies of a dysfunctional blackness (or what Bullins characterized as "the Transcendent Stereotype").[28] Like Jones's "Ratfester" in *J-E-L-L-O*, Bullins's one-act play *The Gentleman Caller* (1969) showcased a "heavy," bandana-wearing African American maid/mammy, who by the end of the play has murdered both of her employers, outfitted herself in an exotic gown and an "au naturel" hairstyle, and ostentatiously claimed for herself the role of "Madame" along with demanding that black people "rise from their knees . . .

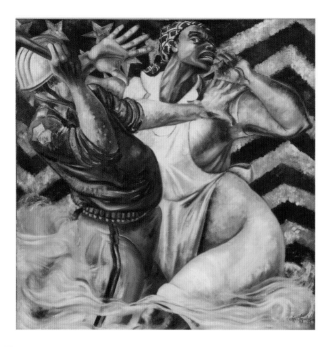

Fig. 71 / Jeff Donaldson, *Aunt Jemima and the Pillsbury Dough Boy*, 1963. Oil on canvas, 48 × 48 in. (121.9 × 121.9 cm). Collection of the Estate of Jeff Donaldson.

meet the oppressor . . . and conquer and destroy him."[29] As Bullins's biographer, Samuel A. Hay, reminds us, Bullins's black maid was a familiar Black Arts movement trope, embodying a clandestine, African American ticking time bomb and frequently appearing in plays, fiction, and visual art.[30]

Although countless art historians have noted the metamorphosis of, say, a debased and subservient figure such as Aunt Jemima into a rebellious entity during the Black Arts movement years, the rehabilitated personifications these stereotypes became have not received close enough scrutiny, nor have the satirical projects they served been sufficiently examined. For example, Jeff Donaldson's unconstrained black woman in his 1963 *Aunt Jemima and the Pillsbury Dough Boy*—created around the same time as *The Civil Rights Yearbook*—shared with that book an irreverence in editorial tenor and artistic deference to figural realism (fig. 71). Ostensibly representing Aunt Jemima—the Quaker Oats Company's black female logo for its popular pancake mix—Donaldson's black woman by default corresponded to her full-faced, bandana-clad, smiling-from-ear-to-ear illustrated counterpart. Were it not for this painting's title, though, viewers would not necessarily associate Donaldson's female figure with Aunt Jemima, nor would they link the baton-wielding white police officer to the Pillsbury Company's

iconic brand. The satire in *Aunt Jemima and the Pillsbury Dough Boy*, similar
to Ollie Harrington's single-panel cartoons, resided in the audience's capac-
ity to sarcastically bridge the titular invocations of these two product icons
with the figures (pictured against a hybrid American Stars and Stripes and
Nazi Germany swastika–patterned background). The woman's hand-to-hand
combat with the police officer, encompassing twisted torsos and flexed limbs,
is the painting's primary focus, more in the manner of a Renaissance ana-
tomical exegesis than a 1960s visual spoof. *Aunt Jemima and the Pillsbury
Dough Boy*, for all of Donaldson's satirical intentions in the implied battle
between the two Madison Avenue advertising mascots, had more resonances
and visual associations with real life, as seen in that era's published photo-
graphs of civil rights protesters clashing with the police.[31]

This critique of not just American racism, but of capitalism's poison-
ous covenant with Madison Avenue, was also present in Joe Overstreet's
The New Jemima, a work with an African American theme and rendered in
a droll, highly sardonic manner (fig. 72). "I wanted to say . . . ," Overstreet
told art critic Charles Childs, "that the old image of Aunt Jemima, unless
things change drastically, can erupt into a whole new personality." Described
by art historian Michael D. Harris as thematically linked to pop art but more
political, *The New Jemima*—a freestanding, eight-and-a-half-by-five-by-one-
and-a-half-foot wooden construction—was clearly a fresh take on an old
stereotype, not just through its gun-toting, grenade-lobbing version of the
iconic brand, but through the work's soaring, barricade-like presence and
hothouse pigments. By creating a gigantic pancake box upon which the famil-
iar face—and now the body—of Aunt Jemima appeared, Overstreet intro-
duced exaggeration: a stock method of visual lampooners for elevating a
target's satirical quotient. The other device Overstreet employed to heighten
The New Jemima's satire was a superficially untutored painting technique
that, through its freely applied colors and stenciled lettering, feigned a guile-
less attack against Madison Avenue and the world's racists (the latter repre-
sented by the naively executed globe in Jemima's firing line). All of this—the
stereotype's armed and, yet, jovial appearance, the enormous pancake box,
the garish, high-key colors, and the cartoonish renderings of gunfire and
airborne pancakes—made *The New Jemima* the quintessential cliché make-
over: an artistic mutation whose prankish, comical stance further ridiculed
this stereotype's iconic stature in twentieth-century America.[32]

Betye Saar's well-known assemblage *The Liberation of Aunt Jemima*
is arguably the most complex statement in this group, combining within a
shallow, glass-fronted box the repeated image of Aunt Jemima from actual

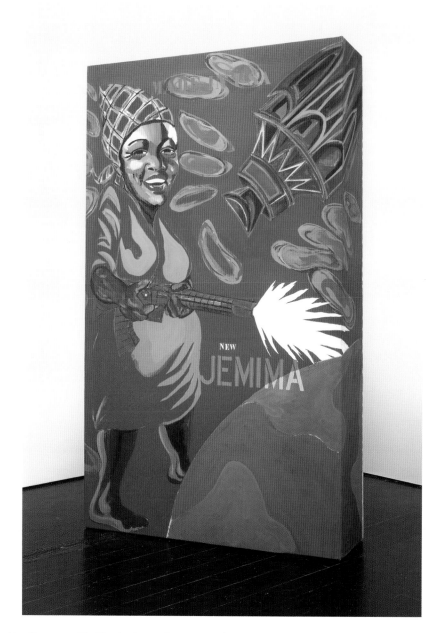

Fig. 72 / Joe Overstreet, *The New Jemima*, 1964, 1970. Acrylic on canvas over plywood construction, 102 ⅜ × 60 ¾ × 17 ¼ in. (260 × 154.3 × 43.8 cm). Menil Collection, Houston. 1970–156 DJ.

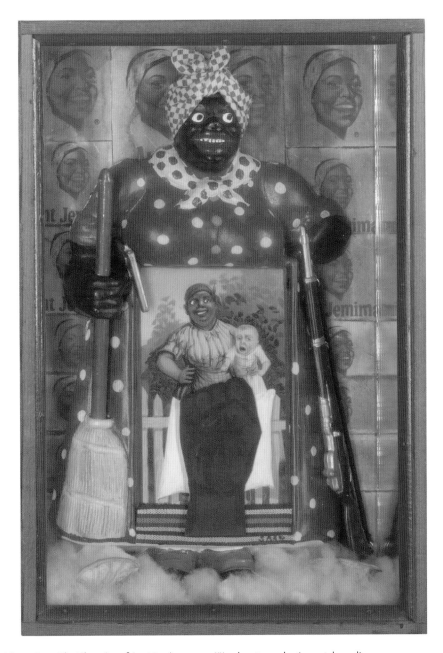

Fig. 73 / Betye Saar, *The Liberation of Aunt Jemima*, 1972. Wood, cotton, plastic, metal, acrylic, printed paper, and fabric, 11¾ × 8 × 2¾ in. (29.8 × 20.3 × 7 cm). University of California, Berkeley, Berkeley Art Museum and Pacific Film Archive. Purchased with the aid of funds from the National Endowment for the Arts (selected by the Committee for the Acquisition of Afro-American Art), 1972.84.

pancake boxes, ceramic and printed memorabilia, a miniature pistol and rifle, the circa 1970s "Afro-kitsch" of an illustrated black fist, and the store-bought ingredients for making an incendiary projectile (fig. 73). Art audiences at the time seemed to comprehend Saar's ironic goals, interpreting the work's confluence of mammy imagery as rhetorical bluster and the addition of a miniature arsenal as a fitting counterstatement.[33] Just as Overstreet's eight-and-a-half-foot-high *The New Jemima* confronted audience with an over-the-top parody, Saar's one-foot-high *The Liberation of Aunt Jemima* offered an intimate, vanity-scale encounter with the stereotype's imagined deliverance. Comparable in form and affect to the multisegmented, confrontational, and prophylactic *nkisi* statuaries of Central Africa's Kongo peoples, Saar's 1972 assemblage functioned similarly, in that it did not so much proclaim demonstrable freedom from the stereotype as it conjured an irony-filled effigy that, via its marshaling of negative and inflammatory imagery, symbolically immunized viewers from its original racist designs and, thus, subverted the stereotype for both spiritual and revolutionary purposes. This was a sculpture, quoting art critic Lucy Lippard, that "used stereotyped images of Black people homeopathically."[34]

Two additional Jemima images illustrated the extent to which some artists advanced the idea of the transformed stereotype but, as evidenced by their shocking narratives and unbridled travesties, they vaulted the moralizing tendencies of their artistic counterparts and, instead, conceived strikingly transgressive and ethically probative types. In an especially scandalous drawing entitled *Jemima's Pancakes,* Robert Colescott took Donaldson's face-off between two product icons to a narrative extreme, foregrounding a voluptuous Jemima and her pancake stack with a series of sexually explicit pictorial vignettes, performed by her with Kentucky Fried Chicken's founder and brand ambassador, Colonel Harland Sanders (fig. 74). The stereotypic Aunt Jemima's single-minded preoccupation with preparing and serving the perfect pancakes to white people was literally upended by Colescott in *Jemima's Pancakes,* first, by pairing her with another caricature—this one Kentucky Fried Chicken's Colonel Sanders—and, secondly, by making the product brands, and the interracial pair, sexual partners. Rather than a recuperation or freeing, *Jemima's Pancakes* mocked any efforts toward salvaging the stereotype and, in a sarcastic turnabout, Colescott made this fantasy of a "company merger" an outrageous pornographic escapade, and the usually insipid, asexual mascots Aunt Jemima and Colonel Sanders both libertines: a statement of sexual and racial egalitarianism that was quite radical for the times.

Another satirically grounded stereotype about-face from this period

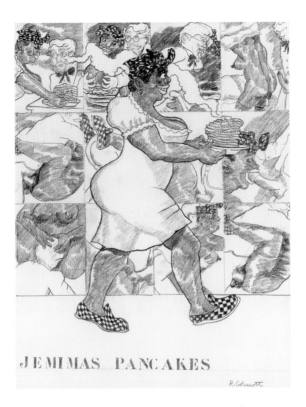

Fig. 74 / Robert Colescott, *Jemima's Pancakes*, c. 1968–71. Graphite on paper, 25¼ × 19¼ in. (64.1 × 48.9 cm). Private collection.

was the 1972 film *Georgia, Georgia* (directed by Swedish filmmaker Stig Björkman, from a screenplay by author Maya Angelou) about a temperamental black entertainer, Georgia Martin (played by Diana Sands), and her contentious relationships with other African Americans, her live-in maid (played by Minnie Gentry), and her inner demons. The film notoriously concluded with the maid/mammy—who throughout the film routinely brushes the black diva's hair in intimate, bosomy sessions—strangling Georgia to death (because of a traitorous, interracial fling), and immodestly restraining the entertainer between her open, clasping legs (fig. 75). Light-years removed from Sargent Johnson's all-embracing mammy and Jeff Donaldson's self-defensive heroine, Angelou's race-avenging maid harkened back to her counterpart in Ed Bullins's 1969 *The Gentleman Caller*: a recent convert from "Uncle Tomitudes" and a black rebel whose destructive attributes were virtually unheard of prior to the 1960s.[35]

In addition to the stereotype's transformations, the other 1960s makeovers that conveyed a satirical message were the dramaturgical applications of pigments on performing bodies—a mid-twentieth-century adaptation of nine-

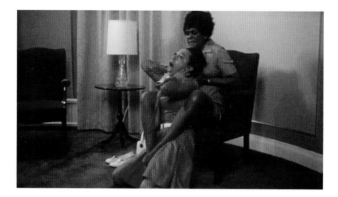

Fig. 75 / Stig Björkman, *Georgia, Georgia* (still), 1972. Film (color, sound),
91 minutes.

teenth-century blackface minstrelsy but, in stark contrast to the latter, mostly
enacted by African Americans and rendered in clown-like white face paint.
Not only did this patently artificial about-face by black artists into a schematic
whiteness have satirical purposes but, curiously, it also established the art-
work's formal aspects, so that the civil rights and/or Black Power scenarios in
these performances were superimposed with discordant, stylized masquer-
ades, more suitable for traditional African rituals and a European avant-garde
theater of the absurd than a standard American theatrical experience.

Along with LeRoi Jones's *J-E-L-L-O*, off-Broadway audiences in 1965
were treated to another farcical play about racism, *Day of Absence,* playwright
and director Douglas Turner Ward's "reverse minstrel show" with black
actors in whiteface comically performing the roles of whites in a stereotypic,
small southern town on the day when — perhaps inspired by George S.
Schuyler's 1931 novel, *Black No More*—all of the town's blacks mysteriously
vanished. The abrupt disappearance of the town's cooks, porters, babysitters,
cleaning ladies, and other African American laborers created a satirical and
humorous scenario in which white southerners, inept at performing basic
day-to-day chores, realized their utter dependence upon the black commu-
nity. The experience of seeing African American actors wearing white face
paint and speaking in exaggerated southern drawls was transformative for
New York audiences, black and white, inviting them into the realm of the bur-
lesque, where such theatrics were standard and the play's intended target —
white racism — was a culpable villain.[36]

Ward's *Day of Absence* has an important place in thinking about min-
strelsy and its uses during the years of the Black Arts movement. Inspired
by the 1961 off-Broadway production *The Blacks: A Clown Show*— French

author Jean Genet's ritualistic, masked play about white racism and black revenge—*Day of Absence* shared with *The Blacks* the Fanonian precept "black skin/white masks" as an epithet of sorts, carried out in glaring racial parodies and role-play between designated oppressors and the exploited. The other common denominator between the two plays is the tactical use of a white mask for black actors and its ritualized, hegemonic insignia, providing both its wearers and the plays' audiences with a setting that reversed the power equation by shifting the objects of dramaturgical catalysis and sympathy.[37]

Ward's other source of inspiration for *Day of Absence* also may have been one of the widely published photographs of Bobby Simmons, the Selma, Alabama, teenager who, while participating in the legendary Selma-to-Montgomery march in the spring of 1965, covered his dark-brown face with a pasty sunscreen and scraped the word "VOTE" on his forehead (fig. 76). Like *Day of Absence*'s white-faced black actors, Simmons's white mask was both parodic and symbolic, criticizing institutional racism and disenfranchisement while concurrently (and, in all likelihood, unintentionally) implementing a work of body art in the manner of an avant-garde performance or ritual.

The year 1970 was important for reverse minstrelsy in art, one of the most significant examples being Larry Rivers's *I Like Olympia in Black Face*,

Fig. 76 / Bruce Davidson, *Young Man with "VOTE"* [scraped onto] *his* [white pigment – covered] *face . . .* (Bobby Simmons, from the Selma-to-Montgomery march), 1965. Gelatin silver print. © Bruce Davidson/Magnum Photos.

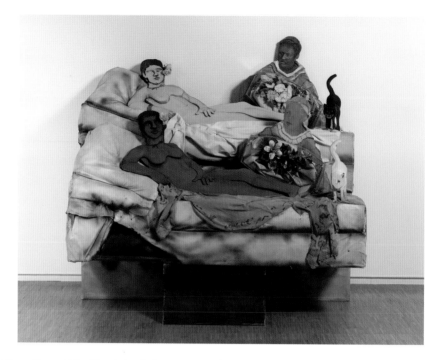

Fig. 77 / Larry Rivers, *I Like Olympia in Black Face*, 1970. Oil on wood, plastic, Plexiglas, 41 × 78 × 33⅞ in. (104 × 198 × 86 cm). Musée National d'Art Moderne, Centre Georges Pompidou, Paris. © 2019 Estate of Larry Rivers/Licensed by VAGA at Artists Rights Society (ARS), NY.

a painted construction comprising two adjacent standees/canvas sculptures inspired by Édouard Manet's iconic painting *Olympia,* but with one of the cutouts featuring a black reclining nude, a Caucasian servant, and a white cat (in contrast to one more closely resembling Manet's original painting) (fig. 77).[38] Rivers, whose other works from this period are similarly preoccupied with social artifice and issues of identity, both racial and ethnic, treated this dual presentation of Manet's *Olympia* as a hybrid painting/sculpture, which subliminally acknowledged the performative dimensions of this particular "minstrel show" extending beyond the gallery wall and encroaching into the audience's sphere.

Filmgoers in 1970 were also presented with the "black skin/white masks" concept, due in no small measure to the relaxing of Hollywood's historic constraints on controversial subject matter, especially issues of race and racism. One of that year's strangest films, Brian De Palma's *Hi, Mom!,* was a multithread satire/comedy about youthful itinerancy (personified in the lead character, played by a twenty-seven-year-old Robert De Niro), set in New York and framed by that particular milieu's incidents of amateur (that

is, adult) filmmaking, politics-inspired community theater, and domestic terrorism and surveillance.[39] The most memorable scenes in *Hi, Mom!* drew attention to the two different forms of minstrelsy, blackface and whiteface. In the first instance, a white radical/pornographic filmmaker (played by Gerrit Graham) is accidentally filmed through his high-rise apartment window while in the act of painting his naked body black, including (to the last, hesitant brushstroke) his genitals. Scripted by De Palma as a clandestine act being filmed without the character's knowledge, this extreme version of black-face—decades before Eric Lott's theory of white male desire through black male (and female) emulation—brought minstrelsy's obsessive dimension before film audiences in a visceral way.[40]

The second minstrelsy episode in *Hi, Mom!* is a black-and-white inter-lude in this color film that documents an evening of avant-garde perfor-mance art entitled "Be Black, Baby" (fig. 78). The sequence shows a black guerilla theater troupe in whiteface (similar to Douglas Turner Ward's black actors in *Day of Absence*) at first giving a group of white suburban theater-goers the artistic-cum-authentic experience of "being black" (including cov-ering their white faces with greasepaint and encouraging them to eat hog maws). In due course the black troupe holds the white audience hostage at gunpoint, robs and beats them, and sexually assaults one of the women in the group (remarkably like Ed Bullins's 1970 "confrontational ritual" *It Bees Dat Way*, where his script called for the cast to "take it as far as it can possi-bly go in vocal and physical action" against their predominately white audi-ence).[41] Finally, the black actors "step out" of their menacing characters and announce that "Be Black, Baby" has ended, to which the white suburbanites

Fig. 78 / Brian De Palma, *Hi, Mom!* (still), 1970. Film (color, black and white, sound), 87 minutes.

break out in applause, idiotically expressing thanks for a thrilling theater experience, and for being shown how responsible they are for racism.

"You take an absurd premise," reflected De Palma years later about the "Be Black, Baby" sequence in *Hi, Mom!,* "and totally involve [the audience] . . . and really frighten them at the same time. It's very Brechtian. . . . Then you say, 'It's just a movie, right? It's not real.'" Commenting about this particular segment of *Hi, Mom!* and its cynicism around racial empathy and its metanarrative of an increasingly suspect mass media, De Palma continued, "It is just like television. You're sucked in all the time, and you're lied to in a very documentary-like setting."[42] Film critic Eric Henderson wrote, "Aided by a deliberate dissection of a very real social stress point, ['Be Black, Baby'] is one of the most thrilling left turns ever filmed." Henderson continued, remarking on this episode's multiperspectival, satirical locus, "The theme of voyeurism . . . becomes a hellish shattering of the seemingly secure fourth wall, both for the on-screen audience of upper-crust whites . . . as well as the actual film's audience."[43]

The other filmic overture to minstrelsy in 1970 was *Watermelon Man,* director Melvin Van Peebles's parable of Jeff Gerber, a white, middle-class insurance salesman who, inexplicably, wakes up black one day, much to his chagrin and the vexation and/or embarrassment of his family, friends, coworkers, and strangers. Based on a story by screenwriter Herman Raucher, the movie was conceived by Columbia Pictures as a film that would showcase Hollywood stars Jack Lemmon or Alan Arkin and, therefore, would have continued the long-standing tradition of white actors performing in blackface. However, Van Peebles's insistence on casting African American actor/comedian Godfrey Cambridge as Jeff Gerber and, at the beginning of the film, putting Cambridge in full-body Caucasian makeup and a dark-blond wig prior to his character's racial transmutation (fig. 79), radically altered Columbia Pictures' original concept and, as a result, became central to the film's satirical pursuances. Clearly Cambridge's real-life blackness was key to audiences coming to terms with white racism and its epidermalizing of social value, beauty, and self-worth.[44]

Filmed with a television sitcom–like ambience (and musically scored by Van Peebles in a parodic mélange of Tin Pan Alley and rhythm and blues tracks), *Watermelon Man* took its metamorphosis fable from an improbable premise to an all-too-true nightmare, showing the multiple stages through which Jeff Gerber will experience racial discrimination, each episode presented to its most hilarious, devastating extreme. Audiences familiar with Cambridge's civil rights–themed comedy routines recognized his character's

laughable encounters with bigoted white neighbors and his satirical one-liners about untoward African American realities (such as the "suspicious activity" in the eyes of many white people of "running while black").[45] Other casting decisions by Van Peebles—such as the "cameo" roles for the pop-eyed 1940s black character actor Mantan Moreland and the 1950s *Three Stooges* pratfall comic Emil Sitka—underlined the film's subliminal references to Hollywood's discriminatory and low comedy enterprises.

Beginning *Watermelon Man* with the "white" Jeff Gerber lying on a tanning bed and solitarily exercising, and concluding it with the "black" Gerber practicing martial arts in a tenement basement with a group of fellow African American men wielding mops and brooms, Van Peebles situated his protagonist's racial conversion in an immutable, politically informed framework (contrary to screenwriter Raucher's originally conceived scenario of an imagined blackness for much of the film that, in the mode of a "feel good" Hollywood ending, reverts back to whiteness upon Gerber waking up). Van Peebles transformed Raucher's screenplay, film critic Racquel Gates writes, "into a multilayered critique of white racism and white privilege, operating on both micro and macro aesthetic levels."[46] Like Van Peebles's none-too-veiled message in the *Watermelon Man* compilation score "Soul'd on You"—a parody of the 1968 Motown hit single "I Heard It through the Grapevine"—Gerber's penultimate, wholehearted embrace of his blackness (fig. 80) and of a community with which he now shares existential realities is comparable to the romances about predestined but ill-fated lovers or, in Van Peebles's wry analogy from black folklore, Br'er Rabbit's assignation with a thorny Briar Patch.

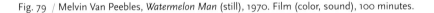

Fig. 79 / Melvin Van Peebles, *Watermelon Man* (still), 1970. Film (color, sound), 100 minutes.

Fig. 80 / Melvin Van Peebles, *Watermelon Man* (still), 1970. Film (color, sound), 100 minutes.

As model examples of what cultural critic George Lipsitz has coined "genre anxiety" or, rather, film treatments that refused to conform to Hollywood's tried-and-true, routinely composed formulas, *Hi, Mom!* and *Watermelon Man* unmasked the darker sides of American life, and did so, surprisingly, with the metaphor of the mask itself.[47] In all likelihood familiar with the theatrical and painterly experiments around the same time with blackface, whiteface, and the countermining functions of racial stereotypes, De Palma and Van Peebles used that liminal, unsettled moment in American filmmaking to upend both the comedy and the white-hero-in-crisis genres by introducing into their respective film scenarios minstrelsy's requisite disorder. By all accounts, the minstrel stain was deployed in both films not only for comic effects, but to destabilize classic Hollywood cinema's racial hierarchies and to expose its phobias and fetishes surrounding race — endeavors that Van Peebles's independent film of the following year, *Sweet Sweetback's Baadasssss Song*, would take to a more extreme level of cinematic subversion.[48]

BURNT CORK/DIGITAL DARKNESS

In the spring of 2018, the black Canadian rap artist, singer, and all-around entertainer Drake had to publicly explain a resurfaced, eleven-year-old photograph of the artist appearing as a blackface minstrel. "This picture is from 2007, a time in my life where I was an actor and I was working on a project that was about young black actors struggling to get roles, being stereotyped

and type cast," Drake wrote. "The photos represented how African Americans were once wrongfully portrayed in entertainment." Drake continued that he and a fellow performer "were attempting [through the photographs] to use our voice to bring awareness to the issues we dealt with all the time as black actors at auditions." Drake concluded, "This was to highlight and raise our frustrations with not always getting a fair chance in the industry and to make a point that the struggle for black actors had not changed much."[49]

While the photograph wasn't as detrimental to Drake's musical career or personal reputation as its recycler, rival rapper Pusha T, had hoped it would be, the angst the picture generated on social media spoke to blackface's derogatory tenor, even well into the twenty-first century, when one might have assumed that consumers of contemporary culture were capable of comprehending this particular masquerade's satirical uses, especially by black artists. Drake's explanation that he was using this mode to critique racism in the entertainment industry suggested, at least in his mind, that African Americans in blackface posed a corporeal condemnation, not so much against his black artistic ancestors as toward the various show business power brokers who controlled which black artists would be given opportunities to perform. Drake may have chosen to depict himself in this way in emulation of Spike Lee's controversial film *Bamboozled,* which helped make blackface, minstrelsy, and stereotypic black imagery topics of heated discussions following its release in 2000.

The practice of blackface in *Bamboozled,* rather than exclusively aimed at the entertainment industry's white executives, casting directors, and so on, was directed at multiple targets, most notably America's television and film audiences who, by accepting the most egregious, off-color forms of black entertainment, in effect unconsciously donned blackface minstrelsy's emblematic madness while embracing its creative trappings. In some of the film's most powerful scenes, the close-up application of burnt cork and bright-red lipstick on the faces of two former street performers, now "new millennial minstrels" (played by comedian Tommy Davidson and dancer Savion Glover), brought to the fore the ironies and melancholia of many black artists, past and present, coerced into submerging themselves into a planar, one-dimensional stage persona and character. This satirical ambition of *Bamboozled* was of a markedly different variety than Lee's cinematic inspirations for his film: Elia Kazan's *A Face in the Crowd* (1957) and Mel Brooks's *The Producers* (1967), whose indictments of show business cynicism were arguably dwarfed by Lee's broadly pitched, racially charged critiques in *Bamboozled.*[50]

The main plot of *Bamboozled* concerns the downfall of an African American writer (played by comedian/actor Damon Wayans), brought on by his championing of a stereotype-infested television show. But as is the case in many of Lee's films, it battled to communicate its message because of a plethora of competing subplots and topics (such as black artistic capitulation and complicity in perpetuating racist tropes and ideologies, the unconscious racism of many white liberals, the alleged trading of sexual favors for job advancement, and mindless racial allegiances). The film's corporate and domestic settings and its overall scenography—bedecked with an odd combination of traditional and popular African art, stereotypic mechanical toys and other memorabilia, and posters of famous African American athletes—contributed to the jumbled messages of *Bamboozled*. On one hand they reminded viewers of society's visual regimes of oppression, and on the other they engulfed audiences in a scintillating, charismatic world of black imagery in which being visually and psychologically hijacked was inescapable. *Bamboozled,* writes the American studies scholar and cultural critic Tavia Nyong'o, "is trapped in the unhappy dynamic of disseminating an iconography that it cannot stop destroying, and which it therefore cannot stop producing."[51] Indeed, the constant presence throughout *Bamboozled* of stereotypic memorabilia such as the infamous "Jolly Nigger Bank" (notably photographed in the work of artist David Levinthal in a likewise dramatic, discomfortingly close-up manner; fig. 81) made the case for these mass-produced, racist curios as being the real stars of *Bamboozled,* with their clap-trap mouths and shifting eyeballs drawing viewers into a surreal world of black corporeality, materialism, and desire.

Beginning the film with an off-camera recitation of a dictionary definition of "satire," Lee clearly wanted his audience to see *Bamboozled* through the lens in which "irony, derision, or caustic wit are used to attack or expose folly, vice, or stupidity."[52] The film's conflation of these aims with the lead character's inconsistent behavior, the represented complexities of blackface minstrelsy, the unassailable talents of the new millennial minstrels, and the continuous phantasmagoria of racial stereotypes all resulted in a satirical discharge like that in a carnival shooting gallery: an almost impossible task to hit one's mark(s) because of the mutable, constantly shifting targets and background cacophony. Literary critic Bill Brown described this unruly accumulation of cinematic motifs, satirical targets, and plot foci in *Bamboozled* as "historical ambiguity" (as opposed to an ontological incertitude).[53] Such conceptual overlaps and visual conflations are, arguably, the standard fare when artists attempt to appropriate racial stereotypes—a conundrum

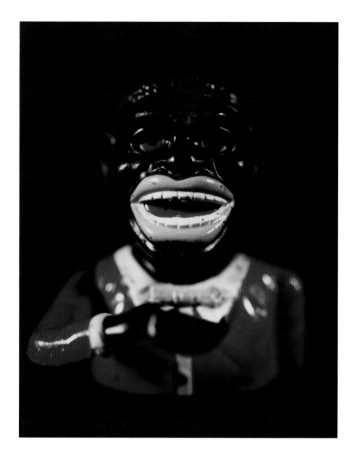

Fig. 81 / David Levinthal, *Untitled*, from the series *Blackface*, 1995. Polaroid Polacolor
ER Land Film, 9⁷⁄₁₆ × 7⁷⁄₈ in. (24 × 20 cm). Collection of the artist.

Levinthal deftly avoided with his part luminescent, part pitch-black still-life
photography of racist memorabilia (see fig. 81). The scattershot broadsides
of *Bamboozled* and its mixed successes in criticizing its individual and insti-
tutional heavies were comparable to the intentionally overwrought jabs at
racial stereotypes that the painter Michael Ray Charles undertook during this
same period (and which, like Levinthal's *Blackface* photographs, were touch-
stones for Lee's *Bamboozled*) (fig. 82). But unlike Levinthal's dispassionate
photography, Charles's graphic re-imaginings of vintage racist imagery
wagered a discountenance of (or perhaps a misallocated sense of awe toward)
the stereotype's inherent malevolence. While many of the artistic examples
discussed in this chapter demonstrate that it is possible to dismantle or
lambaste racism by using jaundiced imagery (both paraphrasing and revising
the black feminist Audre Lorde's "The Master's Tools Will Never Dismantle
the Master's House"), Charles's painted spoofs of noxious advertisements

and Lee's *Bamboozled* illustrated just how matter-of-course it can be for artists to struggle with effectively satirizing racial stereotypes, especially when the psychological tonnage and anomalous nature of blackface minstrelsy were inclined to tip the artist's narrative balance.[54]

The creators of contemporary blackface, no matter how well intended or racially sympathetic the maskers might be, more often than not failed at making their audiences coconspirators in the work's accusatory project. Setting aside for the moment satire's constitutive locus in an uncharted sea of misapprehension, the pioneering postmodernist Cindy Sherman could not have assumed in 1976 that the public would have unconditionally accepted the artistic worth of her *Bus Rider* series, in which her swarthy makeup and simulated African American females essentially enacted a late twentieth-century version of the worst nineteenth-century blackface performances imaginable. As with the earlier blackface minstrels, Sherman's whiteness and

Fig. 82 / Michael Ray Charles, *White Power*, 1994. Aquatint on open bite etching, 29 ¹⁵⁄₁₆ × 22 ⁵⁄₁₆ in. (76 × 56.6 cm). Publisher/printer: Flatbed Press, Austin. Museum of Modern Art, New York. Ralph E. Shikes Fund 421.1999.

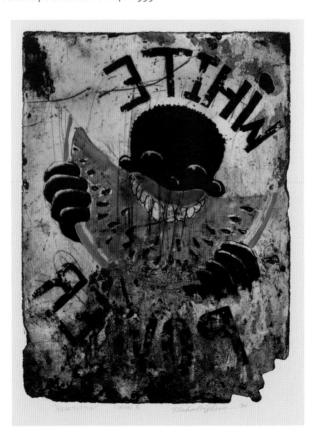

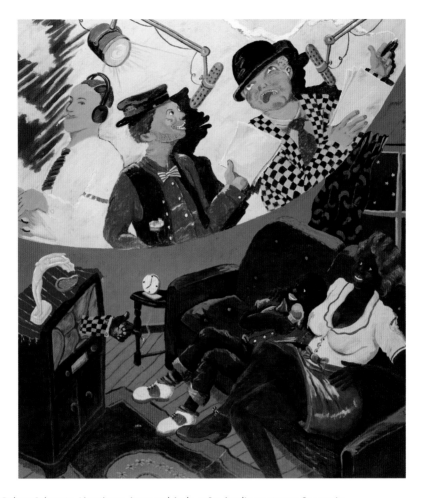

Fig. 83 / Robert Colescott, *Listening to Amos and Andy*, 1982. Acrylic on canvas, 84 × 72 in.
(213.4 × 182.9 cm). Chrysler Museum of Art, Norfolk. Gift of the family of Joel B. Cooper in
memory of Mary and Dudley Cooper, 2002.26.4.

its racial privilege made her imagined Africanity problematic, and like sub-
sequent explorers of an ersatz blackness, from Nikki Lee's 2001 *Hip Hop
Project* to Rachel Dolezal's 2015 racial outing and excoriation by social media,
neither the art label nor the "kindred spirit" defense gave contemporary black-
face a high-ranking station in a creative discourse and substantive discussion
concerning race.[55]

But what if the artist is of African descent and, like artist Adrian Piper
in her bitterly satirical and deadpan 1981 drawing *Self-Portrait Exaggerating
My Negroid Features,* she lays bare the perceptual fault lines of blackness
and, consequently, the unreliability and capriciousness of racial recognition
and dissimilitude? Of course, it helped that Piper was well known in the

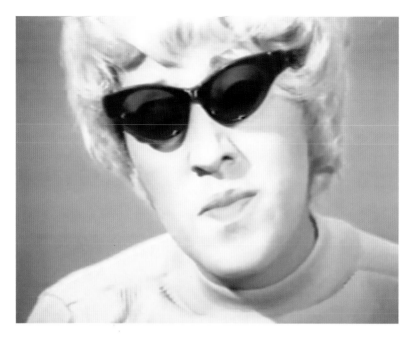

Fig. 84 / Howardena Pindell, *Free, White and 21*, 1980. U-matic (color, sound), 12:15 minutes. Museum of Contemporary Art Chicago. Gift of Garth Greenan and Bryan Davidson Blue 2014.22.

1980s art world, and that that cultural milieu was receptive to—and perhaps even fascinated by—Piper's racial fluidity. Beginning in the 1980s, many African American artists forced audiences to deal with uncomfortable racial realities and, often adopting a satirical stance within these works, they troubled viewers' certitudes on the actual workings of race, and specifically blackness, in the world.[56]

As a 1982 follow-up to his *Shirley Temple Black and Bill Robinson White* (see fig. 63), Robert Colescott revisited in *Listening to Amos and Andy* (fig. 83) a satirical rumination on race and perception not conceptually dissimilar from Piper's *Self-Portrait*. In *Listening to Amos and Andy,* Colescott uncovered the unexpected consequences of an auditory version of blackface, in which an African American woman and her son exult in listening to two real-life white comedians, Freeman Gosden and Charles Correll, impersonating African Americans on the 1930s *Amos 'n' Andy* radio program. Instead of zeroing in on the defamatory aspects of blackface, Colescott revealed parallel worlds in which white entertainers produced black stereotypes while, remarkably, black audiences found pleasure in their own re-imaginings of those impersonations, symbolized in Colescott's painting of the disembodied, cigar-waving black hand extending from the depicted radio cabinet. That a

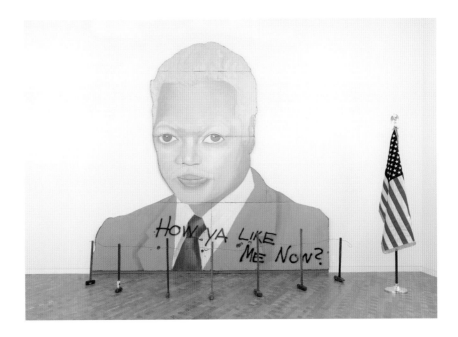

Fig. 85 / David Hammons, *How Ya Like Me Now?*, 1988–89. Tin, plywood, sledgehammers, Lucky Strike cigarette wrapper, American flag, 158 × 222 × 48 in. (401 × 564 × 122 cm) overall. Glenstone Museum, Potomac, MD.

vast gulf existed between Gosden and Correll's black mimicry and the average African American's will to fantasize seemed to be Colescott's main point, visualized in the painting's two, atmospherically distinct, racially segregated circles of activity.

Although the ironies of contemporary whiteface by African American artists were not entirely lost on audiences who encountered them during the Black Arts movement years (mostly in the context of experimental black theater and in films such as *Hi, Mom!* and *Watermelon Man*), subsequent examples of whiteface from the 1980s left many viewers confused and often hostile toward its implementers. When, in the fall of 1980, artist Howardena Pindell premiered her short video *Free, White and 21* (fig. 84), wearing a blond wig, pale makeup, and sunglasses to represent a racially insensitive, arrogant white woman, the mainly white, female, and feminist art crowd who first saw Pindell's piece questioned the work's portrayal and challenged Pindell for her criticisms.[57] A similar satire/audience disconnect transpired when an attempt was made in 1989 to publicly exhibit artist David Hammons's *How Ya Like Me Now?*—an enamel on tin portrait of the black civil rights activist Jesse Jackson, but with blond hair, blue eyes, and white skin— opposite Washington, DC's National Portrait Gallery (fig. 85). Unlike the

rejection that Pindell's *Free, White and 21* experienced from her targeted white female gallery-goers, Hammons's audience—Washington, DC's mostly African American public—was unaware that Hammons was African American, nor was the public armed with a cultural context that might have prepared them for his targeted denunciation, via whiteface, of institutions such as the National Portrait Gallery. The negative reaction that *How Ya Like Me Now?* generated from the black bystanders who witnessed its street installation—resulting in a skirmish with the artwork's installers and its forced removal—was against the imagined perpetrators of this assumed "erasure" of Jackson, and not against Hammons's ironic but misunderstood criticism of institutional racism, captioned in spray paint with rap artist Kool Moe Dee's 1987 bragging, browbeating anthem of the same title.[58]

While audiences in the postmodern era have had mixed responses to blackface, whiteface, and stereotypic black figures, contemporary artists have also used such images to make subliminal overtures to sexual transgression—characterized in the stigmata of blackness or, in the case of whiteface, its insinuations of racial genocide and cultural/ideological impurity. Robert Colescott was an early diviner in this regard, using these minstrel strains and stains to reveal racial fissures and sexual hypocrisies, and to criticize comparable regimes of apperception and desirability. One of Colescott's earliest and most explicit references to Aunt Jemima, *I Gets a Thrill, Too, When I Sees De Koo* (fig. 86), encapsulated minstrelsy's psychological presence on the heels of the Black Arts movement, while also foreshadowing the racial conundrums and visual cluster bombs artists such as Piper, Pindell, and Hammons would soon plant in the art world.

Playfully quoting Willem de Kooning's 1950s *Woman* series and Mel Ramos's 1976 sendup of the same series, *I Gets a Thrill, Too, When I Sees De Koo* made these prototypes the pictorial vehicles for venturing into satire's more hazardous, confusing terrains. By placing Aunt Jemima in a vortex of abstract gestures and disembodied white female appendages, Colescott interjected the notion of racial amalgamation into recent art history and challenged the presumed superiority of white spectatorship, putting the painting's abstract expressionist brushstrokes (and their allusions to more culturally fraught discolorations and stains) in competition with and inside Aunt Jemima's wide-eyed, inclusive purview.

The fact that hiding behind Aunt Jemima and her inscrutable, grinning mask is an equally puzzling, flesh-and-blood black woman was a message proffered by several contemporary black women artists in the wake of Betye Saar's and Maya Angelou's early 1970s art projects. Notable among these

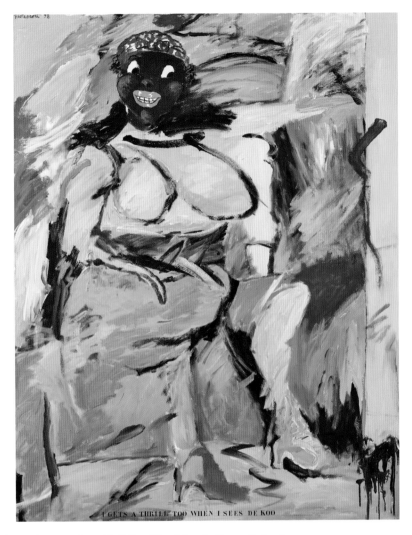

Fig. 86 / Robert Colescott, *I Gets a Thrill, Too, When I Sees De Koo*, 1978. Acrylic on canvas, 84 × 66 in. (213.4 × 167.6 cm). Brandeis University, Rose Art Museum, Waltham. Gift of Senator and Mrs. William Bradley, 1981.25.

postmodern takeoffs on stereotypic mammies were Beverly McIver's painted self-portraits as a black-faced, fright wig–wearing, and housecoat-dressed clown, shown eating watermelon (fig. 87), engaging in common household tasks, and, occasionally, dancing and playfully wrestling with a half-naked white man. The innocuous, everyday situations in which McIver located her Jemima-like alter ego contributed to her enigmatic character: a weird yet familiar presence whose pivotal place in these paintings, as framed by McIver in luscious oil pigments on canvas, unsettled the assumed idiosyncrasy or

Fig. 87 / Beverly McIver, *Silence*, 1998. Oil on canvas, 36 × 36 in. (91.4 × 91.4 cm). Private collection, Durham.

revulsion such black female stereotypes typically conveyed. In several of these richly textured works, McIver emptied the watermelon of its icono-graphic, stereotypic baggage, turning it into a prop and colorful wedge that transected the painting and stood out alongside its black-faced counterpart. McIver's occasional couplings of this stirring black caricature with a white man broached America's deep-seated fears and fantasies about sexual liaisons between the races, but unlike the sex scenes in Colescott's *Jemima's Pancakes* (see fig. 74), McIver's interracial horseplay alluded to a kind of easy intimacy or a filial bond between the stereotype and whites that could be interpreted as more seditious than sexual.[59]

Similar artistic conceptualizations of the normality and invisibility of minstrelsy and racial stereotypes in contemporary life have emerged since these aforementioned artworks. One example was artist Jefferson Pinder's 2006 video installation *Juke* (fig. 88). Consisting of ten unamplified video monitors, *Juke* featured close-ups of ten African American women and men,

who are filmed against stark white backgrounds and all uniformly dressed in white T-shirts. As gallery-goers donned each video monitor's attached headphones, they experienced each monitor's respective black actor lip-synching recordings of stereotypical "white music," such as Loretta Lynn's "Little Red Shoes," Johnny Cash's "Mercy Seat," and Patti Smith's "Rock and Roll Nigger," among other recordings. With each filmed black person's performance of "whiteness," Pinder's intended targets/gallery visitors contemplated their own racial and cultural presuppositions about racial identity and music.[60]

As discussed in the first chapter, another example of contemporary blackface in service to visual satire was when New York–based artist Jayson Musson, circa 2010, adopted the character of the hip-hop art doyen Hennessy Youngman for his mock series of YouTube primers on successfully navigating the contemporary art world. Rather than applying paint on his face, Musson theatrically stepped into the character of Youngman, assuming the language and the fashion sense of a hip-hop artist who, with his physical swagger and colloquialism-rich expressions, enacted a contemporary version of minstrelsy. In many respects Musson was following in the footsteps of the "chitlin' circuit"–era black comedians who, in taking up their own African American "clown" modes, were empowered to voice their own criticisms

Fig. 88 / Jefferson Pinder, *Sean (Mercy Seat)*, from the *Juke* series (still), 2006. Digital video (color, sound), 4:32 minutes. Birmingham Museum of Art. Gift of the Jack and Rebecca Drake Collection, AFI.23.2012.

about people and the world at large.[61] Comparable in many ways to Colescott's *Listening to Amos and Andy* (see fig. 83), Musson's Hennessy Youngman character and Pinder's *Juke* questioned cultural legibility and supposed racial essentialisms by setting conceptual booby traps in their respective artworks around race and class.

Artist Kerry James Marshall has never shied away from making his paintings vehicles for muted satirical commentaries. The lamp-black figures that inhabit Marshall's painted universe go about their everyday activities in neon-hued, quotidian settings that, while not otherworldly, project an atmospheric disquiet and bring a presumed normalcy into serious question. Marshall, an important actor in contemporary figure painting worldwide, was renowned for his emblematically "black" renderings of peoples of African descent, which steered his audiences toward nonliteral interpretations of the depicted scenes in which they appeared. When Marshall added to this equation the ingredient of the racial stereotype—as in the bestial, hypersexualized young man in his painting *Frankenstein*—his intent was clearly to assail society's widespread perceptions of black people (fig. 89). Bookended on one side and below by a trompe l'oeil piece of paper with "Frankenstein" written on it, a discarded and fetishistic two-tone alligator loafer, and a single red brick, *Frankenstein*'s naked black man all at once proclaimed his pseudoscientific status as well as his "street creds," extending author Mary Shelley's early nineteenth-century parable of human hubris to an early twenty-first-century thesis (that is, stereotype) about black male volatility and savagery.[62]

Kara Walker, the fin de siècle's most audacious satirist, emerged alongside Marshall in the mid- to late 1990s as Robert Colescott's heir apparent, with her incisive critiques of racism, sexism, white-washed histories, self-victimization, and every satirist's favorite target, moral hypocrisy. Walker's works on paper, her videos, and her art installations all employed the black stereotype as the most appropriate vehicle for astutely depicting racism's psychological impact on human nature, and the black stereotype's instability of meaning as put forth in pictorial accounts and other discursive modes. Walker's silhouetted slaves and masters, rather than enacting the received narratives of black victimization and white brutality, upended these thrice-told tales with her own representations of abuse, profligacy, licentiousness, and cruelty, perpetrated across the racial and sexual spectrums.

In 2014 Walker's racial musings and satirical proclivities all came to a crescendo with a thirty-five-foot-tall, seventy-five-foot-long, and twenty-six-foot-wide sculpture made from giant blocks of processed white sugar (fig. 90). Entitled *A Subtlety, or the Marvelous Sugar Baby, an Homage to the unpaid*

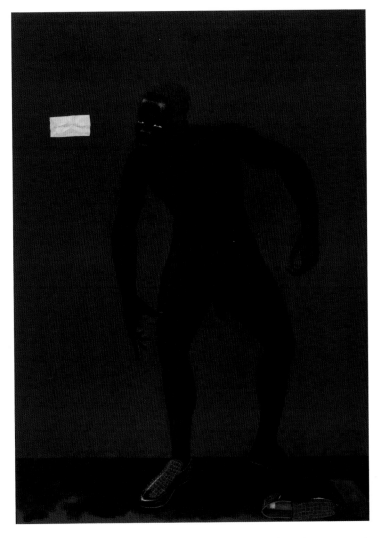

Fig. 89 / Kerry James Marshall, *Frankenstein*, 2009. Acrylic on PVC, 85 × 61 in. (215.9 × 155 cm). Private collection.

and overworked Artisans who have refined our Sweet tastes from the cane fields to the Kitchens of the New World on the Occasion of the demolition of the Domino Sugar Refining Plant, Walker's massive art project (in collaboration with the New York–based art commissioning and presenting organization Creative Time) was one of the most important art events of 2014, employing a large crew of fabricators and installers, and attracting thousands of art aficionados, tourists, celebrities, and curiosity-seekers to its temporary, makeshift exhibition space in Brooklyn.[63] Conceived in the hybrid human/feline form and posture of an Egyptian sphinx, the main sculptural figure in *A Subtlety*

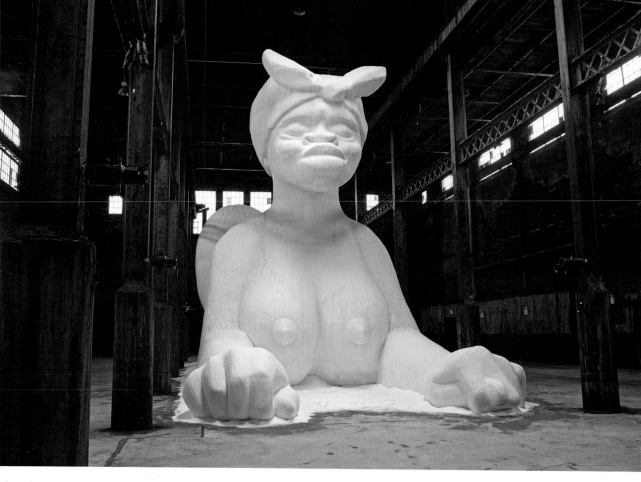

Fig. 90 / Kara Walker, *A Subtlety, or the Marvelous Sugar Baby, an Homage to the unpaid and overworked Artisans who have refined our Sweet tastes from the cane fields to the Kitchens of the New World on the Occasion of the demolition of the Domino Sugar Refining Plant*, 2014. Polystyrene foam, sugar, approx. 35½ × 26 × 75½ ft. (10.8 × 7.9 × 23 m). Installation view: Domino Sugar Refinery, Williamsburg, Brooklyn. Commissioned and presented by Creative Time, Brooklyn.

. . . deviated from the ancient prototype with its pronounced African facial features, large buttocks, exposed female genitalia, and, in the manner of a black, southern mammy, a handkerchief-bound head. Surrounding the gigantic mammy/sphinx and carefully dispersed throughout the deserted plant/ad-hoc gallery were thirteen cast-in-sugar/covered-in-molasses, five-foot-tall stylized sculptures of African boy servants, each posed in a stereotypical "plantation" job (such as carrying large baskets, toting clusters of bananas, and so on). In contrast to the mammy/sphinx's imposing mass and wholly original form, the thirteen boy servants, with their caricatured anonymity, mottled brown surfaces, and allusions to mass-produced kitsch, exuded a fugitive, provisional impression, betraying in their molded, candy-like forms their disintegrated, friable states, and in the end contributing to the work's titular allusions of being subtle, obscure, and fundamentally imponderable.

Thinking about Walker's none-too-modest *A Subtlety* . . . in the context of a visual satire, the question that arises is: "*Whom,* or exactly *what,* is this work's intended target of criticism?" The sugar industry? We, the insatiable consumers of sweets? Or the transatlantic slave trade and its dependence upon black and brown unpaid and overworked laborers? Perhaps, but one suspects that none of these aforementioned villains were Walker's true targets.

Walker's more likely prey in *A Subtlety* . . . were her censors—the sometimes faceless but outspoken arbiters of "community decency" who occasionally obstructed the public displays of her art—as well as the black cultural critics who, since she exploded onto the art scene in the mid-1990s, have disparaged her work and leveled personal attacks against her.[64] From her mammy/sphinx's most explicit, derriere-raised point-of-view, Walker communicated to her censors and critics alike to "kiss-her-you-know-what" in a way not dissimilar from the corporeal taunts and comebacks that defined a vernacular, African American mode of signifying.

And, yet, like the previous examples of misrecognition toward satirical statements of art, *A Subtlety* . . . was itself visually lampooned upon its unveiling by hundreds of online, photo-sharing Instagram users, for humorous and/or exhibitionist purposes. No matter how noble or celebratory-in-tone Walker's title for this work seemed, she certainly knew that, in this postmodern moment of moral skepticism and collective distrust, a work of art in the public arena—especially a visually perplexing nude—would be subjected to not just serious criticism, but Internet trolling and mockery.[65] Walker's own, playful edict, "Demeaning Portraits Should Be Seen and Not Heard," is perhaps the route for how audiences might best engage with such disputable, satirical images: pointedly and, yet, without the assumption that the stereotype's misleading and ambiguous content can be satisfactorily constrained, universally purposed, or thoroughly comprehended.

In conceiving her mammy/sphinx in stark, crystalline whiteness (rather than enveloped in colorful calico or gingham), Walker was perhaps reaching back several decades earlier, to the toolbox of visual interventions that black artists such as Colescott developed for dealing with minstrelsy and the stereotype. Such designs, to quote Mike Sell, connected the minstrel stain "to a repertoire of insurgent representational and material-discursive strategies that constructed a Blackness that was devilishly difficult to reify."[66] Walker's *A Subtlety* . . . was, likewise, a black enigma whose symbolic whiteness not only proclaimed an ironic allegiance to Frantz Fanon's race/skin/mask equation. It also took a satirical stance in which both the stereotype's ghostly aftereffects and its incessant, irrepressible, and often maddening dream work coexisted.

Such an interpretive conundrum was also raised a few years later when the acclaimed South African photographer Zanele Muholi created a series of black-and-white self-portraits, collectively entitled *Somnyama Ngonyama* (*Hail, the Dark Lioness*), in which Muholi's body was digitally altered in each photograph to appear unequivocally black (fig. 91).[67] This digital darkness, along with Muholi wearing elaborate headdresses and costumes created from junk store bric-a-brac, could not avoid the comparisons some art critics made between these self-portraits and blackface performances, although Muholi and other critics denied those associations. "Muholi has chosen the darkest dark," the South African historian Hlonipha Mokoena has asserted about *Somnyama Ngonyama*, "and thus demands that we see the beauty in it, as well as the pain." Mokoena suggests that these contradictory perspectives "might lead to [the series] being viewed only as irony or parody when in fact its message is deadly serious." Speaking to a reporter, Muholi described these self-portraits as a way "to make something beautiful that is not usually perceived as such. . . . To talk about the aesthetic of blackness and the presence of 'black' in spaces that were mainly white." Muholi later expanded, "*Somnyama Ngonyama* is aimed at dealing with the personal, with the me, all the flaws, and all the jerk. I also reference many cases in history that really irritated me, that have to do with race and racism."[68]

Contrary to Mokoena's attempt to disassociate *Somnyama Ngonyama* from an ambiguous, parodic project, Muholi's desire for audiences to see beauty in these pictures and to reflect on individual and institutional racism could not avoid the psychological and perceptual imbroglios that blackface has historically imposed on viewers and, therefore, could not circumvent an ironic position vis-à-vis black portraiture. Even within the distinct South African context of the painted bodies and imaginative masquerades of the Cape Town Minstrel Carnival (an annual event with which Muholi was certainly familiar), the hyper-blackness and elaborate superstructures in Muholi's portraits conflated those South African masked forms with that tradition's genesis in colonial subjugation and black denigration.[69] "Instead of offering a critical reflection on negrophobia," argued the art historian Athi Mongezeleli Joja about this series, "Muholi's game of parody gets entangled in negrophilia. This isn't to disavow the potentiality of subversion, but to note the risky slippage of it subsidizing the already existing white jouissance," the latter referring to the art world's fascination with the racially exotic. Although historically circumspect, Joja's description of *Somnyama Ngonyama* as a "non-performative resistance" was unforgiving and somewhat shortsighted, given Muholi's groundbreaking portrayals of South Africa's lesbian, bisexual,

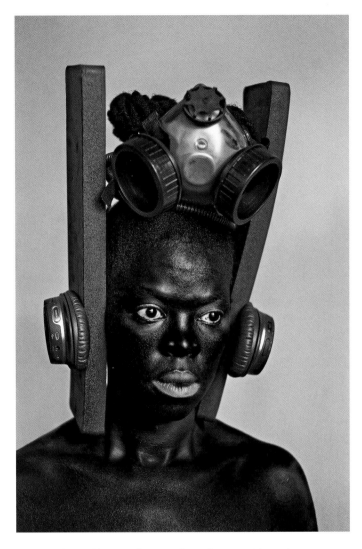

Fig. 91 / Zanele Muholi, *Namhla I, Cassilhaus, North Carolina*, 2016. Silver gelatin print, 31 ½ × 20 ⅞ in. (80 × 53 cm). Collection of the artist.

gay, transsexual, and intersex communities that, similar to these self-portraits, probed the forthright *and* parodic contours of self-presentation.[70] Aware of the critical role that self-adornment has historically played in the creation of queer identities, in *Somnyama Ngonyama,* Muholi embarked on a bricolage-like interrogation of self: a combination cross-examiner/ attestant whose digital blackness fearlessly traversed the legacies of modern minstrelsy as well as the transformative gifts of a drag aesthetic.[71]

The studied materiality and conscripted blackness of the assorted masks in Muholi's *Somnyama Ngonyama* series also made themselves pres-

Fig. 92 / Arthur Jafa, *Apex* (still), 2014. Video (color, sound by Robert Hood, composer), 8:22 minutes. Museum of Modern Art, New York. New York Fund for the Twenty-First Century, 774.2017.

ent in artist/filmmaker Arthur Jafa's *Apex* (fig. 92). This approximately eight-minute-long video—literally hundreds of photographs of people, microscopic organisms, comic illustrations, film stills, traditional and contemporary artifacts, and documented events and cultural phenomena—began as a picture album, but over the course of five years the collection was digitized, chromatically amended, and assiduously sequenced by the artist.[72] Jafa called the seemingly random, serendipitous ironies and "conversations" between the adjacent images in *Apex* "affective proximities" that, in their abstract associations, created paradoxes and potentialities. Set to a staccato, electronic "techno" soundtrack by DJ Robert Hood and rapidly edited by Jafa with no more than one second per image, *Apex* presented a kaleidoscope of visual information shaped by Jafa's career-long interest in an enduring, deep-rooted black aesthetic. This in turn gave rise to what Jafa described in *Apex* as "a kind of preor anti-cinema" or, in other words, an ambitious articulation of black exigency.[73]

 Apex flashed before spectators a dizzying sweep of real-life personalities, both well known and unfamiliar, but the repeated faces of several legendary figures (including soul singer James Brown, jazz trumpeter Miles Davis, singer Billie Holiday, pop star Michael Jackson, and turn-of-the-century blackface comedian Bert Williams) all subconsciously registered the indelible imprint of black America on the world, as well as the haunting denouement of the modern African American cultural archetype: a paradigm that, whether personified in Holiday's sorrowful visage or comprehended in Williams's furtive smile, manifested itself in a virtual minstrel mask. By making these photographic close-ups digital vehicles for an expansive, emo-

tional exposé, *Apex* participated in an act of portraiture not dissimilar from Harlem Renaissance author Jean Toomer's explorations of corporeality in his poem "Face," culminating in the ironic impression:

> . . . And her channeled muscles
> are cluster grapes of sorrow
> purple in the evening sun
> nearly ripe for worms.[74]

Beyond these and the video's other images of black cultural heroes, the repeated iterations of the Disney cartoon icon Mickey Mouse and Paramount Studios' Felix the Cat character optically aligned in *Apex* with an abstract, black-and-white masquerade (as often seen in Haitian and Trinidadian carnival), whose ritualized responses to human suffering and commentaries on mortality paralleled Jafa's interest in "the abject sublime" and in the contingent, incalculable nature of blackness.

Like Jafa's references in *Apex* to African American death (but seen through the lens of cultural contingency and renewal), filmmaker Hiro Murai and rapper/actor/writer Donald Glover (who performs under the name and stage persona Childish Gambino) made a similarly dark and sardonic statement about the precariousness of black lives in their short music video *This Is America*.[75] Set in a large, empty warehouse, the bare-chested Gambino complemented his syncopated, multi-pitched rap about monetary gain and black male prowess with writhing, rhythmically concise choreography and unforeseen acts of senseless gun violence. Gambino's stealth movements (which were backed up by a quintet of school uniform–clad black youth) drew inspiration from an expansive black dance repertoire, including contemporary moves from East and West Africa, steps from African American hip-hop, and breaks reminiscent of vintage Michael Jackson and the iconic nineteenth-century "Jim Crow" pose (fig. 93). The dance theorist Thomas F. DeFrantz has noted in his writings about hip-hop that dances "are constructed like verbal games of rhetoric such as toasting and signifying which simultaneously celebrate and criticize." He goes on to say, "This dynamic amalgamation of pleasure and critique form the basis of power present within hip hop dance forms," presciently describing Gambino's choreographed collage of black collectivity, bodily exegesis, and historical dance references.[76] Indeed, Gambino's corporeal overtures to minstrelsy in *This Is America* contributed to its cynical mood, where the akimbo bodies of the black dancers deliriously cavorted in the foreground while chaos and confusion (in the

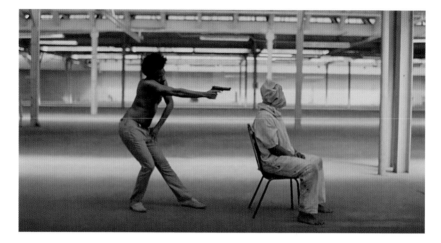

Fig. 93 / Hiro Murai and Donald Glover (aka Childish Gambino), *This Is America* (still),
2018. Video (color, sound), 4:05 minutes.

guise of rioters, police officers with their revolvers removed from their hol-
sters, and fast-moving cars) transpired in the video's background. "There is
an inescapable disdain sewn into the fabric of 'This Is America,'" writes the
New Yorker's Doreen St. Félix.[77] Glover and Murai's *This Is America* created an
absurdist national portrait, one in which African American naïve optimism
collided with consumerism and avarice, resulting in empty acts of artistry,
snuffed-out lives, and thwarted dreams. And yet, unlike Spike Lee's *Bam-
boozled* (which also mocked the mass media and blind capitalism), *This Is
America* refused any gestures toward moral judgments or differentiating
society's heroes versus its villains. Rather, Murai and Glover's satirical por-
trait cast a wide net, implicating African American gangbangers and church
choir members alike in a patently ironic, hip-shaking, "Get your money,
black man" refrain.

ENDURING FANTASIES

Toward the end of *Ethnic Notions* (1986/87) — filmmaker Marlon Riggs's
Emmy Award – winning documentary about racial stereotypes in American
popular culture — the film's narrator, actress Esther Rolle, remarked (in a
voiceover) that by the late 1960s the more extreme caricatures had begun a
slow death. "But," Rolle beguilingly resumed, "did this mean an end to the
more subtle forms of racial stereotyping?" Following this question, Riggs's
camera slowly panned across five grotesque caricatures of black people that
Rolle, now with more irony in her voice, described as "the great grandpar-
ents of many modern images of blacks; these caricatures did as much harm

as any lynch mob." Rolle continued, "True, their hurt was more indirect, yet because of this they left wounds that have proved far more difficult to heal." The assertion that late twentieth-century audiences were still not free of these racial stereotypes was then expanded upon by another evocative pan shot, this one above an informally arranged assortment of contemporary record album covers, film posters, and publicity shots featuring popular African American entertainers such as James Brown, Bill Cosby, Pam Grier, Grace Jones, Eddie Murphy, Prince, Richard Pryor, and Laurence Tureaud (professionally known as Mr. T). Over these images, narrator Rolle announced, "These are their [referring to the stereotypes] descendants. As we turn to contemporary culture, how will we judge? What do these images reveal about our innermost fears, our hopes, our most enduring fantasies?"[78]

Ethnic Notion's concluding salvo—that the images of these late twentieth-century black entertainers, for all of their professional achievements and advancements, still contained traces of the stereotype's flat representations and disquieting façades—reintroduces the idea of the minstrel stain and its emergence in modern and contemporary visual culture. As the works discussed in this chapter made all too evident, forms of visual racism offered contemporary artists irresistible source materials from which to create critical works of art. But what many of these artists had not foreseen was the stereotype's uncanny capacity to untether itself from the artwork's planned narrative and spew its poison anew, blocking the artist's sarcastic designs and confusing a satire-illiterate audience. For example, in Howardena Pindell's *Free, White and 21* (see fig. 84) and Zanele Muholi's *Namhla I, Cassilhaus, North Carolina* (see fig. 91), simulated whiteness and exaggerated blackness, respectively, bewildered segments of each artist's audience because of their unbecoming theatricality and assumed attacks on a virtuous self-positioning within so-called "realness." Similarly, hip-hop artist Drake discovered the specter-like presence and moxie of blackface that, despite being deployed to deride the entertainment industry's power structure, ricocheted back onto the artist, ensnaring him in misidentification and requiring a broad mea culpa. And at the cataclysmic end of *Bamboozled,* viewers were left with the quandary of whether or not minstrel-entrenched African American artistry (such as tap dancing, physical comedy, and expressive musical performances) deserved the death sentence it received under Spike Lee's directorial and moral aegis.[79]

Yet *Bamboozled* betrayed its thematic disdain and ethical superiority toward racial stereotypes with the camera's protracted and doting close-ups on black memorabilia, as if these lifeless, antiquated artifacts not only held

the film's lead character under their spell, but director Lee as well. Lee's use of blackface in *Bamboozled,* while for the most part a badge of dishonor, is an infinite, black reflective pool on the faces of his new millennial minstrels, showing awe, anguish, and revulsion (in successive order with each "blacking up" scene) and, at the same time, a peremptory, Jekyll and Hyde– like metaphysical transformation. The allure, the perverse beauty, and the signifying power of minstrelsy captivated even the most politically committed of contemporary black artists, as seen in *Bamboozled* and in filmmaker Arthur Jafa's unrelenting black-faced figments in *Apex* (see fig. 92).

In painting, the minstrel stain could be a lush, sybaritic experience, as in Beverly McIver's *Silence* (see fig. 87). Here, stereotypic elements are brought to a standstill for meditative scrutiny, forming one body of contemplative matter with the pigment itself, supply and openly operating between form and content. Painterly candor and surrender to minstrelsy had already transpired in Robert Colescott's *I Gets a Thrill, Too, When I Sees De Koo,* but augmented with a satirical imitation and an ironic portrait sketch (see fig. 86). After multiple and prolonged viewings, the face of the bandana-wearing mammy in Colescott's painting loses its offensive, emotional sting and instead operates in service to Colescott's painterly critiques of abstract expressionism and art world canonization. The aestheticizing of the stereotype, explained cultural critic Manthia Diawara in his essay accompanying David Levinthal's photographs of stereotypic toys and memorabilia, "breaks the illusion of identification with the image" and, as a consequence of intense scrutiny, isolation, elaboration, and repetition of the stereotype, the artist has fashioned something that, while informed and perhaps inspired by racist imagery, potentially functions on its own discursive terms.[80]

Despite being aware of the complicated histories and signifying strategies that encircled blackface (especially when black entertainers took up its corporeal language), African American artists beginning in the 1960s dove head-on into the stereotype's and minstrelsy's Stygian waters, emerging from that black hole with the hope that its ineffaceable residue would be recognized as a bold denunciation of racism. As the countless examples of these works carrying the stereotype's stigmata showed, however, those expectations for the audience's grasp and critical discernment of minstrelsy's satiric and ironic capabilities were not always realized. And, yet, contemporary black artists' confidence in the burnt cork's discursive powers did not wane but, rather, grew and arguably metastasized, evolving into artistic statements that basked, or sometimes wallowed, in the stain's equivocal flush.

ROBERT COLESCOTT

BETWEEN THE HEROIC AND THE IRONIC

> Not only does racism express the absurdity of the racists, but it generates absurdity in the victims. . . . If one lives in a country where racism is held valid and practiced in all ways of life, eventually, no matter whether one is a racist or a victim, one comes to feel the absurdity of life.
>
> —CHESTER HIMES, *MY LIFE OF ABSURDITY* (1976)

In the mid-1980s artist Robert Colescott (1925–2008) painted a series of canvases, generically entitled *At the Bathers' Pool*, featuring assemblies of female nudes, each group located in a dreamy, mountainous landscape with expansive horizons and blue-green wading pools. Executed in the then popular neo-expressionist manner, these paintings have an informal, amorphous feeling that extended to the nudes themselves, women of distinct racial backgrounds positioned in archetypal, life-study modeling poses. One such painting, *Judgment of Paris*, compositionally stands apart from the rest, and serves as an apt introduction for discussing Colescott's satirical art (fig. 94).

Colescott was famous for his parodies of Western art classics, and *Judgment of Paris* corroborated his reputation as one of America's leading visual satirists. Colescott's *Judgment of Paris* also signaled the painter's importance

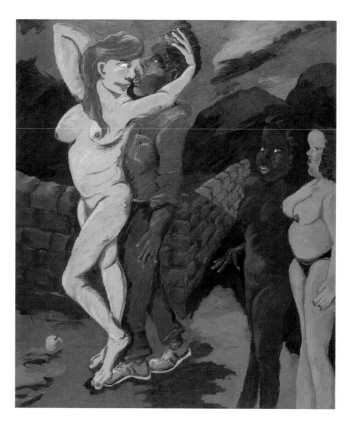

Fig. 94 / Robert Colescott, *Judgment of Paris*, 1984. Acrylic on canvas, 84 × 72 in.
(213.4 × 182.9 cm). Collection of Jordan D. Schnitzer.

to Western art history in that the work's subject matter, apart from its iconicity in modern painting, served as a recurring allegory for the art history discipline itself, prompting art historians from Hubert Damisch to Hal Foster to employ this myth and its age-old metaphors for exegeses on visual criticism, aesthetic criteria, and art history's psychoanalytic strains.[1] Based on the ancient Greek legend of a rivalry among Aphrodite (the goddess of love and beauty), Athena (the goddess of war, wisdom, and the arts), and Hera (the goddess of women and marriage), Zeus (the god of the sky and the ruler of the other deities) enlisted the youth Paris to select the fairest among the three goddesses and present her with a golden apple. After the goddesses displayed their feminine charms and pressed their respective cases before Paris, he chose Aphrodite as the fairest (who coincidentally had bribed him earlier with the promise of making Helen of Troy, the world's most beautiful woman, his wife). The subsequent abduction of Helen on Paris's behalf led to the Trojan War and the fall of the city, but that's another story.[2]

Fig. 95 / William Ebie, *Robert Colescott, Roswell, New Mexico*, 1987. Gelatin silver print.
Collection of the artist.

Apart from the immodest spectacle of three naked women, Colescott's *Judgment of Paris* bore few similarities with its mythological and artistic predecessors. Aphrodite here is a redheaded exotic dancer from a North Beach strip club, and Athena and Hera, the club's racially integrated junior varsity tier, seem to not be in competition at all for Paris's favors. Paris, the lucky appraiser, bears a striking resemblance to Colescott at the time (fig. 95), his thick gray mane and beard framing his brown face, and his pen noticeably sticking out from the breast pocket of his fire-engine red shirt.

While our collective gaze lingers on Aphrodite and her beauties-in-waiting, Paris or, rather, Colescott commands our immediate attention, his cozy yet hapless position—between a brick wall and an alluring nude—introducing the all-too-human elements of sexual infatuation and moral weakness residing in a middle-aged man's body. In contrast to the Greek legend's beauty pageant theme that features a young celebrity judge, Colescott's story is a tale of black male fascination with white women and anticipated cou-

pling with them, an example of emotionally and societally imbalanced lovers more akin to the satirical "ill-matched couple" paintings in sixteenth-century Germany and their mid-twentieth-century American counterparts from *Jet* magazine, publishing socially titillating and frowned-upon instances of interracial marriages.

It would have been expected at the time for the Tucson-based artist to make use of this classical theme for a contemporary meditation on sex, race, and human vulnerability, all couched in a playful, self-satirizing statement. Although not the only visual satirist of note in 1984, Colescott's notorious painting of the previous decade, *George Washington Carver Crossing the Delaware: Page from an American History Textbook* (1975)—appearing in 1984 on the cover of *Artforum* magazine and accompanied by an essay by Metropolitan Museum of Art curator Lowery Stokes Sims—was still remembered as a bold artistic statement, confirming his art world stature and his preeminence among contemporary visual satirists (see fig. 14).[3]

Much of the appeal of Colescott's art can be attributed to its formal qualities. Colescott's paintings are uncommonly colorful, whether flatly rendered in vivid, unmodulated chroma or lathed with brilliant, thickly applied pigments from full-bodied brushstrokes. Their compositions are usually frenetic, packed with interlocking forms and contrasting patterns that engage the viewer's eye; they're never boring. They are perhaps confusing at times, but never dull.

His paintings are populated with human beings of different shapes, sizes, colors, races, and sexes. These corporeal elements invite audiences to look at the depicted bodies, to compare those bodies in relation to themselves, and to sometimes see themselves in Colescott's figures. These figures ultimately serve as the narrative catalysts in his art, and the sight of these figures invariably performs a central role in amplifying each painting's claims to reality, regardless of the painting's figural distortions or exaggerations of anatomy and nature. Colescott's paintings abound with stories. One might say his paintings and artistic intentions are built upon narratives that, themselves, have figurative connotations: that artistic meaning is derived from the depicted people and their implied actions. Thus, these actions become the source materials for extracting meaning, for initiating discussions, and for generating reactions.

Not only did Colescott's *Judgment of Paris* navigate through the same choppy, whitewaters he had already embarked upon with *George Washington Carver . . .* , but it showcased his principally autobiographical approach to visual satire. Colescott, to paraphrase literary critic Darryl Dickson-Carr, was

"the quintessential African American satiric figure, insofar as he [envisioned] the bridges between two worlds, the heroic and the ironic."[4] Taking this idea from narrative art forms and applying it to a visual artist and his creative practice might at first appear to be a conceptual stretch and, yet, for Colescott, such a designation made perfect sense.

"I think what happens to me is I get so zeroed in on my own work that I'm my own best hero," Colescott confessed when asked about his place in and perceptions of the contemporary art scene.[5] Like the protagonist of a picaresque novel or film, Colescott was an observant world traveler who, in tandem with an honesty and frankness in his work, frequently transmitted amazement and mystification concerning the real-life experiences of his subjects. Colescott's bafflement about "the ways of the world" did not stop him from visually editorializing about his unseemly subjects, which he did in a droll and facetious fashion, while retaining a measure of sincerity and the courage to artistically hazard where few of his predecessors had previously ventured. "The *pícaro* inadvertently satirizes society," writes literary critic Curt Shonkwiler, "not only through his actions but through his observations, and so a certain attitude of acceptance, or at least awareness, is necessary in order to register that society's workings."[6] Curator Mitchell D. Kahan added about Colescott in particular, "Implicating himself as artist, black, and man, Colescott implicates the viewer as well." Kahan continued, "If sometimes he portrays us all as victims, more often we are cast as guilty defendants—roles that, for blacks and whites, we are more comfortable in avoiding."[7]

From the vantage point of Colescott's life and status as a twentieth-century artist/pícaro, his cognizance of society and its shortcomings framed his artistic commentaries in such a way as to privilege his own, admittedly prepossessed views of the world and, arguably, to prominently showcase for the first time contemporary black humor in art. My use of "black" in this instance not only references racial and cultural Africanity, but Colescott's attraction to the grotesque and offensive in life: a weighty, dark, cringe comedy that, through its serious joking, broached challenging topics and probed the American psyche like no other artist before or after him. Colescott's black humor is a comedy that interrogates death, violence, and/or immorality, while at the same time situating its explorations within an African American context that, because of its historical and social actualities, contends in particular with black pain.[8] The idea of black humor certainly encompasses the fact that Colescott painted from an African diasporic perspective, albeit an outlook that, as the following account of his life and career reveals, was *both* a quintessential African American experience *and* empirically singular.

The younger of two sons born to Warrington Colescott, Sr., a dining car waiter for the Southern Pacific Railroad, and Lydia Colescott, a teacher and pianist, Robert Hutton Colescott grew up in Oakland, California.[9] Colescott's parents, both circa World War I migrants to Northern California from New Orleans, were members of East Oakland's burgeoning creoles-of-color community, where New Orleans–style music societies and potluck dinners with gumbo and étouffée were routine. As with the offspring of many creole families, Robert and his older brother, Warrington, Jr., appeared racially different, the straight-haired and fair-skinned Warrington easily passing for white, while the straight-haired and darker-skinned Robert alternately looked Latin American, Native American, Middle Eastern, or of partial African ancestry (fig. 96). A *New York Times* obituary for Warrington, Jr., detailing his prominence as a printmaker (and his career's marked separation from his brother's), made the divergent racial identities of the two brothers clear: "Robert considered himself African-American; Warrington considered himself white."[10]

After graduating in 1942 from Roosevelt High School in Oakland, Robert Colescott joined the U.S. Army, serving in Europe and in the Pacific until the end of World War II. Upon being discharged he enrolled at the University of California at Berkeley, where he graduated with a bachelor's degree in art in 1949 and, five years later, with a master's degree in painting. In the midst of his studies at the University of California he spent a year (1949–50) in Paris, participating in the celebrated Salon de Mai invitational art exhibition and studying with the legendary cubist painter Fernand Léger, from whom he got the confidence to paint figuratively, against that era's abstract expressionist tide.[11]

Much of Colescott's professional career was spent teaching in schools and universities in Seattle, Portland, the Bay Area, and Tucson, the latter for almost twenty-five years, until his death in 2009. Colescott also devoted a significant period of his life outside of the United States, visiting Africa, North and South America, the Middle East, and Asia. In 1964 he received a study grant allowing him to work at the American Research Center in Cairo. Egypt was so inspiring to Colescott that, in 1966, he returned there as a visiting professor at Cairo's American University. When Egypt's Six-Day War erupted in early June 1967, Colescott and his family fled to Paris, where he taught in college abroad art programs and exhibited his paintings until returning to the United States in 1970.

Although Colescott was middle-aged by the time he started participating in group and solo exhibitions in the Bay Area and New York beginning in

Fig. 96 / Program cover for *Recent Paintings by Robert Colescott* (Salem, OR: Salem Art Museum/Bush House, 1961).

the 1970s, his parodic subjects and their institutional critiques put him at the forefront of cutting-edge art in these years. From his appearance in such important African American art surveys as *West Coast '74: The Black Image*, to his pivotal place in several thematic exhibitions such as the Whitney Museum of American Art's *Art about Art* and the New Museum of Contemporary Art's *Not Just for Laughs: The Art of Subversion,* Colescott's paintings and their locus in cultural criticisms conspicuously figured in the art world's curatorial turn in the 1970s and 1980s toward painterly expressionism and postmodernism.[12]

The subject of no less than four major retrospectives since 1987, Colescott's art has come to epitomize an extraordinary level of professional

achievement and keen visual intelligence.[13] Yet historians and critics are largely at a loss to explain exactly *what* Colescott's artistic strategies were, or *why* his paintings succeeded. One suspects that the challenge in making sense of Colescott's satirical art is that, like satire itself, no single definition or set of criteria can sufficiently explain the stinging yet revelatory consequences of his work, nor its critical appeal.

However, one possible explanation, reflecting again on Colescott's self-portrayal in *Judgment of Paris,* is that the painter seemed to be his most characteristic self when seeing his artistic subjects/protagonists as outsiders —either in terms of race, gender, and/or social status. This outsider-ness invited a wry perspective within each painting, whether Colescott is the depicted bystander or, as is often the case, another protagonist serves in the role of an outcast. "Colescott does not exempt art or himself from his exposure of 'the absurdity of everything we do,'" writes art critic Kenneth Baker.[14] His is not an outsider endeavoring, through satire's assorted discursive modes, to point out and solve the world's problems but, rather, an outsider whose at-odds footing within an imperfect world, and sarcastic observations about it, are the stuff of an ironic or mocking testimonial in art.

A survey of Colescott's parodies, self-mockeries, artistic travesties, sarcastic juxtapositions, pictorial burlesques, and painterly understatements will hopefully bring to the fore this picaresque outlook: occasions that acknowledged life's absurdities—especially on the subjects of race, sexuality, and class—and humanity's inability to bring satisfactory explanations or resolutions to these contradictions. Colescott's buckshot rounds toward throngs of targets—conventional, institutional, political, and personal—demonstrated his uncanny aptitude for enacting transgressions against misconstrued moral virtues, while at the same time embracing oxymora and resigning himself to ethical ignominy. Discussing the critical and political possibilities in these transgressive acts and in his parodic reinterpretations of previously created works of art, Colescott acknowledged, "I also feel that appropriations, themselves, sometimes inspire a means beyond the confines of the art world, into what Henry [Louis] Gates may refer to as the 'authors of our common sense.'"[15] Somewhat vague in his language, Colescott's notion of a visual seizure (or a sarcastic use of metonymy) instigating a way out of the artistic status quo, and into a more collectively informed sense of the self and society, is interesting, if not for Colescott's stated investments in creative subversions, then certainly for his distant goal of a shared sense of human conditionality in his art. What these examples and comments show is that Colescott's brand of satirical humor, instead of silencing the opposition or

shutting down debates, forced antagonists and friends alike to look deep within their histories (and their own respective closets), to pivot and acknowledge the ghostly intimations therein, and, then, through a serious engagement with the work, to seek out the inconvenient truth and the light.

"I'M MY OWN BEST HERO"

The earliest indications of a satirical streak in Colescott's work appeared circa 1969–70, around the time he returned to the United States from France. Of those first satirical paintings, *Bye Bye Miss American Pie* was distinctive for its explicit sexuality and juiced-up ambience, expository and emotional elements that Colescott would revisit in works over several decades (fig. 97). Notwithstanding its offensive and misanthropic trafficking in female sexual stereotypes and boorish metaphors, *Bye Bye Miss American Pie* queried its viewers with a sarcastic proposition: Will America, conceived here as a naked blond woman in a red, white, and blue miasma, procure for African American men their anecdotally coveted trophy—a white woman—in exchange for putting their lives on the line during the Vietnam War? Such a gendered and coarse interpretation of the psychological and sexual pact between the white woman and the black male in *Bye Bye Miss American Pie* might strike some observers as reprehensively locating Colescott within a no-holds-barred, stereotype-riddled territory, where impolite typecasting and supposed truths about human behaviors are given unencumbered room for full deliberation.

And, yet, if one takes in the entirety of Colescott's hieratic composition and unapologetic equation in *Bye Bye Miss American Pie*—specifically, the bodies on display, the delimiting stereotypes that surround them, and their flesh, blood, and sinew messages—then one cannot ignore his flagrant staging of a black urban legend of mock sexual briberies that inveigled, and for all practical purposes duped, countless draft-age African American men during the years of the highly contentious Vietnam War. In typical Colescott fashion, the metaphor of a "piece" of the American pie functioned doubly and more: as an unmitigated sexual euphemism and, as curator and art historian Lowery Stokes Sims observed, "[a] tantalizing [personification] of American values—liberty, freedom, etc.—... dangled in front of the black man (who represents the entire black community here) [but] forever out of his reach."[16] It is Sims's final point of contention—America's defaulted-upon assurances of racial equality and individual freedom—that aptly served artists such as Colescott and Ollie Harrington in satires aimed especially at the unfulfilled entitlements promised to African American combatants, veterans, and their extended families.

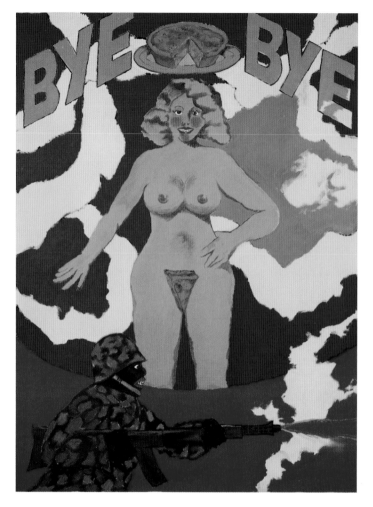

Fig. 97 / Robert Colescott, *Bye Bye Miss American Pie*, 1971. Acrylic on canvas, 78⅞ × 59⅛ in. (200.3 × 150.2 cm). Akron Art Museum. Museum Acquisition Fund, 1992.6.

Not so much a proposal as a provocation (the painting's title riffing off of a popular 1971 song of a similar title by singer/songwriter Don McLean), Colescott heightened the painting's satire quotient with a composition that recalls a human-interest magazine's cover and assembly of masthead words and disparate images. "Returning to California was good for my work," Colescott told a reporter years later about this moment in his career, "because it's an open place where you can do things that would be dismissed as weird anyplace else, and I felt free there to follow my painting where it took me."[17] Indeed, the Bay Area's reputation for lifestyles and political beliefs that diverged from the conservative American mainstream, especially exemplified in radical politics and countercultural habitudes, made the ideal setting for

an artist like Colescott, who saw examples of human folly, such as men at war, as self-sabotaging lunacy rather than something to be excused and commiserated upon, and for whom human frailties, such as sexual displays and desires, were the stuff of pure comedy, spoofs, and visual satires.

Colescott's impolitic interpretations of his subjects were also a characteristic of other Bay Area artists during this period. "For more than a decade," wrote art historian Whitney Chadwick about 1970s Bay Area figurative art, "painters like James Albertson, Olive Ayhens, Robert Colescott, . . . and others have produced works in which social comment, satire, morality plays, puns, and personal mythology combine with flamboyant and eccentric personal styles to form a visual running commentary on the world and the history of art." Chadwick continues, "Their paintings exhibit a maverick sensibility, downplay obvious skill, and break the 'rules' of representation in ways often influenced by the directness of naïve art and popular illustration."[18] After Colescott's first major solo exhibition at New York's Spectrum Gallery in 1973, *New York Times* art critic John Canaday wrote, "Whatever pleasure you take in Mr. Colescott's raunchy, scatological paintings, executed in a style as crude as their humor, will depend on your tolerance for low, very low, comedy. I found them, to my embarrassment, entertaining."[19]

As art historian Darby English examined at length in his book *1971: A Year in the Life of Color,* in and around 1971, artists of African descent with different aesthetic and ideological persuasions independently coalesced around a shared creative urge to reimagine painting, sculpture, and activism in service to a cultural insurgency that was afoot in various African American communities nationwide.[20] As discussed in the previous chapter, this was a period when many African American artists tapped into sentiments that prioritized a black cultural distinctiveness and anti-racism themes within their work. In sharp contrast, a fair number of African American artists rejected these more overt racial strategies, choosing instead to reconcile a political and sociologically informed mindset with assorted abstract and conceptual approaches to art-making. Colescott was part of this multifarious, eclectic movement but, as seen in *Bye Bye Miss American Pie* and especially in his pencil drawing *Heavenly Host and MLK* (fig. 98), his irreverence and askew perspective put him at odds with the majority of black artists and cultural activists at the time.

Only three years after Dr. King's murder in Memphis, Colescott's *Heavenly Host and MLK* phantasmatically depicted the slain civil rights leader in heaven, but thwarted from entering by an enthroned white supremacist god, flanked on either side by white guardian angels dressed as segrega-

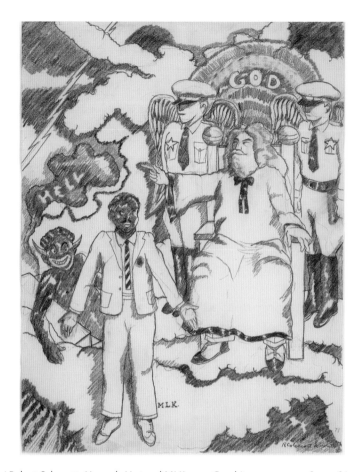

Fig. 98 / Robert Colescott, *Heavenly Host and MLK*, 1971. Graphite on paper, 25.6 × 19.6 in. (65 × 49.8 cm). Private collection, Minneapolis. Promised gift to Minneapolis Institute of Art, L2018.107.3.

tion-era state troopers. King's visible exasperation at being denied entrance into heaven is gleefully met by a grinning, blackface minstrel/devil behind him, with the thunderbolts and sulfurous vapors of "Hell" delineated above. *Heavenly Host and MLK* was related to two comparable works by Colescott that shared with the drawing the artist's brash and injudicious decision to represent in an outrageous and farcical vein well-known, murdered Americans: *Assassin Down* (1968–70), which depicted the televised murder of President John F. Kennedy's assassin, Lee Harvey Oswald, and *Kitchen Assassination* (1971), which was Colescott's reenactment of the 1968 presidential candidate Robert F. Kennedy's slaying. Adventuresome in making Dr. King, a beloved African American icon, the butt of a joke that refused to envision for him an idealized apotheosis, Colescott would not be joined in such a subversive artistic act until some thirty-five years later, when the cartoonist Aaron McGruder's

controversial "Return of the King" episode (for the 2006 television series *The Boondocks*) staged a comparable dive into the racial subconscious.[21]

Like the painting *Bye Bye Miss American Pie,* the drawing *Heavenly Host and* MLK placed its main African American subject in an awkward position vis-à-vis the painting's racial narrative: a black pawn in a proverbial chess game where the match was hopelessly rigged in favor of white dominant forces. But unlike some African American artists in the 1970s whose pictorial scripts comprised unequivocal villains, heroes, offenders, and casualties, Colescott's characters were accessories to a crazy world in flux, where the jagged, stratocumulus clouds in the paintings metonymically corresponded with the tumultuous relations between the depicted parties, and the satirical intentions of the painting's mise en scène were embodied, as in Dr. King's portrayal, in comic desperation.[22] Rather than an unmitigated representation of black victimhood, Colescott's Dr. King, like the eagle excrement–soiled black aviator in his *Ace of Spades* (see fig. 29), found himself in a racist environment that, while especially fraught for black people, could not entirely explain black precarity. Dr. King and the black aviator, while certainly the objects of historical and institutional racism, were conceived by Colescott as aggrieved yet idiosyncratic, flawed individuals and, thus, unfettered by the conventional, overly simplified librettos of white oppression and black suffering. "Sometimes, our flaws all add up to something better than we are," Colescott told curator Ann Shengold. "To be human is to be wonderful and beautiful," he continued, "but to be human is to be the victim of everything."[23] By assuming a sarcastic stance in these early works through the combination of odd grotesqueries and profligate bodies, Colescott staked out a previously uninhabited place among African American artists that ultimately drew an inordinate amount of attention to his work, as well as questions surrounding his racial and cultural loyalties. "Oh," Colescott facetiously relayed to art historian Robert Rosenblum, "colored folks just love my pictures!"[24]

Colescott's abrupt concordances, surprise insertions, and overtures to the carnivalesque in his paintings were tactics that assailed the viewer's sensibilities and struck against an audience's innate desire for narrative stability and aesthetic equilibrium. These provocations would continue especially during the mid-1970s, when Colescott (who was then a visiting lecturer at the University of California at Berkeley, his alma mater) began painting parodies of famous works of art and familiar visual emblems, with auxiliary black bodies and off-color commentaries placing the works within a matrix of oppositional attitudes and counterstatements: testimonials that, along

with the unanticipated black bodies, interjected surplus meanings and innu-
endos.[25] A parody such as Colescott's *Rejected Idea for a Drostes Chocolate
Advertisement,* inspired by a circa 1920s illustration by Jessie Wilcox Smith
(for Mary Mapes Dodge's *Hans Brinker, or the Silver Skates*), combined autop-
sies of product advertisements, racial stereotypes, society's adjudicators of
decency, and sexual hypocrisy, all within an unpretentious, if carnal, cartoon-
like format (fig. 99). The two vectors of Colescott's parody — Hans Brinker's
exposed phallus and Gretel's dark-brown–faced/pink-lipped expression —
took Dodge's Eurocentric tale of sibling fealty and "dike-plugging" into the
realm of a salacious, interracial coupling more befitting a pornographic
tableau than an advertisement for chocolate confections. The painting's sten-
ciled title along its bottom edge — a ploy already seen in Joe Overstreet's
The New Jemima (see fig. 72), communicating amateurism and the absence
of a personal mark or signature — gestured both toward a plebeian perspec-
tive and a faux, preemptive artistic/authorial repudiation of this "rejected" yet
outrageous concept.

Like Colescott's *Rejected Idea for a Drostes Chocolate Advertisement, George
Washington Carver Crossing the Delaware: Page from an American History
Textbook* had a preexisting image pool from which to borrow and generate a
counter-narrative (see fig. 14). In addition to Emanuel Leutze's 1851 history
painting of a similar name and composition, Colescott's other source of
inspiration, Hieronymus Bosch's *Ship of Fools* (see fig. 3), put *George Washing-
ton Carver . . .* in the category of a farce, one that not only disparaged Ameri-
can myths of greatness by way of African American stereotypes, but chastised
human shortcomings and delusions of grandeur, depicted in the bucolic
pleasure principles of racist "coon" personae and "wet" patriotism.[26] Com-
pleted one year prior to America's Bicentennial celebrations, Colescott's
George Washington Carver . . . indicted dumb chauvinism, likening it to a racist
nineteenth-century Currier and Ives chromolithograph and to a water-bound
conveyance for the asinine, not foolish because the passengers are black,
but because they locate their jingoism in an orgy of drunken exhortation and
lascivious flag-hugging. "[An] antagonistic stance toward history and mem-
ory might usefully serve as a counterpedagogy of remembrance . . . ," writes
scholar Tavia Nyong'o about an African American sarcasm similar to Cole-
scott's *George Washington Carver . . .* "The indirect route toward justice pro-
posed in sarcastic improvisations upon historical memory speaks less . . . to
despair at the possibility of justice than to the need to place our hopes else-
where than in the myth of steady progress": a defiant voice that black Ameri-
cans, from Frederick Douglass to Robert Colescott, have long made audible

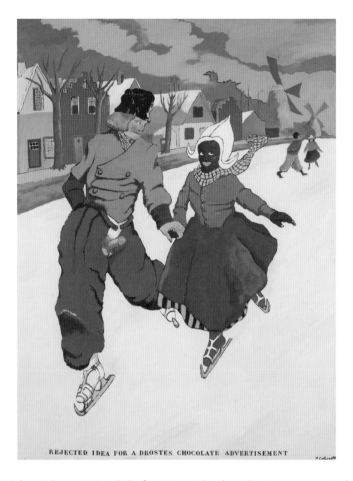

REJECTED IDEA FOR A DROSTES CHOCOLATE ADVERTISEMENT

Fig. 99 / Robert Colescott, *Rejected Idea for a Drostes Chocolate Advertisement*, 1974. Acrylic on canvas, 80 × 59½ in. (203.2 × 151.1 cm). Portland Art Museum. Gift of Douglas and Lila Goodman, 2001.90.8.

and emphatic.[27] "Colescott's pictures are about America," New York art critic Gregory Battcock noted prophetically, several years in advance of the artist's most celebrated parody, "[and about] the underlying sexual fantasies that motivate its fears and prejudices."[28]

By transposing this time-honored scenario into something outlandish, Colescott put a spotlight on the original's affectations and irrationalities. Similar to selected parodies and modern reenactments of Leonardo da Vinci's iconic *The Last Supper*, Colescott's *George Washington Carver . . .* was a none-too-subtle dig at iconicity, showing the power of such idiomatic compositions and their catalytic effects on viewers' emotions. In sharp contrast to Larry Rivers's 1953 parody of the same subject of Washington crossing the Delaware (which Rivers couched in a tentative, expressionistic language of

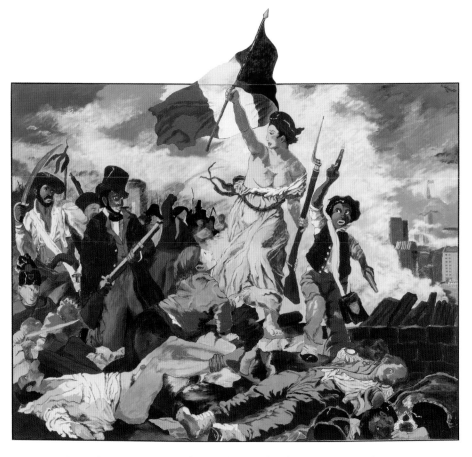

Fig. 100 / Robert Colescott, *Homage to Delacroix: Liberty Leading the People*, 1976. Acrylic on canvas, 84 × 108 in. (213.4 × 274.3 cm). Collection of Harold and Arlene Schnitzer, Portland.

thinly painted gestures and disparate figural passages), Colescott's version is cartoon-clear and manifestly flippant. It refused any overtures toward an elevated painterly discourse, instead being rendered in a coloring-book style in which the graphic components coalesced around a comprehensive story line, so scandalous and contravening that only its most likely beneficiaries— the satirically literate—could fully appreciate Colescott's artistic transgressions. As gleaned from Colescott's redolent scene, the titular "American History Textbook" was not your standard public school reader, nor a Carter G. Woodson correction to historical omissions (in spite of the appearance of the early twentieth-century African American scientist and educator George Washington Carver, a constant citation in older "Negro History" textbooks). What Colescott was perhaps thinking about was a clandestine offprint: the bawdy, racist, and unexpurgated chapbooks and dime novels that occasionally surfaced in barbershops, pool halls, boardinghouses, and other mid-twentieth-century, African American male domains.[29] The lessons learned from these underground tracts, in spite of their problematic content, were abridged,

sarcastic seminars on white America's hypocrisy and obsession with African Americans, realized in lurid scenes and bizarre characterizations not dissimilar from Colescott's composition. At a moment when mainstream parodies in pop art and advertisements employed glib pronouncements, rather than demonstrating a commitment to lambasting societal flaws and political orthodoxies, *George Washington Carver . . .* stood apart from that period's other artistic dissections of America through its expressed confidence in and unconventional overhaul of the emerging genre of modern and contemporary African American art in the post–civil rights era.[30] Colescott's elucidations completely materialized in this and in his other masterpieces from this period not simply because his attacks on patriotism and racism were so pointed and meticulous, but because they were swipes from an artist choosing to paint from the vantage point of a self-proclaimed outsider.

Colescott's adoption of the outsider status and its utility in leveling a highly effective, parodic sideswipe was most evident in his *Homage to Delacroix: Liberty Leading the People* (fig. 100). Reimagining Eugène Delacroix's 1830 masterpiece in what appeared to be the twentieth-century hand of a faux amateur, Colescott introduced a series of "modifications" to the original (for example, extending the 1830 canvas's cropped French tricolor flag, turning selected members of the revolutionary insurgents into people of color, and, in the composition's distant right, adding an American flag atop a New York–style skyscraper). These folksy amendments, in addition to Colescott's intentionally unrefined application of pigment, all drew the audience's attention to certain deficiencies and compositional peculiarities in the Musée du Louvre's original. Furthermore, the incongruous addenda in

Fig. 101 / Robert Colescott, *Dulacrow's Masterwork: A Mockumentary Film* (still), ed. 1/10, 1976. Digital video (color, sound), 43:50 minutes. Rubell Family Collection, Miami.

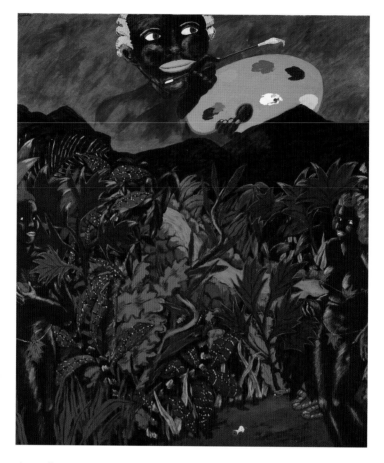

Fig. 103 / Robert Colescott, *A Legend Dimly Told*, 1982. Acrylic on canvas, 84¾ × 72¾ in. (215.3 × 184.8 cm). Mott-Warsh Collection, Flint, MI.

The fact that Colescott was not shy about excoriating himself in a parodic statement (as seen in *Judgment of Paris,* fig. 94) was proffered in *A Legend Dimly Told,* in which he cast himself—in the guise of god—as one of the principal actors in the Old Testament story of Genesis (fig. 103). The verdant world that Adam and Eve inhabited not only wryly commented on Genesis and its narrative of everlasting expulsion from Paradise but, through its Africanesque wax-print fabric colors and all-black dramatis personae, acknowledged the "Out of Africa" theories of contemporary paleontologists and geneticists. Also channeling poet Emily Dickinson's subtle skepticism in one of her poems about the Garden of Eden affair ("Children—matured— are wiser—mostly— / Eden—a legend—dimly told— / Eve—and the Anguish —Grandame's story— / But—I was telling a tune—I heard"), Colescott's omnipresent deity, rather than a magnanimous but patriarchal creator, was a contemplative, brown-skinned *artiste,* poised to paint a color-

ful, if immoderate, picture of creation girded by purple mountain majesties and set against a fiery, rather than saintly, Sistine Chapel–like firmament.[34] Still, Colescott's reimaginings of Genesis, the Miss America Pageant, and Hollywood's Golden Age did not always successfully communicate their satirical wallops and diagnostic aftereffects to everyone during this period. "They make no excuses for their gleeful manipulation of historical settings and skin color," wrote a commentator in her 1981 exhibition review, "Is Shirley Temple Black?," of his solo show at New York's Semaphore Gallery. "[They make no] apologies for the questions they pose but don't solve," the review bluntly concluded.[35]

By the late 1970s Colescott had not only made his mark on the contemporary art world with his remorseless parodies, but he had also mastered the art of satirical understatement—drawing enough viewers into his artistic courses of action which, on the face of things, seemed rather inconsequential or mundane, but almost imperceptibly elevated his subjects to the level of social and political profundity. Such was the case with *Colored TV,* a disarmingly naïve painting of a slender black woman relaxing at home in her negligee and watching television (fig. 104). Conceived in his characteristic "bad painting" style of the late 1970s (an artistic phenomenon codified and developed into a major exhibition by the New Museum of Contemporary Art's chief curator, Marcia Tucker), *Colored TV* contained just enough anecdotal curiosities—a buxom blond on television, a shooting star visible from the window, the smoke from the woman's cigarette forming the words "colored t.v.," and an isolated men's high-top boat shoe on the floor—to suggest this scene was making inferences to white America's underlying racial bias in the media and, in spite of that message from the airwaves, also channeling black aspirations and desires.[36]

In a conversation years later with curator and art historian Susan Landauer, Colescott augmented, and further complicated, what *Colored TV* (occasionally referred to as *Wishing on a Prime Time Star*) was addressing. Colescott shared with Landauer that the black platinum blond's "wish" that she, too, might someday become a star was probably futile because "she" was, in fact, a "he"—a transvestite—as intimated by the men's shoe lying on the floor in front of her. The trailing cigarette smoke spelling out "colored t.v.," explained Landauer, referred not only to the color television set, but to the black (that is, "colored") transvestite watching it, designated by the smoke's descriptive acronym.[37]

While taking in the totality of this painting, one can almost hear the lyrics from the Los Angeles–based soul group Rose Royce's 1977 hit, "Wish-

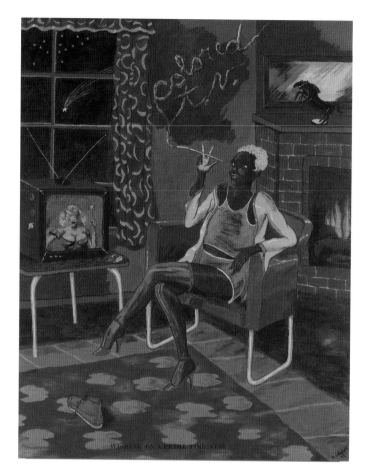

Fig. 104 / Robert Colescott, *Colored TV*, 1977. Acrylic on canvas, 84 × 66 × 1½ in.
(213.4 × 167.6 × 3.8 cm). San Francisco Museum of Modern Art. Gift of Vicki and Kent Logan.

ing on a Star," which articulated one's wishes and desires in the context of
sky-gazing and dream fulfillment.[38] Again, a satirical understatement makes
what's obvious perfunctory, and what's subtle pivotal and often transforma-
tive. And in the context of *Colored TV* the transformative element is this sub-
ject's ability to conjure her own, vibrant world, foretelling of a future where
black drag queens such as San Francisco's Sylvester and Atlanta's RuPaul
will reign supreme. In this world, white privilege is confined to the "boob
tube," and black freedom—as symbolized by the figure herself and the
ceramic horse on the mantle, rearing upward—is put on display in the heat
and starlight of a summer Oakland night.

In *Strange Fruit* (1999), a work of performance art by the performance
and African American studies scholar E. Patrick Johnson, the world of the
transgendered that Colescott's *Colored TV* foregrounds appears as well, but

Johnson perhaps more decisively locates queer identities and cross-dress-ing in a satirical context. Johnson's scenery and stage directions establish at the very outset of *Strange Fruit* a theatrical characterization not markedly different from the protagonist in *Colored TV*: "A silhouette of the PERFORMER's effeminately posed body appears behind the scrim. It is clear from the sil-houette that he is wearing a dress and a wig. The PERFORMER begins singing 'God Bless the Child' and walks from behind the scrim to reveal that he is in drag and blackface." As Johnson's pairing of "drag" and "blackface" sug-gests, *Strange Fruit* recognized the rhetorical power of the mask, not only to draw attention to the wearer's basal, radical identity, but to use queer per-formativity to vest and validate subjects, as well as to interrogate society and its tyrannical constraints surrounding gender and sexual identity. Although operating in the more ambiguous realm of the visual, Colescott's *Colored TV* also celebrated the liberatory effects and instrumentality of gay camp, embod-ied in a black queer subject whose stylish, intimate apparel and graceful body exude self-confidence and a marked counterpoint to the televised, hyper-feminine blond. "Agency is such a drag for those in power," the performer in *Strange Fruit* facetiously laments. "If you don't believe me, ask your mama!"[39]

A chronological and thematic companion to the understated *Colored TV* was Colescott's *The Dutiful Son* (fig. 105). Bereft of any obvious links to African Americans, *The Dutiful Son,* like *Colored TV,* is an interior scene in which an apron-wearing young white man is shown industriously vacuum-ing a living room, while presumably his mother — scantily dressed, smoking, eating chocolates, and reading a "romance" magazine — leisurely reclines on the sofa. Again, like *Colored TV,* nothing in *The Dutiful Son* is palpably amiss or extraordinary, and yet upon zeroing in on the art moderne book on the coffee table with a Frank Stella painting on its cover, one senses that this tacky, tasteless world and its cartoonish inhabitants are being compared to the book's abstract, high-modern pretentions. Thumbing his nose at both an aberrant Norman Rockwell world of mild domestic perturbations and a circa 1970s feminist disputation of gender-based self-sacrifice and privilege, Colescott conceived an outré painting in which "the joke" was also directed toward the lofty, high-minded discourses of art history and, in particular, the New York School's disdain or insensibility toward the American vernacular.

Photographed in 1981 as if one of the picnicking bandits from his painting hung in the background — *Sunday Afternoon with Joaquin Murietta,* a spoof of Édouard Manet's 1863 *Luncheon on the Grass* — Colescott openly embraced the character of a painter-parodist, but saw his role as more than being an art world cutup or, as playfully coded in this photographic portrait

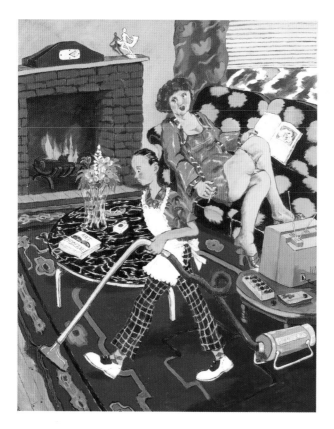

Fig. 105 / Robert Colescott, *The Dutiful Son*, 1979. Acrylic on canvas, 84 × 66 ¼ in. (213.4 × 168.3 cm). San Jose Museum of Art. Gift of Robert Harshorn Shimshak and Marion Brenner with additional support from the Collection Committee, 2000.07.

by Arthur Mones, an artful "banana" (fig. 106). Along with dethroning and making a mockery of the great masterpieces and cultural idols of the past, Colescott's parodies laid bare the Eurocentric, racially exclusive subtexts of the Western art canon, and showed how introducing a black trickster into those heirlooms infused them with sociopolitical potency and a contemporary relevance sorely needed in that era of rising social conservatism in the United States. "It was fun to think of myself as Matisse or Delacroix or whomever," Colescott told an interviewer in 1983, acknowledging the importance for him of role-play as well as parody. "I like that kind of fantasy and playing the hands of your role model to the point where you can become him, [and] then . . . you're doing your own work just like he was doing his."[40]

Reimagined through the subversive lens of late twentieth-century African American satire, Colescott's parodies of the iconic paintings of Emanuel Leutze, Eugène Delacroix, Édouard Manet, Willem de Kooning, Andrew Wyeth, and Pablo Picasso, among others, could perhaps be viewed

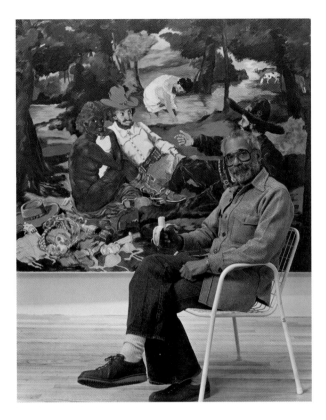

Fig. 106 / Arthur Mones, *Robert Colescott*, 1981. Gelatin silver print, 14 × 10¾ in. (35.6 × 27.2 cm). Brooklyn Museum. 1997.162.14.

as challenging the black feminist Audre Lorde's oft-quoted axiom, "The master's tools will never dismantle the master's house." Conceivably, Lorde might have applied her maxim to find fault with Colescott's two well-known parodies of Picasso's *Les Demoiselles d'Avignon* (1907) — *Les Demoiselles d'Alabama: Vestidas* (1985) and *Les Demoiselles d'Alabama: Desnudas* (1985) — although Colescott has argued that, by rendering his nudes in a somewhat naturalistic manner (and situating them in the African American – influenced southern United States), he essentially undid Picasso's extensive cubist scaffolding and its colonialist appropriations from African art.⁴¹ As proposed in *A Legend Dimly Told* (see fig. 103), the master's tools — paint and brush, an artist's palette, a droll perspective, and a discerning frame of reference — might not necessarily demolish art history's weighty, overwhelmingly white, male-controlled edifice, but they enabled Colescott to present powerful and visually disruptive counter-narratives to the textbook surveys and block-buster art exhibitions at the end of the century, with this painter-parodist

artistically advancing a multitude of black exiles, dark divinities, and "tales from the 'hood.'"

"I MIX RACE"

As both the heavenly architect of the Garden of Eden in *A Legend Dimly Told* (see fig. 103) and the artist/creator of the actual painting, Colescott had no hesitancies about inserting himself into the pictorial wisecracks: an act of auto-portraiture that, whether self-mocking or tactically required to advance the counter-narrative, was a key characteristic of many of the artist's visual satires. Self-effacement or ruefulness—emotional stances that only the most confident or psychologically candid among us can publicly muster—were employed by Colescott to flag and reinforce his work's tongue-in-cheek connotations. What better way to alert his viewers to a painting's sarcastic or ironic message than to make himself, whether explicitly or in lower registers, the butt of the artwork's visual joke and/or satire?

Colescott's spoofs of Delacroix's *Liberty Leading the People* were not only parodic, but served as indirect commentaries on Colescott's years in Paris, where he lived and worked at two distinctive moments: in the early 1950s postwar period and in the politically insurgent, youth-oriented late 1960s. Both of these periods stand out in the annals of the black expatriate experience in Europe, and Colescott, taking a few steps away from his parodies of French art, turned to them to expound upon his Parisian years. *The Lone Wolf in Paris* is not exactly an autobiographical painting, or a self-portrait per se, but a work in which the surface and subliminal witticisms are supported by Colescott's French connections (fig. 107).

Colescott was relatively taciturn about his time in postwar Paris and, later, *"les années soixante-huit,"* but if the memoirs and novelistic treatments of other African American men's lives in Paris are any indication—often recounting a racially amicable and socially limitless environment—then *The Lone Wolf in Paris,* in spite of its cartoonish imagery, can be used to extrapolate something of Colescott's experiences and encounters there. From Chester Himes's colorful reminiscences about the time he and his fellow black male writers spent in 1950s Paris, to Melvin Van Peebles's 1960s novels and short stories about the City of Lights' liberated sexual milieu, it would not be unreasonable to describe the black male artist in Paris as a *loup solitaire,* as rendered by Colescott in *The Lone Wolf in Paris*'s high-drama context of the French dance hall (*"le dancing"*), the French phrase formed by the smoke emanating from a cigar in the mouth of a part wolf, part human figure.[42]

Fig. 107 / Robert Colescott, *The Lone Wolf in Paris*, 1977. Acrylic on canvas, 78 × 72 in. (198.1 × 182.9 cm). Los Angeles County Museum of Art. Promised gift of Ed and Sandy Martin in honor of Howard N. Fox.

The Lone Wolf in Paris features a dancing couple—the male partner, an ostentatiously dressed "wolf-man," and the female partner, her body bent in a supple, revealing pose—engrossed in *la danse Apache*. This notorious and parodic specialty dance, which culminates in the man throwing his female partner to the ground, then lifting and dragging her away while she pretends to resist or feigns unconsciousness, is the source of much satire in French culture. Flanked on either side of the dancers are a stereotypic French woman and man, sitting at checkerboard cloth–covered café tables that match the design on the wolf-man's jacket. By putting the cartoonish, dancing wolf-man in place of a stereotypic black male lothario, Colescott imbricated both his fellow black male "wolves" in Paris and himself, making a mockery of a plot in which he and other African American expatriates,

eager to have sexual liaisons with French women, succumbed to their instincts and desires. As in Aesop's satire-imbued fables (or, a little closer in time and place to Colescott, Jean de La Fontaine's zoomorphic cast of characters in his illustrated *Fables de La Fontaine*), *The Lone Wolf in Paris* employed an animal-like character mimicking *Homo sapiens* behavior for the purposes of a case study in human foibles. The intentionally formulaic and comical setting, underscored by Colescott's farcical characters and innuendos to sexual role-play and stereotypes of the racial, cultural, and gendered categories, pushed *The Lone Wolf in Paris* into the realm of the absurd, and then back into balance by means of the artist's all-important inquest into race-based fantasies and self-delusions.

A twist on Colescott's contrite self-portraits, nuanced by a continued satirizing of the French art canon, appeared in *Beauty Is in the Eye of the Beholder* (fig. 108). Removing art's fourth wall of the creator's invisibility and inviolability, the painting prominently places the artist, Colescott, at its center, ostensibly interrupted from creating a spoof of Henri Matisse's *The Dance* by a blond woman in his studio in the act of undressing.[43] Is this simply a painting that presents real life as a rival to the art world, or does the painting's title, borrowed from popular culture as well as from Colescott's sheepish expression, paradoxically point to the inability of the artist to make a philosophically informed but ethically grounded aesthetic decision (as previously broached in Colescott's *Judgment of Paris;* see fig. 94)? Depicting himself here as both beholder and his own satire's *denouement* (rather than an all-seeing, omnipotent creator), Colescott admits to being susceptible to lust and poor judgment, and contrary to the painting's emphatic title, confesses to an uncertainty about what truly constitutes the aesthetic ideal. While the often controversial issue of interracial desire is rarely absent from Colescott's art, its centrality to *Beauty Is in the Eye of the Beholder,* especially in comparison to a version of Matisse's *The Dance,* is colored and perhaps even undercut by an overarching ambivalence and ambiguity, codified in Colescott's homely, checkerboard house slippers. The same checkerboard pattern was seen in *The Lone Wolf in Paris,* and years earlier in Colescott's sartorial accoutrements for Aunt Jemima, and this symbol of duality and gamesmanship interjected a folksiness and enigma that competes, albeit abstractly, with Matisse and the blond for the artist's authentic, palpable sentiments.

Although humbling and humiliating, to criticize and make light of one's own imperfections and shortcomings can easily slip into self-aggrandizement, making the introspective satirist the unwanted center of attention and the hero of the depicted counter-narrative. Colescott was cognizant

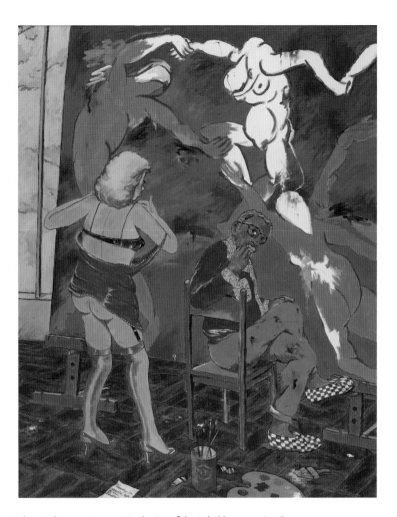

Fig. 108 / Robert Colescott, *Beauty Is in the Eye of the Beholder*, 1979. Acrylic on canvas, 84 × 66 in. (213.4 × 167.6 cm). Portland Art Museum. Gift of Arlene and Harold Schnitzer in honor of Brian Ferriso, 2006.96.

of this risk, and by way of his unseemly and laughable self-portrayals he avoided elevating himself to a holier-than-thou victim of the satire's symbolic yet sentient wounds. As a prelude to the self-ridicule and sexual mortification that will appear in *Judgment of Paris,* Colescott's *The Three Graces: Art, Sex and Death* made the artist a peripheral though insistent punch line in this painting (fig. 109). *The Three Graces* parodied Raphael's Renaissance masterpiece of a similar name, but unlike Raphael's Apollonian figure study, Colescott depicted a trio of modern, idiosyncratic paramours—from left to right, a mixed race lover representing Death (as codified by her dagger), a white admirer embodying Art (through her sculptor's hammer and chisel), and a black sweetheart symbolizing Sex (as symbolized in the "forbidden fruit,"

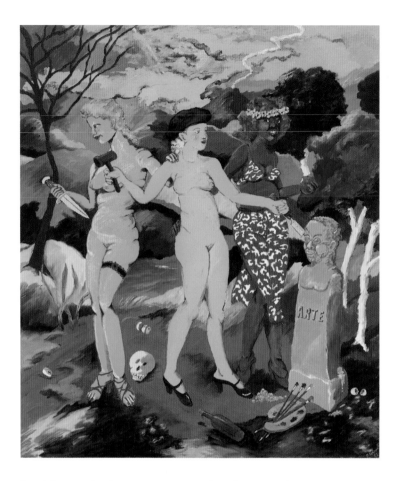

Fig. 109 / Robert Colescott, *The Three Graces: Art, Sex and Death*, 1981. Acrylic on canvas, 84 × 72 in. (213.4 × 182.9 cm). Whitney Museum of American Art, New York. Gift of Raymond J. Learsy, 91.591.

or apple, in her hand)—standing in a garbage-strewn landscape alongside a Greco-Roman herm entitled "Arte." The apotropaic statue, resembling the bearded and bespectacled Colescott, clued viewers into the self-lampooning goal of *The Three Graces* that, rather than exemplifying feminine charms and beauty, disgraced the notion of the muse and reduced the proximate, long-abandoned idol/tombstone to irrelevancy, standing in stony reticence with an artist's palette and upright paintbrushes in place of the herm's genitals. It will be another twenty years or so before an artist like, say, Beverly McIver, will have the self-confidence, along with a self-deprecating humor and diagnostic, satirical eye, to portray herself in such a farcical and emblematic way.

Among the social conundrums that Colescott continually denounced and satirized throughout his career was the curse of white supremacy and

the suppressed fact of racial and cultural heterogeneity. These issues would be a personal obsession for Colescott: an African American man from a racially mixed family, a co-partner in several interracial couplings, and the father of mixed-race children. "I come out of the wedding of races myself," Colescott shared with an interviewer on the subject of racial hybridity. "I think a huge percentage of American black people are here as a result of some kind of sexual liaison between the races at some point in history."[44] Attacking the peddlers of race purity and their bigoted supporters frequently took the form of figural parallelisms (as seen in *Listening to Amos and Andy;* see fig. 83), as well as picturing the impossibility of an unalloyed whiteness, or the improbability of Africanity without some European influences. But his lines of attack almost always took a humorous turn (an early example being the soft-shoe dance routine performed by the interracial couple as they shuffled off to bed in his 1977 painting *My Shadow*), disrupting his audience's prejudices or smugness with regard to an assumed racial quintessence by way of mockery, taunting, and playful provocation. Even Colescott's most extreme postmortems of hypocrisy in matters of interracial sex and the conspiracies of silence around those liaisons and racial passing are, for the most part, humorously framed, with sight gags, inventive wordplay, and a seductive, radar-like focus on racism's dishonesty and the futility of the racial masquerade.

As evidenced in Colescott's raucous, sexually explicit *Jemima's Pancakes* (see fig. 74) and the politically incorrect *Heavenly Host and MLK* (see fig. 98), the artist reserved pencil, charcoal, and pen and ink for some of his most outrageous artistic statements, and his takedowns of the phenomenon of racial passing seemed to be prime candidates for the drawing medium's emotional immediacy and graphic punch. Among several charcoal drawings on this topic from 1982, one, entitled *Passing*, holds a unique position within Colescott's portfolio of works commenting on the concealment of someone's African American background and/or racial identity (fig. 110). The main elements of *Passing* are a gigantic Valentine's Day heart, outlined with jagged scrawls and crowned with a prominent and grotesque rendering of the head and shoulders of a racially stereotyped black man. Lighter charcoal markings create five small hearts on either side of the black man's head and, within the central heart, a drawing of a man and woman embracing. Showing only the couple's upper torsos, the sketch sparsely incorporates light charcoal smudging over the man's head and neck and on the woman's cheek.

The large scale of the central heart in *Passing*—and of the drawing itself—insinuated something preposterous: an overblown Valentine's Day

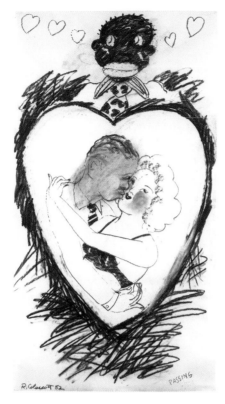

Fig. 110 / Robert Colescott, *Passing*, 1982.
Charcoal on paper, 60 × 33 in. (152.4 × 83.8 cm).
Rubell Family Collection, Miami.

memento that, instead of expressing love and sentimentality, communicated an aberration. If the subtle shading on the man holding the woman in his arms did not sufficiently indicate his undisclosed African American background, then the stereotypic black man emerging from behind the exaggerated Valentine, in the guise of a secret-divulging specter, performed that task. Colescott leaves the question unanswered as to exactly *who* the victim *is* of this male lover "passing" for white: the supposedly deceived white female lover, the outed black man himself, or we, the viewers, Colescott's enlisted adjudicators of this social offense? Compounding this deception with an ugly, racist nightmare-of-a-figure and coconspirator, *Passing* aimed its satire in multiple directions, at the deceivers, the self-deluders, and toward a racist system (embodied in the stereotypic figure) that encouraged concealed identities and, as described in James Weldon Johnson's classic novel about passing, *The Autobiography of an Ex-Colored Man* (1912), the forfeiture and sale of a "birthright for a mess of pottage."[45]

The sting felt when considering Colescott's *Passing*—less good-humored and mirthful than censorious and bitterly comical—marked a shift

in Colescott's satires, especially those examining fantastical reasoning, duplicitous behavior, and misunderstandings in racial matters. Part of a disparate band of adventurous and rebellious mid-1980s African American artists that included Jean-Michel Basquiat, David Hammons, Lorraine O'Grady, and Carrie Mae Weems, among others (whose artistic daring and racial confidence, in the words of cultural critic Greg Tate, "has freed up more black artists to do work as wonderfully absurdist as black life itself"), Colescott tackled the subject of race in ways that, rather than subscribing to comfortable, nonthreatening summaries of racial solidarity and historical rectification, introduced more troubling notions about the disavowals and conundrums of race, specifically the questions of blackness in a moment of increased cultural plurality and identificatory uncertainty.[46] Colescott's self-acknowledged family background—of Creole ancestry—and the complications of racial intermixing he experienced in his personal life undoubtedly shaped his work and, like other self-identified, mixed-race African American artists (such as the cartoonist Ollie Harrington, conceptual artist Adrian Piper, and comedian/filmmaker Jordan Peele), the step toward a satirical and ironical stance in artistic matters pertaining to race was a natural one.

In the mid-1980s (around the time Colescott left the Bay Area and commenced the balance of his teaching years at the University of Tucson), the artist embarked on a series of paintings that disputed society's prevailing historical accounts and mythologies by reinserting history's invisible black actors and catalysts within ironic montages: figural congregations and juxtapositions that bore witness to society's racial, sexual, and class divisions. This body of work, which Colescott collectively entitled *Knowledge of the Past Is the Key to the Future,* imparted an unsettling, truculent tenor, as if each painting goaded viewers, by way of visual quips and compilations of unusual pictorial elements, into a sardonic yet earnest recounting of their respective "stories."

A rather peculiar example from the *Knowledge of the Past Is the Key to the Future* paintings, subtitled *St. Sebastian,* made interracial liaisons the centerpiece of Colescott's sarcasm (fig. 111). In place of the common depictions of the early Christian martyr, St. Sebastian, and his arrow-riddled body tied to a pillar, Colescott inserted a hybrid half-black man, half-white woman in place of the saint, the columnar site of execution solitarily standing in a mysterious and desolate, skull-strewn landscape. Floating on either side of the column are the partial effigies of a white man and a black woman, cast here as palimpsests, and tethered with ropes similar to lynchers' nooses. Apart from Colescott making interracial unions a case of martyrdom, the com-

Fig. 111 / Robert Colescott, *Knowledge of the Past Is the Key to the Future (St. Sebastian)*, 1986.
Acrylic on canvas, 84 × 72 in. (213.4 × 182.9 cm). Private collection.

bined yet split black/white, male/female body invoked a sideshow or carnival freak, which was how many interracial couples typically felt when openly gawked at and belittled in public settings. A huge leap from the self-effacing humor of Colescott's *Judgment of Paris* (see fig. 94), *Knowledge of the Past Is the Key to the Future (St. Sebastian)* was neither comical nor contrite but, rather, bitterly ironic and condemnatory of the cultural prejudices that made interracial relationships indiscreet and, as melodramatically and allegorically conceived here, candidates for capital punishment.

In subsequent years Colescott would return again and again to the problematics of race, but increasingly taking aim at a world where racial intermingling, as in the *St. Sebastian* painting, invited a sarcasm-filled, mortal fate. This less-than-ideal world that, by virtue of its dystopian air, summoned a satirical retort expressing outrage or pessimism was clearly operative in

Fig. 112 / Robert Colescott, *Death of a Mulatto Woman*, 1991. Acrylic on canvas, 84 × 72 in. (213.4 × 182.9 cm). Private collection.

Colescott's *Death of a Mulatto Woman* (fig. 112). In this and other paintings from the late 1980s through the early 1990s, Colescott largely abandoned the conventional, foreground/middle-ground/background format, instead situating his satires on two-dimensional planes of densely packed, interlocking elements whose collective effect appeared more hallucinatory and abstract than logical and real. In *Death of a Mulatto Woman* the assorted parts—the outlines of faces in black and white, the color-coded maps of Africa and Europe, and the contorted and gesturing bodies of multi-complexioned men and women—all evoked a moving if disjointed requiem in which the painting's nominal, deceased character, painted with a mottled or scumbled technique and possessing both Caucasian and sub-Sahara African skin coloring, spanned the picture plane between funereal curtains and the aforementioned components of her purported "passing" (pun intended).[47]

Humanity's penchant for self-delusion, especially in racial matters, was a favorite topic of Colescott's well into the 1990s, as seen in *Lightening Lipstick,* another ironic montage featuring distorted bodies, words and phrases, and seemingly unrelated vignettes (fig. 113). The most bewildering and whimsical of these visual passages in *Lightening Lipstick*—a racial "wheel of fortune" in which disembodied heads numbered one through six incrementally morph from a dark-skinned African to a red-headed, freckle-faced Caucasian— bridged the painting's two worlds: on the left, enslaved Africans and sexual liaisons between a black woman and a white plantation overseer and, on the right, a white woman applying lipstick before the mirror. With these cartoon-like depictions of enslavement, misperception, and the epidermal- ization of self-worth, Colescott mocked the symptomatic blindness and his- torical erasures with which many *so-called* white people are afflicted, encap- sulated in *Lightening Lipstick*'s centralized black Atlantic map, and in the transfixed, makeup-daubing woman's lateral glance toward her Dorian Gray– like "Negrita" mirror image.

Fig. 113 / Robert Colescott, *Lightening Lipstick,* 1994. Acrylic on canvas, 90 × 114 in. (228.6 × 289.6 cm). Eske- nazi Museum of Art, Indiana University, Bloomington. Museum purchase with funds from Lawrence and Lucienne Glaubinger, the Arlene Schnitzer Trust, the Elisabeth P. Myers Art Acquisition Fund, and the Joseph Granville and Anna Bernice Wells Memorial Fund, 2005.2.

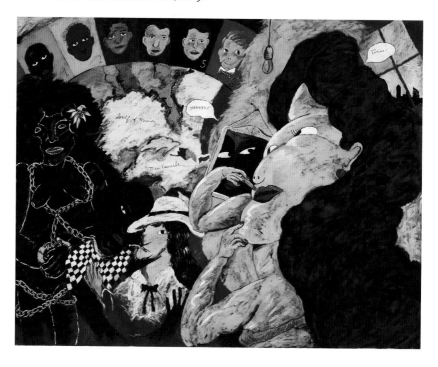

"I mix race," pronounced Colescott in a conversation with art critic and author Robert Becker for Andy Warhol's *Interview* magazine, syntactically sliding between "mix" as a verb and "mix race" as self-description. "I talk [in paintings] about the sociology of race and sex. These are things that have been part of our existence," he continued, by coincidence as a prelude of sorts to *Lightening Lipstick*. "You can't talk about race without talking about sex in America."[48] Shifting between racial identity as a random outcome of historical and biological determinants and as something superficially alterable with the assistance of cosmetics, *Lightening Lipstick* sent out a comical but scorn-filled message about racism and its historical positioning within the slave/master dynamics of New World colonialism and its attendant psychosexual tyranny. *Lightening Lipstick*'s dual emphasis on sexual violence against enslaved black women and, on the composition's right, the self-identified "Latina" applying makeup before a mirror, essentially swung Colescott's satirical rave in both directions, and toward questions about race and identity with which women have especially grappled. But even within *Lightening Lipstick*'s female-centered satire, Colescott's map of the global South and his racial "wheel of fortune" added an autobiographical element as well, putting the brown-skinned, straight-haired artist into the equation—phenotypically somewhere between positions three and four on the wheel—and, therefore, implicating a whole host of fellow creoles (and some undisclosed, racially mixed relations such as his brother, Warrington).

THE MEANINGS OF HISTORY

This contempt for pictorial "law and order" would be further expanded upon with Colescott's ongoing *Knowledge of the Past Is the Key to the Future* series, enabling him to critically and creatively interpret his historical subject matter, whether the topic was the suppressed memoirs and the "social death" sentences of interracial lovers (*St. Sebastian;* see fig. 111), the questionable history of America's founding and the attendant, messy consequences of it (*Some Afterthoughts on Discovery,* fig. 114), or the irony of black America's most prevalent surname originating from America's first president and slave-holder-in-chief (*The Other Washingtons,* fig. 115). The motivation for this series, Colescott told an interviewer in 1988, "was to think about the meaning of history rather than events." He continued, "One meaning is that the lessons of history are left unlearned."[49] Over the course of the three years (1985–87) during which the *Knowledge of the Past Is the Key to the Future* series was created, the paintings underwent an evolution, from vertically oriented clusters of figures placed within psychological and sexual contexts (as seen

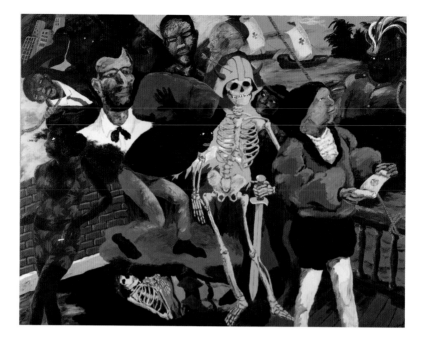

Fig. 114 / Robert Colescott, *Knowledge of the Past Is the Key to the Future (Some Afterthoughts on Discovery)*, 1986. Acrylic on canvas, 90 × 114 in. (228.6 × 289.6 cm). Metropolitan Museum of Art, New York. Arthur Hoppock Hearn Fund, 1987. 1987.166.

in *St. Sebastian*), to horizontally oriented multi-episodic paintings of an expressly cultural and political tenor (as seen in *Some Afterthoughts on Discovery* and *The Other Washingtons*). "He began to experiment more with radical exaggerations in scale and discontinuities in space," observed art historian and curator Miriam Roberts about this particular body of work. "Freed from the confines of specific contexts, his vocabulary of symbolic imagery and associations became richer and more layered."[50]

The later paintings from this series, such as *Some Afterthoughts on Discovery,* presented the historical vignettes like the bracts of an artichoke, each story revealing an incisive message while simultaneously abutting and overlapping with the adjacent ones, with the conjoinments creating their own sidebar annotations and insights. Miriam Roberts—who commissioned and curated an exhibition of Colescott's paintings for the 47th Venice Biennale, making him the first African American artist to represent the United States at this prestigious international art exposition—described these vignettes in the *Knowledge of the Past Is the Key to the Future* paintings somewhat differently, with "each competing element [within the paintings] existing in its own cubist, isolated space, where variations on a theme are acted out by characters, as if in scenes from a movie, conflating time and space and shifting

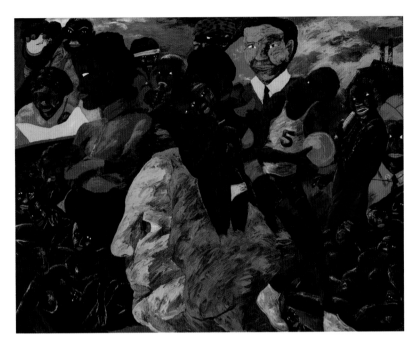

Fig. 115 / Robert Colescott, *Knowledge of the Past Is the Key to the Future* (*The Other Washingtons*), 1987. Acrylic on canvas, 90 × 114 in. (228.6 × 289.6 cm). Sheldon Museum of Art, University of Nebraska–Lincoln. Olga N. Sheldon Acquisition Trust, U-6463.2015.

foreground and background." Roberts continued, "Most important, [Colescott] refined his ability to create works that simultaneously comment on contemporary society and carry on a complex dialogue with the modernist painting tradition."[51]

One can deduce in *Some Afterthoughts on Discovery* that (from left to right) the sixteenth U.S. president, Abraham Lincoln, the fifteenth-century Italian explorer Christopher Columbus, and the early twentieth-century, Jamaican-born black nationalist Marcus Garvey are the real-life individuals who created a conceptual mortar in this particular painting and its main message. The other figures throughout the composition—corporeal, skeletal, and of assorted ethnicities, historical periods, and socioeconomic stations— supplied additional data that comprised a compelling, if disparate, collection of sightings, both historical and metaphorical. Taking in the entirety of Colescott's cast of characters in *Some Afterthoughts on Discovery*, his account is a tale of sacrifice, exploitation, and myopia, all products of the myth that *was* America and, as seen in the shirtless and shoeless, burden-laden black man in the middle, addressing what literary critic Henry Louis Gates, Jr., has described as "the 'shadowy figures' of American history" or, rather, "our unnamed and unknown ancestors."[52] The history lessons Colescott presented

in *Some Afterthoughts on Discovery*—from the fatal encounters between the conquistadors and the indigenous peoples in the "age of discovery," to the exhuming of Emmett Till's lynched body in 1955 and its horrific display—not only provided hard truths about the American experience but, as Colescott pointedly reminds us, supplied viewers with "afterthoughts": reflections on hubris, gullibility, brutality, and the guilty pleasures of spectatorship. The false promise of freedom, like the Old World's futile quest for New World gold, is situated at the center of this painting, and flanked on all sides by discoveries and revelations that, as history constantly reminds us, did not measure up to what the seekers envisioned would come to light.

Similarly, Colescott's *The Other Washingtons* refused to deliver an uncomplicated account of America's genealogies and their diverging lines of descent. Although somewhat incoherent in its jumble of figures, the painting's subtitle and the large, centrally located profile of the first U.S. president, George Washington, compelled viewers to "make sense" of this rumination on history and inheritance, collaged and compressed into a dense racial puzzle. Anchored on both sides by masses of indistinct, naked black bodies (America's enslaved progenitors), and populated by individuals who were either distinguishable, anonymous, exemplary, or contemptible, Colescott's figures pointed to the importance of peoples of African descent to this consequential (if buried) narrative, along with bolstering the painting's satirical purpose. Unable (or loath) to remove the throngs of black people from his dowager-styled blue hair and immediate surroundings, President Washington appears resigned to accept his black relatives and future progeny (such as Chicago Mayor Harold Washington, Tuskegee Institute's famed president Booker T. Washington, basketball great Dwayne Alonzo "Pearl" Washington, and popular 1950s jazz singer Dinah Washington, among other namesakes). Beyond these household names, Colescott's other black Washingtons, from a pen-wielding scholar and uniformed veteran to scantily clad prostitutes and masked felons, are revelatory, reminding viewers of the series' titular admonition that having some historical sentience introduces a predictive and precautionary aperture onto one's destiny.

The equivocal and historically circumspect tenor of the *Knowledge of the Past Is the Key to the Future* series launched Colescott on a dialectical path in subsequent work, in which each painting's principal actors faced ethical quandaries within their respective narratives, dilemmas made more difficult on account of the exigencies of race, gender, sexuality, or class. These existential questions and the hard choices they required of Colescott's protagonists were clearly what activated the black women in his painting

Pygmalion and its episodes of feminine attraction, self-perception, and beau-
tification (see fig. 9). Mischievously making the white-haired and bearded
George Bernard Shaw—the author of the play *Pygmalion* (1912)—a partner
to one of the women in this painting, Colescott seemed to be satirically
asking, "What if Eliza Doolittle, Shaw's white, British, and lower-class main
character (who endures an arduous process of becoming a refined and ele-
gant lady) were black?" Colescott in essence further queried, "And what if,
instead of the play's treatment of Doolittle comically laboring through les-
sons in proper enunciation and genteel manners, the black women in this
version of *Pygmalion* were only left with white women as their indices for
achieving the feminine ideal?" These implied propositions became the per-
fect vehicles for Colescott's ironic montages, with his miscellaneous scenes
bracketed by dreamy apparitions, such as a racially indeterminate Venus de
Milo, a black Mona Lisa, and instances of black male appraisals and inter-
racial body mirroring.

 Literary theorist Darryl Dickson-Carr's observation that black satirists,
because of their unique perspectives as both objects and agents of satire,
are ideally situated to attack perceived injustices and individual shortcomings
by a range of institutions and perpetrators is applicable to Colescott and
his equal-opportunity policy of hurling visual projectiles in multiple direc-
tions. Dickson-Carr's argument that "blacks stand shoulder-to-shoulder with
the rest of humanity in being venal, greedy, selfish and self-sabotaging"
could certainly be the label for Colescott's *Pac-Man* (*The Consumer Consumed*),
which portrays African Americans as the main offenders of a moral prohibi-
tion against greed and, as a result, themselves the objects of ridicule (fig. 116).[53]
From succumbing to the enticements of the 1980s popular video game
Pac-Man (shown in the painting's upper right), to suffering from the ill-ad-
vised purchase of what is seen in the painting's upper-left corner as an auto-
motive "lemon" in flames, African Americans are neither spared nor given
a soft indictment by Colescott but, instead, upbraided for their dumb faith in
materialism and, as featured here, literally eaten alive by a large *Pac-Man*–
like, redheaded proxy for capitalism. The leitmotif on the painting's right
of a half-black, half-white woman eating a hamburger—in close proximity
to a bag of spilled potato chips on the bed alongside a woman playing *Pac-*
Man—repeated the metaphor of gluttony: a symbolic rendering of hedonic
or junk consumption, one of the socioeconomic symptoms of the 1980s.

 The recipients of Colescott's contempt (as seen, for example, in his
personification of capitalism in *Pac-Man* [*The Consumer Consumed*]) encom-
passed a wide swath of humanity with social and moral afflictions. Clustering

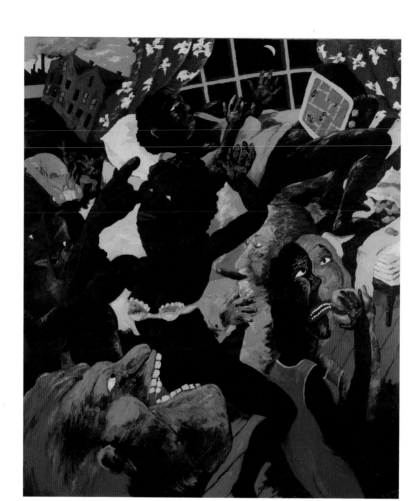

Fig. 116 / Robert Colescott, *Pac-Man (The Consumer Consumed)*, 1989. Acrylic on canvas, 84 × 72 in. (213.4 × 182.9 cm). Private collection.

these reprobates and pathologies together in the painting *Emergency Room,* Colescott unleashed unmatched scorn toward incompetent health care, insensitive social services, a beast-producing penal system, pollution-spewing industries, and unchecked criminality (fig. 117). Imagining contemporary American society in dire, life-and-death circumstances, akin to a hospital's chaotic emergency room, Colescott described the painting in the following terms: "Action is not taken until things get drastic. Everything is dealt with in expediency. The U.S. is the Emergency Room. The patient is already dead when the doctor is called."[54] Uncharacteristically bleak, if also displaying Colescott's special brand of pictorial sarcasm, *Emergency Room* rotates around a centralized television monitor flagrantly showing intimate lovers in tawdry colors, not so much a respite from the surrounding death and

violence as indicative of mass media's emotional disconnect from harsher realities. Among *Emergency Room*'s numerous oddities is the decapitated head of a black man in the painting's lower-right quadrant, nestled in the hands of a white, clerical collar–wearing minister, and applauded by six pairs of bloodied white hands, severed from their limbs. These overtures to sadistic executions and barbaric dismemberments, paired with inner-city murders and scenes of medical malpractice, formed an elegiac meditation on late twentieth-century social malfunction in America not unlike the dark mood of jazz artist Nina Simone's heart-wrenching, similarly titled 1972 album, *Emergency Ward*.[55] Paintings throughout the early 1990s such as *Death of a Mulatto Woman* (see fig. 112), *Lightening Lipstick* (see fig. 113), and *The Triumph of Christianity* (fig. 118) share with Colescott's *Emergency Room* its gloomy outlook, but somewhat relieved by his fanciful perspectives and colorful collectanea of humanity and scenery.

In *The Triumph of Christianity*, Colescott returned to the history lessons in the *Knowledge of the Past Is the Key to the Future* series, but now situated them in compositions that, like in his other early 1990s paintings, incorporated precisely structured visual parallels, spatially informed comparisons, and shifting focal points, all affected by Colescott's unforgiving assessments and profane point of view. Such compositional and attitudinal

Fig. 117 / Robert Colescott, *Emergency Room*, 1989. Synthetic polymer paint on canvas, 90 × 114 in. (228.6 × 289.6 cm). Museum of Modern Art, New York. Jerry I. Speyer and the Millstream Funds, 70.1991.

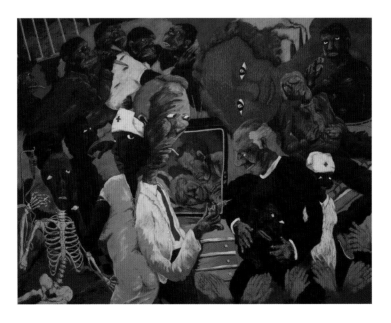

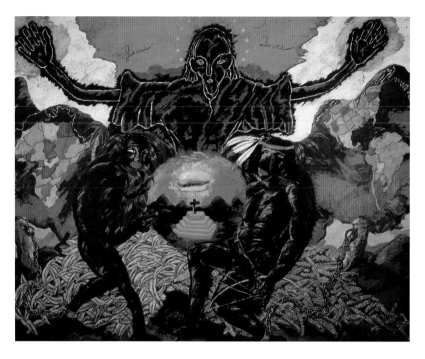

Fig. 118 / Robert Colescott, *The Triumph of Christianity*, 1993. Acrylic on canvas, 90 × 114 in. (228.6 × 289.6 cm). Private collection.

game plans supported the reading of these complicated canvases by creating left/right and up/down pictorial equations in which the satire's intended targets or subjects of inquiry could be more easily identified and gauged with their proximate counter-narratives. The ironic title *Triumph of Christianity* signaled that organized religion was the scapegoat, allowing Colescott to stage a burlesque of deflated religious symbols and coerced followers, with a mapped landscape populated by shackled Africans and Native Americans and covered with piles of confiscated agricultural products. "The exhilarating days of converting peoples of color . . . concealed a murderer's embrace," Colescott rancorously captioned this painting.[56] Jesus's gaunt, ghostly figure and his "come unto me" gesture above a cinematographer's iris shot of a floating and resplendent hamburger were the ultimate blows, framing the Christian missionary's project in ludicrous, disdainful terms, not unlike literary or cinematic satires of a similar ilk. For example, *The Triumph of Christianity* recalls the sacrilegious, contravening commentaries on the church (and its all-too-frequent indulgences) by the mid-twentieth-century Spanish filmmaker Luis Buñuel, especially in Buñuel's metaphorical and ironic characterizations of food and its connotations of charity and spiritual sustenance. Like the slab of meat dangled before a starving child in Buñuel's

Los Olividados, or the impractical pineapple offered to the disillusioned priest at the end of Buñuel's *Nazarin,* Colescott's agricultural products and the hamburger in *The Triumph of Christianity* augured enslavement and deprivation for the converted rather than spiritual and material provisions.[57] Written on either side of Christ's cadaverous head in Colescott's painting was "Jesus Saves," a motto frequently seen on church letter boards across America and satirically employed here, eviscerated of its fast promise of spiritual deliverance.

BICENTENNIAL TRICKSTERS

Textual redefinitions and iconographic reversals were tactics that Colescott would increasingly deploy in the 1990s and beyond, especially when making paintings that were more abstract and less explicit in meaning. Mindful that pure abstraction wasn't a discursive mode that supported narrative strains in art, a relatively late work such as *Education* included intermittent, recognizable imagery—human figures, plumbing, playing cards, clothing, food, and pots of paints—and words—"SKIRT," "SEX," and "RACE"—that, although buried within and alongside painterly actions and impasto textures, rose from the painting's substrata to elucidate its cryptic, one-word title (fig. 119).

Returning to the idea of a literary pícaro whose narrativized journey in the text—step by step, episode by episode—initiated and educated the interloper in the messy truths and unjust systems of the world, Colescott's *Education* walked viewers through his own self-fashioned landscape and epiphanic sojourn that, thanks to the curricular subheadings here of "RACE," "SEX," and "SKIRT" (the latter, his cognomen for female identificatory accouterments), provided him with the tools to best navigate life's *and* art's treacher-

Fig. 119 / Robert Colescott, *Education*, 1997. Acrylic on paper, 42 × 129 in. (106.7 × 327.7 cm). Private collection.

ous waters. In the painting's far-left lower corner—in relative proximity to the word "SKIRT" and what appears to be a strap from a piece of clothing—is, again, the checkerboard motif. Were it not for the recurrences of this design element throughout Colescott's oeuvre, from his earliest spoofs with Aunt Jemima and Colonel Sanders and onward, one might ignore this motif, or dismiss it as simply a visual accent, sans signification. But the checkerboard's frequency and its strategic placement in Colescott's depicted kitchens, on his black bodies, and as contiguous to his painting's localized racial discourses advocate for ascribing a deeper meaning. Rather than an innocuous design element whose presence means nothing, the checkerboard's constitutive oppositionality conceptually alludes to the world of irony and satire, where one thing refers to something else, humor coexists with trenchant criticism, and an African American artist's education involves an abundance of contradictory messages and, like the checkerboard's allusions to chess, life's unpredictable game of personal prowess and luck.

The timing of Colescott's critical ascent—the late 1970s through the 1980s, when the subversive works of selected contemporary African American artists were increasingly shown in galleries and cultural venues, and were considered vital antidotes to a mostly white, exclusive, and intellectually limited art scene—was fortuitous. It was also a moment when mainstream American society—politically influenced by Ronald Reagan's presidency and his market-driven, conservative agenda—was the perfect foil for social parodies and other forms of imaginative criticism.

It was also the artistic halcyon days of the African American comedian Richard Pryor who, like Colescott, gravitated toward controversial racial and sexual subject matter, based many of his stand-up routines on social ironies, and, unflinchingly, turned his aptitude for mockery and ridicule onto himself. Discovering that, like Pryor's deft delivery of a satirical "one-two punch," the satirist had to shoulder a degree of humility and solipsism, Colescott followed a similar path, psychologically positioning himself within his work so that its disquisitions might ring loud and clear through the lens and amplifiers of a predisposed, attentive artist/eyewitness. "There are some people who disagree with my satire, my ironic sense of humor," Colescott told a reporter after his works generated some concerns among people in a display at the Akron Art Museum, "and it's the same feeling I have when I watch or listen to Richard Pryor. . . . I am offended by his language, but I like what he has to say."[58]

"Pryor stands up and says outrageous things that not just allow . . . , but force people to think about areas in their lives and in the life of the soci-

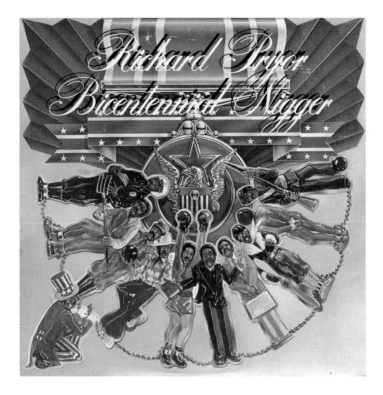

Fig. 120 / Album cover, Richard Pryor, *Bicentennial Nigger* (Warner Bros. Records, 1976).

ety that they don't dare think about *too* hard," Colescott told an interviewer. "The reason they can stand and face it," he concluded, "is because of the humorous element."[59] Reflecting on the title piece from Pryor's album *Bicentennial Nigger* (fig. 120), Colescott said, "[It] was brilliant and reaffirmed what I felt about the dilemmas of rhetoric."[60] Listening to Pryor's short, stinging "Bicentennial Nigger" monologue, in which a two-hundred-year-old slave obsequiously and sardonically recounts his degradations and those of his fellow African Americans, one can perhaps extrapolate something from Colescott's observations on Pryor's deft oratory and its linguistic maneuvers above the perilous abyss of incomprehensibility and misrepresentation.[61] One is also reminded of a circa 1982 treatise by Colescott about his painting *George Washington Carver Crossing the Delaware: Page from an American History Textbook* (see fig. 14): "If George Washington crossing the Delaware is Carver, should I cry for the solitary hero and history because it allowed [not] only one or maybe two heroes, but a multitude of buffoons (me included?). Or, on the other hand, how about all the hat-changing, no-boat-rocking softshoe, no-wave making ball-jiggling routines 'everybody's man' might be doing to 'everybody's man'? Now that's entertainment."[62]

It is perhaps not coincidental that the American Bicentennial com-
memoration was the focus of two of Colescott's most censorious artistic
statements, *George Washington Carver . . .* and *Homage to Delacroix: Liberty
Leading the People* (see fig. 100), and it was the momentous event that also
animated Pryor to develop a collection of stinging comedy routines, mostly
on the subjects of race, sex, and politics. Both Pryor and Colescott, in their
respective work, took up the personas of others and created brilliant, self-
distilled portraits and genre scenes of human failures and social disasters
that were at once laughable and poignant. This shared focus on America's
moment of heady self-congratulation, and for many citizens, somber cere-
bration, attested to a philosophical alignment and a preoccupation with
modes of critical discourse shared by these two black artists. In 1985 Cole-
scott provocatively asked an interviewer, "What if the American Revolution
had flopped?" He ruminated, "What if we had lost? What would the world
have been like?," rhetorically moving along a speculative trajectory similar to
Pryor's introspective and sardonic ex-slave.[63]

Although light-years removed from Pryor's drug-aggravated, illness-
plagued, suicidal life, Colescott shared some of the comedian's familial tur-
bulence and interpersonal rascality, with five marriages (four ending in
divorce), a black man's biting viewpoint on structural racism, and a voiced
defiance of society's false rules: all personal circumstance that, along with
the questionable ways he was racially perceived in his lifetime, place him on
a pathway to skepticism and sarcasm. "Promises, promises," Colescott
began his published comments about one of his paintings, entitled *Heart-
break Hotel* (*Reservations*) (1990). He continued: "Society (the Heartbreak
Hotel) has made commitments to us all. The Indian tribes found out the
hard way that the government had its fingers crossed. I'm still waiting for
that forty acres and a mule, or some truth from an errant lover."[64] Ouch!
Like Pryor's sardonic jabs at an unjust and irrational world in his "Bicenten-
nial Nigger" routine, Colescott unapologetically embraced his outsider/
picaresque hero status in this statement about American society, in quick
succession invoking the betrayals of Native Americans and emancipated
slaves by the U.S. government and, on a surprising personal note, the false-
hoods and/or infidelities he experienced through the actions of a wayward
paramour. These remarks about corruption on the societal and personal
levels, while in the final analysis impossible for Colescott to change or rec-
tify, were nevertheless occurrences that he was artistically determined to
expose. In a career that lasted for almost half a century, Colescott with time
realized that, through the expressed methods of a visual satire—as inflected

through a commonsensical and witty African American lens—he could do battle with injustice and insanity: if not necessarily fighting for a better future then, at least, envisioning a phantasmagoric "here and now" that, in each carefully conceived and executed work of art, offered audiences a case study of ironical commentary and iconoclastic judgment.

Sarcastically lashing out at the latent damages perpetrated by a neo-liberal society and by American racism, credulity, hypocrisy, and insensibility to the false promises of democracy, Colescott nevertheless managed to make viewers reflect on these instances of avarice, naiveté, and their own guilt-ridden delight while visually partaking of these proceedings. Colescott compelled his audiences to consider whether there was a fundamental distinction between a satire and its commitment to a seriously humorous critique, and the vulgar pleasures of watching the failings of humanity, especially as pertaining to and enacted by African Americans. Hence, his "one-two punch" from—and his potent offering to—the black cultural diaspora.

But rather than a black satire that only strikes out at the illogical nature of chattel slavery, institutional racism, the mistaken advocates of racial purity, and other historic social injustices from outside forces and enemies, Colescott's taunt was issued from inside an African American context, and at the social and cultural corruption from both within and outside the beloved community. Like Archibald Motley's vernacular outrages, Ollie Harrington's syndicated travesties, Melvin Van Peebles's cinematic inversions of stereotypes, and Kara Walker's silhouetted, reductio ad absurdum parodies, Colescott's visual satires offer no correctives—only the triumph of vice and recklessness, and a topsy-turvy world of complete madness and exploitation.

And, yet, Colescott is much more than a nihilist or a court jester. Even acknowledging his work's constitutive ambiguity and comprehensive targeting of white scoundrels and black fools, Colescott used satire to initiate discussions of social issues, and to draw attention to forms of social malfunction in America that might not have been recognized as such, but indeed existed, drawing attention as well as to the institutional and phenomenological conditions that fueled the breakdown of communities and the dislocations of black culture in the late twentieth and early twenty-first centuries. This is the unenviable but necessary job of black satire, whose visual modes of exposing the failings of individuals, organizations, and societies rely on a considerable retinue of tools and strategies, and whose cautious standing within black communities, cognizance of suppressed histories, and deep-rooted cultural fluencies and competencies enormously assisted the black visual satirist in the defiant, but necessary, act of "going *there*."

NOTES

CHAPTER 1. "MORE THAN A ONE-LINER"

Epigraph 1: Office of the First Lady, "Remarks by the First Lady at Tuskegee University Commencement Address," White House, May 9, 2015, https://www. whitehouse.gov (accessed June 21, 2015).

Epigraph 2: Oral history interview with Robert Colescott by Paul Karlstrom, April 14, 1999, Archives of American Art, Smithsonian Institution, http://www.aaa.si.edu (accessed June 21, 2015).

1. Michael Kimmelman, "A Black Painting Blacks with an Enigmatic Hand," *New York Times*, April 17, 1992.

2. I discuss *Lawd, Mah Man's Leavin'* in Richard J. Powell, ed., *Archibald Motley: Jazz Age Modernist* (Durham, NC: Nasher Museum of Art at Duke University, 2014), 128, 133.

3. A national meditation on black America, circa 1940, was documented in *75 Years of Freedom: Commemoration of the 75th Anniversary of the Proclamation of the 13th Amendment to the Constitution of the United States* (Washington, DC: Library of Congress, 1940). Also see Archibald J. Motley, "The Negro in Art," n.d., Archibald J. Motley, Jr., Papers, Chicago History Museum.

4. Some of those anxieties are discussed in Andrew E. Kersten, "African Americans and World War II," *OAH Magazine of History* 16 (Spring 2002): 13–17. Also see "Editorials: Out in the Cold," *Crisis* 47 (July 1940): 209.

5. A concise but carefully crafted definition can be found in "Satire," in *A New Handbook of Literary Terms,* ed. David Mikics (New Haven: Yale University Press, 2007), 270–72.

6. For an excellent collection of essays comparing historical and contemporary examples of political cartoons, see Neil McWilliam, ed., *Lines of Attack: Conflicts in Caricature* (Durham, NC: Nasher Museum of Art at Duke University, 2010).

7. Richard Fazzini, *Images for Eternity: Egyptian Art from Berkeley and Brooklyn* (San Francisco: Fine Arts Museums of San Francisco, 1975), 95; and Stephanie Franke, "Narren und Zwerge," in *Hieronymous Boschs Erbe*, ed. Tobias Pfeifer-Helke (Dresden: Staatliche Kunstsammlungen Dresden, 2015), 174–89.

8. Richard Biedrzynski, *Das brennende Gewissen: Maler im Aufstand gegen ihre Zeit; William Hogarth, Francisco de Goya, Honoré Daumier [und] Käthe Kollwitz* (Braunschweig: G. Westermann, 1949); and Michele Hannoosh, *Baudelaire and Caricature: From the Comic to an Art of Modernity* (University Park: Pennsylvania State University Press, 1992).

9. Matthew Israel, *Kill for Peace: American Artists against the Vietnam War* (Austin: University of Texas Press, 2013); and Jonathan David Fineberg, *A Troublesome Subject: The Art of Robert Arneson* (Berkeley: University of California Press, 2013).

10. Steven Cowan, "The Growth of Public Literacy in Eighteenth-Century England" (PhD diss., Institute of Education, University of London, 2012), 17–18. For the parallels between textual and visual literacies during this same period, see Matthew Daniel Eddy, "The Shape of Knowledge: Children and the Visual Culture of Literacy and Numeracy," *Science in Context* 26, no. 2 (2013): 215–45.

11. Ralph E. Shikes, *The Indignant Eye: The Artist as Social Critic in Prints and Drawings from the Fifteenth Century to Picasso* (Boston: Beacon, 1969); and Constance C. McPhee and Nadine M. Orenstein, *Infinite Jest: Caricature and Satire from Leonardo to Levine* (New York: Metropolitan Museum of Art, 2011).

12. Donald W. McCaffrey, *Assault on Society: Satirical Literature to Film* (Metuchen, NJ: Scarecrow, 1992).

13. Gerald A. Powell, *A Rhetoric of Symbolic Identity: An Analysis of Spike Lee's X and Bamboozled* (Dallas: University Press of America, 2004).

14. Ronald Paulson, "Pictorial Satire: From Emblem to Expression," in *A Companion to Satire*, ed. Ruben Quintero (Malden, MA: Blackwell, 2007), 293–324. Also see E. H. Gombrich, "The Cartoonist's Armoury," in *Meditations on a Hobby Horse and Other*

Essays on the Theory of Art (London: Phaidon, 1963), 127–42.

15. W. J. T. Mitchell, "Offending Images," in *What Do Pictures Want?: The Lives and Loves of Images* (Chicago: University of Chicago Press, 2005), 140.

16. I discussed Archibald Motley and the blues in Richard J. Powell, *The Blues Aesthetic: Black Culture and Modernism* (Washington, DC: Washington Project for the Arts, 1989), 25–27.

17. Elizabeth C. Childs, ed., *Suspended License: Censorship and the Visual Arts* (Seattle: University of Washington Press, 1997).

18. Mikkel Simonsen, "Drawn Too Extreme: An Examination of the Satire and the Representations of the Other in the Works of Kurt Westergaard and Zapiro" (master's thesis, University of Stellenbosch, December 2016), 7. For time capsule–like reactions to the 2015 attacks on the Parisian offices of the satirical magazine *Charlie Hebdo* and a Jewish supermarket, see Edward M. Iacobucci and Stephen J. Toope, eds., *After the Paris Attacks: Responses in Canada, Europe, and around the Globe* (Toronto: University of Toronto Press, 2015).

19. *30 Americans: Rubell Family Collection* (Miami: Rubell Family Collection, 2008).

20. Barry Blitt, Cover illustration (of the Obamas), *New Yorker,* July 21, 2008; and Tom Toles, "But One's Ironic" (editorial cartoon), *Washington Post,* July 16, 2008.

21. Thomas Nast, "Colored Rule in a Reconstructed (?) State (The Members Call Each Other Thieves, Liars, Rascals, and Cowards)," *Harper's Weekly,* March 14, 1874; and T. W. (Thomas Worth), "Tu Quoque!," *Daily Graphic,* March 11, 1874.

22. Oral history interview with Robert Colescott by Paul Karlstrom.

23. Jody B. Cutler, "Art Revolution: Politics and Pop in the Robert Colescott Painting *George Washington Carver Crossing the Delaware,*" *Americana: The Journal of American Popular Culture, 1900 to Present* 8 (October 2009).

24. Fiona Deans Halloran, *Thomas Nast: The Father of Modern Political Cartoons* (Chapel Hill: University of North Carolina Press, 2012).

25. Thomas Worth is perhaps best known for his work for the famed nineteenth-century printing firm Currier and Ives, where he was notorious for his racist depictions of African Americans. For Worth's own words as a caricaturist, see Harry T. Peters, *Currier and Ives, Printmakers to the American People,* vol. 1 (1929; repr., New York: Arno, 1976), 80, 82. Worth is also discussed in Tom Culbertson, "Illustrated Essay: The Golden Age of American Political Cartoons," *Journal of the Gilded Age and Progressive Era* 7 (July 2008): 276–95.

26. "Stereotype," in *The Barnhart Dictionary of Etymology,* ed. Robert K. Barnhart and Sol Steinmetz (Hackensack, NJ: H. W. Wilson, 1988), 1066; "Stereotype," in *A Dictionary of Literary and Thematic Terms,* ed. Edward Quinn (New York: Facts on File, 2006), 398; and "Stereotype," in *A Dictionary of Film Studies,* ed. Annette Kuhn and Guy Westwell (Oxford: Oxford University Press, 2012), 402–3. An online definition is available at http://www.oxfordreference.com (accessed June 30, 2015).

27. "Introduction: Roman Satire," in *The Cambridge Companion to Roman Satire,* ed. Kirk Freudenburg (Cambridge: Cambridge University Press, 2005), 1–30.

28. Joel C. Relihan, *Ancient Menippean Satire* (Baltimore: Johns Hopkins University Press, 1993), 34.

29. Barbara Maria Stafford, "Grotesques, or Ars Combinatoria," in *Body Criticism: Imaging the Unseen in Enlightenment Art and Medicine* (Cambridge, MA: MIT Press, 1993), 266–72.

30. For in-depth descriptions and exegeses on Roman satires, see Paul Allen Miller, *Latin Verse Satire: An Anthology and Reader* (London: Routledge, 2005).

31. I am indebted to my colleague N. Gregson Davis, Andrew W. Mellon Research Professor of the Humanities, for his translations of Horace.

32. Horace, *Art of Poetry,* Poetry Foundation, https://www.poetryfoundation.org (accessed December 24, 2018).

33. Charles Martindale, "The Horatian and the Juvenalesque in English Letters," in Freudenburg, ed., *Cambridge Companion to Roman Satire,* 284–98.

34. Victoria Rimmel, "The Poor Man's Feast: Juvenal," in Freudenburg, ed., *Cambridge Companion to Roman Satire,* 84.

35. Bernd Renner, "From Satura to Satyre: François Rabelais and the Renaissance Appropriation of a Genre," *Renaissance Quarterly* 67, no. 2 (Summer 2014): 377–424. Also see M. M. Bakhtin, "Discourse in the Novel," in *The Dialogic Imagination: Four Essays,* ed. Michael Holquist, trans. Caryl Emerson and Michael Holquist (Austin: University of Texas Press, 1981), 353.

36. Elizabeth C. Childs, "Big Trouble: Daumier, *Gargantua,* and the Censorship of Political Cartoons," *Art Journal* 51, no. 1 (Spring 1992): 26–37.

37. Edmond and Jules de Goncourt, "Un Daumier," *Revue Indépendante* (1885): 200–202.

38. The literature on satire is vast, but two especially informative books are George A. Test, *Satire, Spirit and Art* (Tampa: University of Southern Florida Press, 1991); and Ruben Quintero, ed., *A Companion to Satire* (Malden, MA: Blackwell, 2007).

39. Recent scholarship refutes the long-standing assumption that satirical works in ancient Greece had very little to do with mythological satyrs, as argued in Andreas G. Katsouris, "Echoes, Criticism and Parody of Socio-Political Phenomena and Literary Genres of Classical and Post-Classical Athens in Satyr Drama," *Athenaeum* 98 (2010): 405–12.

40. For a fascinating discussion of the satirical targeting of racism in one of the most important works of American literature, see Richard K. Barksdale, "History, Slavery, and Thematic Irony in *Huckleberry Finn,*" in *Satire or Evasion: Black Perspectives on Huckleberry Finn,* ed. James S. Leonard, Thomas A. Tenney, and Thadious M. Davis (Durham, NC: Duke University Press, 1992), 49–55.

41. A discussion of Oscar Micheaux's literary and cinematic output and the question of his racial loyalties can be found in Joseph A. Young, *Black Novelist as White Racist: The Myth of Black Inferiority in the Novels of Oscar Micheaux* (New York: Greenwood, 1989). Also see Charles Musser, "To Redream the Dreams of White Playwrights: Reappropriation and Resistance in Oscar Micheaux's *Body and Soul,*" in *Oscar Micheaux and His Circle: African-American Filmmaking and Race Cinema of the Silent Era,* ed. Pearl Bowser, Jane Gaines, and Charles Musser (Bloomington: Indiana University Press, 2001), 97–131.

42. For Robert Downey, Sr.'s reflections on *Putney Swope,* see "PTA [Paul Thomas Anderson] and Robert Downey, Sr., Talk 'Putney Swope' in Final Criterion Video," Cigarettes and Red Vines, May 30, 2012, cigsandredvines.blogspot.com (accessed December 24, 2018).

43. James Weldon Johnson, *The Book of American Negro Poetry* (New York: Harcourt, Brace, 1922); Sterling Brown, *Outline for the Study of the Poetry of American Negroes* (New York: Harcourt, Brace, 1931); Henry Louis Gates, *The Signifying Monkey: A Theory of African American Literary Criticism* (New York: Oxford University Press, 1989); and Trudier Harris, *Fiction and Folklore: The Novels of Toni Morrison* (Knoxville: University of Tennessee, 1991).

44. Edward Epstein, "Jayson Musson," *Art Papers* 36 (March/April 2012): 52–53. Also see Antonio Brown, "Performing 'Truth': Black Speech Acts," *African American Review* 36 (2002): 213–25.

45. Kalup Linzy, in Alex Allenchey, "Meet the Artist: Kalup Linzy," Artspace, October 10, 2012, https://www.artspace.com (accessed December 20, 2018).

46. Derek Conrad Murray, "We're All Kalup's Churen," in *Queering Post-Black Art: Artists Transforming African-American Identity after Civil Rights* (London: I. B. Tauris, 2016), 146, 147, 186.

47. Kevin Young, "Say Who (The Troof)," in *The Grey Album: On the Blackness of Blackness* (Minneapolis: Graywolf, 2012), 56.

48. Jennifer Wallace, "Tragedy and Laughter," *Comparative Drama* 47, no. 2 (Summer 2013): 205.

49. The parallels between *Lysistrata* and *Chi-Raq* are discussed in depth in Casey Dué, "Get in Formation, This Is an Emergency: The Politics of Choral Song and Dance in Aristophanes' *Lysistrata* and Spike Lee's *Chi-raq*," *Arion: A Journal of Humanities and the Classics* 24, no. 1 (Summer 2016): 21–54.

50. For a musicological discussion of hokum, see Michael W. Harris, "Old Time Religion and Urban Migrants," in *The Rise of Gospel Blues: The Music of Thomas Andrew Dorsey in the Urban Church* (New York: Oxford University Press, 1994), 148–50. I discuss Motley and the hokum musical tradition in Powell, ed., *Archibald Motley*, 125–28.

51. Calvin Reid, "Kinky Black Hair and Barbecue Bones: Street Life, Social History, and David Hammons," *Arts* 65 (April 1991): 59–63.

52. Office of the First Lady, "Remarks by the First Lady at Tuskegee University Commencement Address."

53. Judith Yaross Lee, "Assaults of Laughter," *Studies in American Humor* 1 (2015): v–xiv. Also see Jytte Klausen, *The Cartoons That Shook the World* (New Haven: Yale University Press, 2009).

54. For a discussion of the satirical streaks throughout modern African American culture, see Mel Watkins, *On the Real Side: Laughing, Lying, and Signifying — The Underground Tradition of African-American Humor That Transformed American Culture, from Slavery to Richard Pryor* (New York: Simon and Schuster, 1994).

55. Norman Fairclough, "Introduction: Critical Language Study," in *Language and Power* (London: Longman, 1989), 1–16.

56. "Signifying," in *Juba to Jive: A Dictionary of African-American Slang*, ed. Clarence Major (1970; repr., New York: Penguin, 1994), 416.

57. Limor Shifman, "Meme Genres," in *Memes in Digital Culture* (Cambridge, MA: MIT Press, 2014), 110–17.

58. "Any theory of satire's degenerative potential," write Steven Weisenburger, "should, at any rate, aspire to interdisciplinary utility." Steven Weisenburger, *Fables of Subversion: Satire and the American Novel* (Athens: University of Georgia Press, 1995), 260. Also see Mikhail Bakhtin, *Rabelais and His World* (Bloomington: Indiana University Press, 1984); and David Musgrave, *Grotesque Anatomies: Menippean Satire since the Renaissance* (Newcastle-upon-Tyne: Cambridge Scholars, 2014).

59. Darryl Dickson-Carr, *African American Satire: The Sacredly Profane Novel* (Columbia: University of Missouri Press, 2001), 31.

60. Jordan Peele discusses his film in depth in Eddie Glaude, "The Artist's Mind," *Time*, February 26, 2018, 90–93.

61. Writing about the pioneering conceptual artist Marcel Duchamp and the aesthetic cues he received from cartoons, art historian Dalia Judovitz notes, "As a graphic and linguistic medium, cartooning enables Duchamp to redefine the visual image in conceptual terms as the interplay of visual and verbal puns." A similar translation takes place in other visual satires that incorporate visual punning, from Archibald Motley's visual/verbal paintings in the 1930s and 1940s to David Hammons's culturally generated assemblages from the last quarter of the twentieth century. Dalia Judovitz, *Unpacking Duchamp: Art in Transit* (Berkeley: University of California Press, 1998), 9–11.

62. Lynn M. Herbert, *David McGee: Black Comedies and Night Music* (Houston: Contemporary Art Museum, 1998), 5–9.

63. Adrian Piper, "News," September 2012, www.adrianpiper.com/news_sep_2012.shtml.

64. Darby English, in Thomas Chatterton Williams, "Adrian Piper's Show at MoMA Is the Largest Ever for a Living Artist. Why Hasn't She Seen It?," *New York Times Magazine*, June 27, 2018, 43.

65. Phillip Brian Harper, "Black Personhood in the Maw of Abstraction," in *Abstractionist Aesthetics: Artistic Form and Social Critique in African American Culture* (New York: New York University Press, 2015), 17–67.

66. Paul Beatty, "Black Absurdity," in *Hokum: An Anthology of African-American Humor*, ed. Paul Beatty (New York: Bloomsbury, 2006), 300.

67. For one of the few discussions of Walker that critically broaches the question of gender as informing her satires, see Hilton Als, "Profile: The Shadow Act," *New Yorker,* October 8, 2007, 70–75.

68. Jessyka Finley, "Black Women's Satire as (Black) Postmodern Performance," *Studies in American Humor* 2, ser. 4, no. 2 (2016): 261.

69. For a thoughtful analysis of Genet's impactful play, see Debby Thompson, "'What Exactly Is a Black?': Interrogating the Reality of Race in Jean Genet's *The Blacks*," *Studies in 20th Century Literature* 26, no. 2, article 8, https://newprairiepress.org (accessed July 3, 2019).

70. Carrie Mae Weems, *The Louisiana Project* (New Orleans: Newcomb Art Gallery, Tulane University, 2004), 26.

71. Linda Hutcheon, "Intention and Interpretation: Irony and the Eye of the Beholder," in *Irony's Edge: The Theory and Politics of Irony* (London: Routledge, 1995), 122.

72. Wayne F. Miller, *Chicago's South Side, 1946–1948* (Berkeley: University of California Press, 2000).

73. Stanley E. Fish, "Interpreting the *Variorum,*" *Critical Inquiry* 2, no. 3 (Spring 1976): 473, 474, 485.

74. The Colescott painting that Linda Hutcheon discusses is *Eat Dem Taters* (1975), a parody of Vincent van Gogh's *The Potato Eaters* (1885). Linda Hutcheon, "Risky Business: The 'Transideological' Politics of Irony," in *Irony's Edge,* 20.

75. One of the first art historical studies to successfully grapple with this satirical mode in African American art at the end of the twentieth century is Jo Anna Isaak, ed., *Looking Forward Looking Black* (Geneva, NY: Hobart and William Smith Colleges Press, 1999).

76. Derek Conrad Murray, "Post-Black Art and the Resurrection of African American Satire," in *Post-Soul Satire: Black Identity after Civil Rights,* ed. Derek C. Maus and James J. Donahue (Jackson: University of Mississippi Press, 2014), 10.

77. Irving Sandler, *Beverly McIver: Invisible Me* (New York: Kent Gallery, 2006).

78. The allusive possibilities for the term "going *there*" are not only on my radar. *Glenn Ligon: Going There,* a 2004 New York art exhibition featuring paintings and silkscreens derived from the artist's elementary school report cards and childhood musings on African American historical figures, also struck a satirical chord, via the artist's inventiveness with "found graphics" and with his temerity in making art from his own life's record. Soraya Murray, "Exhibition Review: *Glenn Ligon: Going There,*" *Nka: Journal of Contemporary African Art* 19 (Summer 2004): 88–89.

CHAPTER 2. DRAWING THE COLOR LINE: THE ART OF OLLIE HARRINGTON

1. "Lights and Shadows: A Little Bit of Everything," *Chicago Defender,* July 24, 1926.

2. Morrie Turner, *Humor in Hue, Negro Digest,* December 1965, 10.

3. George S. Schuyler, *Black and Conservative: The Autobiography of George S. Schuyler* (New Rochelle, NY: Arlington House, 1966).

4. William Villalongo, "Strange Material: Black Pulp!," in *Black Pulp!,* ed. William Villalongo and Mark Thomas Gibson (New Haven: Yale School of Art, 2016), 10.

5. Gunther Kress, *Multimodality: A Social Semiotic Approach to Contemporary Communication* (London: Routledge, 2010).

6. "Jive," in *Juba to Jive: A Dictionary of African-American Slang,* ed. Clarence Major (New York: Penguin, 1994), 259–60. In the early 1940s, Harrington actually created a relatively short-lived single-panel cartoon series entitled *Pee Wee's Off-Jive,* revolving around a comical, pint-sized Harlem citizen.

7. The Robeson tribute can be found in Ollie Harrington, "Our Beloved Pauli," *Freedomways* 11, no. 1 (First Quarter 1971): 58–63. Also see Ollie Harrington, "How Bootsie Was Born," *Freedomways* 3, no. 4 (Fall 1963): 519–24.

8. Harrington, "Our Beloved Pauli," 58.

9. Ollie Harrington, "Sitting on the Back Stairs," address for the 1992 Festival of Cartoon Art, Ohio State University, Columbus, October 30, 1992, excerpted in M. Thomas Inge, "Introduction," in *Dark Laughter: The*

Satiric Art of Oliver W. Harrington (Jackson: University Press of Mississippi, 1993), xi.

10. Robert C. Harvey, *The Art of the Funnies: An Aesthetic History* (Jackson: University Press of Mississippi, 1994); and Michael Robinson, *Art Deco: The Golden Age of Graphic Art and Illustration* (London: Flaming Tree, 2009).

11. E. Simms Campbell, *The WWII Era Comic Art of E. Simms Campbell* (Darke County, Ohio: Coachwhip, 2012).

12. George S. Schuyler, "The Negro Art-Hokum," *Nation* 122 (June 16, 1926): 662–63; George S. Schuyler, *Black No More: Being an Account of the Strange and Wonderful Workings of Science in the Land of the Free, A.D. 1933–1940* (New York: Macaulay, 1931); and Oscar R. Williams, *George S. Schuyler: Portrait of a Black Conservative* (Knoxville: University of Tennessee Press, 2007).

13. Oliver Wendell Harrington, *Razzberry Salad, National News,* February 18, 1932.

14. *Bulletin of Yale University School of Fine Arts* 33 (May 1, 1937). Also see Llewellyn Ransom, "PV's Art Editor Ollie Harrington, Creator of 'Bootsie' and 'Pee-Wee,' Enjoyed Life, Despite Setbacks," *People's Voice,* August 8, 1942.

15. James V. Hatch, *Sorrow Is the Only Faithful One: The Life of Owen Dodson* (Urbana: University of Illinois Press, 1993), 45, 50. For Harrington's thoughts at the time about attending Yale University, see Bill Chase, "Bootsie (That Is, His Creator) Takes High Art Honor at Yale," *New York Amsterdam News,* July 3, 1937. Years later, Harrington discussed the racial discrimination he faced while at Yale, in Margrit Pittman, "It Began with Bootsie," *Daily World,* April 12, 1969.

16. Hatch, *Sorrow Is the Only Faithful One,* 50.

17. "Tradition and Technique Are Watchwords at Yale's School of the Fine Arts," *Life,* February 12, 1940, 44–47.

18. Ollie Harrington, response to questions posed by James Vernon Hatch, Berlin, November 1, 1985, James Vernon Hatch Papers, Stuart A. Rose Manuscript, Archives, and Rare Book Library, Robert W. Woodruff Library, Emory University, Atlanta.

19. *People's Voice,* August 8, 1942.

20. Hatch, *Sorrow Is the Only Faithful One,* 50.

21. "Extemporizing in response to the exigencies of the situation in which he finds himself," observed literary critic Albert Murray about the blues-idiom artist, "he is confronting, acknowledging, and contending with the infernal absurdities and ever-impending frustrations inherent in the nature of all existence *by playing with the possibilities that are also there.*" Albert Murray, *The Omni-Americans* (New York: Outerbridge and Dienstfrey, 1970), 58. Among the countless other satire studies I have consulted, another critical exegesis was also helpful: Stephen Weisenburger, "Introduction," in *Fables of Subversion: Satire and the American Novel* (Athens: University of Georgia Press, 1995), 1–29.

22. "In 1938 Ollie Harrington started a syndication," a reporter noted in 1942. "It failed three times." Ransom, "PV's Art Editor Ollie Harrington." In the early 1940s, Harrington restarted his attempts to syndicate his cartoons, as seen in a promotional brochure under the business name "Continental Features and News Service." "Continental Features Are Created Especially For You," c. 1942, Clippings File, JWJ MSS 89, Box 86, Folder "O," Beinecke Rare Book and Manuscript Library, Yale University, New Haven.

23. "Since this is National Negro Newspaper Week," Harrington began his caption for a *People's Voice* cartoon satirically depicting its writers, editors, owner Adam Clayton Powell, Jr., and himself, "artist Harrington decided to do a family portrait on how PV's staff operates." *People's Voice,* March 6, 1943.

24. Adam Clayton Powell, Jr., "I'll Be Glad When You're Dead, You Rascal You," *People's Voice,* September 19, 1942.

25. "Schoolfield Plan Memorial," *Bee* (Danville, VA), January 6, 1943; and Michael Carter, "A 20th Century Confederate," *Baltimore Afro-American,* August 28, 1943.

26. For a concise but thorough recounting of the African American soldiers' struggle to integrate the U.S. Armed Forces, see Jon E. Taylor, *Freedom to Serve: Truman, Civil Rights, and Executive Order 9981* (New York: Routledge, 2013).

27. For a thoughtful discussion of the serialization of Wright's *Native Son* in the *People's Voice*, and its audience's criticisms of Harrington's "detailed" and "grim" drawings, see Inge, "Introduction," in *Dark Laughter*, xxiv–xxvi. Also see Edward Brunner, "'This Job Is a Solid Killer': Oliver Harrington's *Jive Gray* and the African American Adventure Strip," *Iowa Journal of Cultural Studies* 6 (Spring 2005): 36–57.

28. Ollie Harrington, "Southern Maneuvers," *People's Voice*, May 15, 22, and 29, 1943; and Ollie Harrington, "Army Air Force," *Pittsburgh Courier*, October 30, 1943.

29. Ollie Harrington, "No Signs on Anzio's Foxholes," *Pittsburgh Courier*, April 1, 1944.

30. Ollie Harrington, "Fighter Group Invasion Heroes," *Pittsburgh Courier*, August 26, 1944.

31. Ollie Harrington, "Fierce Mountain Fighting Tests Skill of 92nd Unit," *Pittsburgh Courier*, October 7, 1944.

32. "Indict 35 in Riot; U.S. Orders Grand Jury Probe," *Pittsburgh Courier*, March 30, 1946.

33. Oliver W. Harrington, *Terror in Tennessee: The Truth about the Columbia Outrages* (New York: National Committee for Justice in Columbia, Tennessee, 1946). Harrington also lent his artistic skills to a series of courtroom sketches connected to the Columbia, Tennessee, case, published in Harry Raymond, "Chalk Up a Score for Democracy," *New Masses* 61 (October 29, 1946): 8–11.

34. Ollie Harrington, "Why I Left America," in Inge, ed., *Why I Left America and Other Essays*, 103. Also see Michael Denning, "The Politics of Magic: Orson Welles's Allegories of Anti-Fascism," in *The Cultural Front: The Laboring of American Culture in the Twentieth Century* (London: Verso, 1996), 399–400.

35. A version of Harrington's speech to the *New York Herald Tribune* forum appears in Ollie Harrington, "Where Is the Justice?," in Inge, ed., *Why I Left America and Other Essays*, 88–95.

36. For more details on Harrington's deteriorating relationship with the NAACP, see Brian Dolinar, *The Black Cultural Front: Black Writers and Artists of the Depression Generation* (Jackson: University Press of Mississippi, 2012), 211–12.

37. "Ollie Harrington FBI Files," *F. B. Eyes Digital Archive: FBI Files on African American Authors and Literary Institutions Obtained through the U.S. Freedom of Information Act (FOIA)*, Washington University Digital Gateway, http://www.omeka.wustl.edu (accessed May 21, 2018).

38. Chester Himes, *My Life of Absurdity: The Autobiography of Chester Himes*, vol. 2 (Garden City, NY: Doubleday, 1976), 35.

39. Himes, *My Life of Absurdity*, 37. I thank art historian and former baseball player Michael D. Harris for bringing to my attention Harrington's ironic Jackie Robinson intimation in this cartoon.

40. Harry Bosler, "Negroes under Guard Enter Sturgis School," *Louisville Courier-Journal*, September 7, 1956.

41. Langston Hughes to Ollie Harrington, March 14, 1957, Langston Hughes Papers, JWJ Mss. 26, Box 77, folder 1471, Ser. I, Personal correspondence, Beinecke Rare Book and Manuscript Library, Yale University, New Haven.

42. In his introduction to *Bootsie and Others*, Langston Hughes erroneously attributes an especially trenchant cartoon (by artist Don Burr and published in the *People's Voice*) to Harrington. Showing two white boys admiring wall-mounted hunting trophies—the heads of a moose, walrus, tiger, and, discordantly, the head of a black man—the cartoon's caption reads, "Dad got that one [referring to the black man] in Detroit last week." Langston Hughes, "Introduction," in Ollie Harrington, *Bootsie and Others: The Cartoons of Ollie Harrington* (New York: Dodd, Mead, 1958), n.p.; *People's Voice*, July 3, 1943.

43. *The New American Painting, As Shown in Eight European Countries, 1958–1959* (New York: Museum of Modern Art, 1959); and "'Bootsie' Cartoonist in Russia," *Pittsburgh Courier*, May 9, 1959. For the Café Tournon's shared terrain between the Paris Review group and Harrington's fellow black expatriates, see Lawrence P. Jackson, *Chester B. Himes: A Biography* (New York: W. W. Norton, 2017), 354–55.

44. Koritha Mitchell, *Living with Lynching: African American Lynching Plays, Performance, and Citizenship, 1890–1930* (Urbana: University of Illinois Press, 2011).

45. Ollie Harrington, "The Last Days of Richard Wright," *Ebony*, February 1961, 83–86, 88, 90, 92–94. For a discussion about the Café Tournon's atmosphere of collective paranoia, including spying accusations against Harrington, see William J. Maxwell, "Ghostreaders and Diaspora-Writers: Four Theses on the FBI and African American Modernism," in *Modernism on File: Writers, Artists, and the FBI, 1920–1950*, ed. Claire A. Culleton and Karen Leick (New York: Palgrave Macmillan, 2008), 23–38.

46. Ollie Harrington, in Terry E. Johnson, "Black Journalists Visit Eastern Europe," *Black Scholar* 17 (January/February 1986): 37. Also see Stephanie Brown, "'Bootsie' in Berlin: An Interview with Helma Harrington on Oliver Harrington's Life and Work in East Germany, 1961–1995," *African American Review* 44 (Fall 2011): 353–72.

47. Harrington, *Bootsie and Others*, cover.

48. Brian Dolinar, "Introduction," in Dolinar, *Black Cultural Front*, 3–19.

49. Ollie Harrington, *Soul Shots: Political Cartoons* (East Berlin: Long View, 1972).

50. Harrington's "Beauty and the Beast" and its depiction of a monstrous J. Edgar Hoover was prescient, as seen in psychedelic artist Mati Klarwein's satirical portrait of Hoover on the back of the album cover for Miles Davis, *Live/Evil*, Columbia G 30954, 1972, LP.

51. Alison Hafera Cox, "Drawing Boundaries: Comic Critique in the Grotesque Bodies of Louis-Philippe and George W. Bush," in *Lines of Attack: Conflicts in Caricature*, ed. Neil McWilliam (Durham, NC: Nasher Museum of Art at Duke University, 2010), 9–10.

52. Rebecca Zurier, *Art for the Masses: A Radical Magazine and Its Graphics, 1911–1917* (Philadelphia: Temple University Press, 1988).

53. Robert A. Hill, ed., "Introduction," in *The FBI's RACON: Racial Conditions in America during World War II* (Boston: Northeastern University Press, 1995), 1–49; and Kenneth O'Reilly, *"Racial Matters": The FBI's Secret Files on Black America, 1960–1972* (New York: Free Press, 1989).

54. Paul Oppenheimer, "Introduction," in *Till Eulenspiegel: His Adventures* (New York: Routledge, 2001), lxiii.

55. Randall L. Bytwerk, "Official Satire in Propaganda: The Treatment of the United States in the GDR's *Eulenspiegel*," *Central State Speech Journal* 39, no. 3 (Fall/Winter 1988): 304.

56. Peter Nelken, "Die Satire – Waffe der sozialistischen Erziehung: Ein Diskussionsbeitrag," *Einheit*, no. 3 (1962): 103. Also see Randall L. Bytwerk, "The Dolt Laughs: Satirical Publications under Hitler and Honecker," *Journalism Quarterly* 69, no. 4 (Winter 1992): 1038.

57. Ellen Tarry, *Hezekiah Horton* (New York: Viking, 1942); and Ellen Tarry, *The Runaway Elephant* (New York: Viking, 1950).

58. "The Mightiest Pen," *Daily World*, December 9, 1972.

59. W. A. Coupe, *German Political Satires from the Reformation to the Second World War*, pt. 1, *1500–1848*; pt. 2, *1849–1918*; pt. 3, *1918–1945* (White Plains, NY: Kraus International, 1985–93).

60. Harrington's "Boston, Cradle of Liberty" was accompanied in *Eulenspiegel* by the following caption (translated from the German): "In the US city of Boston, which has been called the 'CRADLE OF FREEDOM' since the success of its citizens against British paternalism, in the 1970s it has been the site of repeated riots by racists against the equal treatment of African-American children in the schools." *Eulenspiegel* 40 (1975): 4.

61. *Eulenspiegel* 47 (1982): cover; and Inge, ed., *Dark Laughter*, 102.

62. Aribert Schroeder, "Ollie Harrington: His Portrait Drawn on the Basis of East German (GDR) Secret Service Files," in *Germans and African Americans: Two Centuries of Exchange*, ed. Larry A. Greene and Anke Ortlepp (Jackson: University Press of Mississippi, 2011), 196–97.

63. "75-Yard Dash, Novice Won by Oliver Harrington, Textile," *Brooklyn Daily Eagle*, March 9, 1930.

64. Harrington's changed life after the fall of the Berlin Wall is discussed at length in Brown, "'Bootsie' in Berlin," 364.

65. "People Watching: A Satirist Gets Reacquainted with America," *Emerge* 5 (May 1994): 14.

66. "Harrington happened to be visiting Jackson State University in Mississippi when the conviction of Robert De [*sic*] la Beckwith came down," reported a writer in 1994. "After 30 years, the murder of civil rights activist Medgar Evers had been avenged, yet the shouted threats of Beckwith's supporters to Black passers-by let Harrington know there's still a long way to go in America." Debra Adams, "Return of a Native Son: 'Bootsie' Creator Oliver Harrington Breaks Exile, Teaches Semester at MSU," *Black Issues in Higher Education* 11 (April 7, 1994): 16.

67. Adams, "Return of a Native Son," 16.

CHAPTER 3. THE MINSTREL STAIN

1. Paul Richard, "Robert Colescott's Perspectives on Black and White," *Washington Post*, January 20, 1988.

2. For an in-depth look at selected works by contemporary African American artists, the following publications provide an excellent start: Huey Copeland, *Bound to Appear: Art, Slavery, and the Site of Blackness in Multicultural America* (Chicago: University of Chicago Press, 2013); Darby English, *How to See a Work of Art in Total Darkness* (Cambridge, MA: MIT Press, 2007); Krista A. Thompson, *Shine: The Visual Economy of Light in African Diasporic Aesthetic Practice* (Durham, NC: Duke University Press, 2015); Kobena Mercer, "New Practices, New Identities: Hybridity and Globalization," in *The Image of the Black in Western Art*, vol. 5, pt. 2, *The Rise of Black Artists*, ed. David Bindman and Henry Louis Gates, Jr. (Cambridge, MA: Harvard University Press, 2014), 225–300, 321–25; and Derek Conrad Murray, *Queering Post-Black Art: Art-*

ists Transforming African-American Identity after Civil Rights (London: I. B. Tauris, 2016).

3. The entire content of the *Do You Like Crème in Your Coffee and Chocolate in Your Milk?* album of drawings is published in Philippe Vergne et al., *Kara Walker: My Complement, My Enemy, My Oppressor, My Love* (Minneapolis: Walker Art Center, 2007), 196–267.

4. The literature on minstrelsy is extensive, but the following study offers a succinct introduction: Annemarie Bean, James V. Hatch, and Brooks McNamara, eds., *Inside the Minstrel Mask* (Hanover, NH: Wesleyan University Press, 1996).

5. M. A. Katritzky, *The Art of Commedia: A Study in the Commedia dell'arte, 1560–1620, with Special Reference to the Visual Records* (Amsterdam: Rodopi, 2006).

6. Helen P. Trimpi, "Harlequin-Confidence-Man: The Satirical Tradition of Commedia Dell'Arte and Pantomime in Melville's *The Confidence-Man*," *Texas Studies in Literature and Language* 16, no. 1 (Spring 1974): 171–72. Also see John O'Brien, "Why Is Harlequin's Face Black?," in *Harlequin Britain: Pantomime and Entertainment, 1690–1760* (Baltimore: Johns Hopkins University Press, 2004), 117–37.

7. Michael Tomko, "Politics, Performance, and Coleridge's 'Suspension of Disbelief,'" *Victorian Studies* 49, no. 2 (Winter 2007): 241–49.

8. For a useful discussion of how masquerades function in traditional African societies, see Simon Ottenberg, "Illusion, Communication, and Psychology in West African Masquerades," *Ethos* 10, no. 2 (Summer 1982): 149–85.

9. Claude Lévi-Strauss, *Structural Anthropology*, trans. Claire Jacobson and Brooke Grundfest Schoepf (New York: Basic, 1963), 261.

10. Eric Lott, *Love and Theft: Blackface Minstrelsy and the American Working Class* (New York: Oxford University Press, 1993).

11. Henry T. Sampson, *The Ghost Walks: A Chronological History of Blacks in Show Business, 1865–1910* (Metuchen, NJ: Scarecrow, 1988).

12. "The Uncorked Minstrels: Training the Dusky Sons of Song," *Times* (Philadelphia), December 25, 1882.

13. Karen Sotiropoulos, *Staging Race: Black Performers in Turn of the Century America* (Cambridge, MA: Harvard University Press, 2006), 9.

14. Jayna Brown, *Babylon Girls: Black Women Performers and the Shaping of the Modern* (Durham, NC: Duke University Press, 2008), 97.

15. Two books published in the mid-1990s attempted to codify and interpret the plethora of black stereotypic objects that were created in the nineteenth and twentieth centuries: Kenneth W. Goings, *Mammy and Uncle Mose: Black Collectibles and American Stereotyping* (Bloomington: Indiana University Press, 1994); and Patricia A. Turner, *Ceramic Uncles and Celluloid Mammies: Black Images and Their Influence on Culture* (New York: Anchor, 1994).

16. James Weldon Johnson, *Along This Way* (1933; repr., New York: Da Capo, 2000), 159.

17. Langston Hughes, "The Negro Artist and the Racial Mountain," *The Nation* 122 (June 23, 1926): 692–94.

18. I also examine this painting in the context of his entire oeuvre in Richard J. Powell, ed., *Archibald Motley: Jazz Age Modernist* (Durham, NC: Nasher Museum of Art at Duke University, 2014), 128–33. For a brilliant discussion of the deleterious effects that artistic realism has perpetrated on modern and contemporary African American artists, see Phillip Brian Harper, "Black Personhood in the Maw of Abstraction," in *Abstractionist Aesthetics: Artistic Form and Social Critique in African American Culture* (New York: New York University Press, 2015), 17–67.

19. Lizzetta LeFalle-Collins, "African-American Modernists and the Mexican Muralist School," in Lizzetta LeFalle-Collins and Shifra M. Goldman, *In the Spirit of Resistance: African-American Modernists and the Mexican Muralist School* (New York: American Federation of Arts, 1996), 55.

20. Palmer Hayden's art and its overtures to racial stereotypes have been the subject of numerous studies, most notably John Ott, "Labored Stereotypes: Palmer Hayden's *The Janitor Who Paints*," *American Art* 22, no. 1 (Spring 2008): 102–15; and Phoebe Wolfskill, "Caricature and the New Negro in the Work of Archibald Motley, Jr. and Palmer Hayden," *Art Bulletin* 91, no. 3 (September 2009): 343–65.

21. For a history of this subset of American popular entertainment, see Preston Lauterbach, *The Chitlin' Circuit and the Road to Rock and Roll* (New York: W. W. Norton, 2011).

22. Stuart Preston, "Diverse Moderns," *New York Times,* February 1, 1953. Jacob Lawrence's *Vaudeville* is in the permanent collection of the Hirshhorn Museum and Sculpture Gardens, Smithsonian Institution, Washington, DC.

23. Mel Watkins, *On the Real Side: Laughing, Lying, and Signifying—The Underground Tradition of African-American Humor That Transformed American Culture, from Slavery to Richard Pryor* (New York: Simon and Schuster, 1994), 133.

24. Jeff Donaldson, *The Civil Rights Yearbook* (Chicago: Henry Regnery, 1964), n.p.

25. LeRoi Jones, "blackhope," in *Home* (New York: William Morrow, 1966), 234–37. Also see Lisa Gail Collins and Margo Natalie Crawford, eds., *New Thoughts on the Black Arts Movement* (New Brunswick, NJ: Rutgers University Press, 2006).

26. Imamu Amiri Baraka (LeRoi Jones), *J-E-L-L-O* (Chicago: Third World, 1970).

27. Mike Sell, "Blackface and the Black Arts Movement," *TDR: The Drama Review* 57, no. 2 (Summer 2013): 143–62.

28. Ed Bullins, "The Transcendent Stereotype: Or, the Confession of an Epiphanic Black Rogue," unpublished manuscript, 1991, Ed Bullins Papers, Stuart A. Rose Manuscript, Archives, and Rare Book Library, Robert W. Woodruff Library, Emory University, Atlanta.

29. Bullins's scenic instructions for *The Gentleman Caller* are as follows: "A comfortably furnished living room in a fashionable section of a northern American city. (If there be any.) Against the back wall is a gun rack with rifles and shotguns in it. Upon the wall are

mounted and stuffed heads of a Blackman, an American Indian, a Vietnamese and a Chinese." This absurdist setting recalls the macabre hunting trophies in the satirical *People's Voice* cartoon (1943) by Don Burr that Langston Hughes erroneously attributed to Ollie Harrington (see Chapter 2, n42). Ed Bullins, *The Gentleman Caller* (Alexandria, VA: Alexander Street, 2003). Also see Langston Hughes, "Introduction," in Ollie Harrington, *Bootsie and Others: The Cartoons of Ollie Harrington* (New York: Dodd, Mead, 1958), n.p.; and *People's Voice*, July 3, 1943.

30. Samuel A. Hay, *Ed Bullins: A Literary Biography* (Detroit: Wayne State University Press, 1997), 92–93.

31. One of the photographs that might have inspired Jeff Donaldson, depicting an African American female protester in Birmingham, Alabama, resisting arrest, appeared in the Johnson Publishing Company's weekly magazine *Jet*. John Britton, "Victory in Birmingham Can Be Democracy's Finest Hour," *Jet*, May 2, 1963, 15. *Aunt Jemima and the Pillsbury Dough Boy*'s visual disconnect with its title is very likely the result of Donaldson's retitling the 1963 painting at some point after 1965 when the Pillsbury company first started using the Dough Boy advertising mascot. I am indebted to Marc Wehby, director of the Kravets/Wehby Gallery, for bringing this to my attention. Marc Wehby, interview with the author, June 16, 2018.

32. Joe Overstreet, in Charles Childs, "Larry Ocean Swims the Nile, Mississippi and Other Rivers," in *Some American History* (Houston: Institute for the Arts, Rice University, 1971), 18. Also see Michael D. Harris, *Colored Pictures: Race and Visual Representation* (Chapel Hill: University of North Carolina Press, 2003), 109–11.

33. Art historian Derek Conrad Murray placed Betye Saar's *The Liberation of Aunt Jemima* within the realm of the ironic, rather than the satirical, seeing the latter as "that holistic and cyclical critical engagement with the messiness of culture that is not afraid to employ self-criticality." While Murray had a valid point in differentiating *The Liberation of* *Aunt Jemima*'s critiques of racial stereotypes from the general, uncompromising onslaughts that one experienced in the works of Robert Colescott and Kara Walker, Saar's sculpture was no less satirical, although of the Juvenalian variety, where the attacks take on a more bitter and mono-directional character. Derek Conrad Murray, "Post-Black Art and the Resurrection of African American Satire," in *Post-Soul Satire: Black Identity after Civil Rights* (Jackson: University Press of Mississippi, 2014), 11. Also see Betye Saar, "Unfinished Business: The Return of Aunt Jemima," in *Betye Saar: Workers + Warriors, The Return of Aunt Jemima* (New York: Michael Rosenfeld Gallery, 1998), 3.

34. Lucy R. Lippard, "Sapphire and Ruby in the Indigo Gardens," in *The Art of Betye and Alison Saar: Secrets, Dialogues, Revelations*, ed. Elizabeth Shepherd (Los Angeles: Wight Art Gallery, University of California, 1990), 20.

35. *Georgia, Georgia*, directed by Stig Björkman (1972; Los Angeles: Prism Entertainment, 1986, VHS). Also see Lars-Olof Löthwall, "Redaktör intervjuar redaktör som också är regissör," *Chaplin* 14, no. 3 (January 1, 1972): 85–86.

36. Douglas Turner Ward, *Day of Absence*, in *Two Plays* (New York: Third, 1971), 32–81.

37. Anthony Graham-White, "Jean Genet and the Psychology of Colonialism," *Comparative Drama* 4, no. 3 (Fall 1970): 208–16. Among the legendary actors who appeared in the New York presentation of *The Blacks: A Clown Show* were two who would go on to develop their own, stereotype-informed, and satire-infused film projects: Maya Angelou in *Georgia, Georgia* (1972), and Godfrey Cambridge in *Watermelon Man* (1970). Howard Taubman, "Theatre: 'The Blacks' by Jean Genet; Play from the French at the St. Marks," *New York Times*, May 5, 1961.

38. One of the earliest displays of Larry Rivers's *I Like Olympia in Black Face* took place in 1971, at Rice University's Institute for the Arts, in the oft-cited black history–themed exhibition *Some American History*. Perhaps not coincidentally, appearing along with it, and with additional works by Rivers and several other

artists, was Joe Overstreet's *The New Jemima,* which shared with *I Like Olympia in Black Face* a large-scale, constructed format and a satirical point of view. *Some American History* (Houston: Institute for the Arts, Rice University, 1971).

39. *Hi, Mom!,* directed by Brian De Palma (1970; Santa Monica, CA: MGM Home Entertainment, 2004, DVD).

40. "[Minstrel] acts certainly made currency out of the black man himself, that obscure object of exchangeable desire," theorized Eric Lott. "[The] stock in trade of the exchange so central to minstrelsy . . . was black culture in the guise of an attractive masculinity." Eric Lott, *Love and Theft: Blackface Minstrelsy and the American Working Class* (New York: Oxford University Press, 1993), 53.

41. Ed Bullins, "It Bees Dat Way: A Confrontational Ritual," *Theatre 2* (New York: International Theatre Institute of the United States, 1970), 120–25. *It Bees Dat Way* is described and discussed at length in Sharyn Emery, "Pageants of Propaganda: The Ritual Theatre of Ed Bullins," *Journal of Dramatic Theory and Criticism* 29, no. 1 (Spring 2015): 7–23. Although Brian De Palma's *Hi, Mom!* was completed months before *It Bees Dat Way* was first produced, the black theater scene, circa 1969, frequently experimented with racially provocative and occasionally intimidating pieces. Also, virtually all of the African American actors who performed in the "Be Black, Baby" sequence were either previous collaborators with Bullins at the New Lafayette Theatre, or subsequent interlocutors with the playwright. Lisbeth Gant, "The New Lafayette Theatre: Anatomy of a Community Art Institution," *Drama Review: TDR* 16, no. 4, Black Theatre Issue (December 1972): 46–55.

42. Brian De Palma, in Laurence F. Knapp, *Brian De Palma: Interviews* (Jackson: University Press of Mississippi, 2003), 28.

43. Eric Henderson, "Review: *Hi, Mom!*" June 11, 2004, Slant, https://www.slantmagazine.com (accessed August 1, 2018).

44. *Watermelon Man,* directed by Melvin Van Peebles (1970; Culver City, CA: Sony Pictures, 2004, DVD). Also see Racquel Gates, "Subverting Hollywood from the Inside Out: Melvin Van Peebles's *Watermelon Man,*" *Film Quarterly* 68, no. 1 (Fall 2014): 9–21.

45. *Godfrey Cambridge/Here's Godfrey Cambridge, Ready or Not . . . ,* Epic Records FLM 13101, 1964, LP.

46. Gates, "Subverting Hollywood from the Inside Out," 11.

47. George Lipsitz, "Genre Anxiety and Racial Representation in 1970s Cinema," in *Refiguring American Film Genres: History and Theory,* ed. Nick Browne (Berkeley: University of California Press, 1998), 216.

48. Melvin Van Peebles had already established himself as a dedicated satirist well before *Watermelon Man.* In the 1960s and while living in Paris, Van Peebles was a contributor to the notorious French satire magazine *Hara-Kiri, Journal Bête et Méchant.* And in 1967 he made his first feature film in France, *Le Permission* ("Story of a Three-Day Pass"), which included several scenes that could be described as satirical in both intention and narrative structure. Melvin Van Peebles, *The Making of Sweet Sweetback's Baadasssss Song* (London: Payback, 1996), 162.

49. Joe Coscarelli, "Drake Addresses Blackface Photo Used for Pusha-T Cover Art," *New York Times,* May 31, 2018.

50. *Bamboozled,* directed by Spike Lee (2000; Burbank, CA: New Line Home Entertainment, Inc., 2001, DVD).

51. Tavia Nyong'o, "Racial Kitsch and Black Performance," *Yale Journal of Criticism* 15, no. 2 (2002): 383.

52. *Bamboozled,* directed by Spike Lee.

53. Bill Brown, "Reification, Reanimation, and the American Uncanny," *Critical Inquiry* 32, no. 2 (Winter 2006): 204.

54. Audre Lorde, "The Master's Tools Will Never Dismantle the Master's House," in *Sister Outsider: Essays and Speeches* (1984; repr., Berkeley: Crossing, 2007), 110–14.

55. Margo Jefferson, "Playing on Black and White: Racial Messages through a Camera Lens," *New York Times,* January 10, 2005; Cherise Smith, *Enacting Others: Politics of Identity in Eleanor Antin, Nikki S. Lee, Adrian*

Piper, and Anna Deavere Smith (Durham, NC: Duke University Press, 2011); and *The Rachel Divide,* directed by Laura Brownson (Netflix, 2018).

56. A detail of Adrian Piper's drawing appears on the cover of Maurice A. Berger, ed., *Adrian Piper: A Retrospective* (Baltimore: Fine Arts Gallery, University of Maryland, Baltimore County, 1999).

57. Brian Wallis, "Coming to Voice: Howardena Pindell's *Free, White and 21,*" in *Howardena Pindell: What Remains To Be Seen,* ed. Naomi Beckwith and Valerie Cassel Oliver (Chicago: Museum of Contemporary Art, 2018), 169–92.

58. I discuss the circumstances surrounding the thwarted attempts to install David Hammons's *How Ya Like Me Now?* in Richard J. Powell, *Cutting a Figure: Fashioning Black Portraiture* (Chicago: University of Chicago Press, 2008), 176.

59. Paula Wasley, "Behind the Makeup," *ARTnews* 105, no. 10 (November 2006): 106–8; and Powell, *Cutting a Figure,* 208.

60. Jessica Dawson, "First Impressions, Second Thoughts," *Washington Post,* December 9, 2006. Michael T. Martin and David Wall, "'Where Are You From?' Performing Race in the Art of Jefferson Pinder," *Black Camera* 2 (Winter 2010): 72–105.

61. For an in-depth discussion of Jayson Musson's satirical art projects, see Derek Conrad Murray, *Queering Post-Black Art: Artists Transforming African-American Identity after Civil Rights* (London: I. B. Tauris, 2016), 152–60.

62. Caroline Picard, "Kerry James Marshall: Profile of the Artist," *The Seen: Chicago's International Online Journal of Contemporary and Modern Art,* April 21, 2016, http://theseenjournal.org (accessed August 6, 2018).

63. Roberta Smith, "Sugar? Sure, but Salted with Meaning," *New York Times,* May 11, 2014.

64. A year and a half before *A Subtlety . . .* appeared in Brooklyn, Walker experienced the censorship of one of her large-scale drawings at the Newark Public Library. Brian Boucher, "Kara Walker Artwork Censored at Newark Library," *Art in America,* December 11, 2012,

https://www.artinamericamagazine.com (accessed August 6, 2018).

65. Cait Munro, "Kara Walker's Sugar Sphinx Spawns Offensive Instagram Photos," May 30, 2014, Artnet News, https://news.artnet.com (accessed August 6, 2018).

66. Sell, "Blackface and the Black Arts Movement," 143–62.

67. Zanele Muholi, *Zanele Muholi: Somnyama Ngonyama, Hail the Dark Lioness* (New York: Aperture, 2018).

68. Mark Gevisser, "Profile/Zanele Muholi: Dark Lioness," *The Economist/1843,* June/ July 2018, https://www.1843magazine.com (accessed August 6, 2018); "Hail! The Dark Lioness," pt. 3, *Art Africa,* January 10, 2018, https://artafricamagazine.org (accessed August 6, 2018).

69. Nadia Davids, "'It Is Us': An Exploration of 'Race' and Place in the Cape Town Minstrel Carnival," *TDR: The Drama Review* 57, no. 2 (Summer 2013): 86–101.

70. Athi Mongezeleli Joja, March 2, 2016, http://www.africanah.org (accessed July 27, 2018).

71. Siddhartha Mitter, "Zanele Muholi Brings Her 'Visual Activism' Out of Africa, and into New York," November 7, 2017, *Village Voice.* Also see Zanele Muholi, *Zanele Muholi/Faces and Phases, 2006–14* (Göttingen: Steidl, 2014).

72. Advait, "Arthur Jafa—Apex (extract)," *YouTube,* February 10, 2017, 7:43, https://www.youtube.com (accessed August 6, 2018).

73. "Arthur Jafa, Apex, 2013," Art/Basel, https://www.artbasel.com (accessed August 6, 2018).

74. Jean Toomer, "Face," in *Cane* (1923; repr., New York: Perennial, 1969), 14.

75. Donald Glover, *This Is America,* YouTube, May 5, 2018, 4:04, https://www.youtube.com (accessed May 7, 2018).

76. Thomas F. DeFrantz, "The Black Beat Made Visible: Body Power in Hip Hop Dance," in *Of the Presence of the Body: Essays on Dance and Performance Theory,* ed. Andre Lepecki (Middletown, CT: Wesleyan University Press, 2004), 64–81.

77. Doreen St. Félix, "The Carnage and Chaos of Childish Gambino's 'This is America,'" *New Yorker,* May 7, 2018, https://www.newyorker.com (accessed August 6, 2018).

78. *Ethnic Notions,* directed by Marlon Riggs (1986/87; San Francisco: California Newsreel, 2004, DVD).

79. Although Spike Lee is quoted in numerous interviews about his distaste for television shows and films that satirized and trivialized slavery (such as *The Secret Diary of Desmond Pfeiffer* and *Django Unchained*), that same disdain did not apply to his own cinematic attempts at satirizing, comparatively, some of the more ominous aspects of African American life and history, such as minstrelsy and racial stereotypes (in *Bamboozled*) and black-on-black violence (in *Chi Raq*). Cynthia Fuchs, ed., *Spike Lee: Interviews* (Jackson: University Press of Mississippi, 2002); and Maria Puente, "Spike Lee Says He's Boycotting Tarantino's 'Django,'" *USA Today,* December 24, 2012.

80. Manthia Diawara's explication of the contemporary usage in art of stereotypes was offered in the context of photographer David Levinthal's book of Polaroids of racist memorabilia: a photographic project that, tellingly, was featured in the closing credits of Spike Lee's *Bamboozled*. Manthia Diawara, "The Blackface Stereotype," in *David Levinthal/Blackface* (New York: Arena, 1999), 15–16.

CHAPTER 4. ROBERT COLESCOTT: BETWEEN THE HEROIC AND THE IRONIC

Epigraph: Chester Himes, *My Life of Absurdity: The Autobiography of Chester Himes,* vol. 2 (Garden City, NY: Doubleday, 1976), 1.

1. Hubert Damisch, "Cherchez la femme: Beauty in Relations between the Sexes," in *The Judgment of Paris* (Chicago: University of Chicago Press, 1996), 53–58; and Hal Foster, "Archives of Modern Art," in *Designs and Crimes (and Other Diatribes)* (London: Verso, 2002), 68–70.

2. Edith Hamilton, "Prologue: The Judgment of Paris," in *Mythology* (Boston: Little, Brown, 1942), 256–59.

3. Lowery S. Sims, "Bob Colescott Ain't Just Misbehavin'," *Artforum* 22, no. 7 (March 1984): 56–59.

4. Darryl Dickson-Carr, *African American Satire: The Sacredly Profane Novel* (Columbia: University of Missouri Press, 2001), 36.

5. Robert Colescott, in Robert Becker, "Art: Satiric Mastery—Robert Colescott," *Interview,* December 1983, 142.

6. Curt Shonkwiler, "Humor as Epiphanic Awareness and Attempted Self-Transcendence" (PhD diss., Harvard University, December 2014), 133.

7. Mitchell D. Kahan, "Robert Colescott: Pride and Prejudice: A Memory, Some Thoughts," in *Robert Colescott: A Retrospective, 1975–1986* (San Jose: San Jose Museum of Art, 1987), 27.

8. Richard J. Powell, "Black Humor Squared," in *Art and Race Matters: The Career of Robert Colescott,* ed. Lowery Stokes Sims, Raphaela Platow, and Matthew Weseley (New York: Rizzoli Electa, 2019), 207–11.

9. Warrington Colescott, Sr., worked as a Southern Pacific Railroad dining car waiter alongside sculptor/printmaker Sargent Claude Johnson, who, as one of the leading artists of the Harlem Renaissance, left an indelible impression on Robert Colescott. As recounted by Robert Colescott in *Robert Colescott: The One-Two Punch,* directed by Linda Freeman (L&S Video, 1997, DVD).

10. Richard Sandomir, "Warrington Colescott, Who Etched with a Satirical Edge, Dies at 97," *New York Times,* October 4, 2018. For elaborations on Robert Colescott's estranged relationship with his brother, Warrington, see "Colescott, Robert, in Raymond Saunders' House Oakland, CA, interviewed by Benny Andrews," Benny Andrews Papers, February 7, 1975, Stuart A. Rose Manuscript, Archives, and Rare Book Library, Robert W. Woodruff Library, Emory University, Atlanta.

11. Among the countless interviews with Colescott over the course of his long career, the interview conducted by the Archives of American Art, Smithsonian Institution, provides a fairly comprehensive overview of the artist's early life and many key biographical details: "Oral History Interview with Robert Colescott, 1999 April 14," by Paul Karlstrom, Archives of American Art, Smithsonian Institution, https://www.aaa.si.edu (accessed June 21, 2015).

12. *West Coast '74: The Black Image* (Sacramento: E. B. Crocker Art Gallery, 1974), n.p.; Jean Lipman and Richard Marshall, *Art about Art* (New York: E. P. Dutton, 1978); and Marcia Tucker, *Not Just for Laughs: The Art of Subversion* (New York: New Museum, 1981).

13. Kahan, *Robert Colescott: A Retrospective*; Miriam Roberts, ed., *Robert Colescott: Recent Paintings* (Venice: 47th Venice Biennale, 1997); Peter Selz, ed., *Robert Colescott/Troubled Goods: A Ten Year Survey (1997–2007)* (San Francisco: Meridian Gallery, 2007); and Lowery Stokes Sims, ed., *Art and Race Matters: The Career of Robert Colescott* (Cincinnati: Contemporary Art Center, 2019).

14. Kenneth Baker, "Robert Colescott," in *Robert Colescott: Another Judgment* (Charlotte, NC: Knight Gallery/Spirit Square Arts Center, 1985), n.p.

15. Robert Colescott, in "An Inquiry into the Creative Forces," in Selz, ed., *Robert Colescott/Troubled Goods*, 37.

16. Lowery Stokes Sims, "Robert Colescott: A Retrospective," in Kahan, *Robert Colescott: A Retrospective*, 6. Upon the Akron Art Museum's acquisition and exhibiting of *Bye Bye Miss American Pie,* a local reviewer noted how the painting might be interpreted in different ways, writing, "On one level, [the naked white woman] represents the American dream girl; on another, she represents American ideals for which all soldiers fought, but which only the white ones might realize." Dorothy Shinn, "A Level Headed View of Nudity, Akron Museum Exhibit Could Be Good Education for Those Who Can't Separate Art from Pornography," *Akron Beacon Journal,* January 30, 1994.

17. Robert Colescott, in Kristine McKenna, "Our Man in Venice," *Los Angeles Times,* June 15, 1997.

18. Whitney Chadwick, "Narrative Imagism and the Figurative Tradition in Northern California Painting," *Art Journal* 45 (Winter 1985): 309.

19. John Canaday, "Art: Informal Gallery Tour of SoHo," *New York Times,* April 7, 1973.

20. Darby English, "Introduction: Social Experiments with Modernism," in *1971: A Year in the Life of Color* (Chicago: University of Chicago Press, 2016), 1–50.

21. I discuss Aaron McGruder's highly controversial *The Boondocks* episode, "The Return of the King," in Richard J. Powell, *Cutting a Figure: Fashioning Black Portraiture* (Chicago: University of Chicago Press, 2008), 212–14.

22. The African American art scene that Colescott encountered upon his return to the United States in 1970 could be characterized by the following anthology: Samella S. Lewis and Ruth G. Waddy, *Black Artists on Art,* vol. 1 (Los Angeles: Contemporary Crafts, 1969). Although chronologically encompassing MLK imagery from the entirety of the second half of the twentieth century, the following book features the typical, racially uplifting depictions of King that stand in sharp contrast to Colescott's 1971 drawing: Gretchen Sullivan Sorin and Helen M. Shannon, *In the Spirit of Martin: The Living Legacy of Dr. Martin Luther King, Jr.* (Atlanta: Tinwood, 2001).

23. Robert Colescott, in *Robert Colescott: Another Judgment,* n.p.

24. *Robert Colescott: The One-Two Punch.*

25. Among Colescott's painted parodies from this period are *Tom and Eva: Thank You Staffordshire* (1974), based on the Staffordshire Pottery's *Uncle Tom and Little Eva* (c. 1860); *Eat Dem Taters* (1975), based on Vincent van Gogh's *The Potato Eaters* (1885); *Natural Rhythm: Thank You Jan van Eyck* (1976), based on Jan van Eyck's *The Arnoldfini Portrait* (1434); *Jus' Folks* (1976), based on Johannes Vermeer's *The Milkmaid* (1658); and *End of the Trail* (1976), based on James Earle Fraser's *The End of the Trail* (1918).

26. This painting is discussed at length in Jody B. Cutler, "Art Revolution: Politics and Pop in the Robert Colescott Painting *George Washington Carver Crossing the Delaware,*" *Americana: The Journal of American Popular Culture* 8, no. 2 (Fall 2009), http://www.americanpopularculture.com (accessed April 17, 2015).

27. Tavia Nyong'o, *The Amalgamation Waltz: Race, Performance, and the Ruses of Memory* (Minneapolis: University of Minnesota Press, 2009), 157. The literary and cultural critic Daphne Brooks writes that the ex-slave and

abolitionist Frederick Douglass, "[in his] 1852 landmark speech, 'What to the Slave is the Fourth of July' . . . recognized the subversive political power of irony and influenced a generation of black activists to make use of the form." Princeton Alumni Weekly, "A Moment with . . . Daphne Brooks, on Satire in African-American Culture," *Princeton Alumni Weekly*, January 19, 2011, https://paw.princeton.edu (accessed July 3, 2019).

28. Gregory Battcock, "New York," *Art and Artists* (July 1973): 51.

29. A book that succinctly probes the unfiltered conversations between African American men at midcentury is Steve Chennault, *"Re'lize whut Ahm Talkin' Bout?": African American Tall Tales in Black English, Capturing the Essence of the Black Experience* (Needham, MA: Simon and Schuster, 1997). For a discussion of this subgenre of African American literature, see Susanne B. Dietzel, "The African American Novel and Popular Culture," in *The Cambridge Companion to the African American Novel,* ed. Maryemma Graham (Cambridge: Cambridge University Press, 2004), 156–70.

30. In 1980 the author was a witness to the growing admiration for Colescott's art within selected African American art circles. That spring, the Institute of Contemporary Art at the Virginia Museum of Fine Arts presented *Eight,* an exhibition of artworks by eight African American artists that, in addition to featuring artworks by Betye Saar, Richard Hunt, Margo Humphrey, and the author (who at the time was an active visual artist), included several important paintings by Colescott.

31. A slightly different version of this painting (and, in all likelihood, an earlier rendering), without the French tricolor painted extension and with the phrase "IF ONLY SHE HAD WORN HER LIBERTY BRASSIERE" stenciled along the painting's top edge, appeared in the exhibition catalog *Other Sources: An American Essay* (San Francisco: San Francisco Art Institute, 1976), 37. Marc Wehby, director of the Kravets/Wehby Gallery, New York, confirmed that another version of Colescott's *Homage to Delacroix: Liberty Leading the Peo-*

ple existed, although its current whereabouts are unknown. Marc Wehby, interview with the author, April 26, 2019.

32. Robert Colescott, in Joe Lewis, "Those Africans Look Like White Elephants—An Interview with Robert Colescott," *East Village Eye,* October 18, 1983, 19.

33. Steven Weisenburger, "Introduction," in *Fables of Subversion: Satire and the American Novel, 1930–1980* (Athens: University of Georgia Press, 1995), 5.

34. Emily Dickinson, "The Fascicles" ("Sheet Six," c. autumn 1862), in *Emily Dickinson's Poems, As She Preserved Them* (Cambridge, MA: Harvard University Press, 2016), 201.

35. Sally Eckhoff, "Is Shirley Temple Black?," *Village Voice,* January 14, 1981.

36. Marcia Tucker, *"Bad" Painting* (New York: New Museum, 1978).

37. Susan Landauer, "Having Your Cake and Painting It, Too," in *The Lighter Side of Bay Area Figuration* (Kansas City, MO: Kamper Museum of Contemporary Art, 2000), 38, 43.

38. "Wishing on a Star," on Rose Royce, *Rose Royce II: In Full Bloom,* Whitfield Records WH 3074, 1978, LP.

39. E. Patrick Johnson, *"Strange Fruit:* A Performance about Identity Politics," *TDR: The Drama Review* 47, no. 2 (2003): 94–95, https://muse.jhu.edu (accessed July 4, 2019).

40. Robert Colescott, in Becker, "Art: Satiric Mastery," 142.

41. "Colescott de-abstracts the Picasso composition *Les Demoiselles d'Avignon,"* writes art historian Lowery Stokes Sims, "[restoring] these female apparitions to their original European painterly manifestations." Lowery Stokes Sims, in Kahan, *Robert Colescott: A Retrospective,* 8.

42. Melvin Van Peebles, *Le Chinois du XIVieme* (Paris: Jérome Maartineau, 1966); Melvin Van Peebles, *Le Permission/La Fête à Harlem* (Paris: Jérome Maartineau, 1967); and Himes, *My Life of Absurdity.*

43. "I did a self-portrait seated in front of Matisse's *Dance,* unfinished, as though I were Matisse working on it. That's a kind of a key." Robert Colescott, in Becker, "Art: Satiric Mastery," 142.

44. Robert Colescott, in Becker, "Art: Satiric Mastery," 142.

45. James Weldon Johnson, *The Autobiography of an Ex-Colored Man* (1912; repr., New York: Penguin, 1990), 154.

46. Greg Tate, "Cult-Nats Meet Freaky-Deke," in *Flyboy in the Buttermilk: Essays on Contemporary America* (New York: Simon and Schuster, 1992), 200.

47. Regarding Colescott's peculiar painting technique of "[scumbling] a beige pigment over a brown one for white people" and, conversely, "[scumbling] brown over beige for blacks," curator and art historian Lowery Stokes Sims astutely observed that "as one approaches the surface of the painting and gets lost in the painterliness of the figures, the racial identities seem far more interchangeable than on first glance." Sims continues, "What Colescott promotes is what [the French psychoanalyst and psychiatrist Jacques] Lacan calls a 'heteromorphic identification'—the evolved state beyond infantile homomorphic obsessions that restrict our accommodation of difference." Lowery Stokes Sims, "The Mirror the Other: The Politics of Esthetics," *Artforum* 28 (March 1990): 114.

48. Robert Colescott, in Becker, "Art: Satiric Mastery," 142.

49. Robert Colescott, in "Interview with Robert Colescott," in *The Eye of the Beholder: Recent Work by Robert Colescott,* ed. Susanne Arnold (Richmond, VA: Marsh Gallery, 1988), 8.

50. Miriam Roberts, "Robert Colescott: Recent Paintings," in *Robert Colescott: Recent Paintings,* 42.

51. Roberts, "Robert Colescott: Recent Paintings," 42.

52. Henry Louis Gates, Jr., *Thirteen Ways of Looking at a Black Man* (New York: Random House, 1997), 107.

53. Dickson-Carr, *African American Satire,* 33.

54. Robert Colescott, *"Emergency Room,"* in Roberts, *Robert Colescott: Recent Paintings,* 30.

55. Nina Simone, *Emergency Ward* (1972), BMG 82876 596262, 2004, CD.

56. Robert Colescott, *"Triumph of Christianity,"* in Roberts, *Robert Colescott: Recent Paintings,* 38.

57. For discussions of Luis Buñuel's food imagery in his films, see Gilberto Perez, "The Priest and the Pineapple: Buñuel's *Nazarin,"* La Furia Umana, 2010, http://www.lafuriaumana.it (accessed December 5, 2018); and Raymond Durgnat, "Meat," in *Luis Buñuel* (Berkeley: University of California Press, 1968), 49–51.

58. Robert Colescott, in Dorothy Shinn, "Artist Defends Use of Satire in Works," *Akron Beacon Journal,* June 19, 1988.

59. Robert Colescott, in Becker, "Art: Satiric Mastery," 142.

60. Robert Colescott, "An Inquiry into the Creative Force," in Selz, ed., *Robert Colescott/Troubled Goods,* 39.

61. Richard Pryor, *Bicentennial Nigger,* BS 2960, Warner Bros., 1976, LP.

62. Robert Colescott, in Marcia Tucker, *Not Just for Laughs: The Art of Subversion* (New York: New Museum, 1981), 29.

63. Robert Colescott, *Another Judgment,* n.p.

64. Robert Colescott, *"Heartbreak Hotel,"* in Roberts, *Robert Colescott: Recent Paintings,* 28.

ILLUSTRATION CREDITS

The photographers and the sources of visual material other than the owners indicated in the captions are as follows. Every effort has been made to supply complete and correct credits; if there are errors or omissions, please contact Yale University Press so that corrections can be made in any subsequent edition.

Fig. 1. © Bridgeman Images

Fig. 2. Photo: Gavin Ashworth

Fig. 3. © CNAC/MNAM/Dist. RMN—Grand Palais/Art Resource, NY. Photo: Martine Beck-Coppola

Fig. 4. Photo: The British Museum

Fig. 5. Photo: The Metropolitan Museum of Art

Fig. 6. Photo: Yale University Art Gallery

Fig. 7. © 2019 Estate of George Grosz/Licensed by VAGA at Artists Rights Society (ARS), NY. Photo: Yale University Art Gallery

Fig. 8. © 2019 Estate of Robert Arneson/Licensed by VAGA at Artists Rights Society (ARS), NY. Photo: Hirshhorn Museum and Sculpture Gardens, Smithsonian Institution

Figs. 9, 101, 110. © 2019 Estate of Robert Colescott/Artists Rights Society (ARS), New York. Photos: Rubell Family Collection

Fig. 10. Barry Blitt/*The New Yorker* © Conde Nast

Fig. 11. TOLES © 2008 *The Washington Post.* Reprinted with permission of ANDREWS MCMEEL SYNDICATION. All rights reserved

Figs. 12, 45. Photos: Library of Congress

Fig. 13. Photo: American Antiquarian Society

Figs. 14, 111–12, 116. © 2019 Estate of Robert Colescott/Artists Rights Society (ARS), New York

Fig. 15. © 2019 Catlett Mora Family Trust/Licensed by VAGA at Artists Rights Society (ARS), NY. Photo: The Brooklyn Museum

Figs. 16, 17. Photos courtesy of The Criterion Collection

Fig. 18. Kalup Linzy. Courtesy of the artist and David Castillo Gallery

Fig. 19. Photo courtesy of Amazon Studios

Fig. 20. © David Hammons. MoMA PS1 Archives, Digital Image © The Museum of Modern Art/Licensed by SCALA/Art Resource, NY

Fig. 21. © Copyright Agency Licensed by Artists Rights Society (ARS), New York, 2019. Image copyright © The Metropolitan Museum of Art. Image Source: Art Resource, NY

Fig. 22. © 2017 Universal City Studios Productions LLLP. Photo courtesy of Universal Studios Licensing LLC

Fig. 23. Joyce J. Scott. Courtesy of the artist and Goya Contemporary Gallery. Photo: Ken Ek

Fig. 24. © David McGee. Photo courtesy of the artist and Texas Gallery, Houston

Fig. 25. © Carrie Mae Weems. Courtesy of the artist and Jack Shainman Gallery, New York

Fig. 26. © Wayne Miller/Magnum Photos

Fig. 27. Morrie Turner. Courtesy EBONY Media Operations, LLC. All rights reserved

Figs. 28, 30–35, 37–42, 44, 46–49, 55. © 2019 Estate of Oliver Wendell Harrington. Courtesy of Dr. Helma Harrington

Fig. 29. © 2019 Estate of Robert Colescott/Artists Rights Society (ARS), New York. Photo: University of California, Berkeley Art Museum and Pacific Film Archive

Fig. 36. The LIFE Picture Collection/Getty Images

Figs. 43, 51, 54, 56, 57. © 2019 Estate of Oliver Wendell Harrington. Courtesy of Dr. Helma Harrington. Photos: Library of Congress

Figs. 50, 52, 53, 58–60, 62. © 2019 Estate of Oliver Wendell Harrington. Courtesy of Dr. Helma Harrington. Photos courtesy of Dr. Walter O. Evans

Fig. 61. Jeff Stahler. Courtesy of the artist. Photo: Jeff Stahler Collection, The Ohio State University Billy Ireland Cartoon Library & Museum, The Ohio State University Libraries

Fig. 63. © 2019 Estate of Robert Colescott/Artists Rights Society (ARS), New York. Photo courtesy of Arlene Schnitzer and the Portland Art Museum

Fig. 64. © Kara Walker, courtesy of Sikkema Jenkins & Co., New York. Photo: Walker Art Center

Fig. 65. Photo: The John & Mable Ringling Museum of Art of the State Art Museum of Florida

Fig. 66. Photo: The Library Company of Philadelphia

Fig. 67. Photo: Duke University, David M. Rubenstein Rare Book & Manuscript Library

Fig. 68. Image Copyright © The Metropolitan Museum of Art. Image Source: Art Resource, NY

Fig. 69. Photo courtesy of the Hayden Family Revocable Art Trust and the National Gallery of Art

Figs. 70, 71. © Estate of Jeff Donaldson. Photo courtesy of the Estate of the artist and Kravets/Wehby Gallery, New York

Fig. 72. © Estate of Joe Overstreet/Artists Rights Society (ARS), New York. Photo: Paul Hester, Houston

Fig. 73. Betye Saar. Courtesy of the artist and Roberts Project. Photo: Benjamin Blackwell

Figs. 74, 118. © 2019 Estate of Robert Colescott/Artists Rights Society (ARS), New York. Photo © Christies Images/Bridgeman Images

Fig. 75. Photo courtesy of Scorpion Releasing

Fig. 76. © Bruce Davidson/Magnum Photos

Fig. 77. © 2019 Estate of Larry Rivers/Licensed by VAGA at Artists Rights Society (ARS), NY. ©CNAC/MNAM/Dist. RMN—Grand Palais/ Art Resource, NY. Photo: Philippe Migeat

Fig. 78. Photo courtesy of MGM

Figs. 79, 80. © 1970, renewed 1988 Columbia Pictures Industries, Inc. All rights reserved. Photos courtesy of Columbia Pictures

Fig. 81. © David Levinthal. Photo courtesy of the artist

Fig. 82. © Michael Ray Charles. Digital image © The Museum of Modern Art/Licensed by SCALA/Art Resource, NY

Fig. 83. © 2019 Estate of Robert Colescott/Artists Rights Society (ARS), New York. Photo: Chrysler Museum of Art

Fig. 84. Howardena Pindell. Courtesy of the artist and Garth Greenan Gallery

Fig. 85. © David Hammons. Photo: Tim Nighswander, courtesy of Glenstone Museum

Fig. 86. © 2019 Estate of Robert Colescott/Artists Rights Society (ARS), New York. Photo: Charles Mayer Photography

Fig. 87. © Beverly McIver. Photo: Les Todd

Fig. 88. © Jefferson Pinder. Photo courtesy of the artist

Fig. 89. © Kerry James Marshall. Courtesy of the artist and Jack Shainman Gallery, New York

Fig. 90. © Kara Walker, courtesy of Sikkema Jenkins & Co., New York. Photo: Jason Wyche

Fig. 91. © Zanele Muholi. Courtesy of the artist and Stevenson, Cape Town/Johannesburg and Yancey Richardson, New York

Fig. 92. © Arthur Jafa. Courtesy of the artist and Gavin Brown Enterprise, New York

Fig. 93. Hiro Murai and Donald Glover. Courtesy of the director and artist

Fig. 94. © 2019 Estate of Robert Colescott/Artists Rights Society (ARS), New York. Photo courtesy of Jordan D. Schnitzer

Fig. 95. © William Ebie. Courtesy of the Roswell Artist-in-Residence Foundation

Fig. 96. Program cover photo © Edmund Lee

Fig. 97. © 2019 Estate of Robert Colescott/Artists Rights Society (ARS), New York. Photo: Akron Art Museum

Fig. 98. © 2019 Estate of Robert Colescott/Artists Rights Society (ARS), New York. Photo: Minneapolis Institute of Art

Figs. 99, 108. © 2019 Estate of Robert Colescott/Artists Rights Society (ARS), New York. Photos courtesy of the Portland Art Museum

Fig. 100. © 2019 Estate of Robert Colescott/Artists Rights Society (ARS), New York. Photo: Dan Kritka Photography, Portland, courtesy of Arlene Schnitzer

Fig. 102. © 2019 Estate of Robert Colescott/Artists Rights Society (ARS), New York. Photo courtesy of Kravets/Wehby Gallery, New York

Fig. 103. © 2019 Estate of Robert Colescott/Artists Rights Society (ARS), New York. Photo: Mott-Warsh Collection

Fig. 104. © 2019 Estate of Robert Colescott/Artists Rights Society (ARS), New York. Photo: Don Ross

Fig. 105. © 2019 Estate of Robert Colescott/Artists Rights Society (ARS), New York. Photo: San Jose Museum of Art

Fig. 106. © Estate of Arthur Mones. Photo: The Brooklyn Museum

Fig. 107. © 2019 Estate of Robert Colescott/Artists Rights Society (ARS), New York. Photo: Julian Calero

Fig. 109. © 2019 Estate of Robert Colescott/Artists Rights Society (ARS), New York. Digital image © Whitney Museum of American Art/ Licensed by SCALA/Art Resource, NY

Fig. 113. © 2019 Estate of Robert Colescott/Artists Rights Society (ARS), New York. Photo: Eskenazi Museum of Art

Fig. 114. © 2019 Estate of Robert Colescott/Artists Rights Society (ARS), New York. Image copyright © The Metropolitan Museum of Art. Image Source: Art Resource, NY

Fig. 115. © 2019 Estate of Robert Colescott/Artists Rights Society (ARS), New York. Photo: Sheldon Museum of Art

Fig. 117. © 2019 Estate of Robert Colescott/Artists Rights Society (ARS), New York. Digital image © The Museum of Modern Art/Licensed by SCALA/Art Resource, NY

Fig. 119. © 2019 Estate of Robert Colescott/Artists Rights Society (ARS), New York. Photo © Wilson Graham Photography

Fig. 120. Courtesy of Warner Bros. Records, Inc.a